THE COMPLETE
MOSAIC
HANDBOOK

Projects • Techniques • Designs

THE COMPLETE
MOSAIC
HANDBOOK

Projects • Techniques • Designs

SARAH KELLY

with contributions from

JULIET DOCHERTY

ANNE READ

ROSALIND WATES

FIREFLY BOOKS

A FIREFLY BOOK

Published by Firefly Books Ltd., 2004

Copyright © 2004 Quintet Publishing.

All rights reserved. No part of this publication may be reproduced, stored in a retrieval system, or transmitted in any form or by any means, electronic, mechanical, photocopying, recording, or otherwise without the prior written permission of the copyright owner.

First printing.

National Library of Canada Cataloguing in Publication Data
Kelly, Sarah
The complete mosaic handbook: projects, techniques, designs / Sarah Kelly ; with contributions from Juliet Docherty, Anne Read, Rosalind Wates.
Includes index.
ISBN 1-55297-774-9
1. Mosaics--Technique. I. Docherty, Juliet II. Read, Anne III. Wates, Rosalind IV. Title.
TT910.K44 2004 738.5 C2003-901107-0

Publisher Cataloging-in-Publication Data (U.S.)
Kelly, Sarah.
The complete mosaic handbook : projects, techniques, designs / Sarah Kelly ; with contributions from Juliet Docherty, Anne Read, Rosalind Wates. –1st ed.
[320] p. : col. ill., photos. ; cm.
Includes index.
Summary: Practical step-by-step guide for creating mosaic including basic and advanced techniques and 30 projects.
ISBN 1-55297-774-9
1. Mosaics _Technique. I. Title.
738.5 21 TT910.K29 2004

Published in Canada in 2004 by
Firefly Books Ltd.
66 Leek Crescent
Richmond Hill, Ontario L4B 1H1

Published in the United States in 2004 by
Firefly Books (U.S.) Inc.
P.O. Box 1338, Ellicott Station
Buffalo, New York 14205

This book was designed and produced by
Quintet Publishing Limited
6 Blundell Street
London N7 7BH

Project Editor: Clare Tomlinson
Copy Editor: Alison Leach

Art Director: Tristan de Lancey
Designer: Ian Hunt
Illustrator (for the projects): Julian Baker
Illustrator (for the templates): Jenny Dooge
Photographer: Jeremy Thomas

Managing Editor: Diana Steedman
Creative Director: Richard Dewing
Publisher: Oliver Salzmann

Manufactured in Singapore by
Pica Colour Separation Overseas

Printed in China by
SNP Leefung Printers Ltd

Many thanks to Ann Thomson, for doing "that drive" and for all her practical help, and to Paul Cemmick for everything else

Contents

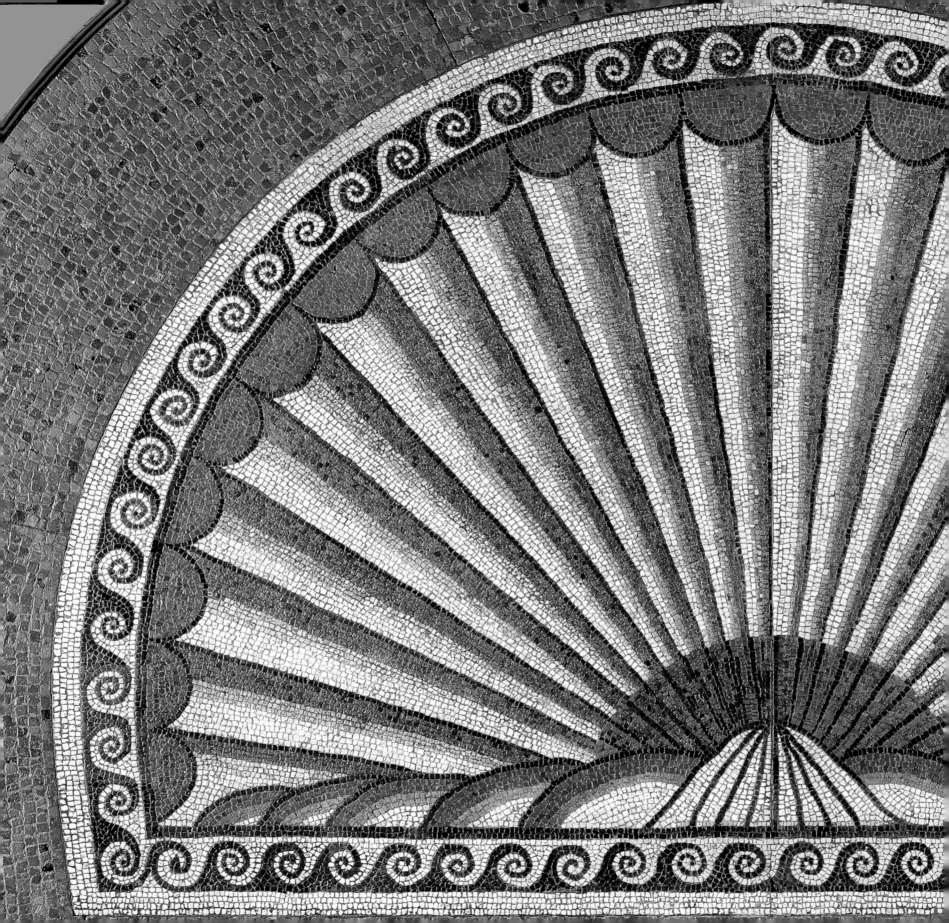

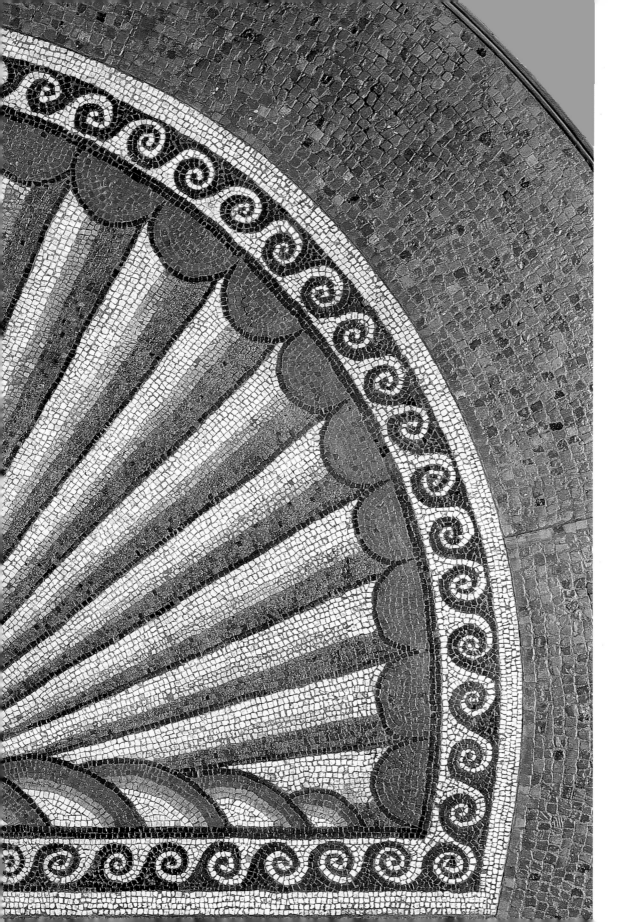

Introduction

Charting the history of mosaics from
3000 B.C. to the present day, this
beautifully illustrated chapter will
provide you with essential background
information about this age-old craft.

Introduction

Mosaics have fascinated people for centuries. Intricate designs created from many tiny gleaming pieces immediately capture the eye and give the viewer a dual pleasure—the image itself and the beauty of its constituent parts. Mosaics are both a functional form and a decorative art, making them endlessly versatile and appealing. When you begin to design and make your own mosaics, the pleasure of creating something out of something else is an intriguing process and quickly becomes addictive. Each tessera seems precious and has a charm of its own, whether it is a fragment of broken pottery, a shimmering glass tile, a richly coloured piece of smalti or a pebble of subtle natural beauty. The anguish of breaking a much-loved piece of ceramic is eased by the knowledge that it can be reincarnated in a wonderful mosaic creation. Nothing is wasted: mosaic can find a use for almost anything. For those with magpie tendencies, mosaic provides the perfect outlet for carefully hoarded treasures that are just too pretty to throw away, or it can provide an excuse for acquiring even more bright and sparkly things…sheer indulgence!

Everyday examples of mosaic art and decoration exist in a variety of forms in many places, just waiting to be noticed. Stores may yield tiled doorsteps of Victorian or Art Deco origin with elaborate lettering and floral patterns or strong geometric designs. Some underpasses, urban areas and underground train stations feature decorated walls or murals, sometimes designed and executed with the help of the local community. In the U.K., the London Underground contains many fine examples of decorated walls, including Edward Paolozzi's fiesta of shape and colour at Tottenham Court Road station. Shopping centres, museums, galleries and other buildings may feature specially commissioned works on floors or walls. Swimming pools may display mosaic designs beyond the usual fare of rows and rows of aquamarine-coloured tiles. Mosaic often features in astonishingly beautiful images and decoration in churches, mosques and other places of worship, as well as appearing on sculptures, works of public art, decorated columns and in gardens, parks and grottoes.

These, of course, are in addition to the places throughout the world where you are likely to find particularly famous examples of the mosaic genre.

Any country that was part of the Roman Empire will possess a treasure trove of examples of the decorated floors and walls that formed parts of villas and other buildings. Churches from the Byzantine and Christian periods contain stunning examples of pictorial mosaic mixing the vivid, realistic colours of smalti with gold. In Ravenna, northern Italy, the church of San Vitale is one of many

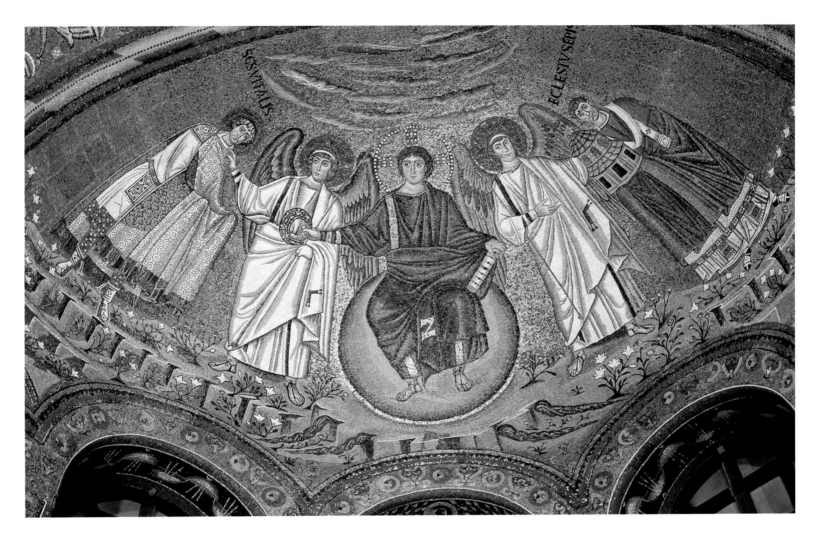

buildings whose interiors feature lushly coloured images, executed in glass smalti, gold and precious and semi-precious stones.

Modern-day Istanbul, in Turkey, formerly the city of Constantinople, was a thriving and wealthy meeting place of European and Asian cultures, which is reflected in the heady mix of art and architecture that exists in the city today. The 14th-century mosaics in the Kariye Camii (Saint Saviour in Chora) are considered by some to be the finest of their kind, with their sensitive rendering of the subjects and sense of vitality. The fabulous Hagia Sophia (see picture overleaf)—once a church, then a mosque and now a museum—also contains beautiful examples of religious imagery. In the ceiling mosaic, believed to be one of the largest mosaics ever made, 150 million gold tesserae were used—the equivalent of 1,000 tons of glass! Remarkable mosaics from this period can be also found in Rome and Venice, and across Sicily and Greece.

The sixth-century mosaic in the church of San Vitale in Ravenna, Italy, of Christ surrounded by two angels, St. Vitalis and Bishop Ecclesius, is a rich example from the Byzantine school of mosaic.

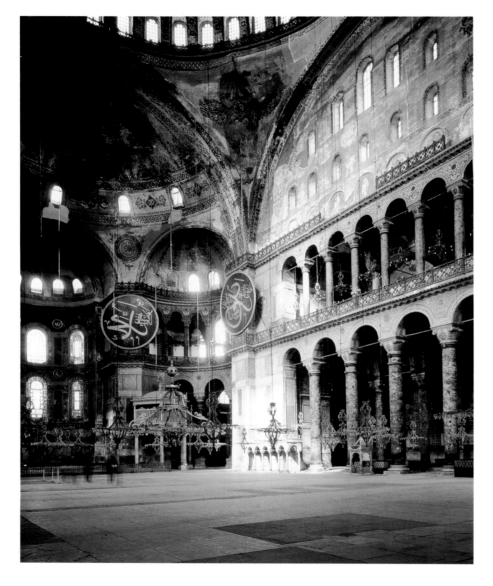

The church of Hagia Sophia (Aya Sophia), in Istanbul, Turkey, shows sixth-century Byzantine mosaics on a grand scale. The walls, ceiling and archways are decorated in beautiful, if now decaying, mosaic patterns.

The Spanish city of Barcelona is home to the unique and exuberant mosaic and architectural designs of Antoni Gaudí. These include the organic-looking Casa Batlló, with its curving, scaly roof reminiscent of the back of a gigantic dragon, the contorted roof towers of Casa Milá (also known as La Pedrera), the soaring towers of the truly awe-inspiring Sagrada Familia and the charming and eccentric Parc Güell, with its mosaic-encrusted pavilions, lizard staircase and undulating benches. All of Parc Güell's features are decorated with a mixture of broken tiles, reconstituted smashed plates, specially made ceramic pieces and shards of glass, varying from shades of white and cream to a riot of color and pattern.

Barcelona is definitely a "must visit" for the mosaic enthusiast, because the city also boasts a number of elaborate *modernista* (Art Nouveau) buildings, often liberally and beautifully adorned with mosaic. La Palau de la Música Catalana is a particularly breathtaking example, combining sculpture, stained glass and mosaic. Delicately sculpted figures of musicians burst out from a mosaic wall in the concert hall, and an exterior balcony is home to an avenue of slender pillars decorated with stylized floral designs.

Remaining in Spain, the southern region of Andalucia contains many mosaics in the Moorish style—known as *zillij*—a remnant from the Moorish occupation of the eighth to the fifteenth centuries. The palace of the Alhambra in Granada is lavishly decorated in this way and, combined with the extreme beauty of the architecture, makes for an extraordinary sight. In Morocco itself, this type of intricately designed geometric mosaic decorates palaces, mosques and public buildings. They are made up from glazed tiles, individually named and ranging in shape from diamonds to stars to stylized petal forms, which are fitted together in a series of prescribed patterns.

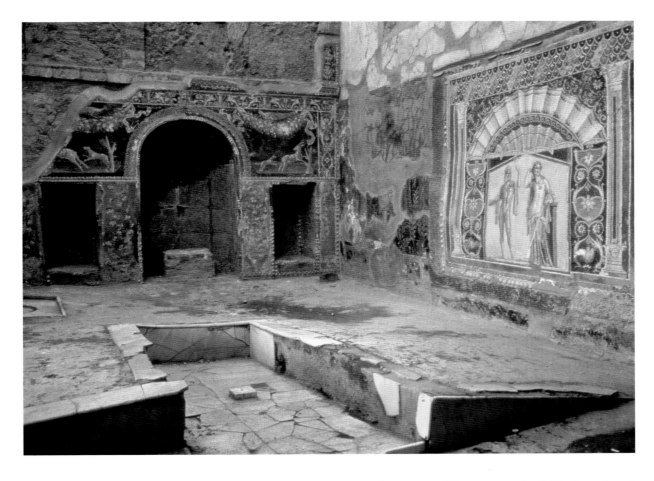

The intricate mosaics found in the ancient city of Herculaneum, Campania, Italy, were frozen in time when Mount Vesuvius erupted in A.D.79, covering the city in ash. This first-century B.C. example was found in the House of Neptune and Amphitrite.

The beauty and complexity of these provide a source of endless viewing pleasure, making for an almost meditative experience as one focuses on the different aspects and rhythms within the pattern.

These works, which have inspired countless others to create mosaics, represent just a few examples. There are many mosaic treasures to discover across the world, contemporary and historical, complex and simple, created from junk or precious materials, executed by the trained practitioner or the enthusiastic novice, for pleasure or purpose or both.

Historically, the first form of mosaic was found in the former country of Mesopotamia, now Iraq, in around 3000 B.C. This consisted of black, red and white clay cones embedded into the walls of buildings, with the prime intention of strengthening the structure. Mosaic developed in different forms throughout the ancient world—the various peoples of ancient Mexico used fragments of turquoise to adorn important ceremonial objects, and the ancient Greeks used variously colored pebbles to create designs for floors. In Pella, Macedonia, pebble mosaics were created in the fourth century B.C. using carefully chosen stones to achieve contrast and subtle gradations of light and shade, with lead strips inserted between areas of pebble to give definition to

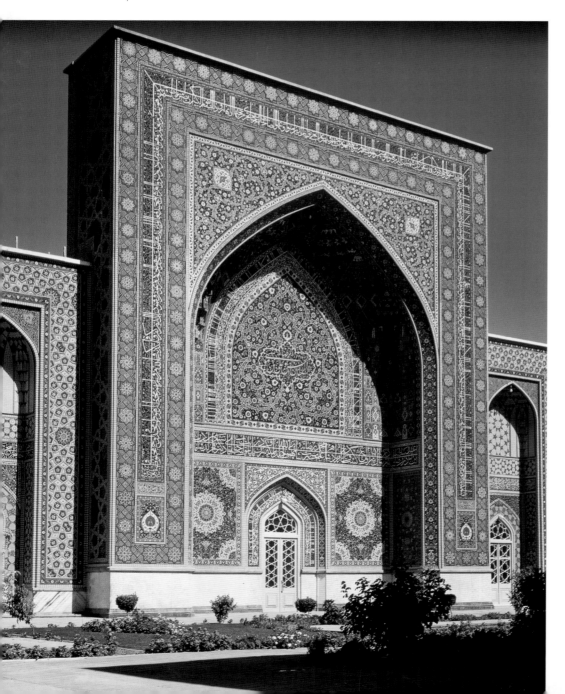

The entrance portal to the shrine of Gawharshad Mosque, Mashhad, Iran, which dates from 1418, is lavishly decorated with beautiful mosaic.

form. As time progressed, this technique became more complex, with smaller stones being used. Eventually, stones were specially cut into regular geometric forms, which made them easier to fit together. Small pieces of glass also began to be included.

However, it was the Romans who took mosaics to a greater level of sophistication. They transformed a functional technique into a highly artistic one. The planning of the mosaics also became more precise, with designs tailored specifically to fit into a particular room or area. Narrative panels, featuring stories of the Gods and scenes of everyday life, like fishing, hunting and harvesting, were created, as well as a bewildering array of decorative borders, with lushly flowing vegetation or simple geometric patterns. These detailed pictorial sections set into large backgrounds are known as *emblema*.

Mosaics of the Christian period were widely used to decorate the walls of churches, and coloured glass and gold were used to full effect. They were often sited some distance from where the congregation sat, so colours were exaggerated and heightened and figures simplified. The style in which the tesserae were laid (known as *opus*) gave more definition to the objects in the foreground, which meant that there was not such a great need for contrast between them and the background, although full gold backgrounds soon became popular.

Craftsmen of the Byzantine period began to make full use of the reflective qualities of the glass and gold tesserae by angling them in different ways within the mosaic to catch light from the available sources and reflect it down to the viewer. They also began using natural stone to create faces, utilising between six and eight subtle shades that gave the flesh tones a realistic, almost painterly, quality. The mosaics created in Ravenna in the sixth century featured tesserae cut

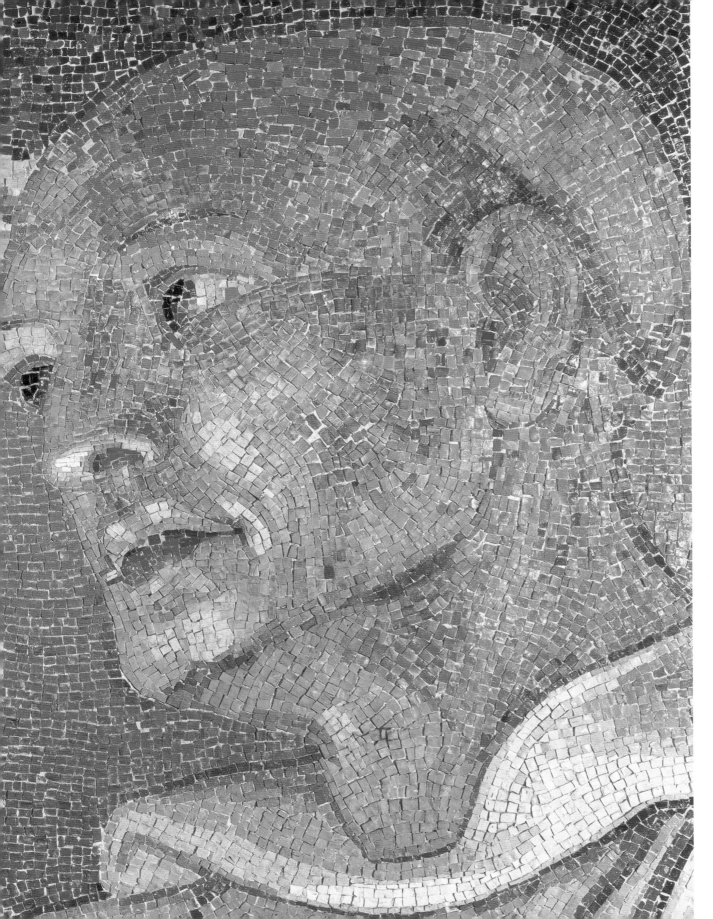

Smalti has been used for mosaic portraits for centuries. It is available in a wide variety of colours and tones, which the mosaicist can use to create subtle effects. This 15th-century representation of St. Bernard of Clairvaux (c. 1090–1153) can be found in the Crypt of St. Peter's church, The Vatican.

In 1433, the Museo dell'Opera del Duomo in Florence, Italy, commissioned Donatello to design a Cantoria (singers' gallery). Completed in 1439, the area is embellished with marble statues and mosaics of glass and marble.

tesserae cut specially to fit the contours of faces, which gave them a real sense of vitality. By contrast, the garments of the figures became quite stylised, with the folds of the fabric flattened and decorated with surface pattern, as seen in the mosaics of the Emperor Justinian and the Empress Theodora in the presbytery of San Vitale in Ravenna.

The Renaissance period saw mosaics develop in sophistication and technical effect as craftsmen succeeded in emulating paintings so well that they no longer resembled mosaics. One artist dubbed mosaic as *"la vera pittura per l'eternitá"* (the true way of painting for eternity), and while these pieces are quite amazing to look at, the techniques of the mosaic are completely disguised and do not communicate the joy and exuberance of the earlier styles.

Mosaics became further refined when a technique for making tesserae was invented in the early 1870s

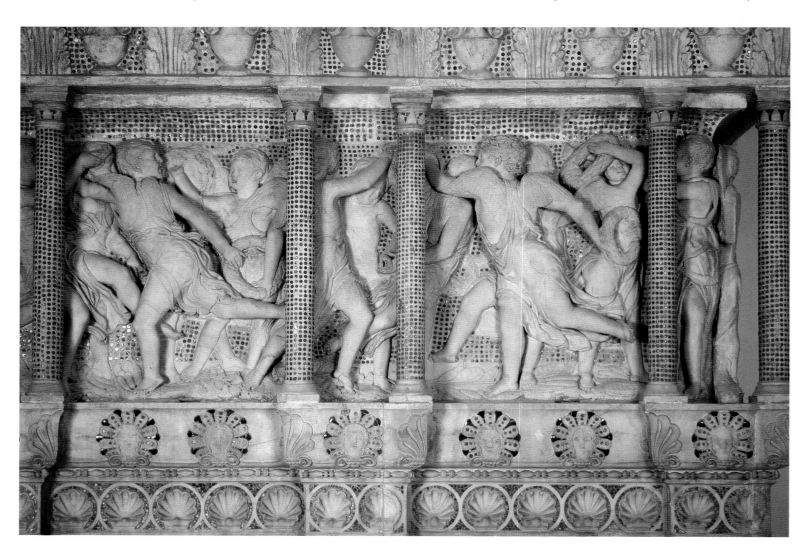

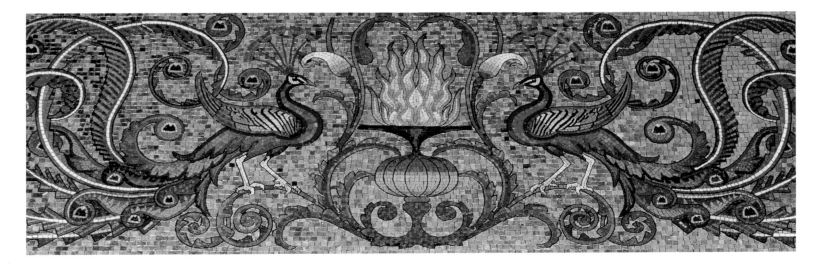

by Giacomo Raffaelli. Called *filati*, some of these tesserae were only 1 mm (⅕ inch) wide. This inspired a wave of "micromosaics," work so finely rendered that the mosaicists striving for that painted effect finally succeeded—the mosaic effect became almost totally invisible. This technique was also used to create and decorate furnishings, tables, vases, snuff boxes and pieces of jewellery. This painstaking attention to detail, with the aim of making mosaic resemble something else, resulted in a deadening of its creativity, which was to change only with the advent of Art Nouveau.

The Art Nouveau period of the late 19th-century—also known as Modernism and the Secession—revived an interest in using mosaic on a larger scale. The Viennese painter Gustav Klimt designed a frieze for the Palais Stoclet in Brussels in the early 1900s. It featured exotic spiralling trees and stylised figures with gloriously patterned clothing in Klimt's customary style and was executed in the richest and most luxurious materials possible—marble, copper, gold, faience (painted and glazed earthenware), coral and semi-precious stones—all specifically manufactured for the project.

But it is the Catalan artist Antoni Gaudí who is credited with infusing mosaic with fresh enthusiasm. His incredible buildings and structures are covered in an anarchic but fascinatingly beautiful blend of mixed-media mosaic, which often included found items (see overleaf). The ceramicist Josep Maria Jujol and a team of craftsmen were responsible for most of the mosaics that covered Gaudí's work, although it is Gaudí himself who usually gets the credit. This innovative attitude paved the way for sculpture and other 3-D forms to be decorated with mosaic, later examples of which include the work of the artists Niki de Saint Phalle and Simon Rodia.

In the late 1970s and early 1980s, French artist Niki de Saint Phalle created a fabulous sculptured garden near the town of Capalbio in Italy. The garden, known as the Giardino dei Tarocchi, or Tarot Garden, is based on the 22 cards of the major arcana (those representing main characters or themes) of a deck of tarot cards. The sculptures are huge and surreal—some even contain rooms—and they are decorated inside and out with flamboyant mosaics using mirror and brightly coloured ceramic tiles and objects.

This peacock frieze was created by Walter Crane (1845–1915) for the Arab Hall in Leighton House, London, U.K.

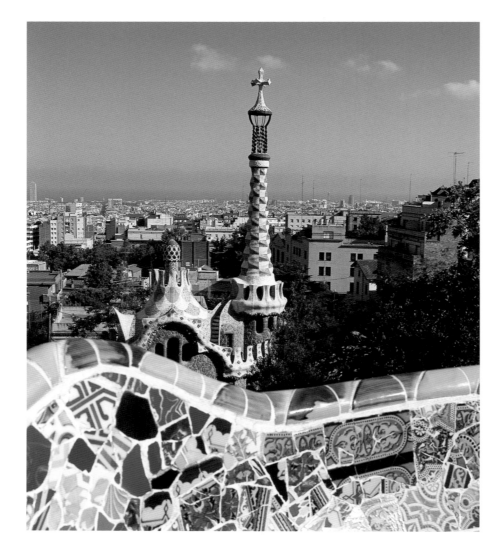

Perhaps some of the best-known mosaics in the world are to be found in Barcelona. Antoní Gaudi's work, made up of broken ceramic, paved the way for a more liberated architectural and artistic expression, particularly in the field of mosaics.

Simon Rodia was an Italian immigrant who constructed huge steel and concrete towers outside his home in Los Angeles, California. Decorated with a mixture of found objects, including shells and glass, they are over 100 feet tall and are known as the Watts Towers.

This urge to decorate with found objects on a grand scale also appeared in France. In 1938, Raymond Isidore began covering the whole of his house near Chartres in a mosaic of broken crockery and tiles. This mosaic covered all the walls, inside and out, the garden, the furniture and even a stove. The house is called Maison Picassiette, taken from the name the locals jokingly called him: *pique assiette*— literally, plate stealer. This term is now used to describe working with found and broken ceramic.

In Mexico in the 1950s, artists such as Diego Rivera (see right), Juan O'Gorman, D.A. Siqueiros and Francisco Eppens took their inspiration from Gaudí's decorated buildings and covered entire buildings in Mexico City with huge murals depicting political and social themes.

Other 20th-century artists have also been closely associated with mosaic. Works by Marc Chagall and Oskar Kokoschka were translated into mosaics that celebrated their original styles of painting. Mosaic also appeared as part of the art movements of Futurism, Cubism and Dadaism.

Today, with this fabulous heritage to draw from, mosaic is again emerging as a popular art form, with incredibly varied techniques demonstrated over a range of applications. There is something for everyone in mosaic, both in the process of creating and the pleasure in the finished piece, a pleasure that can be both visual and tactile. To create your own mosaics requires nothing more than a mastery of the basic techniques, the urge to create, and a mind open to

inspiration and exploration. Your own interests and tastes will help to develop your ideas and your choice of materials and techniques, and the huge range of possibilities means that making mosaics can be as cheap or as expensive as you like.

The intention of this book is to present a full range of mosaic techniques, materials and projects, as well as sections on finding inspiration and designing mosaics. It aims to show you what can be achieved in the hope that you can take the art of mosaic in any direction you please and discover for yourself the many delights of this fascinating medium. A substantial gallery section, as well as additional examples to accompany each project, are included to demonstrate a wide range of approaches, subjects and styles.

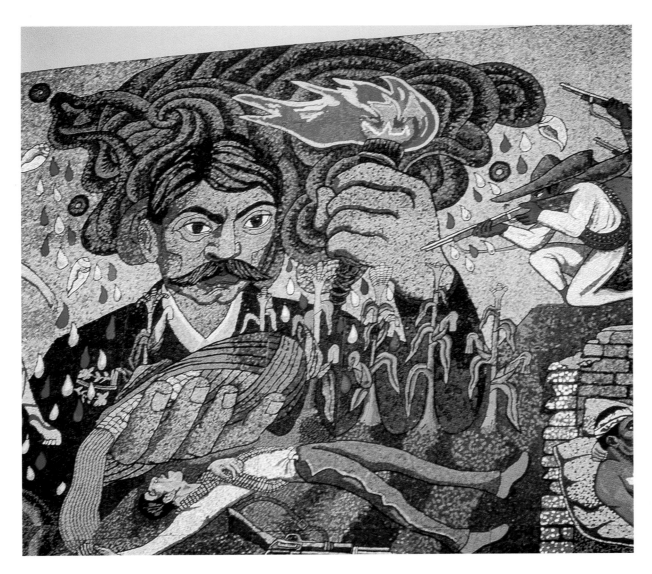

In 1953, the famous muralist Diego Rivera was commissioned to design a mosaic mural for the facade of the new Teatro Insurgentes in Mexico. The resulting piece, A Peasant Revolutionary, is both passionate and powerful.

Gallery

This selection of wonderful mosaic pieces, both old and new, will amaze and inspire in equal measures. The contemporary pieces show just how far this art form has developed.

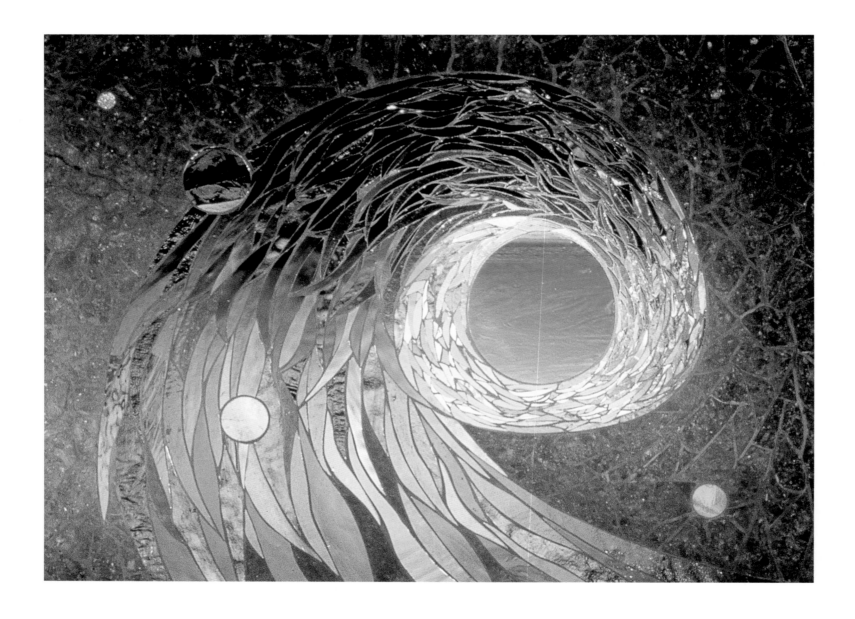

Toby Mason
Forming of the World
1997
21 × 28 in / 53 × 71 cm
Colored mirror, made from reflective cathedral glass, silvered
antique glass and thinly sliced Labradorite

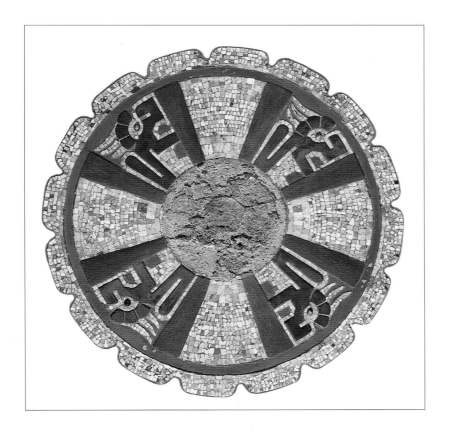

Teotezcacuitiapili, belt buckle depicting the four fire serpents, worn by dignitaries. From El Castillo, Chitchen Itza, Yucatan State (A.D. 987–1185), Mexico. This piece is housed in the Museo Nacional de Antropologia, Mexico City.

Laura Hiserote

Rite of Passage

2000

2¼ × 1⅗ in / 57 × 46 mm

Enamel-glass thread microtesserae (also known as smalti filati). Each thread is 0.13 to 0.24 mm in thickness and 3 mm in length. The threads are stood on end next to each other, but do not touch. There are an amazing 16,394 threads in this piece.

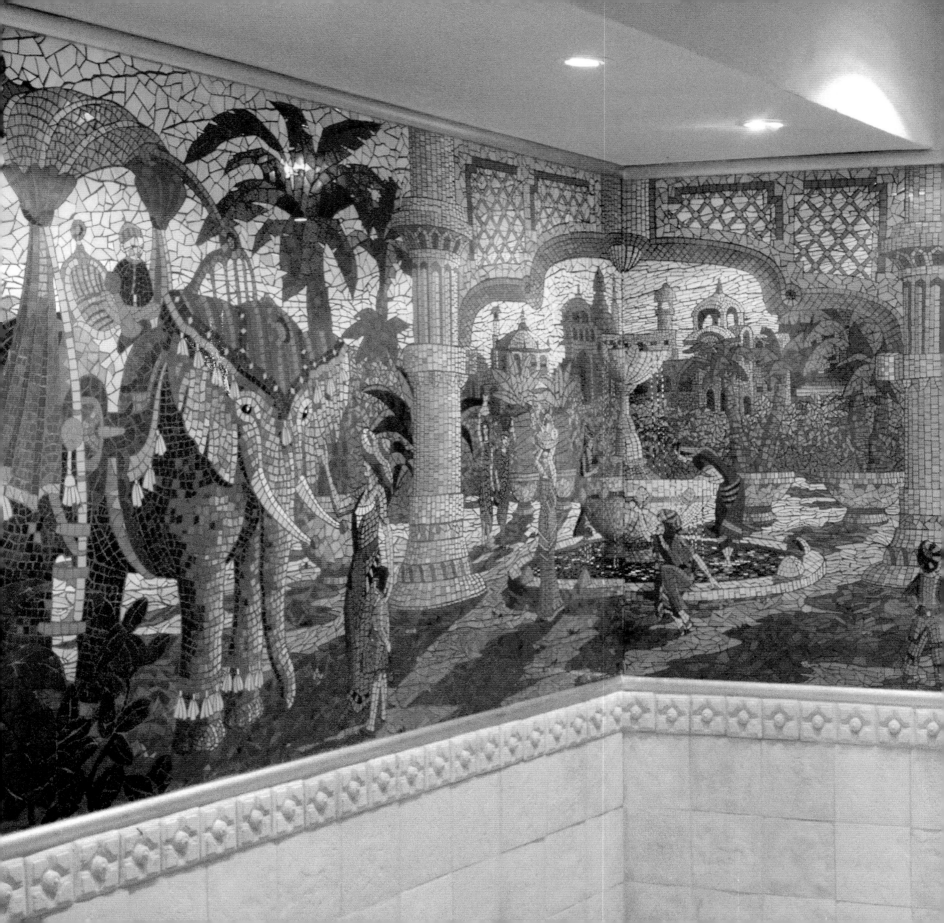

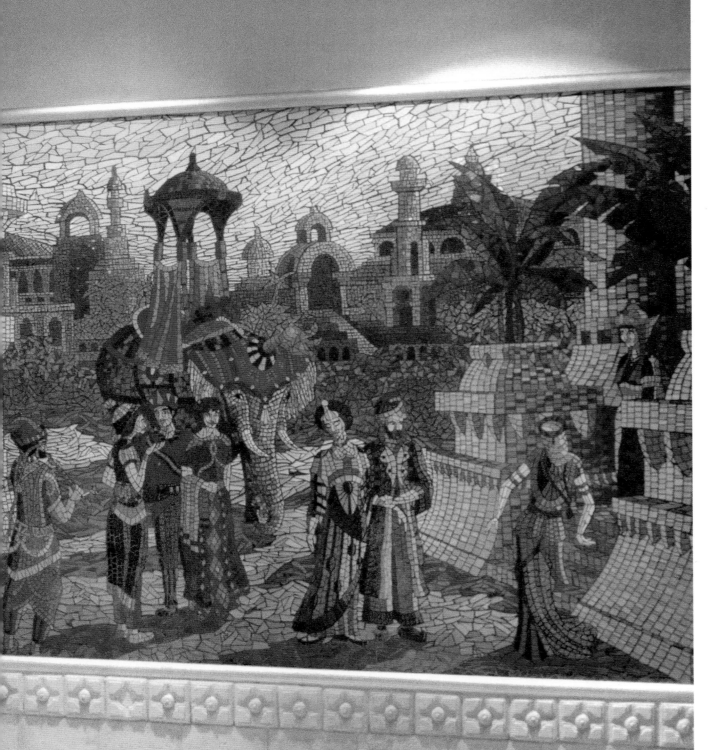

Mosaïka Art and Design
Crossroads and Cornerstones
1999
15⅝ × 4⅓ ft / 4.8 × 1.3 m
Custom-glazed ceramic tile

Sonia King
Flying Colors
2001
7 × 2⅓ × 6 ft / 2.1 m × 0.8 × 1.8 m
Glass gems and mirror

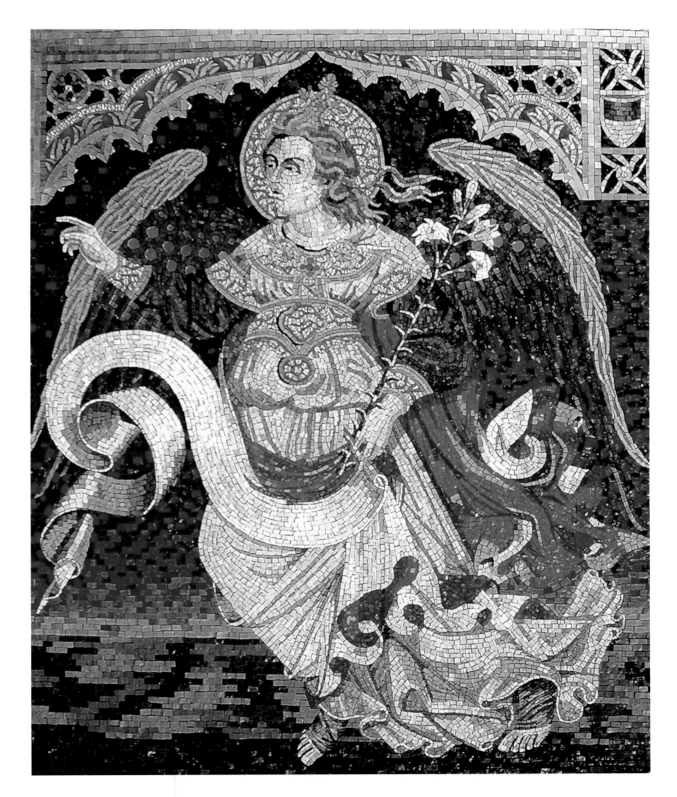

Lia Catalano
Angel Gabriel
2001
42 × 50 in / 107 × 127 cm
Smalti, gold

Mosaïka Art and Design
Arabica
2002
6 × 2⅚ ft / 1.8 × 0.85 m
Custom-glazed ceramic tile

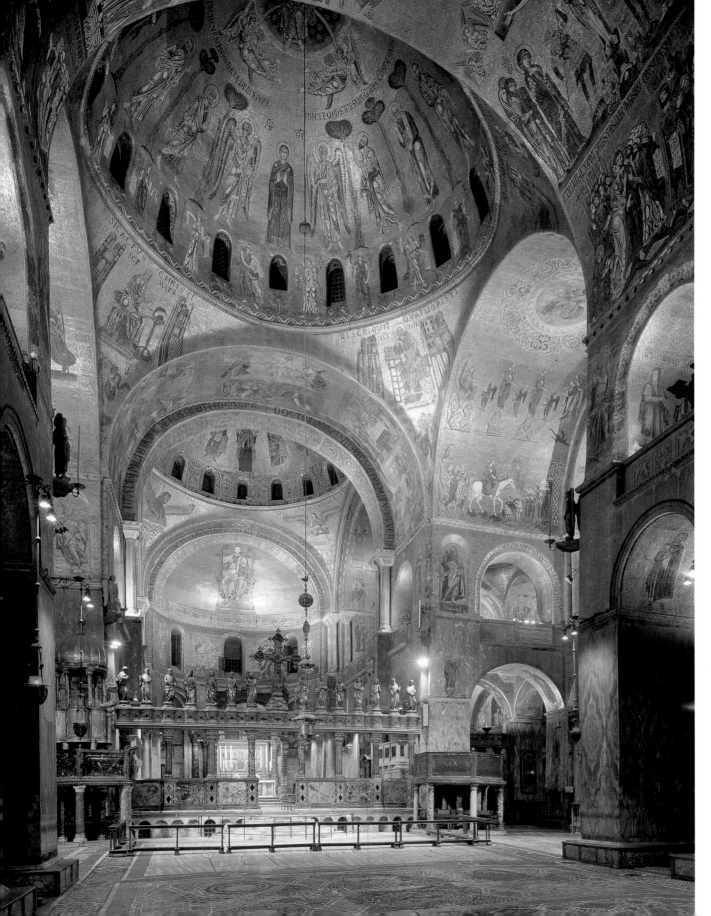

Interior view of the mosaiced nave of the Basilica di San Marco in Venice, Italy. This work is from the Veneto-Byzantine school.

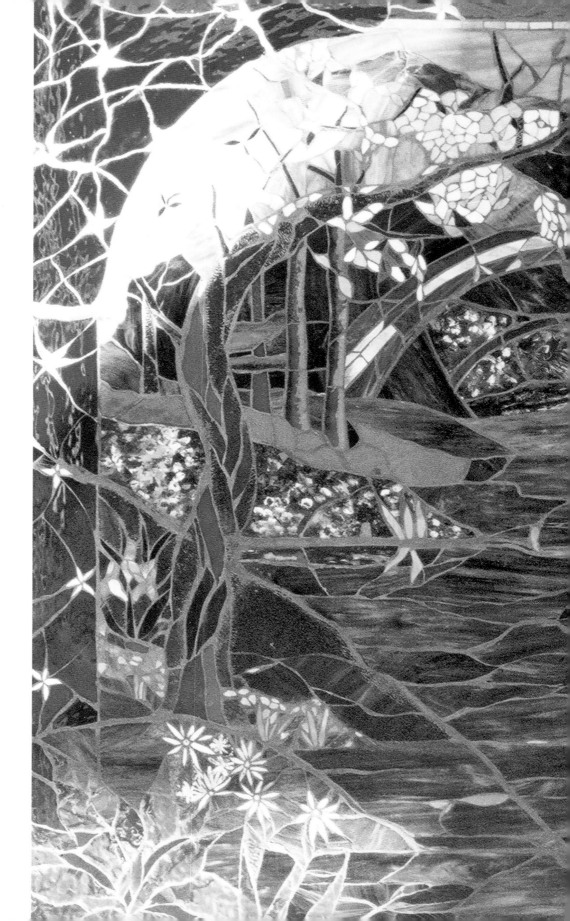

**Darlene Mace-Harvey
(Hello Darlly Garden Art)**

Pax Cum Tempore
2002
9 × 7 ft / 2.75 × 2.1 m
Stained-glass and painted clear
glass set into concrete, fiberglass
mesh and mortar

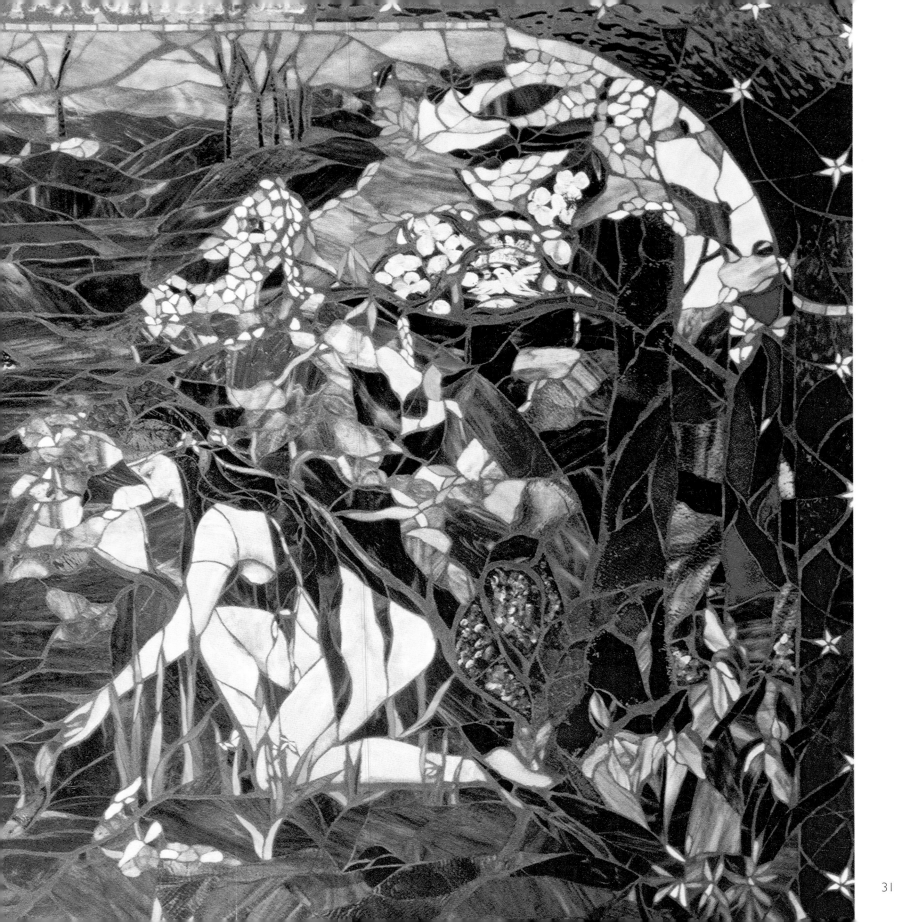

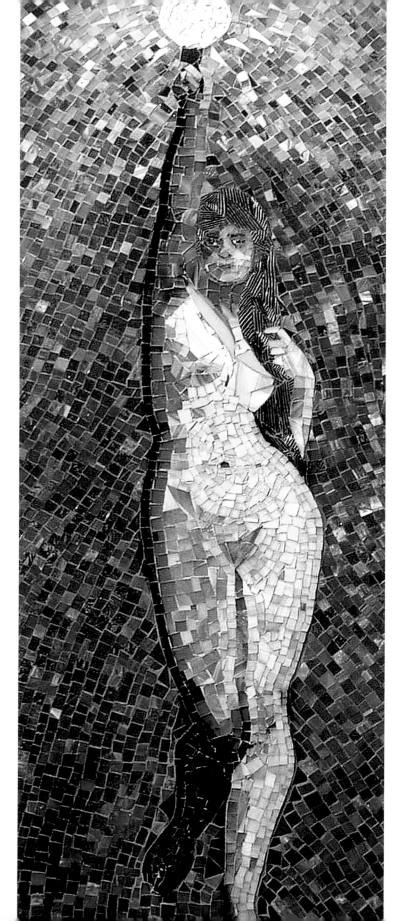

Jeannie Wray
Liberty
2001
24 × 48 in (61 × 122 cm)
Stained glass

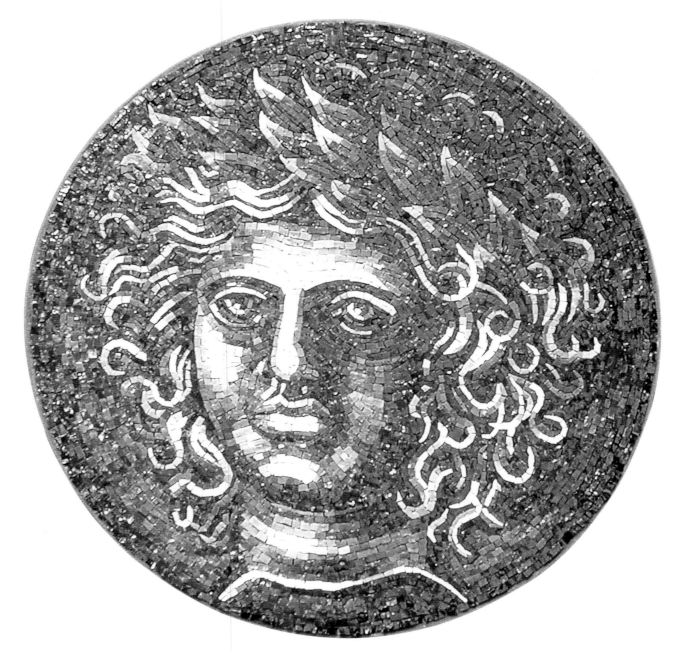

Lia Catalano
Apollo Coin
2002
24 × 24 in / 60 × 60 cm
Smalti

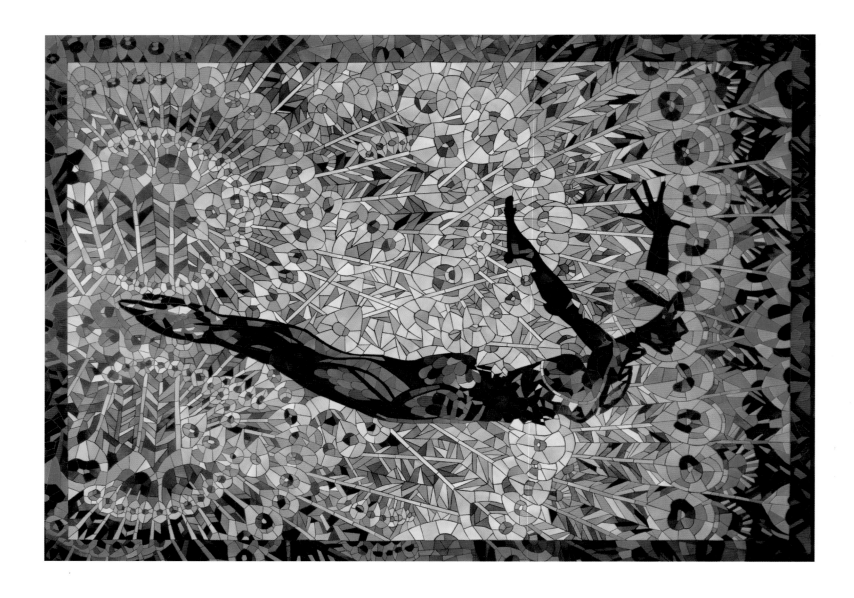

Mosaïka Art and Design
Blü
2002
6⅛ × 4¼ ft / 1.9 × 1.3 m
Custom-glazed ceramic tile

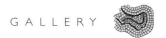

Gordan Mandich
Kingfisher
2002
35½ × 47¼ in / 90 × 120 cm
Glazed ceramics

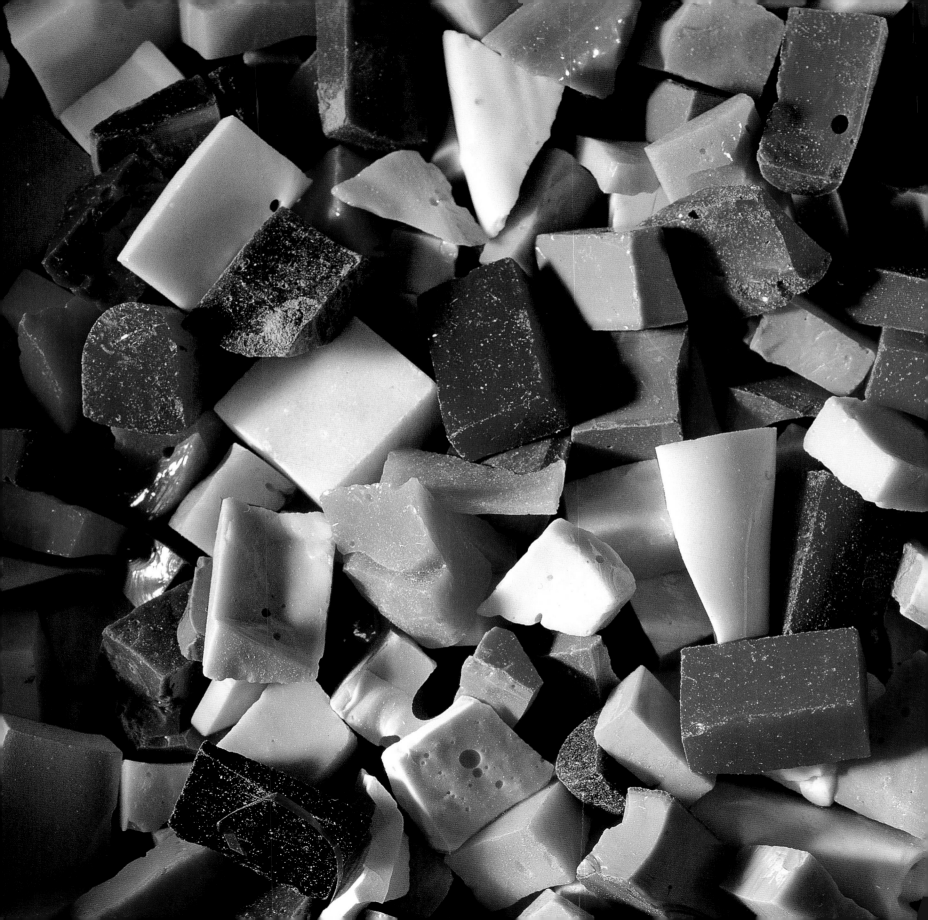

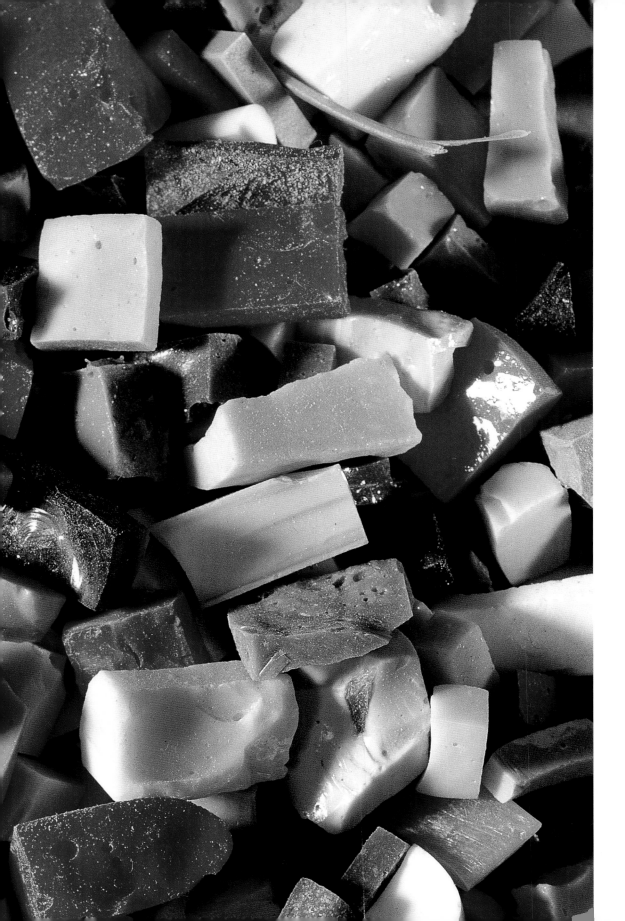

Equipment and Materials

An in-depth look at all the equipment
the mosaicist will need, plus the diverse
types of material that can be used, from
the classic, such as unglazed ceramic
and vitreous glass, to the unusual, such
as found objects and junk.

The workspace

A room that you can devote entirely to mosaic is the ideal arrangement. A collection of tiles and other materials takes up a great deal of space, especially when combined with the other paraphernalia you will acquire, such as tools, mosaic bases, tubs of adhesive and bags of grout. The room should have good ventilation, as the whole process of creating a mosaic produces a lot of dust and some adhesives smell strongly. Having a well-lit space is a must for designing and creating the mosaic, and access to running water is helpful. A bulletin board or blank wall space is likewise helpful, so that you can put up things that inspire you. The flooring should be easy to sweep clean.

It is important to be comfortable at your workstation, and to have all the necessary equipment and materials to hand.

If it is impossible to have a separate room, the floors and furniture in the room that you use as a temporary workshop should be well protected with drop cloths or layers of newspaper, and mosaic debris should be swept up and cleared away as soon as you have finished for the day. Children and pets should be kept at a distance, because fragments of broken glass and ceramic can inflict nasty cuts, and grouts and adhesives can be hazardous if handled incorrectly.

Shelves are good for storing tiles. The tiles should be kept in separate clear containers, so that you can identify each color quickly and easily. You can use kitchen storage containers, but old coffee jars with their labels removed are just as good. Larger tiles, broken crockery and bigger pieces of glass are best stored in strong plastic storage boxes. It is preferable to separate them by color or general color families so that they are easier to sort through when you are choosing pieces for a mosaic. Powdered grouts and adhesives should be kept dry and sealed in either bags or jars. If children have access to the room, these materials should be kept out of reach.

A large, strong table or workbench provides the best work surface. Place it so that you have access to all sides, especially when working on larger pieces. The surface should be of an appropriate height so that you can work while standing. If you prefer to sit down, a chair that lets you work without straining your back in any way is the best option—when seated with your arms by your sides, your elbows should be level with the surface and your hips higher than your knees. The time involved in creating a mosaic makes it essential that you are comfortable while you work to avoid putting unnecessary strain on your body. If you are spending long periods on a project, make sure you take regular breaks to stretch, especially your arms and hands, as repetitive strain injury (RSI) can occur after prolonged use of the mosaic nippers to break up the tesserae. Pads or cushions take the pressure off your knees if you are working on the floor.

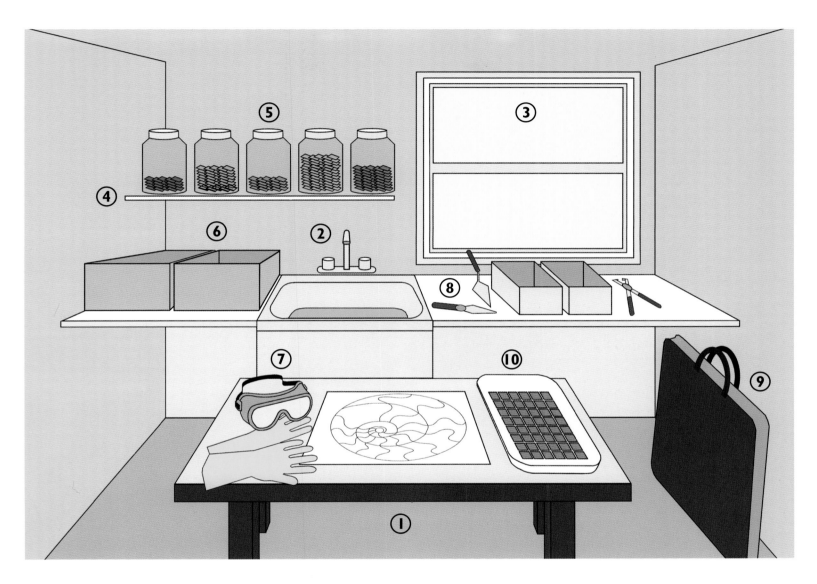

1 WORKBENCH
Of a comfortable height whether you are sitting or standing to work.

2 SINK
With running water.

3 WINDOW
A window that opens provides good ventilation and lighting.

4 SHELVES
For storing materials and equipment.

5 STORAGE JARS
For standard-size tiles.

6 STORAGE CONTAINERS
For large, random-shaped tesserae, such as broken ceramics.

7 GOGGLES AND GLOVES
To protect yourself while working in mosaic.

8 TOOLS
Tools should be stored safely when not in use.

9 PORTFOLIO
For storing sketches, photographs and other sources of inspiration.

10 SOAKING TRAY
For soaking tesserae off paper backing.

Tools and equipment

Over time, you will build up a collection of useful tools and equipment. Certain items, such as tile nippers, are essential for almost all types of mosaic, but others, such as a hammer and hardie, are only used for very specialized work.

HAMMER

A hammer is useful for breaking tiles and larger ceramic objects into random objects, especially when you are creating a crazy-paving mosaic. A hammer is also more effective (and easier on the hands) than nippers for breaking heavier materials, such as very thick ceramic and stoneware. Place the objects in a heavy-duty plastic bag to avoid flying shards, and start with three or four brisk taps with the hammer, checking how the pieces are breaking before you resume. A clear plastic bag is best, so that you can see what you are doing. (See page 68)

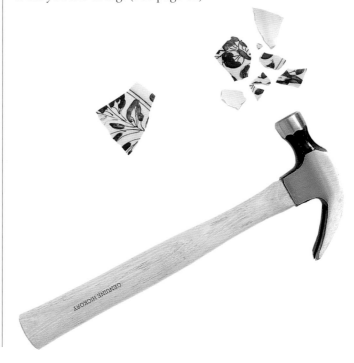

TILE NIPPERS/MOSAIC NIPPERS

Available from mosaic suppliers, nippers are an essential tool for the mosaicist, because they are used to break tiles and crockery into pieces, as well as for "nibbling" them into specific shapes. If you are a beginner, they may be the only tool you need, and in fact some mosaicists use nothing but tile nippers for their work. Nippers have beveled edges of tungsten carbide that cut cleanly through glass and ceramic. The action of the nippers in your hand should feel smooth and easy, not stiff in any way, and it is worth investing in a good pair. Always aim to hold the nippers near the bottom, so that they, and not your hand, take most of the strain in breaking the tesserae. (See page 60)

TILE CUTTERS

To cut large tiles into smaller pieces with straight sides, use tile cutters rather than nippers. First, score a line down the tile with the tungsten-carbide wheel. Then, using the jaws of the cutter, break the tile along the line. (See page 64)

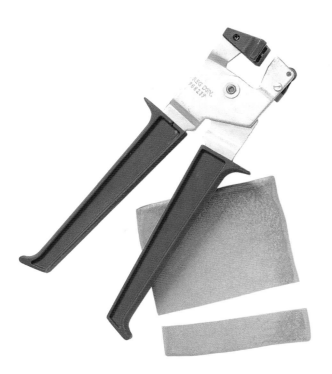

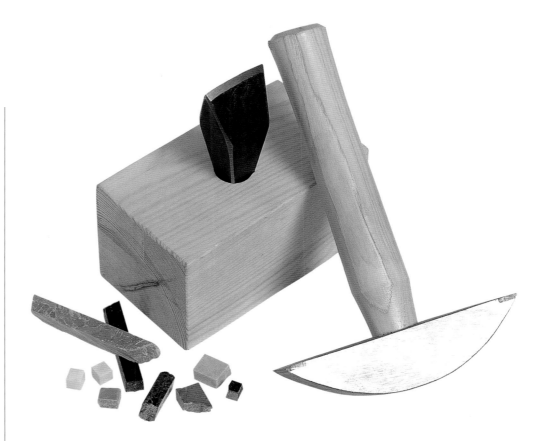

HAMMER AND HARDIE

The hammer and hardie are used for cutting smalti and marble, but they can be quite hard to track down (try specialized mosaic suppliers) and are quite expensive. The hammer has a curved head and a tungsten-carbide tip. The hardie, or anvil, has a corresponding tip and is generally set into the top of a wooden block, which should be placed at a comfortable height for working. The sizes of the hammer and hardie should be in proportion, and the hammer should feel good in your hand and be of a comfortable weight—around 4 pounds (1.5 kg). The tessera is held over the hardie at the exact point at which it needs to be cut, then broken with the hammer. Some practice may be needed to master this cutting technique. (See page 68)

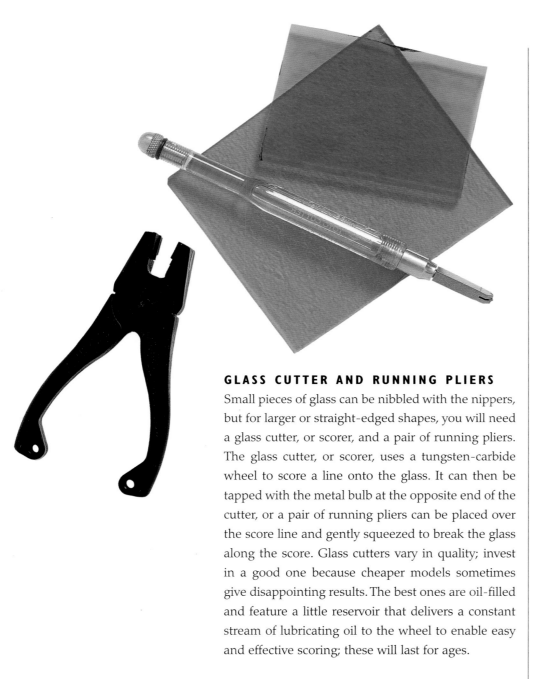

sort of material (especially with nippers and hammers) to prevent sharp fragments from flying into your eyes. Wearing a protective mask over your nose and mouth while cutting is also recommended, because quite a lot of dust is produced, especially from ceramic, and it should not be inhaled. Strong protective gloves should also be worn when cutting—although excessively large ones can make it difficult to cut smaller and more fiddly shapes. A mask is also essential while mixing dry grout, adhesive, sand or cement. Rubber gloves should be worn during all stages of the grouting and mixing processes, because cement and all types of grout have an unpleasant drying effect on the skin.

Protective goggles

Protective glasses

GLASS CUTTER AND RUNNING PLIERS

Small pieces of glass can be nibbled with the nippers, but for larger or straight-edged shapes, you will need a glass cutter, or scorer, and a pair of running pliers. The glass cutter, or scorer, uses a tungsten-carbide wheel to score a line onto the glass. It can then be tapped with the metal bulb at the opposite end of the cutter, or a pair of running pliers can be placed over the score line and gently squeezed to break the glass along the score. Glass cutters vary in quality; invest in a good one because cheaper models sometimes give disappointing results. The best ones are oil-filled and feature a little reservoir that delivers a constant stream of lubricating oil to the wheel to enable easy and effective scoring; these will last for ages.

PROTECTIVE EQUIPMENT

Cutting tesserae introduces the potential for injury if you do not take sensible precautions. Goggles or some form of eye protection are essential when cutting any

Mask for nose and mouth

Thin plastic gloves

Rubber gloves

Heavy-duty protective gloves

GROUTING TOOLS

Grout should be applied with a flexible rubber implement, the size and type of which will vary depending on the job. A squeegee is perfect for applying grout to large flat surfaces of mosaic, such as walls, floors or large panels. It is not suitable for smaller pieces or mosaics made from tesserae of uneven thicknesses. A small rubber spatula (like those used in the kitchen for scraping out containers) is ideal for these jobs, as is a rubber kidney (as used by potters and available from good craft stores or potters' suppliers). Grout should be mixed in an old bowl or similar container that can be wiped clean for the next time. Old flatware, or even a stick, will serve

as mixing tools. A trowel is necessary for mixing grout made from cement and sand, as are boards to mix it on. To clean the mosaic of grout, you will need a sponge and some old rags, plus a lint-free cloth for polishing. A grout sponge is recommended because it is less likely to drag the grout from the spaces between the mosaic. Newspaper is also very effective at removing certain types of grout (see page 79). A bucket of water nearby is essential for grouting jobs.

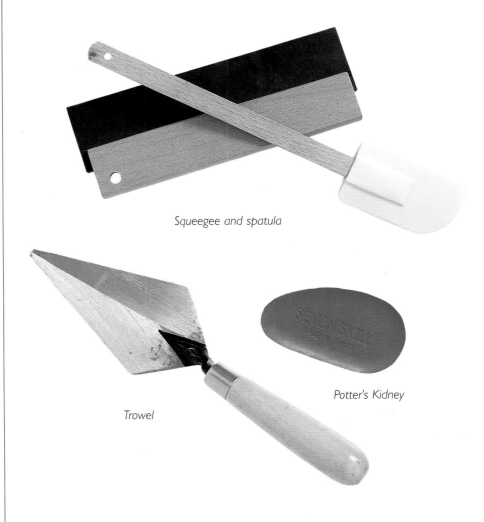

Squeegee and spatula

Trowel

Potter's Kidney

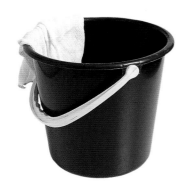

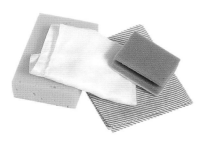

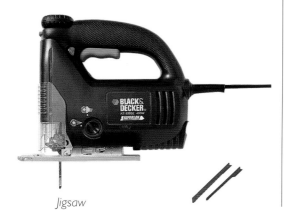

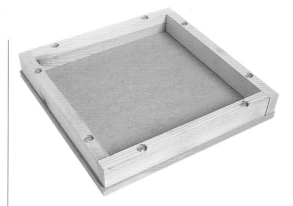

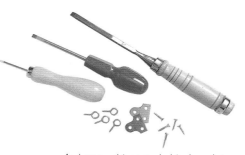

Bucket

Tilers' sponge, pan scourer and cloths

Spatula and plastic glue spreader

Jigsaw

MISCELLANEOUS

Not all of the following items are essential, but they will often prove useful. Many household implements also make unique and useful mosaic tools.

Bowl—for soaking tiles off backing paper

Bucket—for holding water when grouting

Casting frame—for creating concrete slabs; it is possible to make your own frame from four battens and a base of plywood and eight screws

Cloths and sponges—for cleaning off grout and polishing the finished mosaic

Craft knife—for scoring, or "keying" bases and cutting templates

Gimlet or awl—for making holes in the mosaic base for screws etc. during the fixing process.

Glue spreaders—small plastic spreaders for applying adhesive to small tesserae; knives or spatulas will do for larger pieces

Graph paper—for creating designs

Jigsaw—for cutting wood into shaped bases

Masking tape—for taping designs in place when using mesh and for protecting and isolating areas while grouting

Notched grout float—for preparing thick cement bases or beds; smooth with the flat surface, then use the notched side to create a "key" in the cement for better tile adhesion

Paintbrushes—for applying sealant to wood bases and hydrochloric acid for cleaning cement sand grouts, as well as for painting exposed areas of the mosaic base as part of the finishing process

Casting frame

Awl, screwdriver and chisel, eyelet screws, picture fasteners and screws

Paintbrushes

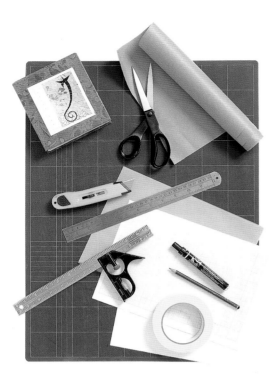

Cutting, drawing and designing materials

Brown paper

Mixing equipment

Paper/sketchbook—for recording ideas and designs

Pencils and felt-tip pens—for drawing designs

Picture fasteners—for fixing and hanging mosaics

Rubber cutting mat—to protect work surfaces while using a craft knife; also acts as a nonslip base when scoring tiles or glass

Ruler—for measuring and drawing

Screwdriver and screws—for fixing and hanging mosaics

Small chisel—for removing incorrectly placed tesserae from an ungrouted mosaic

Spirit level—for ensuring mosaics on floors are level

Strong brown wrapping paper—for gluing tiles onto when using the indirect, or reverse, method

Tracing paper—for transferring designs to the base, if necessary

T-Square or **metal-edged set square**—essential for drawing or cutting straight edges

Tweezers and/or **fine dental tools**—for laying very small tesserae and pushing them into place

Various small containers—it is always worth having a variety of these around

Waffle board or **jig**—an indented tray for laying out tiles in a simple grid pattern for indirect or reverse method mosaics

Notched float

Spirit level

Tweezers and dental tools

Waffle board or jig

45

Materials

You can mosaic with anything from glass and beads to broken crockery and trash. The tiles that are manufactured specifically for use in mosaics different characteristics and can be used in a variety of ways.

VITREOUS GLASS TILES

Vitreous glass is extremely versatile and comes in a range of colors, including some that are mixed with metallic powder. They come in a standard thickness of ⅙ inch (4 mm). The most common are ¾ inch (20 mm) square, but they are also available in ⅜ inch (10 mm) square and occasionally 1½ inches (50 mm) square. Vitreous glass is easy to cut and suitable for interior and exterior work, but it is not recommended for use on floors because it is vulnerable to chipping from constant use. Vitreous glass tiles have a flat side and a grooved side—the latter provides a good adhesion to the mosaic base. They are normally supplied upside down on a brown paper sheet, so they need to be soaked off before use. Some suppliers also sell mixed bags of tiles, which are excellent for experimentation.

Vitreous glass varies in price depending on color—as a general rule, the darker or more opaque the color, the more expensive (including the metallic ones).

UNGLAZED CERAMIC TILES

These come in a neutral and earthy range of colors—creams, browns, russets, grays and soft blues—and are the cheapest form of mosaic tile you can buy. The color is the same on both sides, so these tiles can be used either way up, unlike most. They are frost-proof, nonreflective and work well as contrasts to shinier materials in addition to being an excellent choice for floor mosaics. They also make a good edging tile for mosaic designs, because they are less likely to chip than vitreous glass. The tiles are ⅙ inch (4 mm) thick and 1 inch (25 mm) square, although it is possible to find smaller ones. Some suppliers stock circular tiles too, although the color range is limited.

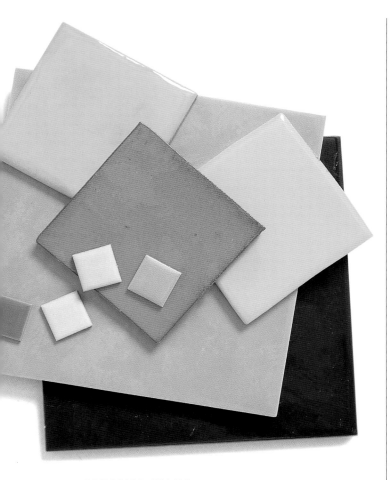

CROCKERY

Most forms of crockery and china can be used in mosaic and will give fantastic effects; they come in a huge mixture of colors, textures and patterns. This technique is known by a number of terms, including *pique assiette* and folk mosaic. Even the most unappealing ceramic pieces are totally transformed when broken up and incorporated in a mosaic. This is an inexpensive way of making mosaic, because pieces can be picked up cheaply at junk stores, garage sales and flea markets. It is also the perfect way of finding a use for broken items from your home. Pieces can be broken up with nippers or a hammer. As well as the main part of the item, handles from mugs and cups and the bottoms of pots and bowls may also be incorporated into mosaic in many interesting ways.

CERAMIC TILES

This type of tile is probably the easiest to find and comes in a range of sizes, colors and patterns. Larger tiles can be broken with nippers or a hammer, but tile cutters are required for cutting regular or straight-edged shapes. Some glazed terra-cotta tiles respond poorly to breaking, with parts of the glaze having a tendency to flake off, so experiment first before investing in a lot of them. Some ceramics are vulnerable to frost, so may not be suitable for outdoor mosaics. The fact that some smaller tiles have slightly rounded corners may pose problems if you want to cut them into equal tesserae.

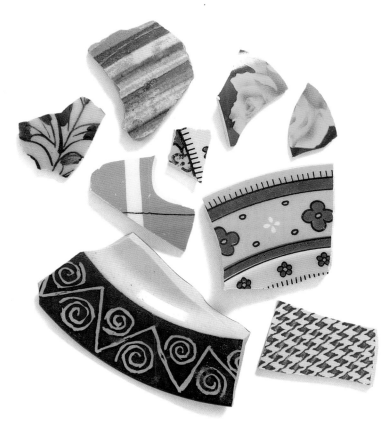

SMALTI

As used by the Byzantine craftsmen, these richly colored, highly reflective pieces of glass come in small rectangular chunks—roughly ⅖ × ⅗ × ⅖ inches (10 × 15 × 10 mm)—in an excellent range of colors. They are particularly useful for pictorial mosaics, especially portraits, because of the realistic range of flesh tones. Unlike vitreous glass, the colors do not vary in price and are sold by weight, but they are all expensive. Smalti are made by pouring molten glass into flat, round cakes about ⅖ inch (10 mm) thick and 12 inches (310 mm) in diameter, which are cut into rectangular chunks when cooled. Smalti are usually cut using a hammer and hardie, although it is also possible to use nippers. The mosaic should not be grouted in the normal way because the grout becomes embedded in the uneven and sometimes pitted surface of the smalti, ruining the effect. Instead, they should be laid in a thickish layer of adhesive, or "half-grout." Smalti are not suitable for wet areas, floors or for functional wall areas because of their uneven surface. Gold and silver smalti are also available, although they are very expensive. These are created by sandwiching a fine layer of gold or silver leaf between two layers of glass. They come with smooth or rippled surfaces, most commonly in tiles of ¾ × ¾ × ⅙ inches (20 × 20 × 4 mm).

MARBLE

One of the oldest mosaic materials, marble is available in a gorgeous array of natural colors and patterns, with interesting variations occurring in the same batch or color. It can be finished in different ways. Polished marble enhances the natural color, which is revealed in the glassy reflective surface. Honed marble has been polished to a lesser extent to produce a mat rather than a shiny surface. Riven marble is the name given to pieces that have been broken open to reveal the crystalline formation inside, which provides an interesting texture. Porous marble needs to be sealed with a stone sealant, especially if it is to be sited outside or exposed to wet conditions. Marble is available from specialized mosaic suppliers and comes in loose cubes—about ⅖ inch (10 mm) thick—on a net backing sheet or in the form of rods, which can be cut into cubes or to any desired length. Take care if buying marble on a net backing sheet because the tiles may be stuck down with white craft glue, which means you will be unable to soak them off. A hammer and hardie is required for cutting marble, although nippers can be used to break up marble rods and thinner cubes. It is a fairly heavy material, which can make it quite difficult to fix to some surfaces. To fix, use a cement-based tile adhesive and grout with a cement-based grout. Hydrochloric acid should not be used on marble.

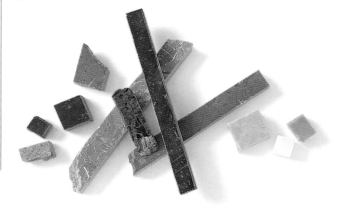

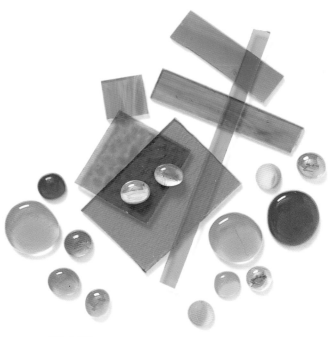

GLASS

Stained glass can be used extremely effectively in mosaics, both alone or combined with other materials. The range of colors and finishes is extremely appealing and come in transparent and opaque forms. Glass is available from specialized glass suppliers and some craft stores and varies in price depending on color and quality. Some suppliers may have a scraps bin, where you can pick up cheaper odds and ends. Glass can be cut into shapes using glass cutters or nibbled into smaller random pieces with the nippers. Glass nuggets or gems can also be incorporated effectively into mosaics and come in bags of various colors from craft stores. Both these and pieces of transparent glass can be enhanced by backing with gold or silver leaf. Glue the glass to the leaf with a thin layer of white craft glue, and leave to dry. Carefully peel the backing sheet away, and stick the piece, leaf-side down, onto the mosaic. Don't be tempted to use faux gold leaf, because this may develop a dull, greenish patina under the glass when dry.

MIRROR

Use either mirror tiles or regular household mirror pieces to add sparkling highlights to a mosaic. These can also be used over large areas to give a brilliant reflective effect, although this is not recommended for floors. Mosaic mirror tiles are available from specialized suppliers and come either on sheets or individually cut. Regular household mirror or large mirror tiles can be broken up with nippers, glass cutters or a hammer, but a great deal of care must be taken when doing so, as mirror splinters easily. It may be necessary to peel off a sticky backing sheet before breaking the mirror. Ideally, mirror should be stuck down using silicone sealant, but you can also use tile adhesive. White craft glue should not be used because it can eat away at the silver backing over time.

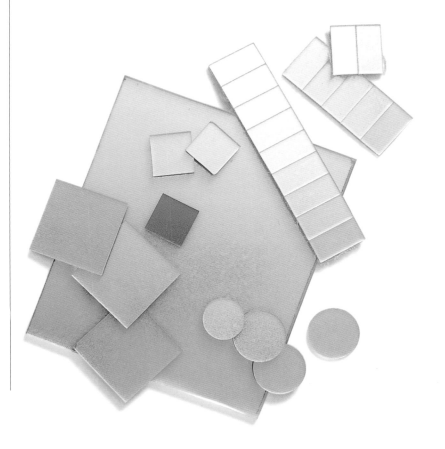

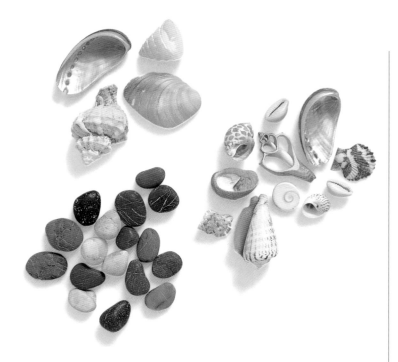

PEBBLES AND SHELLS

Instead of collecting pebbles and shells from the beach, which can be unethical (and sometimes illegal if it is part of a nature reserve or conservation area), buy them from craft suppliers, interior design stores or garden centers. Their strengths lie in their subtle natural colors and individuality of form. They are usually embedded into a cement base or cement-based adhesive and not grouted. The base can be precolored if desired. Black and white pebbles used together make a simple and stunning combination and full use can also be made of the subtle gradations of other natural colors. Hard pebbles, such as granite, quartz, flint and limestone, make the best choices. If shells or pebbles have been collected from the beach, they may need disinfecting before use. They should then be soaked in clean water for several days, and the water should be changed every day. Leave them to dry for at least two days to make sure all traces of moisture are gone.

PAPER

Paper can be used to give an inexpensive mosaic effect and is particularly useful for decorating objects that cannot support too much weight or that require a very flat, smooth surface. The range of papers available for use is vast and includes colored drawing paper, patterned gift wrap, wallpaper and handmade paper. Papers can also be painted to create tailor-made colors. The tesserae can be easily cut into any size or shape with scissors and stuck onto a colored background with white craft glue. The background color acts as the "grout" from an aesthetic, if not functional, point of view, and so needs to be of either a neutral color or a color that does not appear in the rest of the mosaic. Several coats of clear varnish will seal and protect the surface if necessary. Even when varnished, paper is obviously not suitable for functional mosaics, such as floors, walls and wet areas, and should be regarded as a decorative technique only.

OTHER MATERIALS

Fantastic mosaics can be conjured from a variety of everyday or found objects. Imaginative experimentation can result in some stunning effects from unusual materials or things that would otherwise be considered garbage. These will tend to be more suitable for decorative pieces than for functional ones.

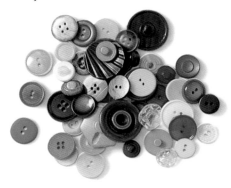

Buttons

Buttons can be used to decorate wooden and ceramic surfaces and come in masses of beautiful shapes and colors. A mosaic created entirely from buttons can look stunning; particularly lovely or unusual ones also look very effective mixed in with mosaics of other materials. You may find odd cards (or even boxes if you're lucky) of buttons at junk shops and garage sales, which is the cheapest way to buy them. Flea markets may often sell buttons more cheaply than stores or notions departments, but if you are looking for specific types or colors, the latter will be a better bet. Buttons can be stuck down with strong clear household glue (use the completely flat type of button for this) or pushed into a thick layer, or half-grout, of adhesive. You may want to precolor this, because quite a lot of this base is likely to show between the buttons due to the nature of their shape. If the buttons are very textured, it is probably best to leave them ungrouted.

Beads and jewelry

These can be used for similar applications as buttons and can be found from the same sources. The two materials could also be combined to create a stunning design or a piece of kitsch. Pieces of costume jewelry—small pins, pendants and earrings in diamanté, plastic, metal or ceramic—could be added to a mosaic as highlights. Neither beads nor most jewels respond well to grouting.

Aquarium gravel

Available in bags from pet stores and aquarium stores, these small stones come in a variety of colors, from natural to fluorescent, and are very inexpensive to buy. They should be pushed into a cement-based adhesive base, which can be colored first, if necessary, and left ungrouted.

Junk

Small china or plastic figures, corks, beer bottle caps, coasters, badges, or metal nuts and washers can all be incorporated to make unique and crazy mosaics. Flat pieces and simple shapes surrounded by other flat materials could be grouted if desired, but if in doubt, use the half-grout method or strong clear household glue. American artist and sculptor Larry Fuente uses all manner of junk to decorate 3-D forms, including dominoes, Scrabble tiles, shoe insoles, knives, colored pencils and dolls' faces, transforming them into fascinating *objets d'art*. Artist Hap Sakwa's mosaic work consists of objects, like vases and kettles, intricately covered with American memorabilia, giving them a distinctive Pop Art effect.

Bases

Almost any nonflexible surface is suitable for mosaic, as long as the right adhesive is used. Flat or gently curving surfaces are easiest to work on. Small, intricate shapes and tight curves (on furniture, for example) should be covered with small tesserae. All surfaces should be clean before work is started. A finished mosaic, made up of tesserae, adhesive and grout, can be extremely heavy, so the base must be strong.

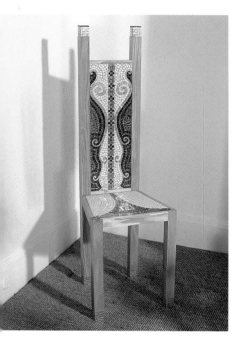

It is possible to mosaic on all kinds of bases, including furniture.

WOOD

Wood makes an excellent surface for mosaic. For indoor pieces, use medium-density fiberboard (MDF) or marine plywood. Water-resistant, exterior-quality plywood is best for outdoor projects, but make sure that areas not covered in mosaic are treated to make them weatherproof. The thickness of wood selected depends on the purpose of the mosaic, but try to avoid anything thinner than ⅓ inch (9 mm). The wood must not be warped, as it cannot be flattened out. Before you begin, the wood should be scratched, or keyed, with a knife to give the tiles something to grip. Untreated wood should be sealed with a mixture of white craft glue and water. A jigsaw can be used to cut wood into interesting shapes; lumber stores may do it for a small charge. A protective mask is essential when cutting MDF, as the dust is extremely dangerous.

TILE BACKER BOARD

A relatively recent product, tile backer board is a waterproof base for mosaics, ideal for using in wet areas such as showers (but not for use in swimming pools). It consists of a light material, similar to polystyrene, sandwiched between two layers of cement, which is then reinforced with nylon mesh on both sides. It comes in different thicknesses ranging from ¼ to ¾ inch (6–20 mm).

FURNITURE

Varnished or painted wood should be sanded down thoroughly, then keyed and sealed with a white craft glue and water mix. The best furniture bases are sturdy enough to hold the weight of the mosaic and are not too intricately shaped, because this makes covering with tesserae difficult. Flea markets and secondhand furniture stores are ideal hunting grounds, because peeling paint or the odd scratch is not important if you are going to transform the piece with mosaic. If you want the piece of furniture to remain absolutely flat, cover it with tesserae of the same thickness, or use the indirect method (see page 86). Areas of the furniture that remain uncovered can be painted with latex or acrylic paint. You can use cabinets, tables, shelves, fireplaces, chairs, benches, storage boxes, mirrors, frames, stair risers, doors and window frames.

CERAMIC

Most forms of ceramic can be used as mosaic bases, including garden planters, vases, lamp bases, bowls, plates, teapots (for decoration only), window boxes, figures, heads or animals. Tile adhesive or white craft glue can be used to stick ceramic to tiles; cement-based adhesive should be used for exterior pieces; and silicone sealant can be used to stick glass and

ceramic onto ceramic. Porous bases, such as terra-cotta, should be sealed with a white craft glue and water mix first, because the surface draws the moisture out of cement-based adhesives and weakens the bond.

A range of bases that can be used for mosaic: mesh, tile-backer board, plywood and MDF

STONE AND CEMENT

These bases need no prior preparation (except, in some cases, cleaning) and are suitable for placing outdoors, providing the mosaic on the top is as well. Statues, garden ornaments, birdbaths, ponds, fountains, paving stones and doorsteps all make good bases. If you are making a mosaic that will be exposed to water, make sure that both the adhesive and grout are waterproof.

MESH

Mesh or netting is great for producing mosaics off-site. The mesh is placed over a drawing of the mosaic and the design transferred by tracing it with a felt-tip pen. If the finished mosaic is large, it can be cut into sections before sticking into place. Mesh is ideal for use on walls, sections of walls and floors, and tabletops and can also be applied to large, gently curved bases. It is not suitable for wet areas.

WALLS

It is important that the wall is capable of bearing the weight of a mosaic—if you are in any doubt, consult a professional tiler or builder. The wall surface should be smooth, dry and free of dust and grease. Ideally, it should be prepared with a smooth cement and sand mix. Ask a builder to do this if you feel that it is not a job you can tackle. Plaster surfaces should be sealed with a white craft glue and water mix. For walls, use a cement/sand or cement-based adhesive. For cement/sand bases, greater strength of adhesion can be created by applying a fairly thick slurry (made from a small amount of wet cement/sand further mixed with water) with a brush to the dampened surface of the wall before a layer of the cement is added. This is not recommended for plaster walls, which would benefit from a relatively quick-drying cement-based adhesive. If the mosaic is to cover an area of wall in a shower, for example, it is best to keep it as smooth as possible; avoid mosaics of mixed thickness tesserae with jagged edges sticking up.

FLOORS

Floors should be prepared in a similar way to walls, with a cement/sand mix providing a good base. Make sure that there are no dips or hollows where water can collect. Because it is essential that the floor should be flat and smooth, use the indirect method (see page 86). If you are covering a wooden floor, do not mosaic directly onto floorboards, but cover them with a water-resistant plywood about ⅗ inch (15 mm) thick. It should be screwed down firmly at regular intervals, so that it cannot buckle or shift around, then scored and sealed. Mosaic materials for floors should be hard-wearing, smooth and easy to clean, like marble and ceramic.

Adhesives

Adhesive provides the bond between the tesserae and the base, which should be permanent. There are several options available, and the choice often depends on the materials and the base. However, some adhesives suit a variety of functions, and so it is often a case of personal preference and working style that will dictate your choice.

White craft glue

Tile adhesive

Cement-based adhesive

WHITE CRAFT GLUE

This glue can be used both as an adhesive and also as a sealant for porous surfaces when mixed 50:50 with water. The term 'white craft glue' covers several options so that it is important that you choose the right one for the job. For sealing bases and sticking tesserae to mosaics that will be sited indoors, choose the versions that are non-water soluble when dry. Some white glues are permanent and can be used for external mosaics, but check the information on the tin first. Water soluble white craft glue (diluted 50:50 with water) is used for sticking tesserae onto brown paper in the indirect method, as this allows the paper to be peeled off when the process is complete.

TILE ADHESIVE

Used for interior tiling, tile adhesive usually comes ready-mixed and is best for affixing ceramic to wood, walls and ceramic. This is a good adhesive to use when you are starting off with a few experimental pieces, but it does not have the strength and permanence of a cement-based adhesive. It is not suitable for exterior use. Don't be tempted by products that are described as being both a grout and an adhesive, as they do not create as strong a bond as an adhesive and, conversely, are very sticky and difficult to remove as a grout.

CEMENT-BASED TILE ADHESIVE

As favored by most mosaicists, cement-based tile adhesive is usually sold in powdered form and must be mixed with water to form a thick cake-mix consistency. It provides a strong, permanent adhesion suitable for interior and exterior work and will stick most tesserae to walls, terra-cotta, wood, stone and concrete bases. It is ideal for providing a half-grout for smalti or found objects and can be colored using cement dye powders for this purpose if necessary. Use a notched float, another notched tool or even a fork to create grooves in the adhesive to act as a key. Cement-based adhesive comes in different varieties, which should be chosen to suit the job at hand. Rapid setting dries quickly; flexible is the best choice for use on woods, as it is mixed with latex to give it a greater tolerance of movement; and exterior grade is frost-proof and waterproof. It is also possible to buy a latex admix that can be added to an ordinary cement-based adhesive to give it greater flexibility.

CEMENT/SAND MIX

Cement mixed with sand can be used as both an adhesive and a grout and will stick most materials to walls, concrete and stone, as well as serving as a mortar base for indirect mosaics and pebble mosaics. Sand varies in color and texture—as a general guide, the

Portland cement

finer the quality of tesserae, the finer the sand should be (it can be sieved if necessary), and the coarser the sand, the harder the mortar. The dry ingredients should be mixed together thoroughly on a board using a trowel (roughly three parts sand to one part cement) and the water added gradually to a small well in the center to create the consistency of thick mud (see page 72). White craft glue (mixed with water in one part glue to three parts water) can be added to give extra bonding strength for the cement adhesive. Cement polymers or plasticizers can also be added for extra flexibility and slower drying times. Cements vary according to purpose—for external use, a slow-drying, waterproof and frost-proof preparation is best. Cement takes time to dry out, or cure, properly—a process that should last as long as possible to ensure a permanent and secure bond. The mosaic can be covered with polyethylene sheets or dampened cloths to stop the cement drying too quickly, especially in a warm, dry environment. Keying the cement base will improve adhesion of tesserae.

EPOXY RESIN

This is a two-part adhesive consisting of a resin and a hardener that need to be mixed together just before use. Epoxy resin gives off unpleasant fumes, so it is vital that it is used in a well-ventilated space. It is the only adhesive that will permanently stick objects to a metal surface and is suitable for many other applications, including exterior work. It also dries quickly, which makes it difficult to reposition tesserae, although it is possible to buy resins that take up to an hour to dry instead of a few minutes. However, as it is not an easy adhesive to work with and is expensive, it is probably best used only when essential.

CLEAR SILICONE SEALANT

Clear silicone sealant can be used to stick glass and ceramic to glass, and glass to any other base. Because it is clear, it is useful for sticking glass to glass, so that light can shine through both surfaces. In this case, the sealant must be very thoroughly applied to the tesserae before affixing so that grout cannot seep under the edges and spoil the effect. It is also useful with mirror, because, unlike white craft glue, it will not eat away at the silver backing. It dries very quickly and also has a strong, unpleasant smell, so a well-ventilated room and/or a mask are recommended.

WATER-BASED/WATER-SOLUBLE ADHESIVE

Water-based or water-soluble adhesive is used during the indirect method to attach the tiles temporarily to a brown-paper backing. When the mosaic is installed, this backing is peeled away from the tesserae, so the glue should be water-soluble. White water-soluble craft glue—the kind that children tend to use in school—further diluted with a little water, is ideal for this purpose. Check the can carefully before using the glue to make sure that it is not water-resistant, because if it is, you will be unable to remove the backing paper.

Sand

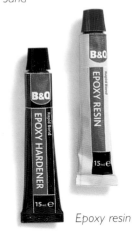

Epoxy resin

Silicone sealant in dispensing gun

Grouts

The choice of grout usually depends on where the mosaic is to be sited. Cement-based grouts are most commonly used and are suitable for most mosaics. Grouts are produced in a growing range of colors in addition to the usual grays and whites. They can also be colored with powder or paint to complement your color scheme.

WALL TILE GROUT/UNSANDED GROUT

This fine-textured grout, sold in most tile stores, is used for interior-wall tiling. It comes in a ready-mixed form, usually sold in tubs, or in a powdered form, must be mixed with water. It is easily colored to create interesting grout effects, and it suits mosaics made from fine and delicate tesserae. However, this grout is not suitable for exterior mosaics, and it does not have the durability of cement-based preparations. It can also develop cracks if used in mosaics that have wide gaps between the tesserae. Apply with a squeegee or spatula and remove excess with lightly dampened cloths until the mosaic is clean. Polish with a lint-free cloth.

CEMENT-BASED GROUT

Cement-based grout comes in fine or coarse versions—fine for walls and delicate mosaics where the gaps between the tesserae are small, and coarse for floors or mosaics with wider gaps between the tesserae. For finer mixes, apply and clean off as described in the previous section. Coarser mixes may be cleaned off simply by rubbing with newspaper. Cement-based grout usually comes in shades of gray and white, and it can also be colored. It is suitable for both interior and exterior mosaics, but check the manufacturer's directions to make sure you have the right product for the job.

CEMENT/SAND

As well as being an adhesive, a cement/sand mix can also be used as a grout. Portland cement comes in a good neutral shade of gray and makes an excellent choice. Sands vary in color and texture and can be chosen to suit the mosaic to be grouted. Powdered cement color can also be added if desired. The disadvantage of using cement/sand as a grout is that it needs to be cleaned off the mosaic with a solution of hydrochloric acid, a delicate process that requires a lot of care (see page 80). However, cement constitutes a hard-wearing and permanent grout for mosaics both indoors and out.

EPOXY THINSET

Epoxy thinset, which is quite expensive, is suitable for pieces that will hold water. It comes in two parts, which need to be mixed together.

GROUT COLORANTS

Grouts can be colored with pigmented powders available from tile suppliers. These can be used to color all types of grouts, although specialized cement powders are recommended for use with cement-based products. Acrylic paint, from art suppliers, is also a very effective coloring medium and is available in a huge range of colors.

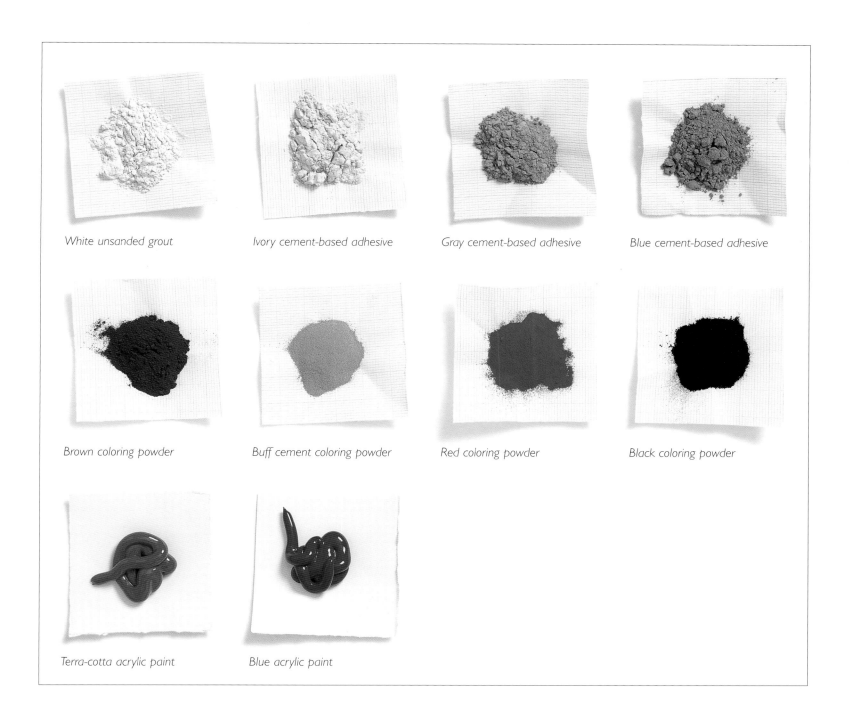

White unsanded grout

Ivory cement-based adhesive

Gray cement-based adhesive

Blue cement-based adhesive

Brown coloring powder

Buff cement coloring powder

Red coloring powder

Black coloring powder

Terra-cotta acrylic paint

Blue acrylic paint

Techniques

The major processes that all mosaicists
must learn before beginning their
own projects are lavishly detailed
here with step-by-step photography
and easy-to-follow instructions.

Cutting

The following entries describe how to cut various materials into tesserae. Several techniques are the same even when different materials are used. Tiles can also be used uncut, but the irregular shapes produced by cutting add life to the mosaic. Combining cut with uncut tesserae will introduce contrast and definition to your design. Some techniques may require a little practice before you achieve the results you want, so experiment with some spare or inexpensive tiles first.

B e sure to wear safety goggles when cutting any material; protective work gloves and a face mask are also strongly recommended. Don't cut the tiles over your mosaic, because tile fragments can become embedded between the tesserae or into areas of adhesive. Always use a dustpan and brush to remove the leftover shards, never your bare hands.

Tiles may first have to be removed from their backing sheets of paper or netting. To do this, soak them in water in a bowl, or something equivalent, for about 15 minutes, then remove them from the paper. Spread out to dry on a towel. Make sure that the tiles are all separated from one another while they dry, because traces of the adhesive can remain and they can stick together. Use clean water for each soaking.

USING THE NIPPERS
Tiles can be cut into smaller squares, rectangles, strips and random shapes using the tile or mosaic nippers. The nippers can also be used to "nibble" specific shapes such as petals or circles, as well as trimming the edges of tesserae. Most tiles will break easily, but it is wise to have more than you actually need for each project, just in case you have any mishaps. Certain shapes are harder to get right than others,

and some of the very opaque colors of vitreous glass have a tendency to break unevenly. You can save any rejects for crazy-paving mosaics (see Opus Palladianum, page 130).

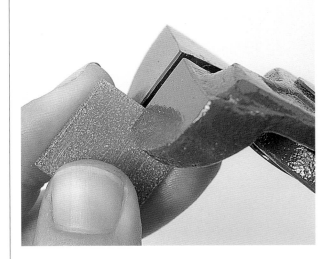

1 Hold the nippers with your hand close to the bottom of the handles. To break a ⅛ inch (20 mm) tile in half to make two relatively equal rectangles, place the jaws about ⅜ inch (10 mm) over the edge of the tile, halfway down one side.

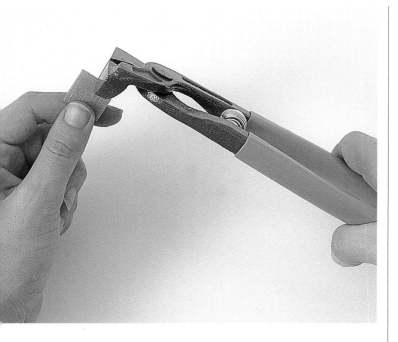

4 The smaller squares can be snapped in half again to make thin strips.

2 Squeeze firmly and gently with the nippers while exerting a counter pressure on the tile with your fingers opposite the line you wish to break.

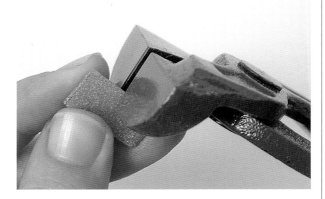

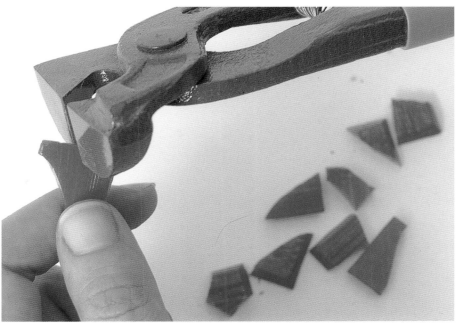

3 Repeat the process on the rectangles to create four small squares roughly a quarter of the size of the original tiles.

5 For a crazy-paving effect, place the nippers anywhere over the tile, and break into random and irregular halves or quarters.

61

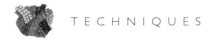
NIBBLING

The following techniques apply to most tesserae, ceramic and glass.

Circles

1 Hold the nippers close to the edge of the tile. Use little "nibbling" movements to break off small areas of glass in a series of straight cuts, moving clockwise around the tile. Don't remove too much at once.

Medallions

Use a similar technique to cut out medallions of specific images, like flowers, from crockery.

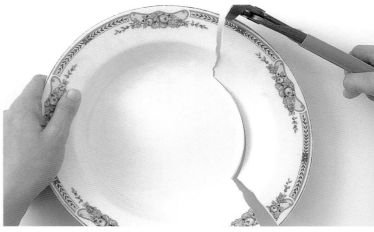

1 Carefully remove the areas around the design you want to keep. This is best done gradually.

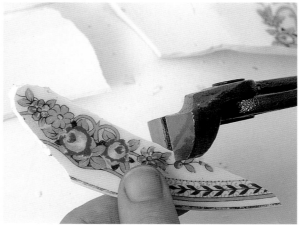

2 Slowly nibble the remaining edges away with the nippers, keeping them close to the edge of the tile and "nibbling" away very small areas at a time in a series of straight cuts.

3 Don't worry if the medallion breaks at any time during this process—sometimes this is unavoidable. Just piece it back together when you stick it down, leaving small spaces between the pieces as you would normally.

Petals

1 Hold the tile with one of the corners uppermost. This corner and the one opposite it will stay intact.

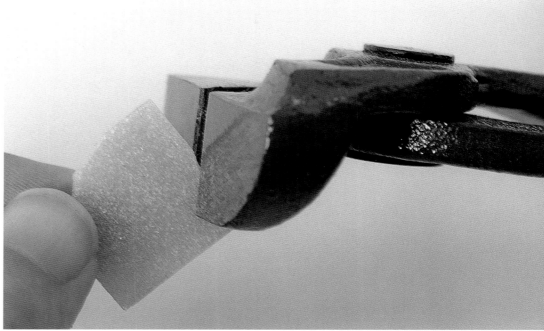

3 Turn around, and repeat the same process on the other side to form a petal.

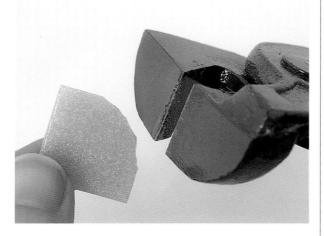

2 Starting about halfway down on one side, begin to nibble away the next corner. Aim to remove a section shaped like a triangle with a concave bottom.

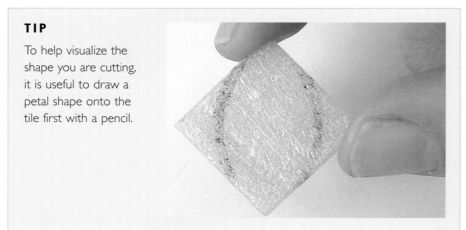

TIP

To help visualize the shape you are cutting, it is useful to draw a petal shape onto the tile first with a pencil.

TRIMMING

Use a normal cutting action with the nippers to trim tesserae to fit into specific spaces or to shape pieces to follow the flow of a certain line or fill a specific area.

When square tesserae are required to define a fairly tight curve, trim them so that the top section is slightly wider than the bottom.

BREAKING MARBLE WITH TILE NIPPERS

Marble tends to come in thick pieces that are difficult to cut. The veins can make for unpredictable results. Marble can be cut using tile nippers or a hammer and hardie (see pages 60 and 68).

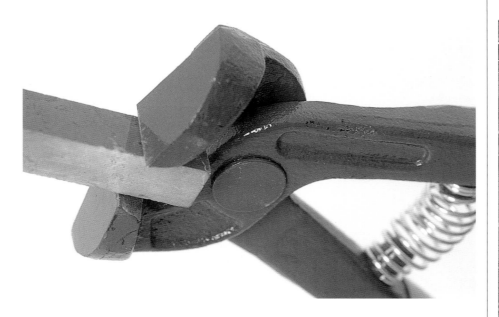

1 Unlike cutting other types of tile, when cutting marble, the nippers need to be placed centrally over the desired fracture line.

2 Squeeze the nippers with a firm sharp action. Marble is prone to crumbling, caused by a cracking along the veins, so do not cut too slowly.

USING THE TILE CUTTERS

Tile cutters are used for cutting larger tiles into regular shapes with straight edges. The tungsten-carbide wheel is used to score a line onto the tile, which is then snapped with the breaking jaws of the cutter. A rubber cutting mat on the table will protect the surface and help keep the tile from moving around when you are scoring it.

Cutting a large tile

1 To cut a large tile into even, regular strips, use a T-square or a metal-edged set square to get a perfectly straight edge.

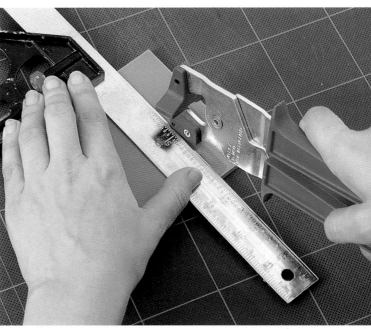

2 Holding the tile and T-square firmly, score a line with the wheel of the tile cutters. You will need to press quite hard, so make sure the height of your work surface lets you put a bit of weight behind the cutter.

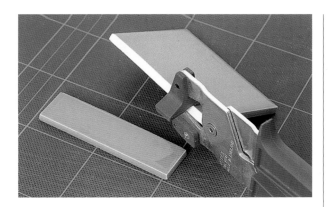

3 Insert the tile between the breaking jaws of the cutters, with the scored line in the center of the notch. Squeeze firmly.

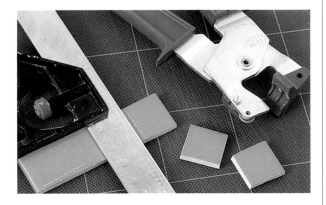

4 If desired, cut the strips into squares using the same method.

Removing handles

When using the *pique assiette* method, you may want to incorporate specific sections of crockery, such as cup handles, in your mosaic. Despite your best efforts, some attempts may end in disaster, so it is advisable to have more handles than you think you will need.

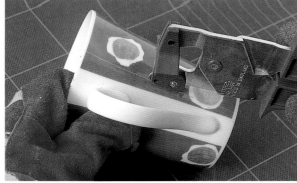

1 Put down a cutting mat to protect your work surface. Score down either side of the handle with a tile-cutter wheel or a good-quality tile scorer. It is very important to wear gloves for this process, in case the cutter skids off the surface of the cup.

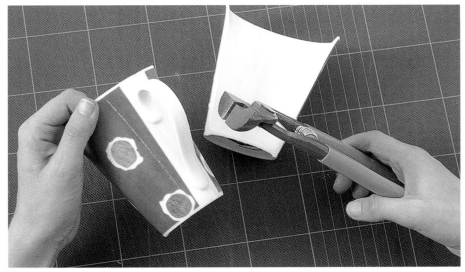

2 Using the score lines as a guide, gently break the unwanted part of the cup away with the nippers.

3 If necessary, nibble away any unwanted ceramic around the handle.

USING THE GLASS CUTTER

Cutting from sheets of glass

The overall principle for cutting glass is the same as that for cutting tiles with tile cutters. Score a line along the glass using a scorer or glass cutter, then snap the edge off using the ball at the end of the cutter or a pair of running pliers. If using the T-square as a cutting guide, the glass should be placed on a piece of wood or at the edge of the work surface so that the straight edge of the T-square lies flat.

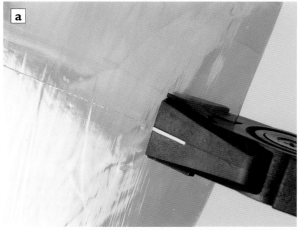

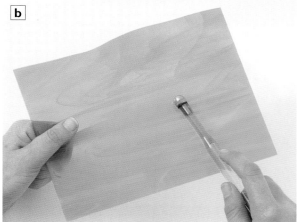

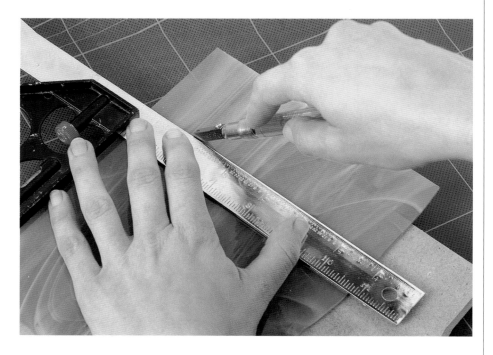

1 Score a line along the glass with the cutter. The depth of the score required will depend upon the thickness of the glass.

2 Snap along the line with the running pliers (a), or turn the glass over and give a sharp tap to the back of the score line with the end of the cutter (b).

Cutting triangles from tiles

Glass cutters and running pliers are very useful for cutting smaller tiles into perfect triangles. They can also be used to cut gold and silver smalti, where accuracy is important because of the cost of the tiles. The process of cutting two perfect triangles from one small tile using the nippers is a very hit-and-miss affair, and you are more than likely to get only one usable triangle out of it. Using the glass cutters gives you a much greater chance of getting it right, although it is still advisable to have more tiles than you think you need. Any failures can be saved to use in crazy-paving style mosaics.

2 Hold the tile centrally in the jaws of the running pliers, with the line or notch on the pliers over the scoreline, and snap the tile in half.

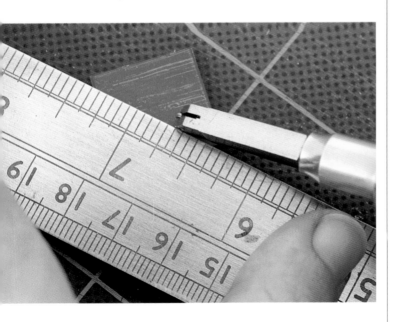

1 With a cutting mat underneath, hold a metal ruler diagonally across the tile, and score with the wheel of the cutter. The ruler may have to be held slightly off-center to allow for the width of the cutter's head. Press firmly but not too hard. One clean line is better than several attempts, or the glass will not snap evenly.

Follow a similar procedure for cutting gold and silver smalti or mirror tiles into triangles, squares and rectangles.

USING THE HAMMER AND HARDIE

The hammer and hardie are used to cut marble and smalti. This technique requires practice to get it right, so don't lose heart if your pieces shatter at first.

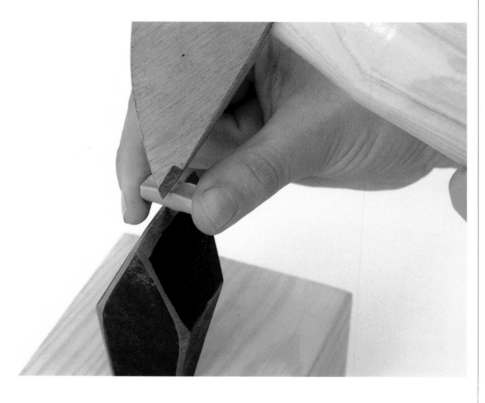

1 Position the piece to be cut over the hardie, holding it between your thumb and forefinger. The point at which you want the piece to break should be directly over the tip of the hardie. Tap the tile with the edge of the hammer, and try to strike directly at the point where it lies over the hardie.

USING A HAMMER

Use a hammer to break up a large piece of crockery. The nippers can then be used to create more precise tesserae. A hammer is also useful for breaking up thick pieces of ceramic or stoneware for *pique assiette*, and for random breaking of tiles and ceramic for a crazy-paving effect.

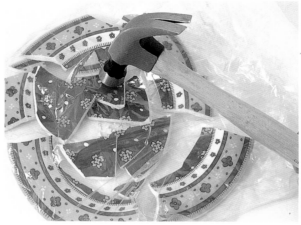

1 Place the piece to be broken in a strong plastic bag—a transparent one is best, because it lets you see what you are doing. Break the piece in several places with the hammer, checking the size and shape of the broken pieces as you go, until you achieve the desired result.

BREAKING AND REASSEMBLING A PLATE

For *pique assiette*, you may want to incorporate a design from the center of a plate, which is broken up and then reassembled.

1 Use the nippers carefully to break off the rim of the plate. Nibble away any unwanted edges.

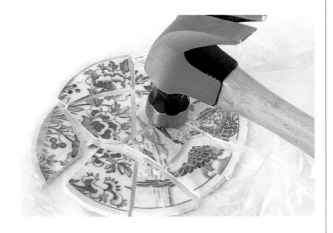

2 Place the plate in a plastic bag as before, and break in several places with sharp taps of the hammer. Take care not to over-break, or the design will become too fragmented.

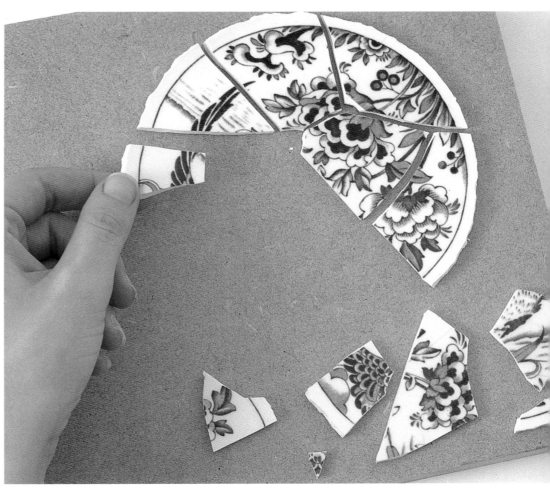

3 Remove the pieces from the bag, and reassemble them on a flat surface before transferring them to the mosaic base.

Adhesion

Choosing the correct adhesive with which to stick your tesserae down is essential. The choice of adhesive depends on the base and its ultimate situation, particularly whether it will be indoors or outdoors. Other considerations come into play when mosaicing with materials that you will not be grouting, such as shells, buttons and found objects, because the adhesive needs to be extra strong,

Interior wood—Seal with a 50:50 mix of white craft glue and water (following the directions on the tin) first. Use either white craft glue or a flexible cement-based adhesive, or add a latex mix to ordinary cement-based adhesive.

Exterior wood—Seal first with a 50:50 mix of white craft glue and water. Use a white craft glue or frost-proof cement-based adhesive with a latex additive.

Interior walls and floors—Use a cement-based adhesive or a cement/sand mix.

Exterior walls and floors—Use frost-proof, cement-based adhesive or a cement/sand mix.

Plaster walls—Seal first with a 50:50 mix of white craft glue and water mix. Use a quick-setting cement-based adhesive.

Ceramic wall tiles—Prepare with a specialized primer. Use a cement-based adhesive or a tile adhesive.

Ceramic objects—Use a silicone sealant, epoxy resin or white craft glue.

Terra-cotta—Seal first with a 50:50 mix of white craft glue and water mix. Use a frost-proof, cement-based adhesive if pot is to be sited outdoors.

Metal—Use epoxy resin.

Glass—Use silicone sealant.

Wet areas—Use cement-based adhesive.

Fountains and swimming pools—Use frost-proof, cement-based adhesive.

Exterior stone and cement—Use frost-proof, cement-based adhesive.

MIXING THE ADHESIVE

Cement-based adhesives mostly come in powdered form and need to be mixed with water. These are preferable to the ready-mixed variety. Read the manufacturers' directions thoroughly, especially if you are adding latex additives or any other preparations to the cement.

YOU WILL NEED

Spoon

Cement-based adhesive

Bowl or similar container

Water

Coloring powder (optional)

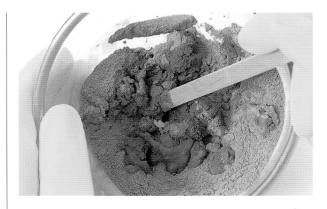

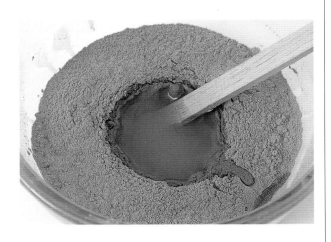

1 Spoon a small amount of the cement-based adhesive into a bowl. It is better to make up small amounts rather than a huge batch, which may dry out too quickly and become useless.

2 Make a well in the center of the powder, and slowly add water.

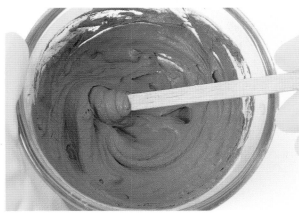

3 Stir well until a cake-mix consistency is achieved. The adhesive should not be too sloppy.

TIP

If you aren't grouting the mosaic and are using tesserae that will expose areas of the adhesive as part of the design (shells, found objects, beads, etc.), you may want to color the adhesive. Add powder pigments to the dry mix or paint to the wet mix, and stir in well.

MIXING SAND AND CEMENT

This process is also known as making a mortar.

YOU WILL NEED

Sand

Cement

Board to mix on

Trowel

Cement coloring powder (optional)

Water

White craft glue (optional)

Paintbrush

Notched grout float

Polyethylene

Cloths

Water spray bottle

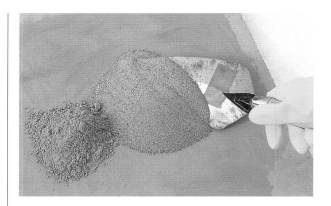

1 Mix sand and cement on a board using a trowel. The usual ratio is three parts sand to one part cement. These should be mixed together thoroughly. Cement coloring powders can be added at this stage if desired.

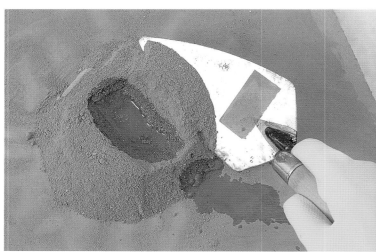

2 Make a well in the mixture, and slowly add water. Craft glue can be added to the water before mixing for greater bonding strength (three parts water to one part craft glue).

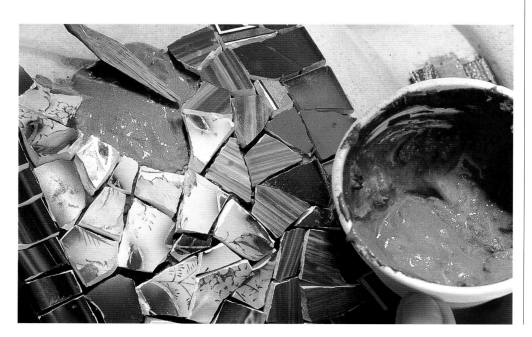

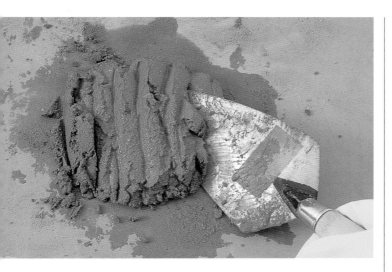

3 Mix the water into the sand and cement carefully with the trowel, taking the mix from the outside and working it inward. The mixture should be firm and not runny to prevent cracking and weakening during the drying-out process.

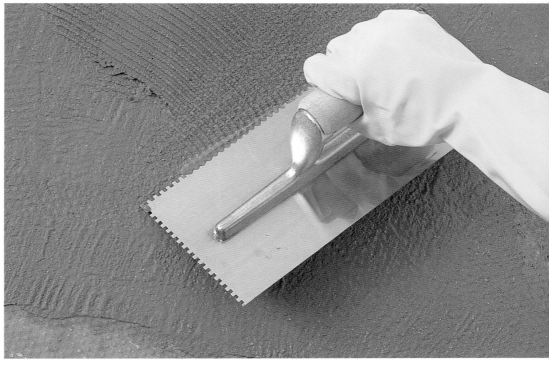

5 Use a notched grout float to apply the cement/ sand mix to the base—the notches being used to key the adhesive base.

4 If the cement adhesive is being applied to a plastered wall or floor, a layer of slurry should be applied first. This is a runnier version of the cement/sand mix. Wet the area to be covered with water using a paintbrush, then trowel on the slurry before the cement/sand adhesive.

TIP

Cement/sand mixes need time to cure properly (about two to three days) and should be kept damp during this process to avoid cracking. They can be wrapped in polyethylene or dampened cloths, or dampened using sponges, cloths or a spray bottle.

Laying the tesserae

The way in which you lay your tesserae (known as *andamenti*) affects the overall look of your mosaic, especially once it is grouted. The choices you make about details such as the spaces left between the individual pieces of tesserae are what gives the mosaic its sense of rhythm.

There aren't really any hard-and-fast rules in the designing of your *andamenti*—the choice you make in laying the tesserae depends on the effect you want to achieve with the final piece. Usually the most straightforward way is the one that will look the most natural, so it is often best to go for the most obvious solution. However, there are a few points you should be aware of before you begin.

It is often best to begin by doing the foreground areas, details or defining lines first. Because of the nature of mosaic, its natural flow can be expressed in a way that will alter the original outlines of the drawing. If you work on the background or other less important areas first, this will not happen, and the mosaic might end up looking somewhat cramped and unnatural.

Tesserae making up one line or section should be laid next to one another as part of a continuous line or shape to maintain the flow. Don't start from two or three different places and expect everything to meet up neatly at the end.

As a general rule, it is best not to leave very large gaps between the tesserae, because this can give the mosaic a very fragmented look and ultimately interfere with the image or pattern. However, leaving slightly larger or irregular spaces (or interstices) between the tesserae is a creative approach that is effective for highlighting particular areas. A mosaic

Right way
Tesserae are laid in a continuous line

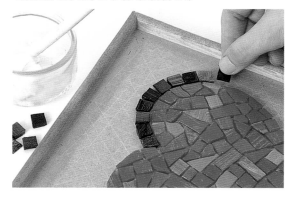

Wrong way
Tesserae are laid in broken lines

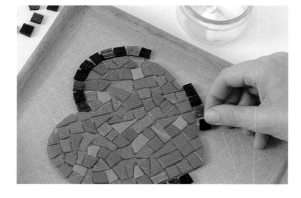

Right way

Angled tesserae are the same size and shape, and a border is used.

Wrong way

The angled tesserae are different sizes, and no border is used.

Right way

The tesserae forming the curve and circle are even.

Wrong way

The tesserae forming the curve and circle are uneven.

Right way

These three examples all show correct ways in which to lay mosaic tiles. The spaces are even, giving a harmonious effect.

Wrong way

Spaces are uneven and the tesserae crooked.

laid with varying spaces between the tesserae for no apparent reason will look sloppy and unprofessional. To give the mosaic a sense of unity and flow, the spaces should be the same throughout. A mosaic with interstices of about ¼ inch (6 mm) or larger should be grouted with a coarse, heavily sanded grout like the one used for flooring.

Try to avoid using very small fragments at the edges of the the mosaic or where one section of *andamento* meets another. When a line of tesserae hits another section at an angle, cut the final tesserae in each line to a similar size and angle for a neat and even look. The preceding tesserae can be subtly widened or narrowed to avoid the last one looking small and uneven.

As well as making the mosaic appear untidy, tiny slivers on the edges are very vulnerable both during grouting and when the mosaic is in its final location. To avoid this, subtly widen or narrow the preceding tesserae as before, or use tesserae to create a border around the edges of the mosaic before you fill in the background. If you are using cut tesserae to create a border, it looks neater if the uncut edges are laid on the outside.

When laying tesserae around a circle or curve, cut them all to a similarly angled shape. A mixture of shapes and angles will look untidy.

For more ideas on different ways of laying tesserae, *andamenti* and opus, see page 130.

Grouting

Grouting is the process by which the spaces, or interstices, between the tesserae are filled. Don't be put off by the thought of grouting, because it is an important part of making a mosaic: it unites the mosaic's elements and creates one whole surface. Grout emphasizes the *andamenti* that have been used in the mosaic, and the mat quality of the grout highlights the glossiness of vitreous glass and glazed ceramic.

The mosaic's adhesive should be left to dry thoroughly before grouting—for at least 24 hours, or longer if a cement/sand mortar has been used.

Mosaics made using smalti should not be grouted, because the grout lodges in the pitted surface of the glass and dulls its brightness. Other decorative mosaics can be left ungrouted if desired, but all functional and exterior-sited mosaics must be grouted to protect the tesserae.

Different types of grout suit different mosaics. Powdered grouts that you mix with water yourself are preferable to ready-mixed varieties. If the mosaic is to be permanently outside, the grout must be frost-resistant. Floors and exterior mosaics should not be grouted with regular household wall tile (or unsanded) grout, while mosaics with wide interstices require a coarser sanded variety to fill them, so that the grout will not subside or crack over time. Products that are advertised as adhesive and grout in one should be avoided, because they make a very sticky grout and the action of cleaning it off can pull the tesserae away from the mosaic base. The most versatile grout is the cement-based variety, which comes in colors ranging from white through gray to black. Some manufacturers also produce ready-colored grouts in shades of blue and brown, for example. Most grouts can be further colored if required by using specialized pigment powders or acrylic paint (see page 81), but if you are unsure of what color to choose, a mid-tone gray is sufficiently neutral to suit most mosaics.

When mixing powdered grout, it is essential to wear a protective mask over your nose and mouth, because inhaling the powder can be detrimental to your health. Rubber gloves should be worn at all times during the grouting process, because grout dries out the skin; keep some hand cream close by to use after grouting. If you are using your hands to rub grout into the mosaic (sometimes suitable for dry, sandy grouts or when you are attempting to grout awkward areas on 3-D mosaics), make sure your rubber gloves are thick enough to withstand the sharp edges of cut glass and ceramic. Thin ones may soon be cut to ribbons on the surface of your mosaic.

When mixing colored grout, make more than you think you need, because batches can be hard to match. Just in case you do need to mix some more grout to an exact color, keep a note of the quantities of grout and coloring powder or acrylic so that you can

remix it exactly. Alternatively, make up large dry batches of color mixes and store them in plastic bags with the colors clearly indicated, mixing up small amounts with water as you need them. (This method only works if you are coloring grout with powder. You can not reuse dried grout once it has been mixed with water.) Also, bear in mind that the grout will look much lighter dry than wet.

While grouting, keep a bucket or bowl of water handy to rinse out your sponge. The sponge should be kept clean to avoid dragging the grout from the interstices when cleaning the mosaic.

THE GROUTING PROCESS

YOU WILL NEED

Newspaper or plastic sheeting

Rubber gloves

Protective mask

Spoon

Powdered grout

Grout coloring powder (optional)

Bowl or container

Water

Tilers' squeegee or rubber spatula

Masking tape (optional)

Bucket

Grout sponge

Cotton bud (optional)

Soft cloth

Matchstick or craft knife

TIP

Under no circumstances must this water be emptied down a sink, because grout can harden inside the pipes and lead to serious blockages. Tip into a discreet corner of a garden or outside area, bearing in mind that when the water evaporates, a colored residue will be left.

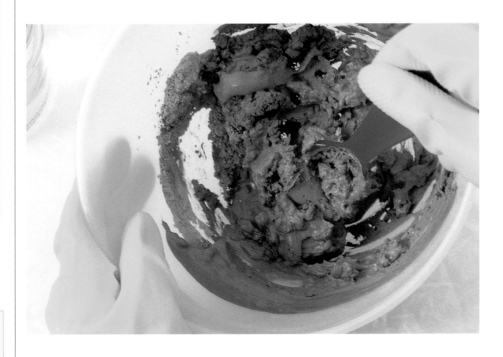

TIP

If grouting a panel or something similar, protect the edges of the base from the grout with masking tape (see page 80).

1 Protect the work surface with newspaper or plastic sheeting. Wearing rubber gloves and a protective mask, spoon some powdered grout into a bowl or

container. A smooth, wide-topped bowl is best, because this makes it easier to mix thoroughly. The grout should feel silky and lump-free—sieve it first if necessary. Slowly add water to the grout, mixing thoroughly with your hands or a spoon until you have a thick cake-mix consistency. Make sure there are no lumps of unmixed grout left at the bottom.

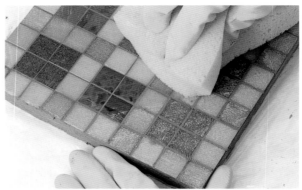

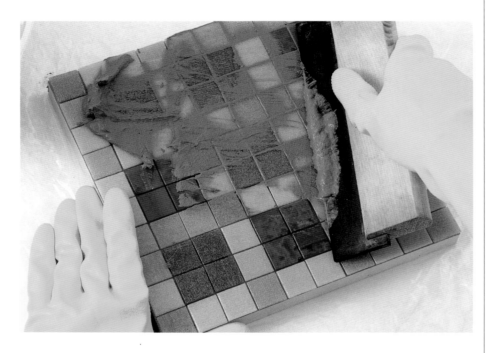

2 Apply the grout to the surface of the mosaic and work it into the interstices using a squeegee (for large flat surfaces) or a rubber spatula (for smaller, irregular surfaces or 3-D objects). Make sure that every space is completely filled with grout.

3 Set the mosaic aside for about 15 to 20 minutes (if you are grouting very large areas, the first section may be ready to clean by the time you have finished grouting the last). Fill a bucket with water and wet the sponge, squeezing out all the excess water until the sponge is just barely damp. The wetter the sponge, the more it will drag the grout from the interstices, which is what you want to avoid. Start cleaning the grout from the surface of the mosaic using a clean face of the sponge each time. When all the faces have been used, rinse the sponge thoroughly, because a dirty sponge will start to drag grout from the interstices. Don't discard any excess grout until the grouting process is complete in case you find areas that have not been filled properly. Just patch these up as you go along.

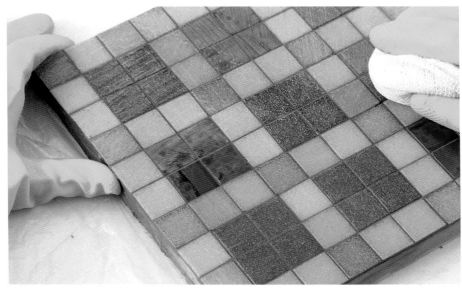

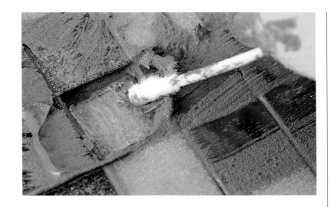

surface of the mosaic, making sure you change the newspaper when it becomes dirty. If the mosaic surface is uneven, a final wipe with a damp sponge will help to smooth the grout.

4 If tesserae become unstuck during the grouting process, remove grout with a tipped swab and re-stick the pieces in place with adhesive. Very gently regrout around the tesserae, taking care not to dislodge them while cleaning. If care is taken, you should not have to wait until the adhesive has dried thoroughly before regrouting. However, if large areas of tesserae are coming loose, finish the grouting and replace them properly.

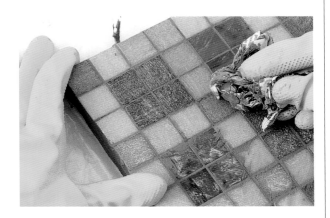

6 When a milky haze develops on the mosaic, polish it off with a soft dry cloth or rag. Use a matchstick or craft knife to gently remove any dried-on grout or adhesive. The grout will be properly dry after a few hours.

5 Newspaper can also be used to remove the excess grout, although it may be better to avoid this technique if the mosaic is white or very pale, in case the newspaper discolors it. Tear off a piece of newspaper, crumple it up and rub the grout off the

TIP

Cleaning off the grout using strokes diagonal to the direction in which the tiles have been laid also helps to stop the grout from being dragged out of the interstices.

7 Wash all grouting implements thoroughly in a bucket of water directly after grouting because dried-on grout is difficult to remove, especially from nonflexible tools or containers, where it is almost impossible. Scrape out and discard unused grout from the bowl or container before washing it. Never wash anything in a sink, because grout will block up the pipes.

TIP

If you have protected the edges with masking tape, peel it off after grouting and cleaning the mosaic for a neat, clean finish.

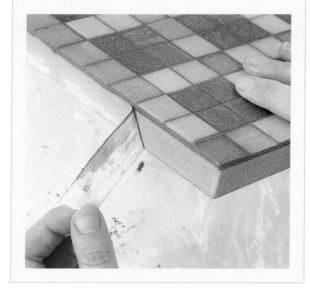

GROUTING WITH CEMENT AND SAND

A cement/sand mortar can be used as a grout as well as an adhesive. Mix up the mortar (see page 72) and press into the mosaic using your hands (wearing rubber gloves) or a squeegee. Wipe off the excess grout, and leave the piece to cure for two to three days wrapped in polyethylene or damp cloths, or dampened regularly with wet sponges, cloths or a spray bottle.

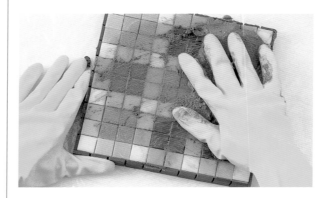

If polishing does not remove the dull, milky haze that appears on the cured mosaic, hydrochloric acid may be needed to clean it. It is essential that great care be taken, because the acid is very powerful. The cleaning is best done in an outside area, and strong rubber gloves should be worn at all times. It is a good idea to protect clothing with an apron. Any spillages should be washed away immediately with large amounts of water. Pour a small amount of acid into a glass jar and dilute it with 15 times the amount of water. Paint it onto the surface of the mosaic with a large paintbrush. A fizzing noise will be heard as the acid eats into the cement. Wash the mosaic immediately with lots of water—if any acid is left on the surface, it will continue to eat away at the cement. If cleaning a large mosaic, use this process on small sections at a time. Leave to dry, then polish with a soft cloth.

COLORING GROUT

Some mosaics benefit from having a particular colored grout, because it can be used as part of the color scheme of the design. Different colored grouts affect the way the colors within the mosaic are perceived by the eye (see page 108). However, don't be tempted to try and achieve really strong, bright colors when coloring the grout—the more color you add, the more the strength of the grout becomes diluted, and it also becomes harder to clean off.

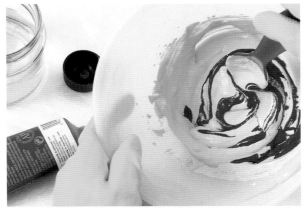

Acrylic paint: Mix the dry grout with water, then add the paint, and stir in thoroughly.

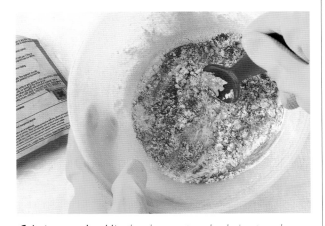

Coloring powder: Mix the dry grout and coloring powder together first, before adding water and stirring thoroughly.

There are two ways of coloring the grout—powders and paint. Add coloring powder to the dry grout, and mix in thoroughly before adding the water. If you are using paint to color the grout, add it after the water, again making sure it is thoroughly mixed in.

It is also possible to color the grout on a grouted mosaic after it has dried. Mix some acrylic paint with a little water on an old saucer or plate, and apply to the lines of grout with a fine brush. Wipe any paint off the tesserae with a cloth as you go along.

Painting after grouting: To change the color of the grout after it has been applied to the mosaic, wait until the grout is completely dry before painting the lines.

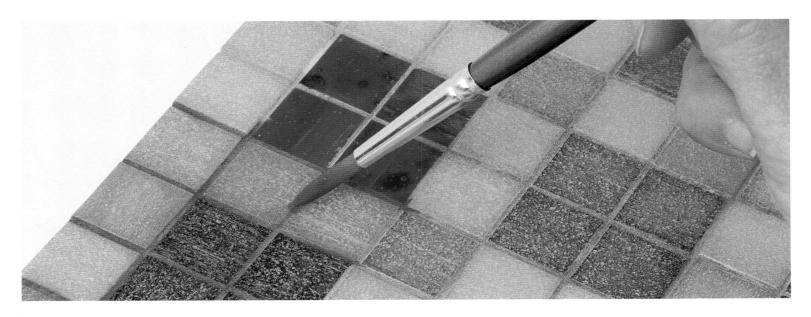

The direct method

The direct method involves sticking the tesserae straight onto the base. It can be used for all surfaces and is the best technique to use for covering 3-D objects.

YOU WILL NEED

Adhesive

Spatula or glue spreader

1 Seal wood, terra cotta or plaster bases with a water-soluble craft glue and water mix before starting. Wood bases will also need to be keyed with a craft knife or hacksaw blade. Ceramic bases may need sealing with a primer for impervious surfaces if you are using cement-based adhesive.

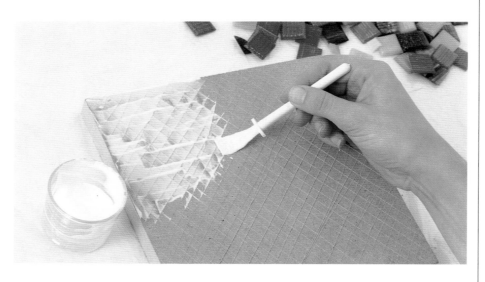

2 Apply a layer of adhesive to an area of the base. Large areas of cement-based preparations and tile adhesive will need to be keyed first using a notched or pronged tool. The tesserae can also be individually "buttered" with the adhesive and stuck directly onto the base—use whichever technique you feel most comfortable with. In all cases, the adhesive should not be applied so thickly that it pushes up between the tesserae and onto the surface of the mosaic.

3 Wipe off any adhesive from the surface of the mosaic as you go along.

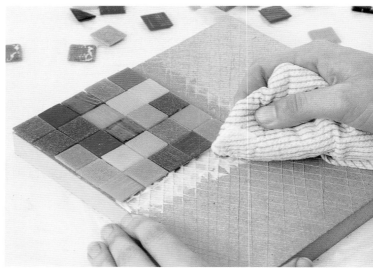

4 If you are completing your mosaic in stages, it is important to wipe or scrape away any extra adhesive from the base while it is still wet before you finish work for the day. If it is left to dry, it will make an uneven surface for the next section of tesserae.

BUTTERING

Buttering is the term used to describe applying adhesive directly to the back of the tesserae. If you are working with tesserae of uneven heights, it may be necessary to butter the backs of the thinner tesserae with extra adhesive to raise it up to the level of the thicker pieces. This technique will only work with thick adhesives.

1 Use a knife, spatula or plastic spreader to apply a layer of adhesive to the back of the tessera.

2 Push the tessera into the layer of adhesive on the base until the correct height is achieved. If it is too high, scrape off some adhesive and try again. Wipe away any adhesive from the surface of the tesserae.

MESH

If the area to be covered is in a tricky location, you can mosaic onto nylon mesh, which can be positioned later. Tiles of the same depth should be used for this.

YOU WILL NEED

Masking tape

Mesh

Sheet of clear polyethylene or plastic wrap

White craft glue

Glue spreader

Scissors

Notched grout float or trowel

Cement-based adhesive

Wooden block

Hammer

1 Place the design to be copied on the work surface and secure with masking tape. Make sure it can be seen clearly through the mesh. Lay a sheet of clear polyethylene or plastic wrap over the design (to stop the mesh from sticking to it), tape it down, then tape the mesh over the top. The mesh should be slightly larger than the design.

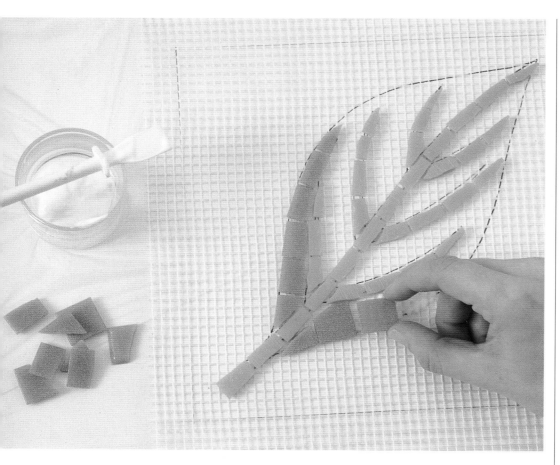

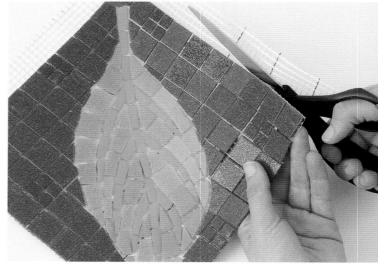

3 Leave the mosaic to dry, remove the tape, and trim the mesh with scissors before laying in position in the desired location.

2 Apply white craft glue to a small area of the mesh, and push the tiles onto it. Continue in this way until the mosaic is finished.

TIP

Make sure that all the areas of glue are either covered with tesserae or wiped clean if you are leaving the mosaic unfinished for any length of time. Dried-on adhesive will create an uneven base for the next round of tesserae.

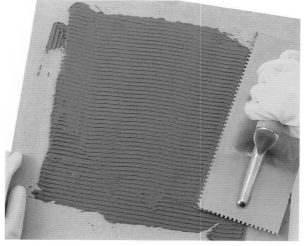

4 Using a notched grout float, apply a thin layer of cement-based adhesive to the area on which the mosaic is to be laid, making it slightly larger than the mosaic itself.

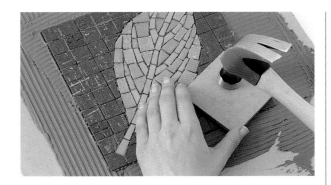

Using white craft glue on 3-D surfaces

5 Carefully place the mosaic into position, and use a block of wood and a hammer to tamp it down. The adhesive should push up through the holes between the tesserae but should not squeeze over the edges. Scrape away the excess adhesive, and grout when dry.

3-D SURFACES

For 3-D surfaces in terra-cotta and stone, cement-based adhesive will hold the tesserae firmly in place while you are working, even on vertical surfaces. It will also stick tesserae onto glazed ceramic, providing it has been primed with a primer suitable for impervious surfaces. For glass and glazed ceramic bases, silicone sealant holds glass tesserae well, but it has an unpleasant smell. However, white craft glue works just as well on glazed ceramic but should be left to become tacky to prevent tesserae slipping.

When covering a 3-D object with mosaic, don't rest the mosaiced surfaces on anything until they are completely dry.

Remember that on 3-D pieces, the edges will be vulnerable, so make sure that the tesserae are firmly stuck down. It is best not to stick tesserae absolutely flush with the bottom of the object, because these can be easily knocked. Instead, leave a gap of around ¼ inch (7 mm), and fill with grout during the grouting process. All exposed edges should be filled with grout.

1 Apply a layer of white craft glue to a small area of the surface and to the backs of the tesserae.

2 Let the glue become tacky (this is when it starts to become transparent). This takes around five to ten minutes, depending on your work environment.

3 Press the tesserae onto the base. The adhesion should be firm and instant. Repositioning will often weaken the bond, so try and get it right first time. If the tesserae continue to slip, wait a little longer for the glue to dry before sticking them down.

The indirect method

The indirect, or reverse, method is the process in which tesserae are stuck face down onto brown wrapping paper before being stuck onto the mosaic base. The paper is then peeled off, creating a smooth surface. This makes it the ideal technique to use when the mosaic needs to be completely flat, and it is especially suited to walls and floors.

YOU WILL NEED

Strong brown wrapping paper

Wooden board and gum strip (optional)

Cloth or sponge

White craft glue

Small paintbrush

Craft knife (optional)

Grouting equipment

Rubber gloves

Tilers' squeegee

Cement-based adhesive

Notched grout float or trowel

TIP

If the mosaic is quite small, stretch the brown paper on a board first. This ensures that the paper does not stretch when glue is applied and contract when dry, which may cause a disturbance in the mosaic surface. Wet a sheet of strong brown paper, about 2½ inches (60 mm) larger all round than your design, with a cloth or sponge, and lay it over a dampened board that is larger than the paper. Waxing the board with a candle beforehand will help the paper come away easily once the mosaic is finished. Use gum strip to fasten the paper to the board, making sure all the edges are firmly stuck down. Leave to dry and draw on the design.

1 Draw out the design onto the mat side of a piece of strong brown wrapping paper, the exact size of the intended mosaic. Remember that however it is drawn here, the finished mosaic will be the reverse of it, so any lettering or designs that must face a certain way when installed must themselves be reversed in this drawing.

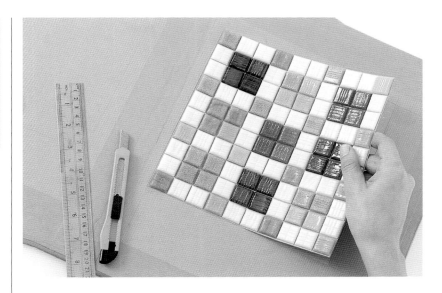

2 The tesserae must be glued down with white craft glue. This is very important, because if the glue is water-resistant in any way, the brown paper backing cannot be soaked off. You can use white craft glue (mixed 50:50 with water), gum arabic or dilute wallpaper paste.

4 When the mosaic is completed, leave to dry. If the paper has been stretched, use a craft knife to cut it carefully away from the board.

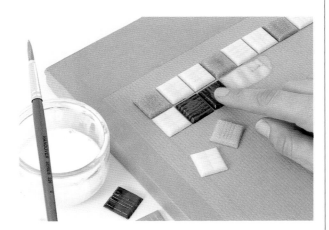

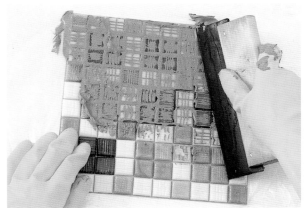

3 Using a small paintbrush, apply the glue to a very small area of the paper. Do not apply too much, especially if the paper has not been stretched, or it will buckle. Stick the tesserae on, flat side down, then move on to the next area. Hold the sheet up occasionally to check that the tesserae have stuck properly. Avoid having very small tesserae at the edges of the mosaic.

5 You will need to pregrout the mosaic before it is laid in place to prevent the adhesive creeping up between the tesserae. Put on rubber gloves, and mix up some grout in a container. Work it over the mosaic with a squeegee, making sure the grout fills up all the spaces between the tiles.

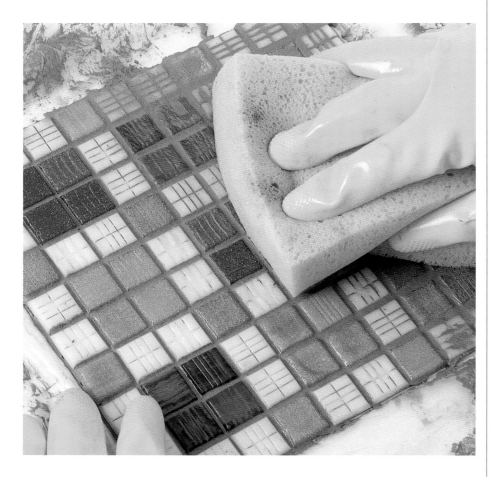

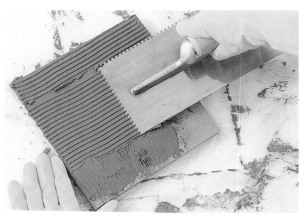

7 Prepare a layer of adhesive (not too thick) on the base with a notched grout float or trowel, making sure that the surface is even and free from lumps.

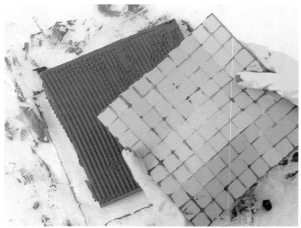

6 Remove the excess with a dampened sponge until no grout remains on the surface. Leave for no more than 20 minutes before laying into the adhesive bed in the mosaic's final location.

8 Pick up the mosaic, taking care not to roll it up or scrunch it in any way, and gently place it, tesserae side down, paper side up, onto the adhesive. If the mosaic is square or rectangular, position one corner first, then the rest of piece should line up accurately. There will be enough give in the adhesive to gently move the mosaic around if the initial placing is incorrect.

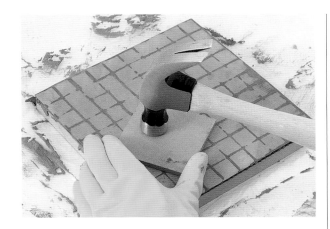

9 When satisfied with the placing, wet the surface of the paper with a sponge and rub the mosaic in circular motions with your hand or tamp it down with a block to make sure that all the tesserae are in full contact with the adhesive.

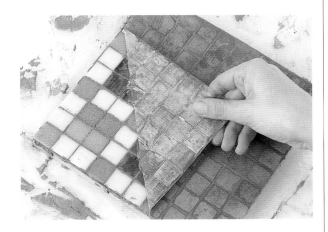

10 Wait until the paper is dark brown and the white craft glue has dissolved. This should take about 10 to 20 minutes. Then carefully peel the brown paper away from the mosaic, holding the paper right back over the surface, not at 90 degrees away from it, because this could pull the tesserae off the mosaic. It is important to wait until the paper

pulls away effortlessly from the mosaic, because you don't want to lift up any tesserae. If any do come loose, replace them immediately, making sure that there is sufficient adhesive underneath.

11 Use the sponge to carefully wipe off any grout that may remain on the surface of the mosaic, and scrape away any adhesive from the edges with a spatula or small grouting tool.

12 When the mosaic is completely dry, regrout from the front.

The indirect method is also used when casting cement slabs (see pages 290–303).

Finishing and fixing

A few additional touches to the finished mosaic can make a real difference and are well worth the effort. Mosaic panels can be displayed on walls with either temporary or permanent fixings, and any undecorated edges can be covered in a variety of ways. A little bit of extra time spent on this part of the process will complement and enhance the work you have put into your piece.

FINISHING

Decorative panels, mirrors and tabletops can be framed to give a neater finish. Mosaic tiles, simple wooden frames and metal edging strips can all be used. Alternatively, the edges can simply be painted with acrylic or latex paint. Sections of furniture that have not been covered with mosaic can also be painted.

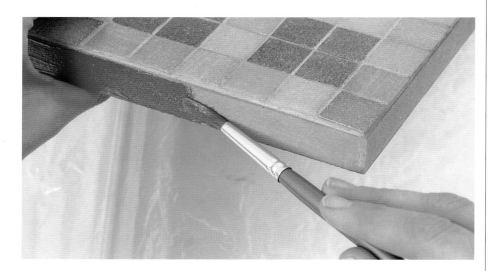

Painting

This can either be done before starting the mosaic or after grouting. The color of the paint could match the grout, complement the colors used in the mosaic or be a neutral color such as gray or brown. Use a small brush to paint the edges and the back of the panel. If this is being done after grouting, take care not to get any paint onto the grout. If you have painted the edges before you started the mosaic, you can protect them with masking tape before you grout.

Tiles

Framing with mosaic tiles is not recommended for large, heavy pieces or ones that are likely to be moved around a lot. A tiled frame suits circular mosaics because there are no corners, where the tiles tend to be most vulnerable. Whole, half or quarter tiles can be used, depending on the depth of the panel. Unglazed ceramic tiles are better than vitreous glass for this, because the latter are vulnerable to chipping.

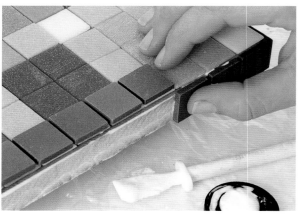

Frame the mosaic with tiles before grouting. Place the mosaic on a small, sturdy surface, like a stool, because it will provide easy access to all the edges and you won't need to move the mosaic around, which could dislodge the tiles. Calculate how many tiles you need by laying them along the surface of the mosaic. If you are using whole tiles, it is better if you don't have to cut any to fit the end of the row. Juggle with the spacing to make them fit neatly. Stick the tiles around the edges, and leave to dry without moving for at least 24 hours before grouting. Make sure that none of the tiles overlap the base of the mosaic.

glued or nailed around the edge, giving a neat look. It is better to frame the wooden base of a mosaic in this way before starting the work, so that the tesserae on the edge butt snugly up to the frame. If framing the mosaic afterward, take care to ensure that you stick all the tesserae on the edges flush with the base. If you are using this method to frame a table, the top of the wood strip or frame should be level with the table surface; otherwise, it will be difficult to keep clean.

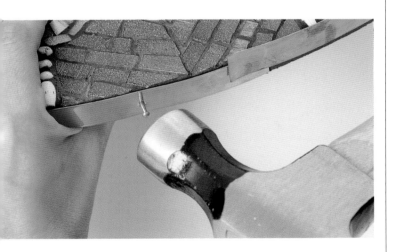

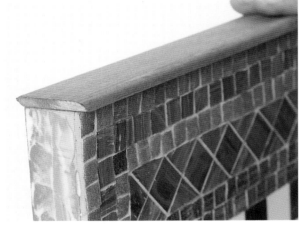

Ensure that the first side of mitered wood is perfectly placed; otherwise, none of the other edges will meet.

Once all the sides are in place and before the glue dries, use a frame tightener to ensure the frame is lined up perfectly and securely.

Metal edging strip

A metal edging strip is ideal for framing circular panels and tabletops. The top edge should be level with the mosaic surface. It is nailed on with finishing nails, which should be rustproof if the mosaic is going outdoors.

Wooden frames

Mosaics are enhanced by simple wooden frames—anything too decorative detracts from the mosaic. Simple strips of mitered wood standing about ⅜ inch (5 mm) higher than the surface of the mosaic can be

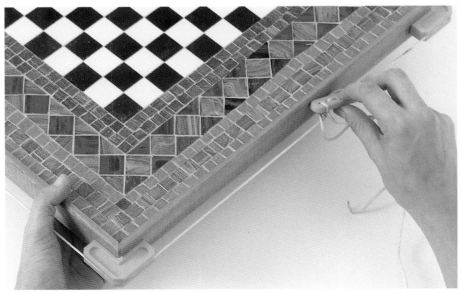

FIXING

Mosaic panels can be hung on walls using both temporary and permanent methods. To hang a mosaic on a wall temporarily, eyelet screws, D-rings or picture fasteners can be used. For permanent fixing, the mosaic can be attached directly onto the wall by means of screws through countersunk holes, which are made in the panel before the mosaic is started.

Temporary fixing light pieces

Small, light mosaic pieces can be hung on the wall using eyelet screws or D-rings, which enables them to be hung and moved around easily. Use two eyelet screws per panel.

2 Use a gimlet or awl to bore holes in the points you have marked, and screw in the eyelets. The screws must be shorter than the thickness of the panel or they will go straight through the base and cut into the mosaic, potentially cracking the tiles you have placed. Use picture wire or something similar to join the two screws. Hang the panel from a double picture hook that is wall-mounted in a position strong enough to take the weight of the mosaic.

1 Measure the points where you want the eyelets to be attached on the back of the panel, and mark with a pencil. Each one should be an equal distance away from the edges and roughly three-quarters of the way up the panel.

Temporary fixing heavy pieces

Heavier pieces are best hung using picture fasteners, which still provide a temporary fixing but make the panel less straightforward to move once in place. These can be screwed in at the top or the sides of the piece but should be placed in the same position on either side to make it easier to hang the panel straight. Use between two and six fasteners, depending on the size and weight of the mosaic.

1 Measure equal distances on the back of the panel where you want the fasteners to go, lay them over the base and use a pencil to mark through the holes.

2 Use a gimlet or awl to bore the holes and screw the fasteners firmly to the wood. Again, the screws you use should be shorter than the thickness of the base. Mark and drill corresponding holes into the wall, insert wall anchors, and screw the mosaic onto the wall.

Permanent fixing

In order to attach a mosaic panel permanently to a wall, you will need to drill and countersink holes in it before starting the mosaic. A countersink tool bevels the edge of the drilled hole so that the head of the screw will sit comfortably in it without jutting up into the base of the mosaic. Mosaic and grout the panel as usual, keeping the holes uncovered (leave an appropriate space for tesserae to be glued on later). Hold the panel up to the wall, and mark through the holes with a pencil as a drilling guide. Drill the holes, insert wall anchors, and screw the panel to the wall. Once it is in place, cut tesserae to fit into the spaces, glue them over the screws, and then grout.

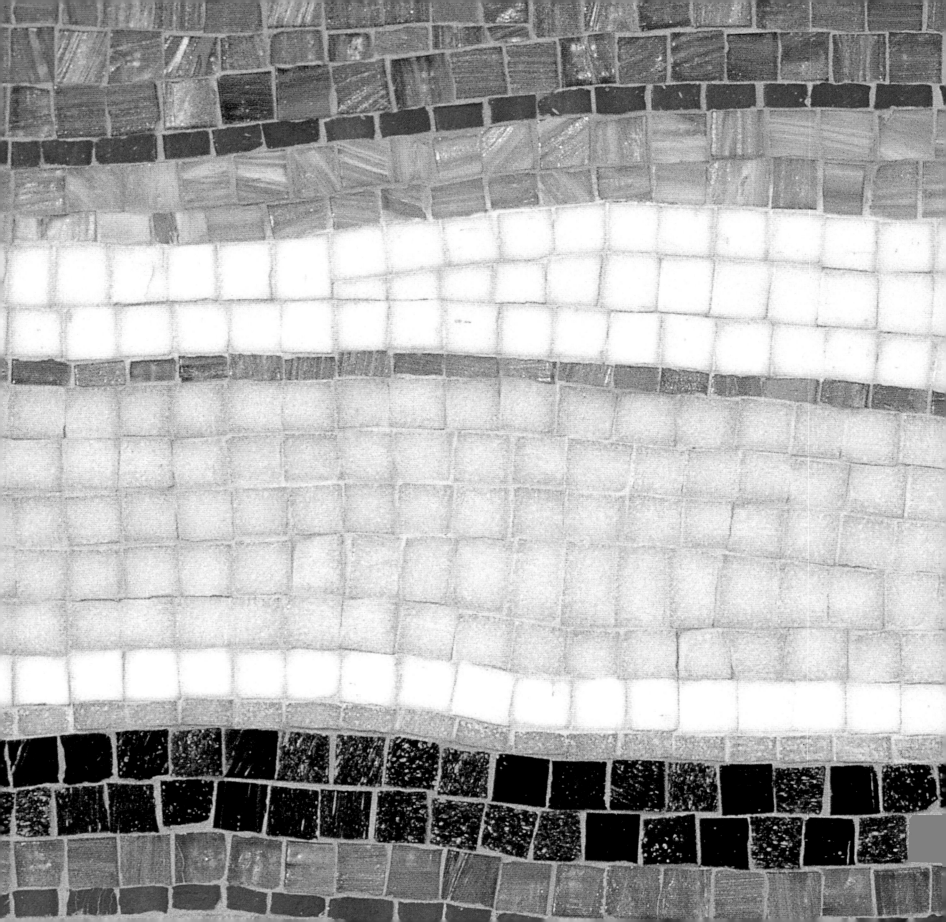

Design

This section explores the elements of good design as they apply to mosaics. You'll learn how to find inspiration in everything from architecture to nature and start to understand color and how to use it to its best effect. Discover the elements of design, such as line and contrast, through practice with small projects.

There are no rules for designing mosaics, but for a successful design it is important that you are enthused and inspired by the subject matter. What inspires one mosaicist may not inspire another.

Think about pictures or objects that attract you. What is it about them that appeals to you? Is it the color, the shape, the texture, the pattern or something else? Making a conscious effort to identify these factors will help you begin to understand exactly what it is that you are drawn to.

Keep a sketchbook or visual diary, and fill the pages with anything that inspires or appeals—magazine

The author's sketchbooks

Cut and torn pieces of a gift bag designed by Antoni Gaudí, from La Pedrera, a design house in Barcelona, Spain, are combined with a postcard of the pavement tiles Gaudí also designed.

Additional color ideas are displayed in this sketch of a traditional house and a collection of ephemera from Mallorca, one of the Balearic islands off the coast of Spain. Note the composition on the left-hand page.

clippings, photographs, postcards and memorabilia, swatches of fabric or gift wrap, sketches, interesting color combinations, whatever you like. Record anything and everything that attracts you, no matter how small or unremarkable it might seem in context, because it may be useful for color schemes, backgrounds or patterns. Take a camera and sketchbook with you on outings and vacations.

The design section of this book suggests possible sources of inspiration and explains basic color theory and the principles of design. Seven simple related projects are featured.

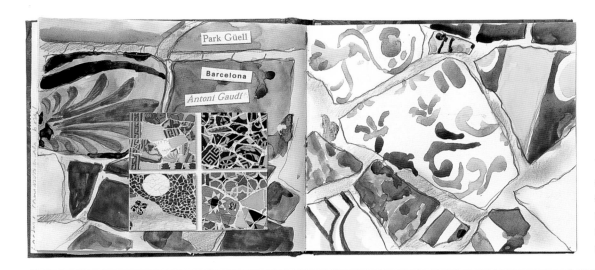

The decorated benches of Parc Güell, another example of Gaudí's design work, inspired this page of watercolor sketches mixed with cut up postcards.

Ideas for possible mosaic designs are sketched out in rough form.

Finding inspiration

Only you can decide what excites you visually, but the following areas all provide an endlessly rich source of inspiration for mosaic design. Look for examples of them in your own environment, your home and garden, in books, galleries, museums and stores.

Nature

The natural world is a treasure chest of visual imagery, full of colors, textures, patterns, shapes and contrasts. Plants, seashells, reptiles, animals, exotic birds and tropical fish make excellent subjects for mosaics. Fish are especially easy to represent in mosaic, because the tesserae perfectly mimic the idea of scales. Landscapes can be portrayed directly or can inspire a color scheme, and their shapes and textures can be converted into rich abstract designs. Decorative patterns, as found on the coats of animals, for example, can be used as the basis for a design, and patterns can also be found in repetition of the same form, such as a flock of birds, a pile of shells or pebbles, or the leaves of a tree. Making a feature of a detail can be just as interesting as showing the whole, and there are lots of natural forms that reveal interesting design aspects when viewed close up, such as fruit, vegetables and shells. Weather conditions affect landscapes in compelling ways—the cracks in dried earth, the snow on chain-link fences and branches, icicles, patterns of frost or raindrops on a window or on water, storm clouds—all of these can produce beautiful, inspirational effects that are well worth recording.

Mountain ranges can be inspiring for large-scale projects and can be used to add height or depth to a landscape mosaic piece.

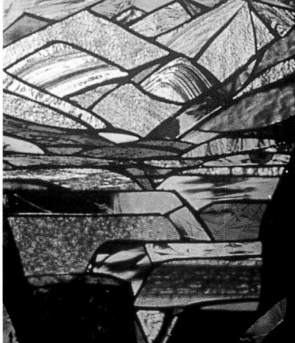

The thousands of species of flowers that exist provide a seemingly endless supply of natural beauty and inspiration. Look closely at the color, shape and texture.

Here, two very different mosaic pieces have been inspired by flowers. The heliconia (far right) shows the vibrant colors and intricate detail, whereas the nasturtium (below, right) has been inspired by the curvaceous shape of the petals.

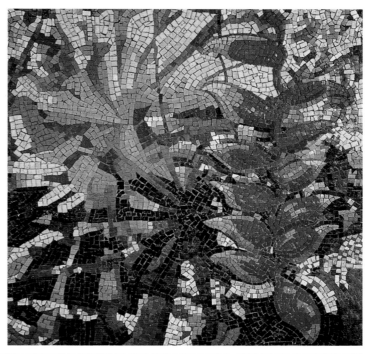

Art and culture

Existing art forms, such as painting and sculpture, can also provide inspiration for mosaic design. Many artistic movements are fantastic sources of rich decorative elements that can be copied or adapted in mosaic. Art Nouveau and Art Deco lend themselves particularly well to mosaic—in fact, the craft itself was often incorporated in these styles. The painters of the Impressionist movement often created images using blocks of pure color, in much the same way that a mosaicist would—so these, too, could provide inspiration. Illuminated manuscripts, jewelry, cave paintings, children's art—all of these can stimulate ideas for designs. Ancient art and cultures are also a fertile ground for images—Egyptian, Greek, Roman and Aztec, for example. Ethnic art forms and styles from around the world provide a huge variety of designs, colors and images, as well as different ways of looking at things and stylizing them. Do further research in galleries, museums and books.

Movements such as Art Nouveau have inspired all the major craft forms, including mosaic. The sensuous curves, stylized representations of nature and subtle colors make this a popular movement in art history. This color litho, by the Czech Art Nouveau printmaker Alphonse Mucha (1860–1939), shows these elements to their fullest and also includes some mosaic detail.

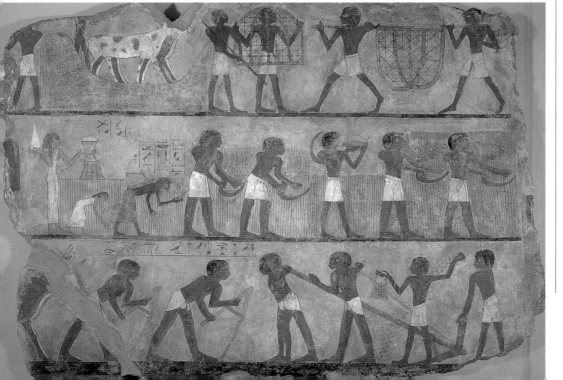

Ancient art forms can be as inspirational as their modern counterparts. This Egyptian pigment-on-clay wall painting, showing scenes of sowing and harvesting, was discovered in the tomb of Usnou, East Thebes, from the Egyptian New Kingdom, c.1555–1080 B.C. It can now be seen in the Louvre in Paris, France.

Architecture

Both architectural landscapes and details can be used as the basis for designs. Notice how buildings react together to form interesting lines, shapes and combinations of textures or repeat patterns. The surfaces of ancient walls, the mix of textures and markings on city roads and sidewalks, the patterns of windows in a modern office block—all of these are possible starting points for a mosaic design. Architectural details on buildings, such as balconies, moldings, doorways and window frames, can also yield interesting patterns and shapes. Unusual buildings or landmarks in the community where you live or places that you visit become even more interesting if you start looking at them as a potential source of inspiration.

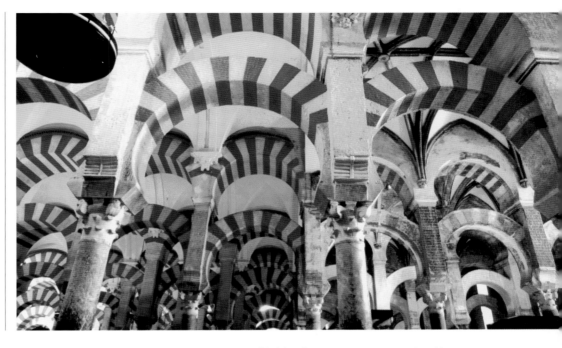

Some architectural scenes can provide virtually ready-made compositions for artists. The instantly recognizable hillside houses of Amalfi, Italy, (below, left) can easily be adapted to create a beautiful mosaic (below, right).

La Mezquita in Córdoba, Spain, contains an awe-inspiring mix of Christian and Moorish architecture. These arches occupy a huge space and provide a wealth of fascinating views and angles from which to inspire a composition.

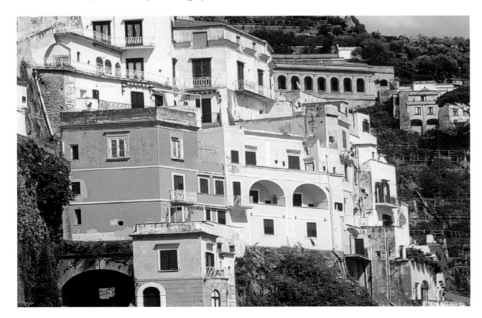

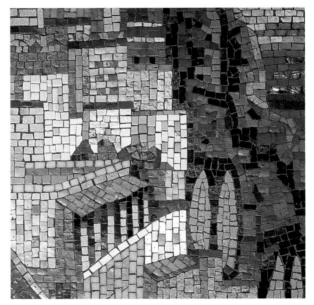

Textiles

Textiles provide another rich and varied source of inspiration with their endless combinations of color, pattern and texture. Even simple fabrics can take on fascinating new dimensions when viewed in different ways. Folding or crumpling them adds movement or distortion to the pattern and changes color tones. A random mixture of clothes seen through a closet door, piled on a shelf or strewn across a chair can generate ideas for original color combinations or mixes of textures and patterns. Highly decorated fabrics can be used as the bases for mosaic designs—think of Indian textiles, encrusted with embroidery and tiny mirrors; the designs and bright colors of ethnic or tribal prints; the stylized representation of exotic flowers found on Asian robes—all of these would make interesting subjects.

Richly decorated textiles, like those found in India, are a wonderful source of inspiration for pattern and color. These Rajasthani women are wearing expensive red and pink saris with gold-thread embroidery.

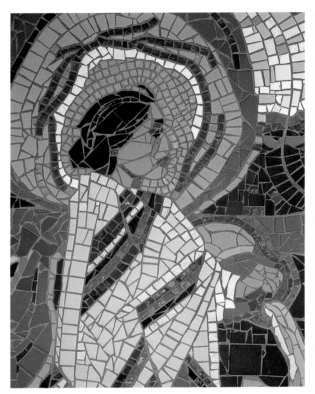

In this mosaic, the features and contours of the face have been formed by specially cut tesserae.

The human form

Portraiture and the depiction of human form have long existed as part of the mosaic tradition. The disciplines inherent in the laying of the tesserae can subtly change and stylize faces and bodies in many exciting ways. A portrait can make a challenging subject for a mosaic, but other approaches are possible. These could include looking at specific sections of the body, such as the curve of the spine, the hands, the feet or an interesting muscle definition. Silhouettes and shadows present another possible approach. Portraits could be made simpler by representing the subject in profile rather than face on, without the challenge of arranging and balancing features!

Geometry

Geometric designs have been featured in mosaics for centuries. The Romans and Greeks used them for floors and borders , while the Moroccan mosaic technique of *zillij* uses complex geometric patterns. If you are not comfortable with using free-flowing curves or realistic imagery in your mosaic but love precise mathematical techniques, you can use geometric forms to produce a huge variety of exciting designs. Experimenting with colors and textures can take these to another level, transforming a simple idea into a stunning mosaic. Add geometric borders to mosaic designs, or use them to decorate mirrors, frames or fireplaces.

This watercolor shows a mosaic design from the Alhambra, a Moorish palace of the Nisrad dynasty, southern Spain.

Size and location

Once you have an idea for a mosaic, some thought is required to make sure that it is suitable for the function you intend it to fulfill. Deciding where your mosaic will be situated and how much space it will take up can help you make other decisions in planning your piece.

Consider the size of the mosaic. A complex design with a lot of detail will be extremely fiddly and difficult to achieve in a small area. If you are planning a large mosaic, it is important that its location will enable that complexity to be seen clearly. It will be difficult to fully appreciate a large, detailed image in a small space, as people will not be able to get enough distance between themselves and the mosaic. Consider also how the site for the mosaic is lit. A dark mosaic or a mosaic with subtle shades or contrasts may be lost if displayed in a poorly lit area. Conversely, direct bright light on a glass or glazed ceramic mosaic produces a constant dazzling effect, which can also make the details of the design difficult to see.

The location of the mosaic sometimes presents restrictions on the use of certain materials, so this also needs to be taken into consideration when thinking about your design.

Color

Color plays a vital part in influencing how we feel about the things we see around us. It can affect mood and create atmosphere. With a little knowledge and understanding of basic color theory, colors can be used to produce specific and very different effects. The following terms are used when referring to colors.

Hues—this term refers to the different colors in the spectrum, like red, blue, violet and so on. White, black and shades of gray are not considered hues.
Tones—the amount of light or dark in a color. Different hues can be tonally similar, having the same intensity or quality of lightness and darkness. This is the overall effect of the color.

Warm colors—colors that have warm undertones, like red, orange and yellow.
Cool colors—colors that have cool undertones, like blue and green.
Neutral colors—colors that do not stand out, clash, contrast or compete with any other colors. Different shades of ochre, brown, gray and off-whites are considered neutral.

The many shades of each color can create different feelings. Here, we see a warm purple and a cool purple.

Neutral colors such as these work well as subtle backgrounds, as well as being useful for showing natural forms.

A selection of different warm colors, based around the primary color red, ranging from orange to pink.

Primary
Red

Secondary
Orange

Secondary
Purple

Primary
Yellow

Primary
Blue

Secondary
Green

The color wheel

The color wheel demonstrates color relationships simply. The colors that are next to each other on the wheel are harmonious colors and blend well when used together. There are no sudden shocks or challenges to the eye, and the effect can be very calming, especially in the cooler end of the spectrum (purples, blues and greens). The colors that are opposite each other on the wheel are known as complementary colors, and when used together, produce a contrast that is immediately exciting and stimulating to the eye. Surrounding a color with harmonious or complementary colors can dramatically change the way the eye perceives it, as shown opposite. The harmonious colors merge smoothly, almost disappearing in the case of the green and blue, but the complementary colors give each other real impact.

Color relationships

The colors that lie next to or surround any color can have a potent effect on how that color is perceived, which is something that you should be aware of when designing. You can plan your colors before you start to see exactly how they influence each other and work together—although sometimes stunning combinations can be stumbled upon by accident! Strong colors will immediately stand out in a pastel or pale scheme, and delicate colors may get lost or overpowered when surrounded by bright or dark colors.

 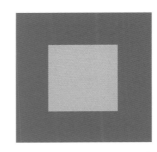

When surrounded by one of its neighboring colors on the color wheel, the blue blends in and becomes quite subtle. When surrounded by its opposite, or complementary color, it takes on an eye-catching vibrancy.

Exactly the same shade of gray appears in the two images above, but it is made to appear different by the colors that surround it. The blue background makes the gray appear warmer, while the orange makes it look cooler.

Put a section of red within a green frame and it appears to be very bright and intense (left). Surround it with a similar hue, like orange, and the red becomes less significant (right).

Dark colors stand out against pale or pastel colors. The contrast is not as intense when they are placed with more vivid and/or darker colors.

White grout	Gray grout	Black grout

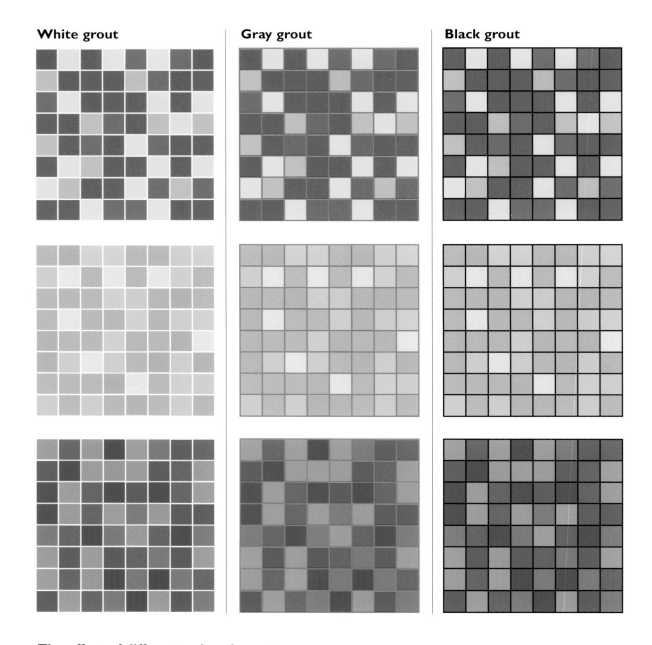

The effect of different colored grouts

The choice of grout can also have a great effect on a mosaic's colors. As a general guide, a mid-tone gray is the best choice if you are unsure of what color to choose, but particular effects can be achieved by using different colors. Be cautious when choosing white grout, because it can produce too great a contrast, drawing the eye away from the tesserae and to the interstices, so the subtleties of the mosaic are lost. A dark grout gives a dramatic look and can create a stained-glass window effect, but it can be too heavy for delicate colors.

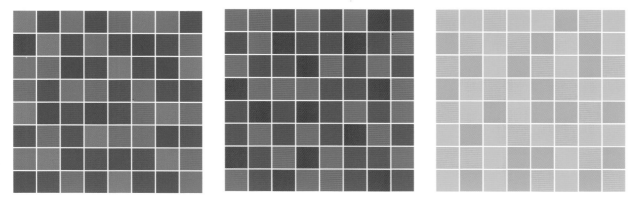

These three examples show the effects of blending colors of similar tonal value.

Mixing colors

As a mosaicist, you will not have the endless color palette of a painter available, so it is useful to be able to master certain techniques to create lively areas of color. Compromises on color will also have to be made, as some important colors are woefully lacking in range—such as yellow, pink and purple in vitreous glass, for example. This will challenge your color preconceptions, and by having to think around the problem, you may end up with a more interesting and carefully considered design.

To liven up large areas of flat color on backgrounds, for example, it is possible to mix in other colors with the same tonal value. These could either be very similar in hue or quite different for a more striking effect. To blend smoothly from one color to another in a mosaic, begin with one color and start to add the occasional tesserae of the second color, gradually increasing them and decreasing the first color as you go.

In this simple yet effective vase, there is a gradual gradient of color from red through purple and blue to green.

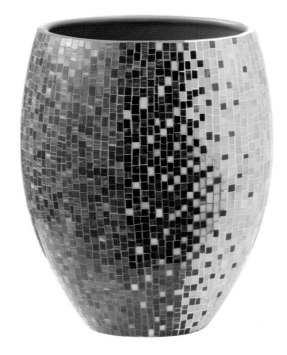

These two examples show how to gradually blend colors.

Bathers at Asnières (1884) by Georges Seurat (1859–91). This is an example of Pointillism, where dots of color are blended by the eye and brain of the viewer. A similar effect can be achieved in mosaic with small tesserae, as can be seen by the two examples on the right.

It is also possible to let the eye and brain of the viewer blend the colors, by mixing reds and blues to create a purple effect or yellows and blues to create a green. This technique was used by the Pointillist painters. Pointillism is a form of painting in which tiny dots of pure color are used and blend together when seen from a distance, creating the illusion of secondary and tertiary colors to the viewer's eye. This theory came from that used by tapestry makers who could only use colors available in the correct thread, so an overall impression was created using juxtaposed thread.

However, this technique will only work on mosaics where the tesserae are small in relation to the base and the viewer is some distance away.

Another important point to remember is that the color of some tiles can vary quite a lot from batch to batch, so if you are making a large mosaic, you should buy as many tiles as you will need at the same time to ensure the colors are identical.

Elements of design

Design can be broken down into a number of formal elements, such as line, form, shape, contrast and composition. A knowledge and understanding of all of these is valuable when looking at and planning images. Individually, each element can provide ideas for a mosaic. Experimenting with different ways of using them can go a long way to creating sophisticated and interesting mosaics, and various effects can be achieved depending on how you lay your tesserae. For example, the method or element that you use to suggest water may be different from the one you use to describe rocks, cliffs, birds or buildings.

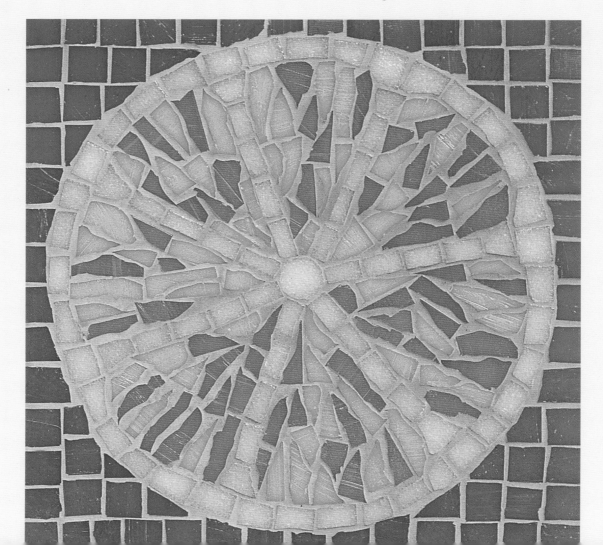

Line

Line is an important starting point in creating a mosaic design, because essentially, mosaic is created out of many lines of tesserae. A feature can be made out of lines by using them expressively. Lines will always draw the eye in the direction they are traveling, so they can be used to "point" the way to an important area of the design. A diagonal line is a very strong, eye-catching element in any image. Lines of tesserae of different widths can build up or suggest contours. Ideas for linear-based designs might be found, for instance, in industrial landscapes, the sea and shore, a plowed field, maps and aerial views. Straight lines give a mosaic a sense of structure and formality, and curving, flowing lines give it life and movement. Giving an outline to an area will emphasize it and root it firmly in the design.

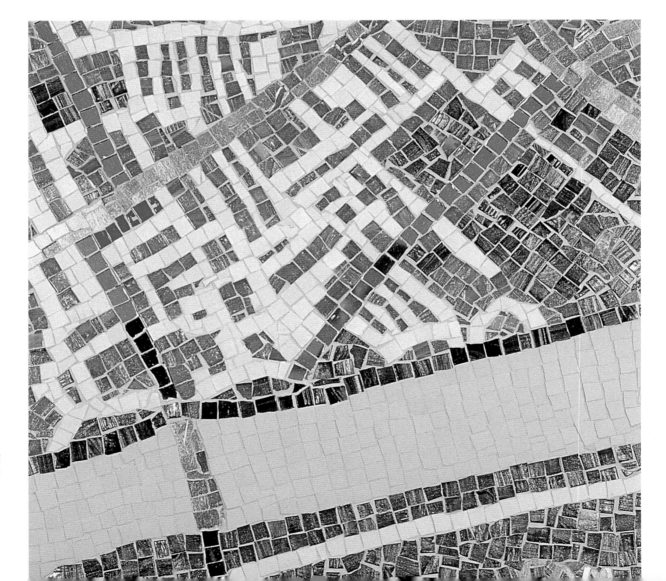

This abstract mosaic— created in 2002 by Claire Milner—was inspired by a street map of Chelsea, London. It was made using ceramic, vitreous glass and gold-leaf tesserae.

PROJECT TO EXPLORE LINE:

Decorative balls

✳ COST ✳ TIME ✳ DIFFICULTY

(the above categories vary depending on how many balls you make and what type of vitreous glass colors you choose)

This project uses lines of tesserae in a very simple and decorative way and encourages you both to try out different cutting and laying techniques on a 3-D surface and to experiment with color combinations. The colors of the balls could be inspired by the color scheme of the room that you are going to display them in, or you could choose a series of colors that you think work really well together. Play with either contrasting or harmonious colors and see how they look. The balls resemble the decorative eggs or spheres cut from onyx with their irregular bands of color, so perhaps colors found in these or other natural forms will inspire you. A whole collection of these balls would look stunning displayed together in a large, shallow bowl. They are recommended for interior use only.

MATERIALS

Vitreous glass tiles

Silicone sealant or white craft glue

Polystyrene balls (you can use wooden ones if you prefer, but the polystyrene ones are cheaper and lighter), around 3¼–4 inches (80–100 mm) in diameter.

Tile grout or fine cement-based grout

Grout coloring powders or acrylic paint

EQUIPMENT

Pencil

Protective mask, goggles and gloves

Rubber gloves

Tile nippers (a glass cutter is also useful for cutting triangles)

Old saucer or equivalent

Small plastic glue spreader or spatula

Rags

Old cups or mugs to rest the balls on while working

Mixing bowl

Rubber spatula or potters' kidney

Grout sponge

Soft cloth for polishing

1 Decide on a color scheme for the first ball. You could keep the palette very simple—choosing two or three colors—or go wild and choose a different color or shade for every band. Choosing only one color to cover the entire ball would draw attention to the shapes and lines of the tesserae.

2 Decide on which shape of tesserae to use for the first row, starting at the center of the ball. This is the best place to use larger tesserae, like uncut squares, triangles or bands of half tiles laid horizontally.

3 Cut the tesserae into the desired shapes with the nippers or glass cutter.

4 When using silicone sealant, wear a protective mask, and work in a well-ventilated space. Squeeze a small amount of sealant onto an old saucer, and use a glue spreader or spatula to smooth it over a small section of the area you want to cover. Don't make it too thick, or the sealant will squeeze up over the edges of the tesserae. If this happens, wipe the excess off immediately with a rag.

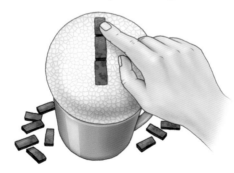

5 The silicone sealant dries quickly, so be decisive when positioning and sticking. Press the tesserae onto the sealant-covered areas on the ball, leaving small gaps between each one. Rest the ball on top of a cup while you work, if you find that easier.

6 Use the glue spreader to scrape away any sealant from the edges of the line. Continue to apply sealant and stick on the tesserae until you reach the end of the first line. If necessary, trim the final tessera to fit into the last space.

7 Continue to work in lines around one side of the first ball, varying the shapes and sizes of the tesserae. It is easier if you confine the bigger tesserae to the center. Toward the edge of the ball, you will need to use simpler shapes such as rectangles and squares, since uncut tiles and triangles will need too much trimming. You will also need to start cutting the tesserae so they fit the circumference better. Experiment with not trimming some of the tesserae and leaving larger gaps between the tops, although these shouldn't get too big. To fit comfortably around a circle, the tesserae will need to be trimmed so that they are wider at the top than the bottom.

8 Nibble a tile into a circle to fit the last space on this half of the ball.

9 Fill in the other half of the ball in a similar way, varying the patterns and colors of the tesserae so that you don't get a mirror image of the first half of the ball.

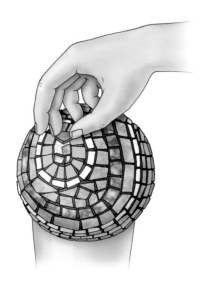

10 To make a ball with undulating lines of tesserae, mark a curving line over the ball with a pencil. Think of making something that roughly resembles the continuous line on a tennis ball. Make sure that the curves are not too shallow, because this will make some of the later lines too difficult to fill in. To add interest, draw a separate round shape inside a large area.

11 The undulating lines suit squares and rectangles rather than triangles and whole tesserae, which would need too much trimming to fit around the curves. Experiment with quartered tiles cut in half to make tiny rectangles; these can be laid vertically as well as horizontally. Follow the same process as described in Steps 4 to 8. In the narrow centers of the curving shapes, use smaller tesserae. A crazy-paving effect can also be used to fill in the center.

12 Set the balls aside to dry on the top of the mugs for at least 24 hours. Be careful not to dislodge any tesserae from recently covered areas.

13 Choose a neutral grout color, such as gray, or mix up individual grouts with coloring powders or acrylic paint (see page 81) to complement the colors used in each ball. Use a small, flexible rubber spatula or potters' kidney to grout, and clean off with a sponge or newspaper and a sponge. Polish with a soft cloth when the grout is completely dry. The grouting process really brings the balls to life and emphasizes the patterns of the cutting techniques you have used.

Shape and form

In this mosaic, by Antonietta Di Pietro, interlocking shapes are defined by line as well as the contrast of tesserae in different textures and sizes. Some sections use smooth lines of square tesserae, while others incorporate the dynamic qualities of marble.

The shapes that you use in your mosaic will immediately provoke a response in the viewer. Straight edges, squares, rectangles and lines can appear formal, man-made, hard and direct, whereas curves, circles and undulating edges are softer, more organic and natural. Jagged lines and shapes have a very strong impact that suggest prickles, spikes or horns and are eye-catching and dynamic in the same way as diagonal lines are. Shapes can be defined using line, color or tone.

To suggest form, you need to create a sense of light and shadow that gives a 3-D effect. A light, medium and dark tone of one color in the chosen tesserae will work well, along with a basic highlight (usually white), if necessary. More subtle shading can be achieved with a range of different tones of the same color. To blend tones smoothly, begin adding touches of one color in a line of another, and add a few more to each line every time (as described on page 109). Being able to define form is essential for creating realistic images in mosaic.

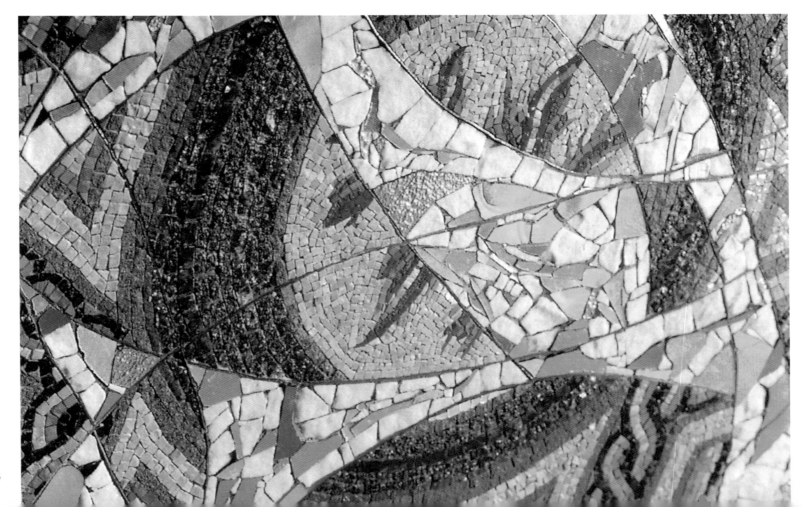

PROJECT TO EXPLORE SHAPE AND FORM:

Window box

✳ COST ✳✳ TIME ✳✳ DIFFICULTY

This project demonstrates how to give objects basic form and definition by using different tones of color to suggest light and shade. The mix of broken pieces of ceramic introduces liveliness and texture to the mosaic. This window box is suitable for exterior use, but because some glazed ceramics are not frost-proof, it should be brought inside during the winter.

MATERIALS

Plain terra-cotta window box

White craft glue (see page 54)

Charcoal (or pencil and tracing paper)

Glazed ceramic—broken china, crockery and tiles

Cement-based adhesive

Blue and black grout colorants

Cement-based grout

EQUIPMENT

Paintbrush

Protective mask, goggles and gloves

Tile nippers

Hammer

Towel

Small plastic glue spreader or spatula

Craft knife

Mixing bowl

Flexible rubber spatula or potters' kidney

Grout sponge

Bucket

Rubber gloves

Soft cloth for polishing

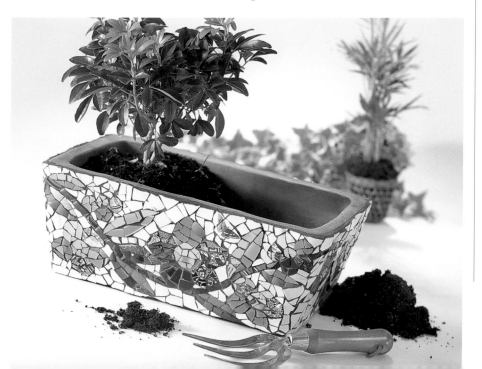

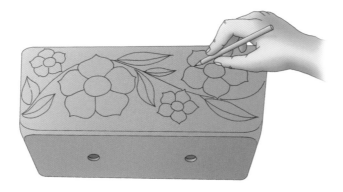

1 Seal the window box with a 50:50 mix of white craft glue and water. Trace the design or draw it on using charcoal, which can be easily wiped off if you make a mistake. Make sure that the stem forms a continuous line around all four sides.

2 Break a selection of plain and patterned ceramics into random shapes—in white and various shades of blue, green and yellow—using either the nippers or a hammer. Sort them into color groups, and keep them separate—this makes it much easier to work.

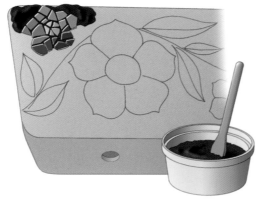

3 Arrange the window box on your work surface so it is stable and easy to access—lay it on a folded towel or prop it up on a sturdy pot or bucket. Begin with a flower, filling in the center with yellow, using lighter tones at the top and darker or more greenish

ones at the bottom. Keep the spaces between the tesserae as small and regular as possible. Apply cement-based adhesive to the base or to the tesserae, whichever you find easiest, and use the buttering technique to raise the height of thinner tesserae.

4 Fill in the petals one by one, starting with lighter blues at the top and gradually getting darker toward the bottom (make some flowers darker than others). Mix plain tesserae with patterned ones, and use your judgment when combining them—if a piece seems to fit in well with the rest of the petal and doesn't stand out or look too garish, then stick it down. It may help to arrange the tesserae on a piece of paper first so you can remove and rearrange them at your leisure until you think it looks right.

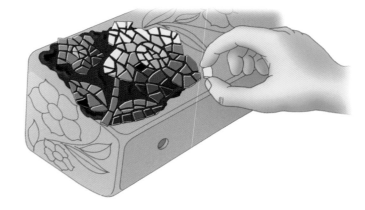

5 Do the section of stem around the flower next, using thin tesserae in olive green or brown, and then move onto the leaves. Choose either turquoise, emerald or yellow shades of green, and stick to this basic color for individual leaves—mixing them too much will distract the eye from the light and shade effect that you are creating. Use lighter tones on the upper half of the leaf and darker ones on the bottom.

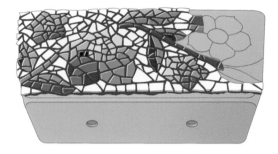

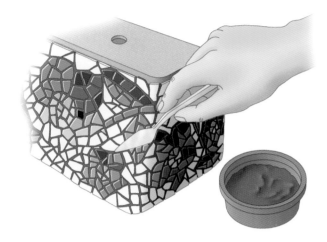

6 Fill in the section of background around the flower with white tesserae. Remember to leave a gap of about ¼ inch (6 m) between the lowest tesserae and the bottom of the box, as these tesserae can be very vulnerable if they are too close to the edge. Keep the top row of tesserae level with the top of the box, and aim to keep this line as smooth as possible.

7 Continue working around the window box in the same way. If you like, add the occasional detail to the background, like insects or tiny flowers. When the mosaic moves onto another side, keep the tesserae small enough to follow the curve of the base comfortably. Tesserae with a similar curve of their own will come in useful here. When you have covered the entire box, leave to dry for at least 24 hours.

8 Add some blue and black colorant to a gray cement-based grout to make a dark slate-blue color—this will look lighter when dry. Work the grout into the mosaic with a small, flexible grouting tool, smoothing it over the top row of tesserae and filling the gap you have left at the bottom of the mosaic. Try not to get too much grout onto the exposed terra-cotta surfaces. Clean the mosaic with a damp sponge, making sure that all the grout has been removed from the surface of the tesserae, particularly from any uneven areas. Polish when dry.

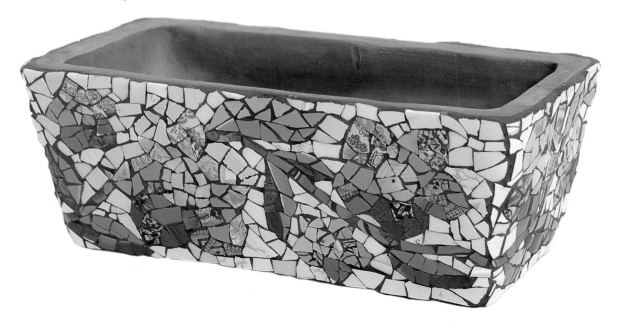

Contrast

The light and dark tones in this fifth-century Byzantine smalti mosaic perfectly illustrate good use of contrast.

The effect of contrast can exist in many different forms, such as texture (rough with smooth, shiny with mat), color (dark with light, warm with cool) and size. Other contrasting effects include showing one object set against a group and using curved lines with straight ones. Any of these will create impact.

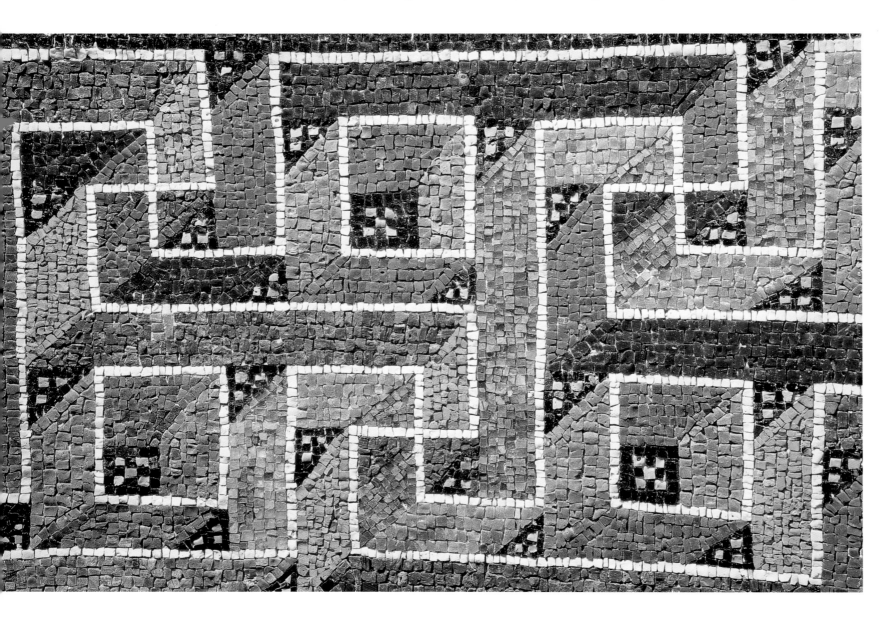

PROJECT TO EXPLORE CONTRAST:

Chessboard

✳ COST ✳✳ TIME ✳ DIFFICULTY

This chessboard makes use of the contrasts of texture and color in a very simple way. The uncut black and white unglazed ceramic of the playing surface is mat and gives a formal feel, while the rich, warm colors of the vitreous glass border have a lovely shiny texture. This border is created using lines of different-sized squares and triangles and is good practice for basic cutting and laying.

MATERIALS

14-in (360 mm) square of medium-density fiberboard (MDF)

1-in (25-mm) square black and white unglazed ceramic tiles—32 of each color

Vitreous glass tiles in metallic pink, chestnut, light and mid-brown

White craft glue (see page 54)

Cement-based grout

Masking tape

Thin, mitered strips of wood for framing (optional)

EQUIPMENT

Paintbrush

Ruler

Pencil

Craft knife

Protective mask, goggles and rubber gloves

Small plastic glue spreader or palette knife

Glass cutter

Tile nippers

Mixing bowl

Rubber gloves

Grouting squeegee

Grout sponge

Bucket

Soft cloth for polishing

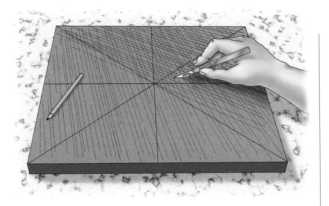

1 Seal the MDF with a 50:50 mix of white craft glue and water, then use a ruler and a pencil to draw four lines crossing the center of the board. Score the surface with a craft knife to provide a key. You can frame the board before or after you do the mosaic. The wood can be stained to blend in with the colors of the border or painted with acrylic or latex paint.

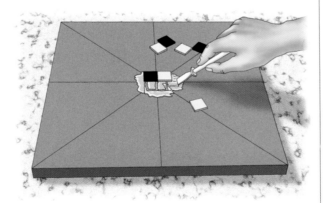

2 Beginning at the center and working outward, spread a thin layer of white craft glue on a small section of the board, and begin laying the black and white tiles, buttering each one on the back with craft glue as well. Make sure the glue is not so thick that it oozes up between the tiles. Use the guidelines to ensure that the tiles are straight, and leave small, even gaps between each one.

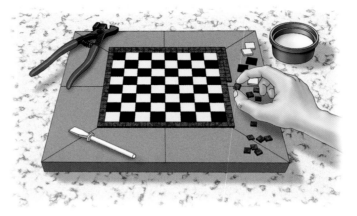

3 When the chessboard section is complete, lay a double row of quartered mid-brown vitreous glass tiles around it, once again keeping the spaces between each tessera regular.

4 Cut some pink and chestnut triangles using the glass cutter. Starting at the top of one side of the border, begin laying two rows of red triangles interspersed with uncut pink tiles. To ensure an even fit, you may need to move them around slightly after the whole row has been laid. Top the row with a pink triangle.

5 As the border design moves round the corner, the colors naturally reverse, so use pink triangles and red squares on the adjoining side. Continue like this around the whole border.

6 Use the lightest brown tiles cut into quarters to make a single line around the border. Use tesserae of the same color as the first row in each corner.

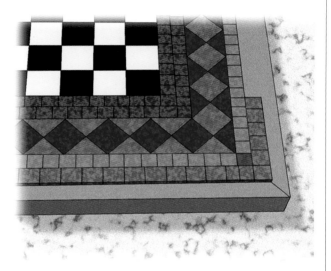

8 Finally, lay a row of the light brown tiles around the edge. Use the uncut, beveled edges of the tesserae on the outside edge for a neater finish.

9 Allow at least a day for the craft glue to dry out thoroughly before grouting with gray cement-based grout. Tape the edges of the board with masking tape beforehand to protect them, and peel it off when the grout is dry. Frame the edges if you have not already done so.

7 Cut the pink tiles into ½-inch (12 mm) squares, and lay them around the border. Make sure that the space left at the extreme edge of the border is the right size to accommodate a final row of quarter tiles—adjust the size of the pink squares if necessary.

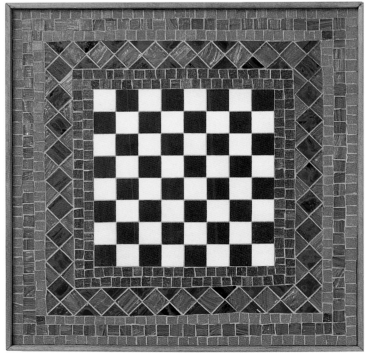

Composition

Composition refers to the arrangement of objects in the design and their relationship with each other and the space they occupy. There is definitely more to designing an image then just drawing it randomly onto the background and leaving it at that.

To start with, you may want to consider whether the subject needs to be positioned exactly in the center. Sometimes a more interesting relationship is established with the space around it when one subject is moved to one side. If the subject is placed in the center of your image, make sure that it "sits" comfortably and is not squashed up to one side or cramped in any way. It is often better to leave slightly more space between the subject and the bottom of the image to prevent creating the illusion that it is sliding down the background. Sometimes, the subject may fill the space around it more comfortably if it is placed at an angle. It is really worth taking that extra bit of care with composition, as it makes a lot of difference to the finished design.

When looking at the subject that you wish to depict in your mosaic, consider whether you need to show the whole thing. Sometimes focusing on a particular area, or "cropping in," may give a much more interesting design. To help you do this, cut out two large "L"-shaped pieces of paper, put them together to form a movable square or rectangle, and move them around the image you are working with, making the shapes larger or smaller as necessary until you see something that really excites you. It is possible to recognize a subject from even a small section, or conversely, an everyday object may take on a fascinating sense of mystery when viewed close up.

A peacock feather (below, right) is as fascinating close up as it is as part of the whole bird (below, left). Each has great potential for mosaic design. The angle at which the single feather lies within the rectangle also creates interest.

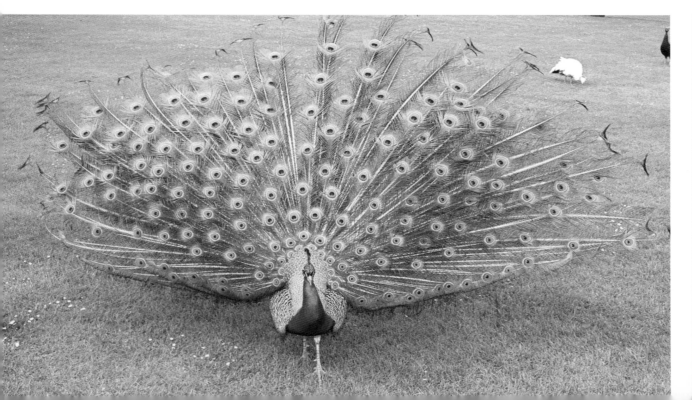

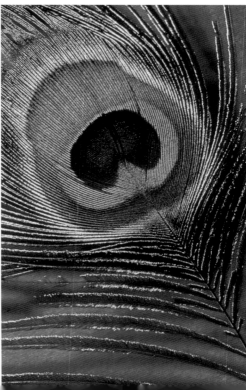

The subject can be placed centrally or to one side.

Always leave slightly more space at the bottom than at the top; if equal space is left between the top and bottom of the subject, it looks as though the subject is sliding out of the frame.

Tilting the subject allows it to sit more comfortably in its space and will create a more interesting composition.

PROJECT TO EXPLORE COMPOSITION:
Fruit tiles

✳✳ COST ✳✳ TIME ✳✳ DIFFICULTY

These tiles demonstrate simple ways of placing an object in a space. They can be mounted as wall tiles or backed with squares of felt and used as pot stands or coasters. Three finished designs are shown here, but you can also experiment with your own ideas based on a similar fruity theme—melons, figs, lemons and limes, apples and star fruit are all good starting points. Keep the colors bright and the designs simple.

MATERIALS

Pencil

Tracing paper

Thick brown paper

Gum strip

Vitreous glass tiles

Ceramic tiles (6 in/150 mm square or larger)

Water-soluble craft glue

Sealant for impervious surfaces

Cement-based grout

Cement-based adhesive

EQUIPMENT

Scissors

Wooden board

Tile nippers

Protective mask, goggles and gloves

Small paintbrush

Craft knife

Small rubber spatula or potters' kidney

Small notched grout/adhesive spreader

Mixing bowl

Grout sponge

Small block of wood

Bucket

Rubber gloves

Soft cloth for polishing

Fine sandpaper

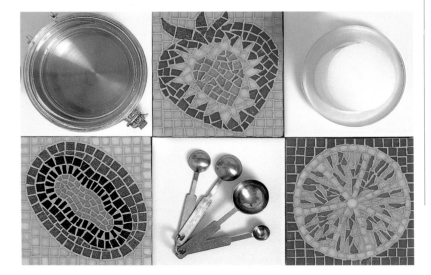

1 Cut the brown paper into a piece about 2½ inches (60 mm) bigger all round than your tile. Wet the wooden board with a sponge, and dampen the paper on both sides. Smooth the paper over the board, mat side up, and fasten the edges down securely with the gum strip. This process is called stretching the paper and means that it won't buckle when it is made wet again. When the paper is dry, trace down the design. Remember that this will be the reverse of the final image on the tile.

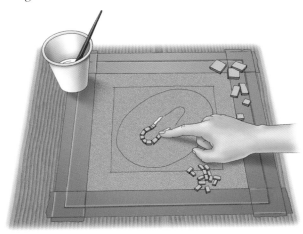

2 To make the kiwi fruit design, you will need vitreous glass tiles in yellow, black, lime, emerald and dark green. Cut the lime green tiles into quarter squares and then into small rectangles. Mix the water-soluble glue 50:50 with water, and paint it onto the outline of the shape in the center of the fruit, applying only a small amount of glue at any one time—enough to lay five or six tesserae. Working from the outside in, lay the tesserae, flat side down, onto the glued area. Trim them to fit around the curves and in the small areas left in the center.

3 Cut some black tiles into similar rectangles and use these to surround the central part of the fruit, laying them vertically this time. Then lay a line of quarter tiles in the darkest green around these, again trimming their edges where necessary to fit around the curves.

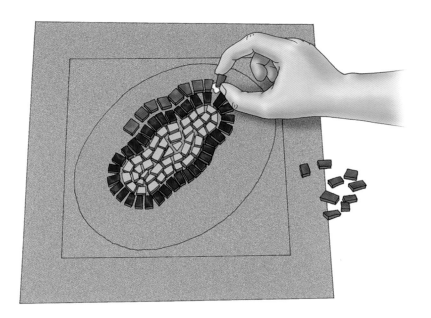

4 Move onto the outside of the fruit and outline it with a ring of quarter tiles in the remaining shade of green, then fill in the space left over, cutting the tiles into appropriate sizes and shapes.

5 Finally, fill the background with yellow quarter tiles, beginning from the outside corners and working round and then in toward the fruit. Try and cut the tiles so you don't end up sticking down tiny slivers of glass where the background meets the fruit. Leave to dry. While waiting, seal the ceramic tile base with a sealant for impervious surfaces, which will help it to bond with the cement-based adhesive.

6 Pregrout the mosaic, using the spatula to work the grout into the interstices. Leave for a few minutes, then dampen the sponge, wring it out thoroughly and wipe away all the grout from the mosaic's surface.

7 Use the notched spreader to apply a thin layer of about ⅛ inch (3 mm) of cement-based adhesive to the ceramic tile, making sure that it is evenly distributed all over the surface, including the edges. Carefully lift the mosaic, and place it face down onto the tile, lining up all the corners. Use the block of wood and the end of the nippers to tamp the mosaic down, making sure that all the tesserae are in contact with the adhesive. Thoroughly wet the back of the paper with the sponge, and leave it until the paper becomes dark brown.

8 Starting at a corner, carefully peel the paper away from the mosaic (if tesserae start coming unstuck, replace the paper, wet it again, and wait for a few minutes before trying again). Once the paper

is off, very carefully clean the surface of the mosaic with a sponge to remove any lumps of grout and glue residue. Take care not to dislodge any tesserae—if they start shifting about, stop at once, and try again later. Scrape away any adhesive from the edges of the tile.

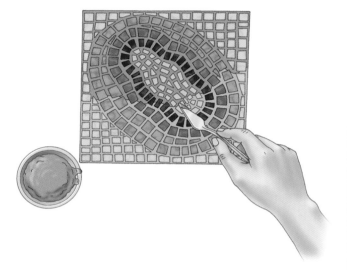

9 When the adhesive is totally dry, regrout the mosaic from the front, working it into the edges of the tile as well. When the grout is dry, polish the mosaic, and sand down any uneven areas of grout on the edges and back of the tile.

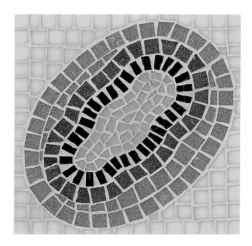

Other designs

To make the strawberry, start with the center section and work progressively outward using a crazy-paving style of randomly cut tiles. Fill in the leaves with tesserae cut to fit the shapes of the sections of the leaves, starting with the ones in front. Fill in the border as for the kiwi. To make the orange, outline the segments and the outside of the shape first, using tiny rectangles and quarter tiles trimmed to shape. Break light and dark orange tiles into long shards (they will break quite naturally into these pointed shapes) and fill in each segment starting from the outside and working inward, randomly alternating the two shades of orange. Fill in the background as before.

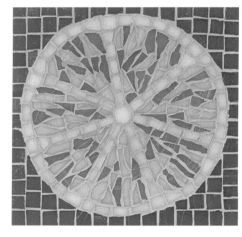

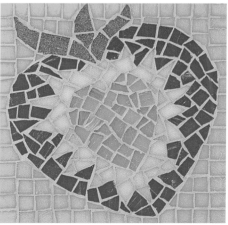

Opus

The Romans developed many different patterns and effects by laying particular shaped tesserae in certain ways. Each of these patterns is called an *opus* (*opera* in the plural). Below and opposite, you can see some examples of the most used and recognised *opus*. The same pattern or picture can be drastically altered by the way in which the tiles are laid. Combining two or more *opera* in the same piece can further add interest. The most common and age-old *opera* have their own Latin names, as detailed below. But do not feel limited by the traditional forms—experiment with the mosaic and you will develop your own style.

Opus tessellatum
This technique was a favorite of the Romans and involves surrounding the subject with a line (or sometimes two or three lines) of tesserae and then filling in the background with simple lines. This provides an anchoring effect to the image and gives definition.

Opus reticulatum/ regulatum
This refers to an even grid of tesserae, which gives a formal and structured effect to the mosaic.

Opus vermiculatum
"Vermiculatum" means worm and refers to the snaking, wormlike effect of lines of tesserae curving around the subject. This pattern gives a lively sense of flow and emphasizes movement.

Opus palladianum
This is a random pattern of tesserae, mixing a range of shapes in a haphazard way. It suggests neither structure nor flow but gives an all-over sense of liveliness. It is a good way of filling in irregular areas.

Other ideas

Different laying techniques can be used and combined to enhance areas and suggest a subject's nature or characteristics. You can experiment with imaginative ways of laying—the fan pattern was popular in Roman designs and is especially good for backgrounds. Mix a pattern of rectangles in different directions, or interspace them with squares or circles. Using rectangles to form a basket-weave pattern is another interesting way of filling in large areas. An area made up entirely of circles would provide an interesting contrast in a mosaic and could be used to denote fish scales or flowers seen from a distance.

PROJECT TO EXPLORE OPUS:

Three hearts

✳ COST ✳✳ TIME (NOT INCLUDING FRAMING TIME) ✳ DIFFICULTY

These panels are created in the same colors, but it is the variety of ways in which the tesserae are laid (*andamenti*) that makes each one very distinctive. The lines and spaces of the tesserae create totally different effects—some appear lively, others more static. This project demonstrates how powerfully an individual *andamento* affects the way a mosaic looks.

MATERIALS

Three ⅜-in-thick (9 mm) medium-density fiberboard (MDF) panels, sized 9 × 7½ in (230 × 190 mm), framed with simple strips of wood (these can be stained if desired)

Masking tape

Vitreous glass tiles

White craft glue (see page 54)

Grout

Eyelet screws and picture wire

EQUIPMENT

Tracing paper

Pencil

Craft knife

Tile nippers

Protective mask, goggles and gloves

Paintbrush

Small plastic glue spreader or palette knife

Mixing bowl

Rubber spatula or potters' kidney

Grout sponge

Soft cloth for polishing

Awl or gimlet

Trace the heart design onto all three panels, then seal with a 50:50 mix of white craft glue and water and score the surface of the wood. Do not touch the frames.

PANEL 1

This heart is executed in random lines of half and quarter tiles with the background in Opus Vermiculatum.

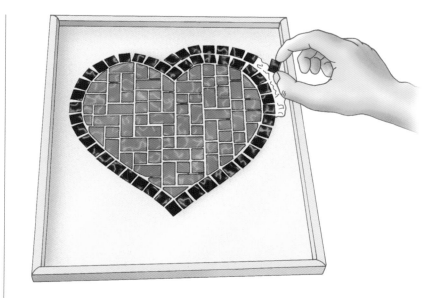

1 Cut a mixture of half and quarter tiles. Starting at one side of the center of the heart, lay a vertical line of tesserae, mixing up the sizes of the tesserae and the direction of the half tiles as you go. Trim the tesserae appropriately when you get to the edges of the heart, again avoiding using very tiny pieces. Carry on laying vertical lines like this, continuing with the random mixing.

2 Surround the finished heart with a line of quarter tiles, then a second line, and continue to work outward in this way.

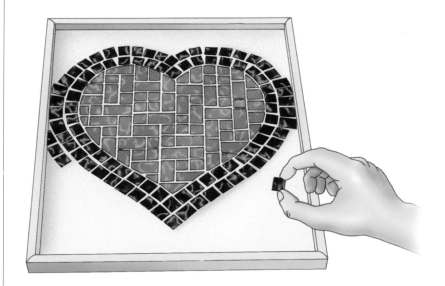

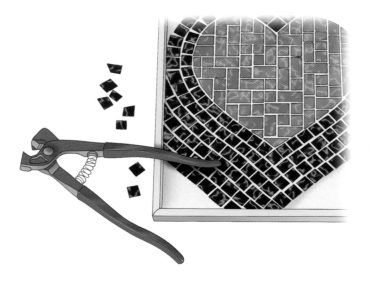

3 Where the mosaic meets the frame, try and cut triangular tesserae of the same size and shape to avoid an untidy look (see laying the tesserae, pages 74–75).

3 When you reach the center, trim the quarter tiles a little to make two rows of slightly thinner tesserae that fit comfortably into the space.

PANEL 2

This heart is executed in Opus Vermiculatum and the background in Opus Regulatum using half tiles.

1 Cut a mixture of red and deep orange tiles into quarters and halves. Outline the heart using quarter tiles. You should not have to trim this first set as they go around the curves at the top of the heart, but make sure the tops of the tesserae lie parallel with the outline.

2 Work inward in similar rings of quarter tiles. Trim half tiles into shape to follow the curves as they get tighter.

4 Cut a selection of black and other very dark tiles into halves, and outline the panel with them, pressing them right up against the frame. Fill in the remaining background, maintaining the lines set by the outline. When the tesserae meet the heart, try to avoid using tiny slivers by cutting slightly larger shapes to overlap into the smaller spaces.

PANEL 3

This heart is executed in Opus Palladianum and the background in Opus Tessellatum.

1 Break the tiles into a series of random shapes (or use leftovers from unsuccessful tile cutting) and fill in the heart in a crazy-paving style, placing the tesserae quite close together and trimming them where necessary, especially at the edges.

2 Surround the heart with a ring of quartered tiles as in the first panel.

3 Fill in the rest of the background following the same procedure as given in Step 4 in Panel 1, but use quartered tiles instead of halved ones.

When all the panels are finished, leave for at least 24 hours before grouting, using a brown-colored grout that will dry to the same color as the frames. To hang, make two holes in the same positions of the back of each panel with an awl, screw in the eyelet screws, attach the picture wire and hang the panels as a set in either a vertical or horizontal line.

Mixing media

Texture is an obvious idea to play with in mosaic, especially in the use of mixed media, and what appear to be very simple designs can become incredibly sophisticated in their exploration of surface textures. Each tessera has its own properties, and these can be combined in endless ways. If you were doing a seascape in mosaic, you may consider how to suggest the different textures of water, sand, pebbles, fish and seaweed by using different materials, rather than just depicting them realistically. Abstract mosaics benefit greatly from the additional textural interest that mixed media provides.

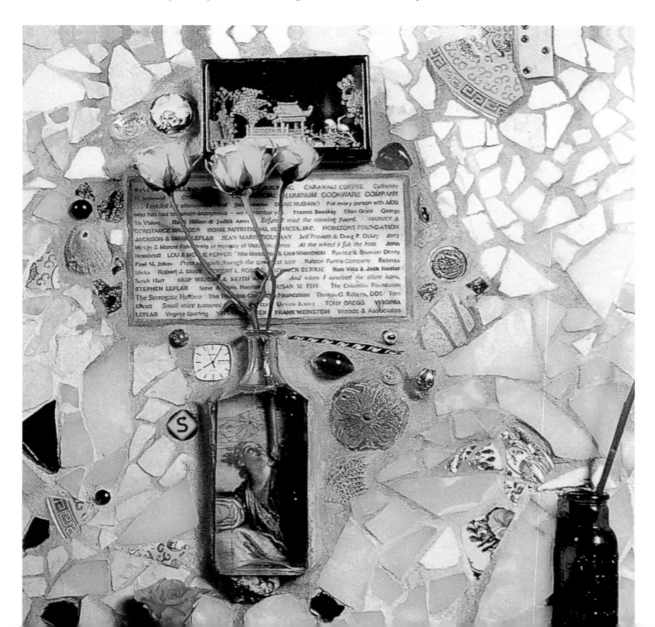

PROJECT USING MIXED MEDIA:

Glass vase

✳ COST　　✳ TIME　　✳ DIFFICULTY

This project uses a mixture of glass materials to decorate a clear glass vase. It can be used as a vase (displayed against a window for maximum effect) or as a holder for tea light candles. It is quick and simple to make, and the result is very effective.

MATERIALS

Glass vase (square or cylindrical)

Clear silicone sealant

Colored glass

Glass tiles

Translucent vitreous glass tiles

Mirror tiles or household mirror (up to ⅛ in/4 mm)

Glass nuggets

Cement-based grout

Blue and green grout colorant

EQUIPMENT

Protective mask, goggles and gloves

Glass cutter

Metal rule or straight edge

Tile nippers

Towel

Old saucer

Small plastic glue spreader or spatula

Rags

Mixing bowl

Small rubber spatula or potters' kidney

Grout sponge

Bucket

Rubber gloves

Soft cloth for polishing

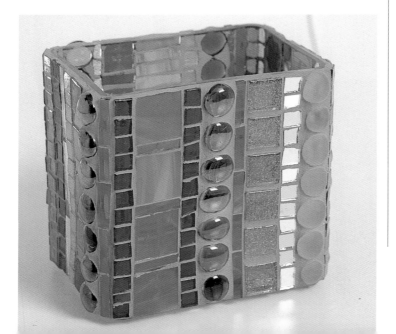

1 Use the glass cutter to cut pieces of colored glass in different shapes. These could be large squares, long, thin pieces or even narrow strips the same length as the height of the vase. Trim them down with the nippers if necessary.

a mask over your mouth and nose while working. Make sure that the sealant covers the base of the tesserae, so that grout cannot penetrate underneath and spoil the effect. Starting at one corner, lay a column of small, thin tiles, such as quartered vitreous tiles or narrow vertical strips of glass, if the vase has curved corners. If it has straight edges, lay any size tesserae butting right up to the edge. (Lay larger or longer tesserae over the vase first to check the spacing.) It is important that you leave space of ¼ inch (6 mm) between the bottom of the vase and the tesserae, so that these tesserae are not damaged when the vase is moved around.

2 Tip the vase on its side, (supported on a folded towel, if necessary) so that you are working on top of it. This makes it much easier to lay the tesserae. Squeeze out a small amount of silicone sealant onto an old saucer and butter the back of each tessera using the spreader. Silicone sealant dries quickly, so don't prepare too much. It also has a strong smell, so wear

3 If you want to lay uncut tesserae but they do not fit exactly, intersperse them with other shapes. For example, try thin strips of glass laid horizontally between square glass tiles. If you are using quartered tiles, cut the penultimate one a little shorter or longer if necessary when you reach the end to avoid having any tiny pieces at the edges.

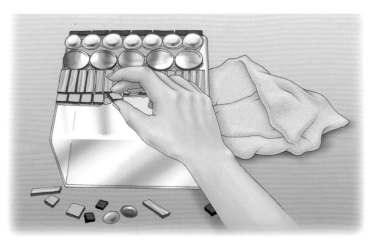

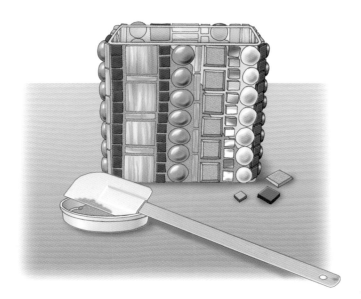

4 Work your way around the vase, mixing shades and colors, types of material and shapes. The odd line of mirror tiles left whole or uncut creates an interesting highlight, but don't use too much, or the translucent quality of the vase will be lost. The same applies for the vitreous glass tiles. Wait until the sides of the vase are completely dry before working on the opposite ones. Keep a rag handy to wipe clean your tesserae, your spreader and your fingers, as the sealant is very sticky and hard to remove when dry.

5 Grout with a pale gray grout tinted with a little blue and green when the vase is completely dry. Make sure that the grout fills the space between the tesserae and the bottom of the vase and that the top looks neat and smooth. The process of cleaning with a damp sponge will help to smooth the grout around the sharp edges of the cut glass tesserae and define the glass nuggets.

PROJECT USING MIXED MEDIA:

Mobiles

✳ COST ✳ TIME ✳ DIFFICULTY

In this project, thin squares of MDF are decorated with a mixture of *pique assiette* and vitreous glass, which are then hung from the ceiling on a fishing line to create an unusual mobile. You can experiment with groups of them suspended at different lengths. The colors and designs can be tailored to match elements in the home.

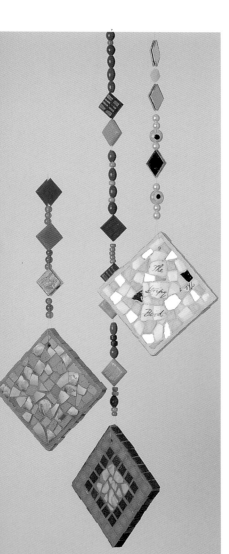

MATERIALS

3½-in (80 mm) squares of ⅛-in-thick (3 mm) medium-density fiberboard (MDF)

White craft glue (see page 54)

Clear silicone sealant

Broken crockery (fairly thin)

Mirror

Vitreous glass

Cement-based adhesive with a latex additive (if you are using tesserae of different thicknesses—if not, white craft glue is an easier, cleaner option)

Grout

Fishing line

Beads

EQUIPMENT

Drill

Craft knife

Protective mask, goggles and gloves

Tile nippers

Small plastic glue spreader or spatula

Paintbrush

Mixing bowl

Small rubber spatula or potters' kidney

Grout sponge

Bucket

Soft cloth for polishing

Scissors

1 Drill a small hole in a corner of each square, about ⅜ inch (10 mm) away from the top. Seal with a 50:50 white craft glue and water mix, and score the MDF with a craft knife.

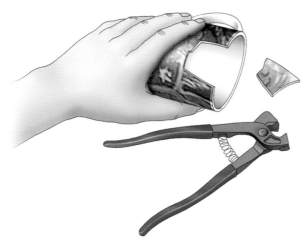

2 Choose a motif or design from a piece of crockery and cut it away with the tile nippers. Trim off any excess background, and break the image into pieces, trying not to cut through any important visual areas, such as eyes. If the design has come from a curved surface, such as a cup or mug, break it into several small tesserae so that it is fairly flat when reassembled.

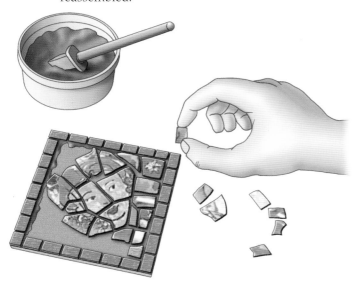

3 Arrange the design on the square, and glue it into place when you are satisfied with the positioning. Fill in the background with random pieces of ceramic, mirror and vitreous glass tiles that match or complement the colors in the central design. Butter any tesserae that need raising, and keep the edging tesserae flush with the edges of the square.

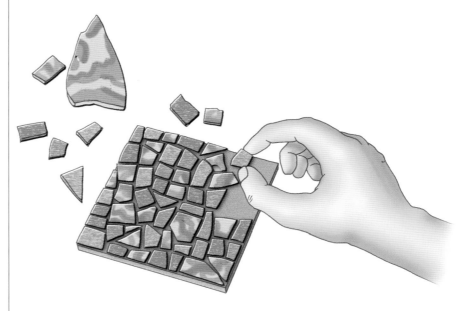

4 If you want to keep the mobile very light and simple, leave one side plain, without any mosaic tiles, and paint it or cover it with a square of patterned or decorative paper after grouting. Otherwise, leave the first side to dry for about 30 minutes, and mosaic the other side. You could incorporate another fractured image, an abstract design or random mosaic in a similar color range as on the first side, or do something completely different—whatever you prefer.

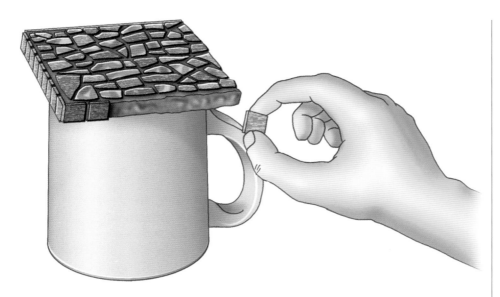

5 Leave to dry for another 30 minutes or so before covering the outer edges of the square with a line of mosaic tiles. Vitreous glass tiles of a ⅜ inch (10 mm) thickness are best for this, as they will display the beveled edges on both sides, but if you cannot find these, halved or quartered ¾-inch (20 mm) vitreous glass tiles will do. You can leave the edges blank if you prefer, and smooth them over with grout.

6 Leave the squares to dry for about 24 hours before grouting. Choose either a neutral color or one that will complement the colors in the mosaic. Do not forget to plug the drilled hole with a nail while grouting. Grout one side at a time, making sure the grout has a smooth finish, especially around the edges. Clean off the grout, remove the plug, and polish the mosaic. Decorate the reverse side if it has not already been covered with mosaic.

7 Decide how far from the ceiling you want each mobile to hang, and cut each piece of fishing line to just over double this length. Thread it through the holes to form a loop, and thread on some beads to hold the two strands together. Choose some vitreous glass and/or mirror tiles, and use the silicone sealant to sandwich a pair of these over the fishing line just above the beads. Reversing the vitreous tiles (sticking the flat sides together) gives a neater effect. Decorate as much of the line as you like, leaving a few minutes for each "sandwich" to dry before continuing. Alternate tiles with more beads if you like. Tie a knot in the ends of the fishing line, and suspend the finished mobiles from the ceiling using small hooks.

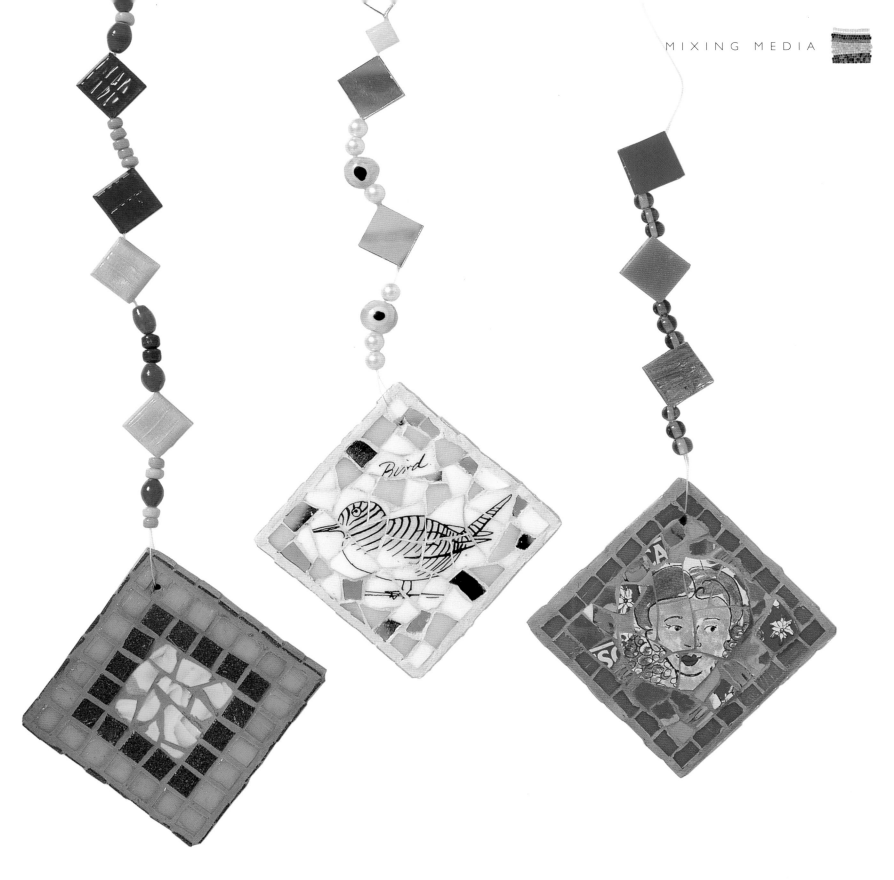

Producing designs

Familiarize yourself with the colors available to you when designing your mosaics, and ensure that the ones that feature in your design correspond with those in your tile range—for example, a vibrantly colored design will not be suitable for a mosaic using unglazed ceramic, as these come in very muted tones.

Use a good set of colored pencils or paints so that you can produce inspiring and accurate initial color drawings. Plan the designs in rough form in your sketchbook. An artist's layout pad is also very useful for developing designs, as the pages are transparent. Working from the back of the book, it is possible to turn the pages and still see your previous drawing through the paper, so you are able to refine each drawing until you are satisfied with it. Graph or squared paper is helpful in planning mosaics that use Opus Regulatum. When drawing up designs on a smaller scale, make sure the proportions are the same as the base or area for which the mosaic is destined. Designs can be enlarged on a photocopier and traced down, or drawn onto the base and enlarged at the same time by a process known as squaring up. This is done by dividing your original drawing into equal squares and doing exactly the same on the base using larger squares. Working square-by-square, copy whatever is in the smaller square onto the larger corresponding square on the mosaic base, until you have transferred the whole design.

All the major projects in this book have templates that you can trace and square up to your desired size. Alternatively, you can copy the design freehand, which will give an air of spontaneity to the design. If you use charcoal, you can easily rub out any mistakes.

Computers and design

If you have access to a computer, it can be a very useful aid in the planning stages of your mosaic. You can use image software such as Adobe Photoshop, or purchase specialized software specifically designed for mosaics.

Adobe Photoshop is a good program to use for speeding up parts of the design process, especially when it comes to selecting and changing colors and trying out several variations of a design. Simple line drawings can be scanned in and colored up relatively quickly, and it is very easy to experiment with different colors to see which ones work best.

The "mosaic" filter on Photoshop can pixelate an image to various degrees, which provides a great guide for producing images in Opus Regulatum. It allows you to select the size of the pixel, so you can choose how detailed to make the mosaiced image.

Tilecreator software, which is available from www.tilecreator.com, is specifically designed to translate any scanned image into a mosaic design. It provides a tile-by-tile template, telling you which color to use where, and it even gives you a shopping list so that you know exactly how many tiles of each color you need to buy.

Remember, however, that computers are no substitute for creativity. They are useful tools that can aid the mosaicist in visualizing a finished piece. Beginners may find software and tools useful for learning how to relate material, but sticking rigidly to a prescribed grid can stifle a design. Use wisely!

A closeup photograph of a dolphin (top left) was run through the "mosaic" filter in Adobe Photoshop to show how this image can be built up using squares of color.

Beginners' Projects

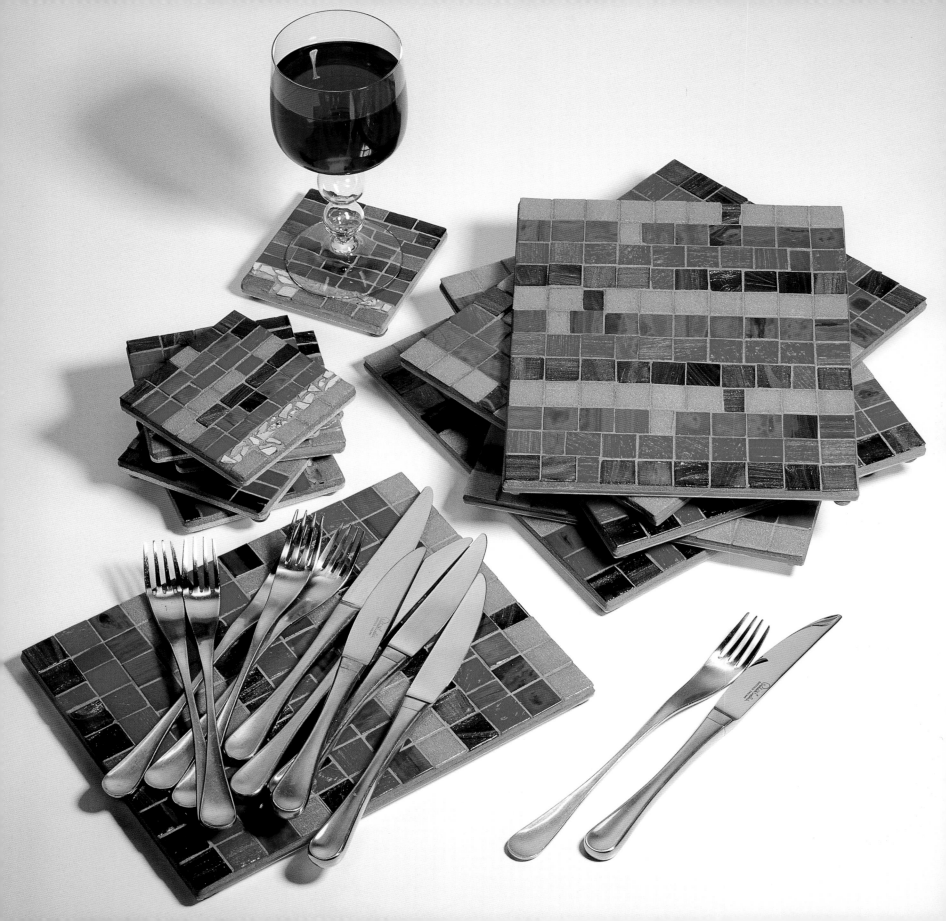

Place mats and coasters

** COST * TIME * DIFFICULTY

CREATED BY ANNE READ

MATERIALS

6 tiles, 10 × 8 in (250 × 200 mm)

6 tiles, 4 in (100 mm) square

White craft glue (see page 54)

Vitreous glass tiles:
 240 each of red, terra-cotta, brown gold-veined and honey beige; 8 riven gold smalti. Extras allow for practice cutting

Exterior-grade gray cement tile grout

Wax polish

48 self-adhesive rubber feet

EQUIPMENT

Paintbrush

Protective goggles, gloves, and mask

Tile nippers

Pencil

Ruler

Rubber gloves

Grouting squeegee

Grout sponge

Bucket

Soft cloth for polishing

The twinkle of mosaics in the candlelight on a dining table is magical. These mats are not only good to touch but can also be easily cleaned. This rich mix of colors is most effective when placed on wood. There is a hint of gold on the coasters; the gold smalti is thicker than the vitreous glass, so it is kept to the edge, leaving enough space to place a glass or cup. Pieces of broken gold-colored china could be used as a cheaper alternative to the smalti—so remember to save those broken dinner plates. Leftover bathroom tiles used on the reverse side form the bases.

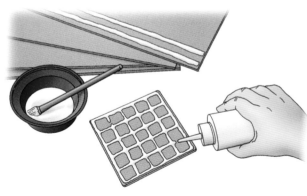

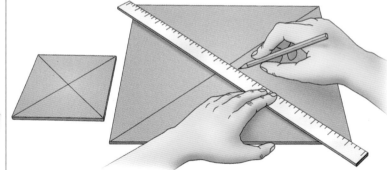

1 Coat the reverse, rough side of the tiles with a 50:50 mix of white craft glue and water. Leave to dry.

2 Cut the vitreous glass tiles, ready for the coasters. All the colored tiles are cut in halves. The gold smalti is cut into small random pieces.

3 Find the center on each side of the tile and make a small pencil mark; this will act as a visual reference guide to keep your lines straigh.

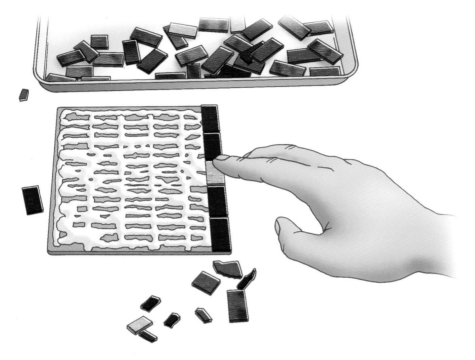

5 Check that the tiles are straight and not overhanging the edge of the tile. Leave to dry.

6 Working on the large tile, mark your center points with the pencil as before.

7 Squeeze a line of craft glue around the edge of the tile. Here, whole tiles are used and the only cutting needed is to nip a piece off for the inset tile.

8 Affix the top row of tiles in this order—honey, terra cotta, red, brown gold-veined—and repeat until the last piece, which is brown gold-veined.

9 Lay the left-hand column, three tiles down from the top, then work six tiles up from the bottom and inset with brown gold-veined.

10 Affix the bottom row in exactly the same color order as the top.

4 Squeeze lines of craft glue onto the coaster tile. Place the cut tiles, with the flat side uppermost, on the tile, leaving a ¹⁄₁₆ in (1 mm) gap between them. For the first row, start from the top and affix two brown gold-veined tiles, then put two up from the bottom. The inset gap is not big enough for a half tile, so you will need to nip a small piece off the bottom of it to fit—this piece is honey beige. Next row is terra cotta with a brown gold-veined inset. Make sure the inset gap is not aligned with the previous one. Continue—red with terra-cotta inset, then honey beige with red inset, brown gold-veined with honey-beige inset, terra-cotta with brown gold-veined inset, red with terra-cotta inset. Now place a row of honey beige on the outside edge; the inset is gold smalti. Fill the narrow column gap with small pieces of gold smalti.

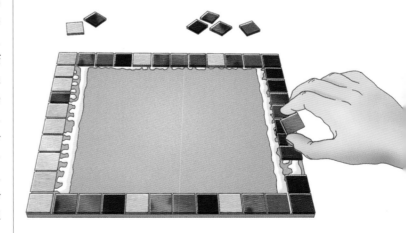

11 Affix the right-hand column, which is dark brown gold-veined. Inset red tiles two up from the bottom and seven down from the top.

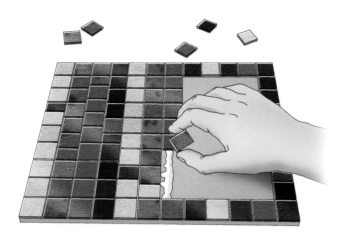

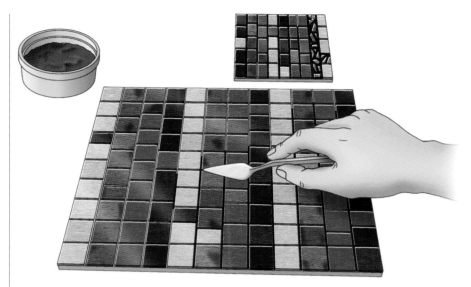

12 Fill in the rest of the columns, taking care that the insets are not aligned with the adjoining columns. Having placed the top and bottom rows, it will be easier to keep the columns straight.

13 Check that the tiles are straight and not overhanging the edge of the tile. Leave to dry for at least 24 hours.

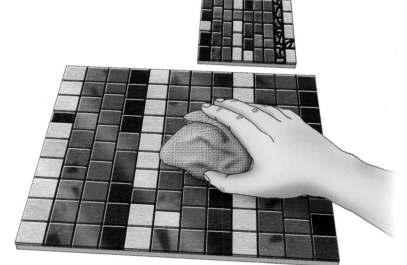

14 Grout, leave for one day, and apply wax polish, which improves the appearance of the tile and prevents the grout being stained from food and drink spillages.

15 Affix the rubber feet—one in each corner of the underside of each tile.

TEMPLATE

Place mat: 9 × 10 inches (20 × 25 cm)

Coaster: 4 × 4 inches (10 × 10 cm)

Enlarge template by 200%

Lia Catalano
Elephant Tile
12 × 12 in / 30.5 × 30.5 cm
Unglazed porcelain ceramic

Beaded picture frame

✳ COST ✳ TIME ✳ DIFFICULTY

CREATED BY SARAH KELLY

MATERIALS

Wide, flat wooden frame

Tubular plastic beads

White craft glue (see page 54)

Sheet of paper the same size as the frame (optional)

Cement-based adhesive (with craft glue or latex additive) or strong household glue

Acrylic paint or latex

EQUIPMENT

Sandpaper

Paintbrushes

Utility or craft knife

Set square

Pencil

Small plastic glue spreader or spatula

A mosaic of small, inexpensive plastic beads transforms a plain wooden frame. This bold and colorful design is inspired by ethnic textiles from Central America. The texture created by the closely laid beads also contributes to the feeling of a tapestry or piece of woven fabric. You can use any kind of beads and vary the design accordingly; these brightly colored plastic ones can be bought in bulk very cheaply.

Before starting, do an adhesive test with some chosen beads on a spare piece of wood. Cement-based adhesive mixed with a 50:50 mix of water and craft glue or latex additive should hold the beads in place securely, but if they fall off under pressure, especially at the edges, use a strong, clear household glue instead. This dries very quickly and usually permanently, so the placement needs to be accurate.

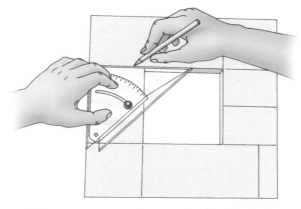

1 Prepare the frame. Sand off any paint or varnish if necessary, then seal with a 50:50 craft glue and water mix and score.

2 Use a set square and a pencil to divide the frame up into sections.

3 Decide which patterns to use on the frame. You may first want to practice laying the beads on a piece of paper cut to the same size as the frame. The beads are laid on their sides and placed close together because the mosaic will not be grouted. Make sure that the beads line up flush with the edges of the frame on all sides. To achieve this, you may need to edge the frame with the beads laid on their ends or slightly increase the spaces between the beads.

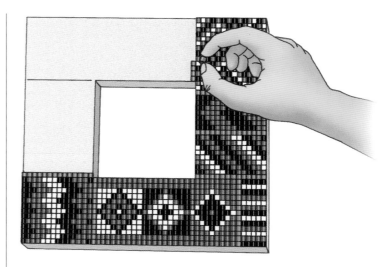

4 When you are happy with the design, apply the chosen adhesive to a small area of one of the marked sections on the frame, and begin to stick down the beads. If you are using a cement-based adhesive, make it thick enough to embed the beads but not so thick that it squeezes over them.

5 When you reach the end of one section of the design, add a line of beads in a contrasting color before continuing with the next. Continue working around the frame in this way.

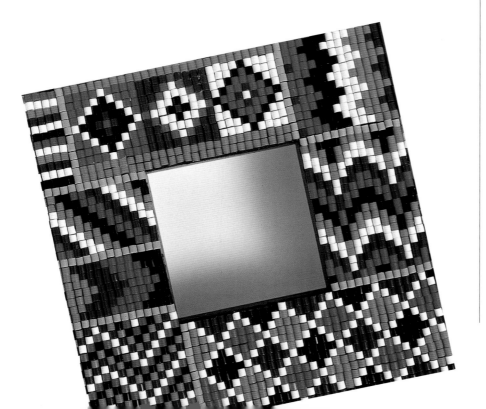

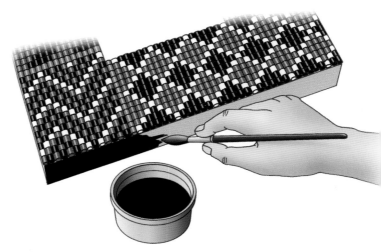

6 Choose a color that complements the colors of the mosaic, and paint the inside and outside edges of the frame using acrylic or latex paint

TEMPLATE

9¾ × 9¾ inches (25 × 25 cm)

Enlarge template by 166%

Linda Edeiken (Mad Platter Mosaics)
Fallen Leaf (Detail)
2001
Diameter: 16 in / 40.5 cm
antique china, beaded grout, glass, tile

Tiny sparkling beads have been mixed with the grout
for this box, giving it a highly decorative look.

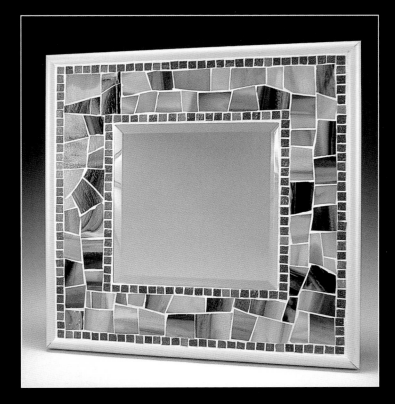

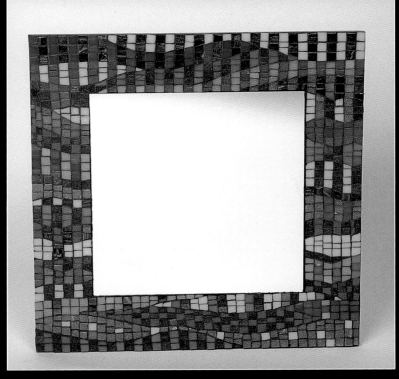

Anita Garrison (Looking Glass Mosaics)
Tropicale
2001
16 × 16 in / 41 × 41 cm
stained-glass, vitreous glass

Anita Garrison (Looking Glass Mosaics)
Untitled
2000
18 × 18 in / 46 × 46 cm
vitreous glass

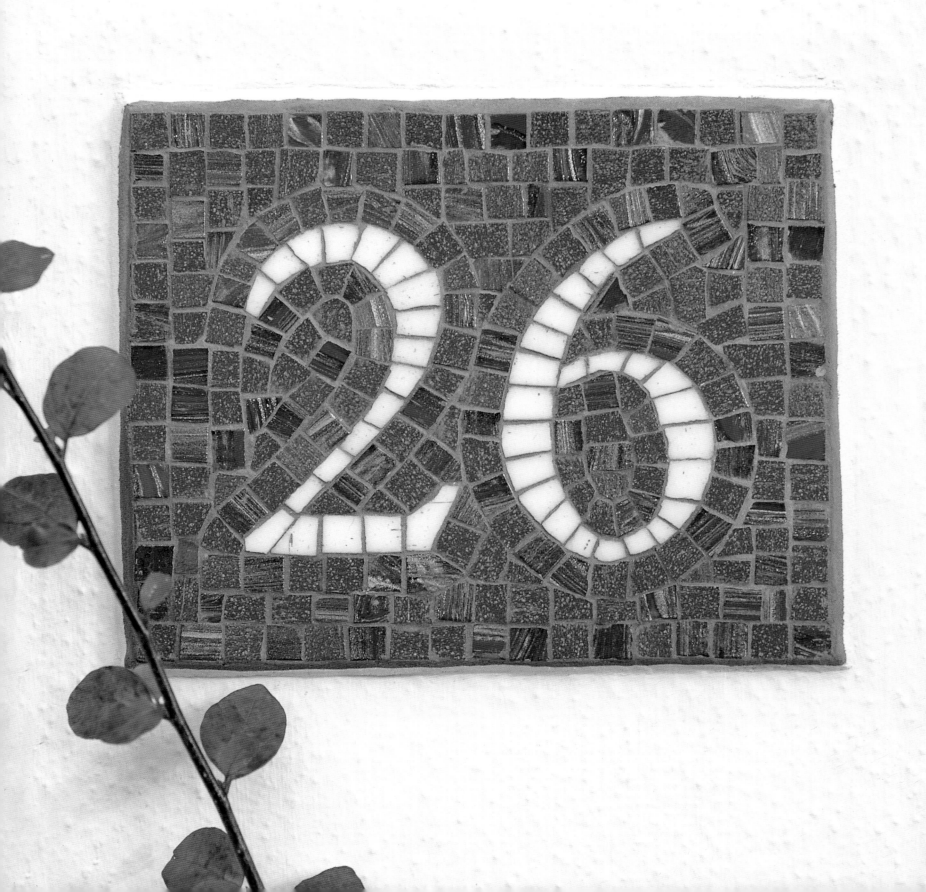

Direct method house number

✳ COST ✳ TIME ✳ DIFFICULTY

CREATED BY JULIET DOCHERTY

Making a house number is a very rewarding weekend mosaic project and will give you the satisfaction of seeing your work on display every day. It takes about a day to lay the mosaic tiles and a few hours to ensure that it is attached securely to the wall. Inspiration for this project comes from Victorian shop signs. This blue and white house number, made using vitreous glass tiles, shows the direct method.

1 Print out the number on white paper at full size. This can be done either with a computer or using a photocopier to enlarge a number in the typeface of your choice. Mark a rectangular border around the number, leaving at least 1⅛ inches (30 mm) between the border and the edge of the number.

3 Cut a selection of the blue tiles into quarters, and glue these neatly onto the mesh, flat side facing up, around the rectangular border. When attaching the tiles to the mesh, use tiny blobs of glue, and carefully lift the mesh away from the paper as the glue is drying to prevent the paper from sticking to the mesh.

2 Cut a piece of nylon mesh and lay it over the number. Make sure that the mesh is large enough to overlap the marked border.

MATERIALS

Nylon mesh

Printout of number on white paper

Vitreous glass tiles: bright white, cobalt blue, and gold-veined dark blue

Resin-based wood glue

Frost-proof exterior cement-based adhesive

Exterior powdered gray grout

EQUIPMENT

Pencil

Scissors

Protective goggles, mask, and gloves

Tile nippers

Rubber gloves

Notched spreader for cement

Bowl and spatula for mixing grout

Flexible grout spreader

Damp cloth

Spatula

Soft cloth for polishing

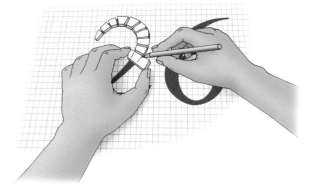

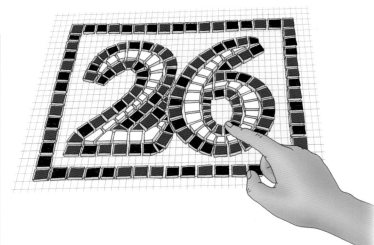

4 When the border is complete, use cut pieces of the white tiles to form the number. Use fan-shaped pieces of tile when tackling curves such as the top of a "2." Remember, use only just enough glue to stick the tile to the mesh, and keep carefully lifting the mesh from the paper to stop the paper sticking to it.

5 When the number is complete, fill in the remaining areas with the blue tiles. First use fan-shaped or quarter tiles to mosaic around the edges of the number before filling in the remaining gaps.

6 When the glue is dry, pick up the mesh and hold it along one edge to check for loose tiles. If any tiles fall off at this stage, glue them back on. When all the tiles are secure, trim the excess mesh from the edge of the mosaic.

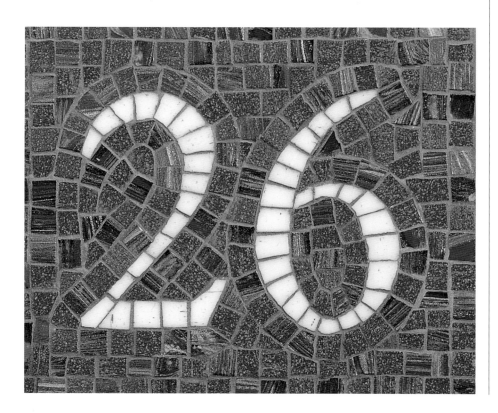

7 Mark out the position that the mosaic will take on the wall. Mix the cement-based adhesive into a stiff paste according to the manufacturer's

directions. Using a notched spreader, apply a thin layer—about 3⁄16 inch (4 mm)—of adhesive to the marked area of the wall. Ensure that it is evenly spread and covers the entire area of the mosaic.

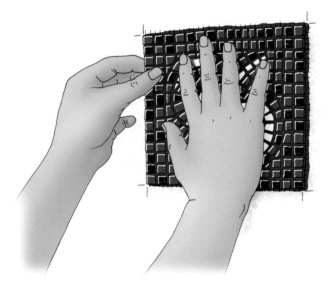

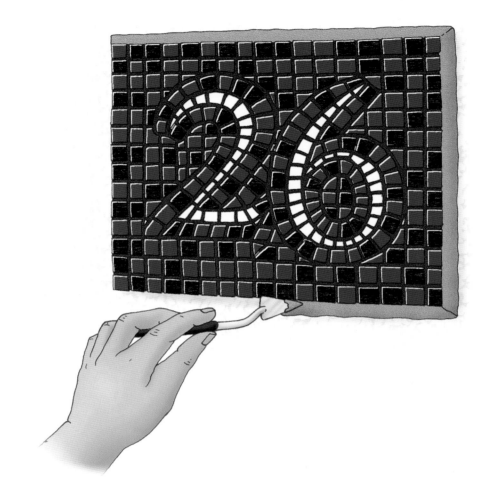

8 Carefully position the mosaic on the cement, pressing firmly enough so that the cement grips the mosaic but not so hard that the cement squirts to the front from the gaps between the tiles. Leave the adhesive to set for a couple of hours.

9 Mix the exterior grout into a stiff paste. Grout the mosaic using a flexible grout spreader and remove any excess grout with a damp cloth. Use a spatula to get a neat beveled edge around the mosaic.

10 Leave the grout to dry for several hours before buffing up with a lint-free cloth.

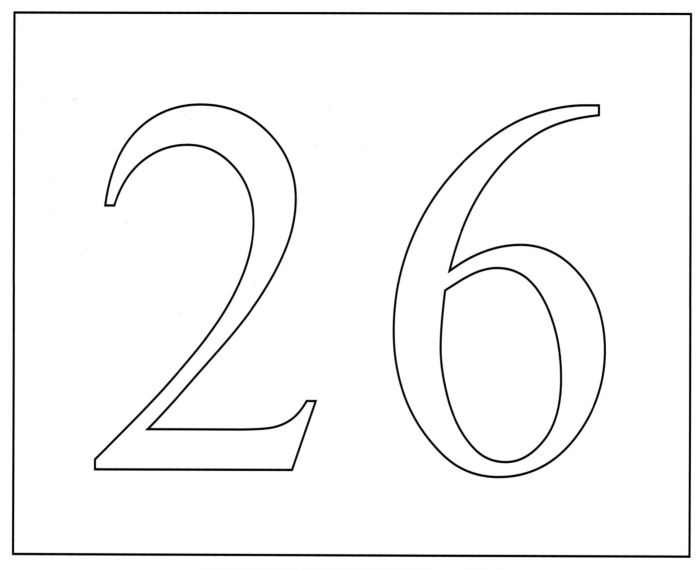

TEMPLATE

7 × 6 inches (18 × 15 cm)

Template is 100%

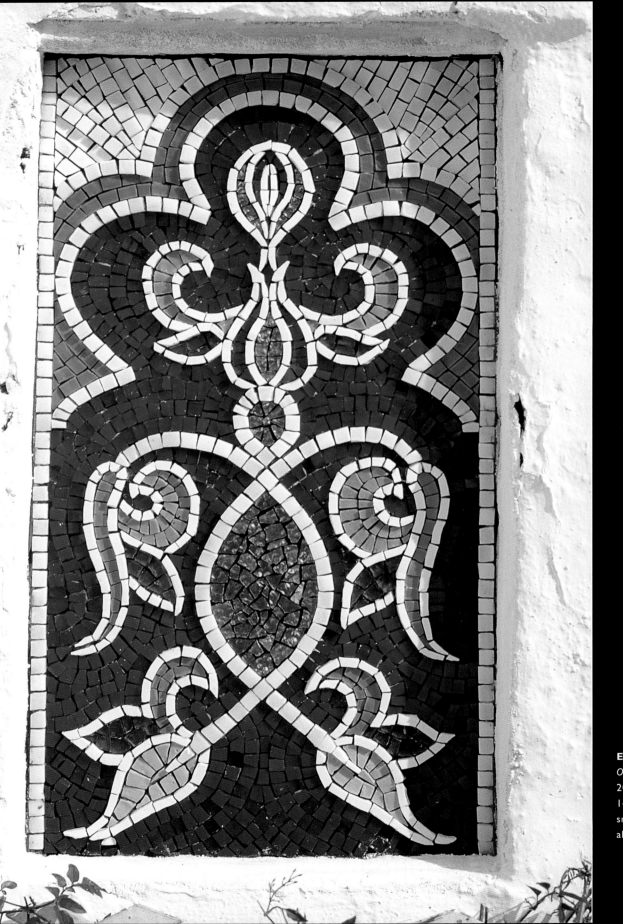

Elaine Goodwin
Outdoor niche
2000
14 × 24 in / 36 × 61 cm
smalti, china, marble and
aluminum-leaf-backed glass

Indirect method house number

** COST * TIME ** DIFFICULTY

CREATED BY JULIET DOCHERTY

MATERIALS

Printout of number on white
 paper

Black vitrified porcelain tesserae

Gold tesserae

Brown wrapping paper

Butcher's tape

White craft glue (see page 54)

Frost-proof exterior-grade,
 cement-based adhesive

Exterior-grade powdered grout,
 charcoal-colored

EQUIPMENT

Paintbrush

Candle or wax crayon

Pencil or charcoal

Tile nippers

Protective mask, gloves,
 and goggles

Thin board

Scalpel

Rubber gloves

Bowl and spatula for mixing
 grout

Flexible grout spreader

Notched spreader for cement

Sponge

Spatula

Jar

This house number is created using the indirect method. As with the direct method project (see page 160), it takes a day to lay the tiles and a few hours to ensure it dries and attaches permanently to the wall. The inspiration for this comes from pavement mosaics, which incorporate beautiful calligraphy and often use gold tesserae. In this project, dark porcelain tiles are used for the background and stunning gold tesserae for the number.

1 Obtain a full-size printout of the number on white paper. This can be done either with a computer or using a photocopier to enlarge a number in the font of your choice.

2 Mark a rectangle on the thin board that is larger than the completed mosaic will be. Use a candle or wax crayon to wax this area. Cut out a piece of brown wrapping paper that is about the same size as the waxed area. Soak the brown paper in water, and lay it ribbed side up onto the waxed area of board. Tear off four strips of the butcher's tape, wet these, and use them to stick the brown paper to the board. Leave the brown paper to dry.

TIP

When using the indirect method, wax the board before taping down the brown paper to prevent the paper from sticking to the board as a result of glue soaking through.

3 Trace a mirror image of the number onto the brown paper using the printout. To do this, draw over the number on the printout in pencil or charcoal; place the number face down onto the brown paper; then trace the outline of the number with a sharp pencil, thus leaving a mirror image of the number traced onto the brown paper. Draw a border on the brown paper around the number, leaving at least 1⅛ inches (30 mm) between the border and the edge of the number.

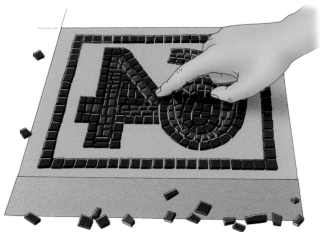

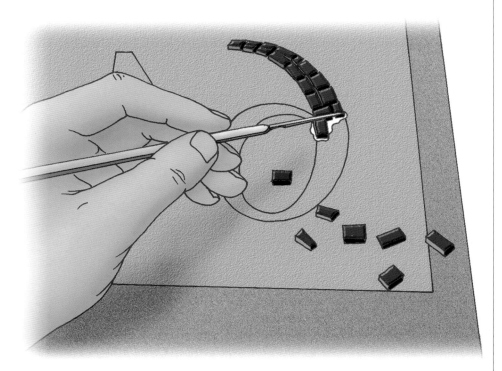

4 Mosaic the number with cut pieces of the gold-veined tesserae. Mix equal amounts of craft glue and water in a jar. Use the watery glue to stick the tesserae pieces face down onto the brown paper. Remember that you are working on the reverse (underside) of the design.

5 When the gold number is complete, cut some of the black porcelain tiles into quarters and glue these neatly around the border of the mosaic, using the watery glue mixture. Then fill in the remaining areas with pieces of the black porcelain tiles. First use fan-shaped or quarter tiles to mosaic around the edges of the number before filling in the remaining gaps.

6 When the glue is dry, use a scalpel to cut out the mosaiced area, trimming off any excess brown wrapping paper. Because the board was waxed, the brown paper should come away from the board easily; if you do not wax the board, the glue can soak through the paper and stick it to the board.

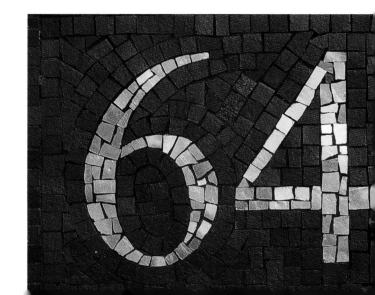

7 Mark out the position of the mosaic on the wall. Mix the cement-based adhesive into a stiff paste according to the manufacturer's directions. Using a notched spreader, apply a thin layer of about ³⁄₁₆ inches (5 mm) of adhesive to the marked area of the wall.

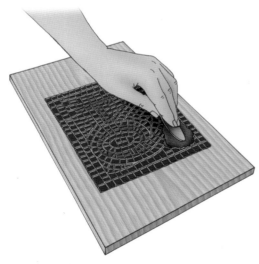

8 Mix the exterior grout into a stiff paste. Apply the grout to the mosaic using a flexible grout spreader, and remove any excess grout with a slightly damp cloth. Cover any remaining grout to prevent it from drying, because this can be used later for the edge. Note that you are grouting the mosaic from the back while it is still attached to the brown paper. This step needs to be completed immediately after Step 7 (or at the same time, if working with an assistant) so that the adhesive on the wall does not dry out too much.

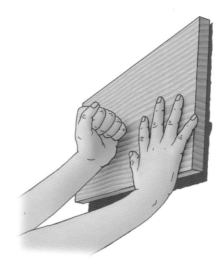

9 Carefully position the mosaic on the adhesive, place a board over the mosaic, and firmly tamp it down. Leave to settle for about 20 minutes, then gently soak the brown wrapping paper with a wet sponge.

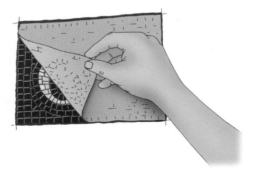

10 When the paper changes color, test a corner of it to see if it peels away easily. Once the paper is soaked sufficiently, carefully peel off the paper.

11 Leave to set for 1 hour. The grout remaining from Step 8 can be used to give a neat beveled edge with a spatula and also to touch up any small gaps in the grout. The front of the mosaic can be cleaned with a damp cloth. When fully dry, buff it up with a lint-free cloth.

TEMPLATE

7 × 6 inches (18 × 15 cm)

Template is 100%

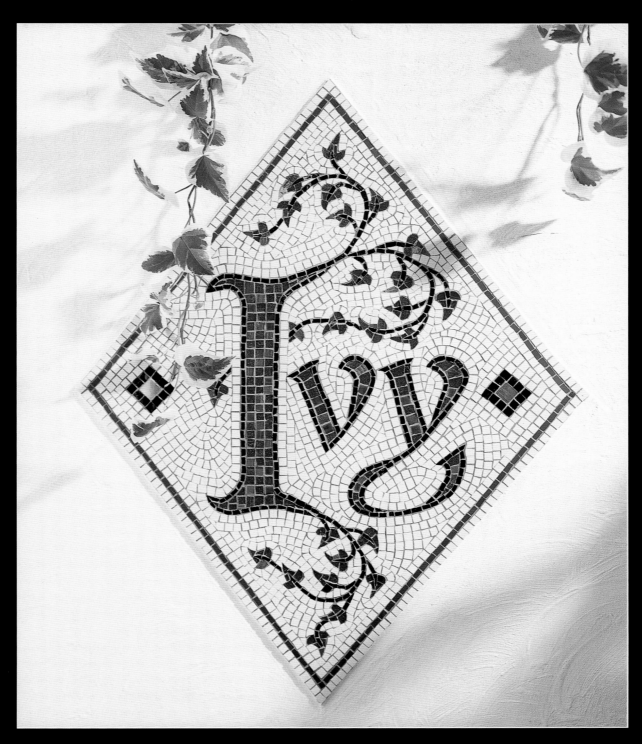

Elaine Goodwin
Illuminated letters
2000
24 × 34 in / 61 × 86 cm
ceramic, china, vitreous glass

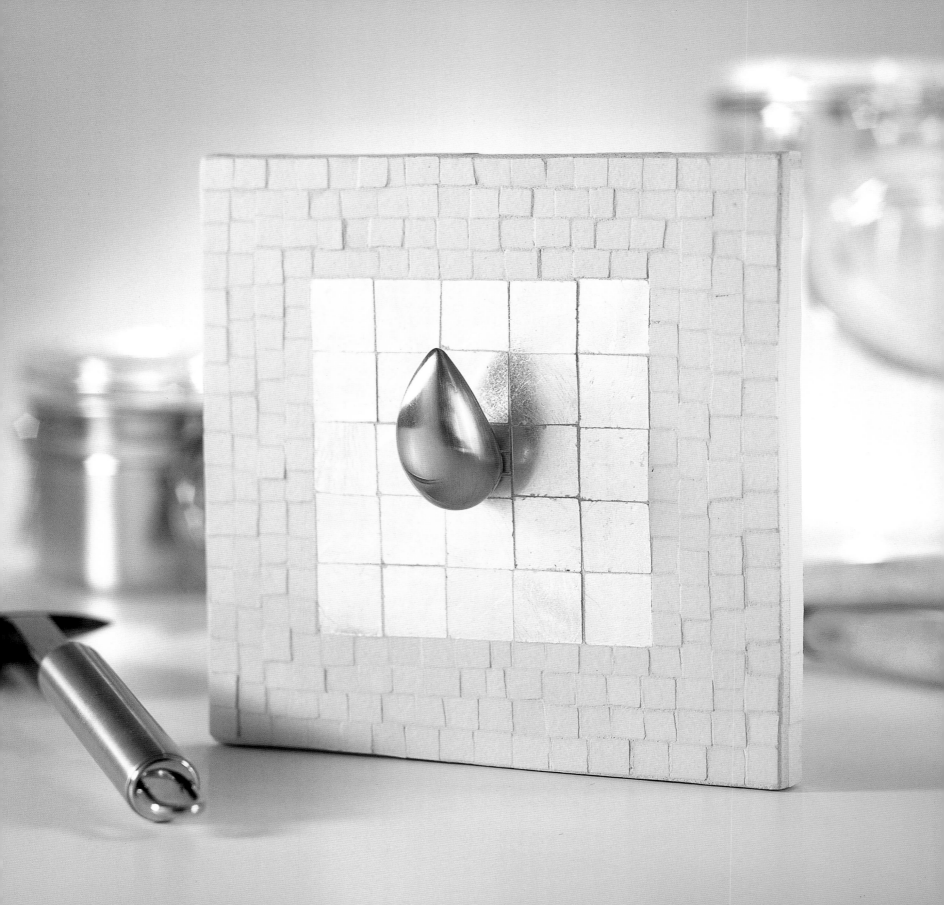

Wall hook

MATERIALS

Square panel of plywood or
 medium-density fiberboard
 (MDF), about ⅜ in (10 mm)
 thick, the size of a standard
 wall tile

Silver tesserae

White craft glue (see page 54)

Porcelain cream tesserae

Ivory-colored grout

Brushed-steel teardrop hook

Screw

EQUIPMENT

Handsaw

Protective goggles, mask
 and gloves

Power drill

Pencil

Tile nippers

Rubber gloves

Bowl and spatula for mixing
 grout

Flexible grout spreader

Soft cloth for polishing

** COST * TIME * DIFFICULTY

CREATED BY JULIET DOCHERTY

This project is suitable for a beginner as it is fairly small and not too complicated. The idea comes from the natural handmade paper called "chinese money" that can be bought in Chinese supermarkets. These beautiful pieces of paper contain a square sheet of silver leaf that is so thin it appears to be part of the paper. The subtle, metallic surface of the silver contrasts with the natural unbleached paper.

The silver tesserae that form the central square of the panel are packed together without any gaps for grout so that it appears like a piece of silver leaf. The surrounding porcelain tesserae are exactly the same height as the silver tesserae and are also packed closely together. This results in a natural, textured cream background on which there appears to be a square of silver leaf. The brushed-steel teardrop hook complements the materials used in the backing panel.

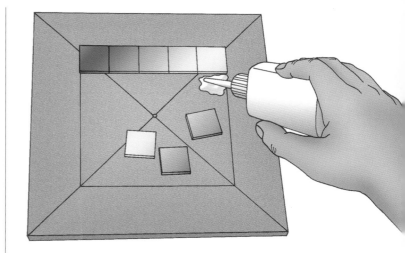

1 Locate the center point of the panel of MDF or plywood by drawing two diagonal lines from opposite corners. Drill a hole through the center point so that the hook can be secured with a screw from the back when the mosaic has been completed.

2 With a pencil, mark out a square made up of 25 silver glass tesserae centered in the middle of the panel. Glue the silver tesserae onto the marked square, skipping the center tile where the drill hole is located.

3 Insert a screw through from the back, and fill in the central piece with tiny pieces of cut silver tesserae. Once complete, the screw can be removed.

and wait for the glue to go tacky. Once the glue is tacky, attach the half pieces of tesserae, making sure that the top of the tesserae is flush with the surface of the panel.

4 Cut some of the porcelain tesserae in half to tile the edges of the panel. Apply glue to the edges of the panel, smooth the glue out with your finger,

5 Mosaic the remaining area of the panel with small pieces (quarters or eighths) of the porcelain tesserae. Ensure that they are tightly packed together and that there is a gap of about $\frac{1}{16}$ inch (2 mm) at the edge which will be filled with grout.



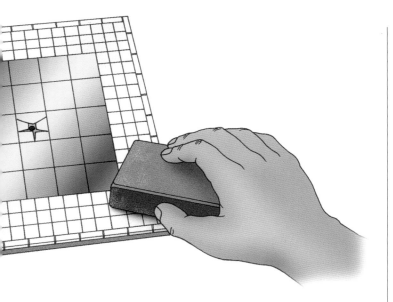

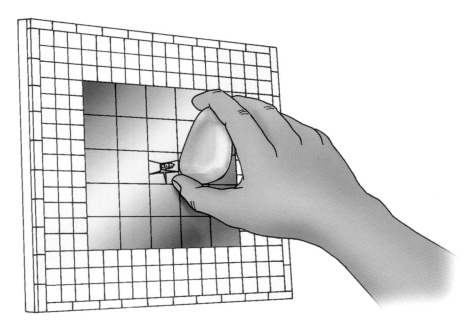

6 Mix up a small amount of an off-white grout. Apply with a flexible grout spreader, and use a blade to remove excess from the edges to give a crisp finish. Make sure that you do not grout over the hole in the middle. When it is dry, use a sanding block to finish the edges, and remove any excess grout with a damp cloth. Buff up the silver area with a dry cloth.

7 Attach the hook by securing with a screw from the back. The finished piece can be attached to a wall either by using small mirror plates attached to the edges of the panel or by securing the piece with strong adhesive.

TEMPLATE

6 × 6 inches (15 × 15 cm)

Template is 100%

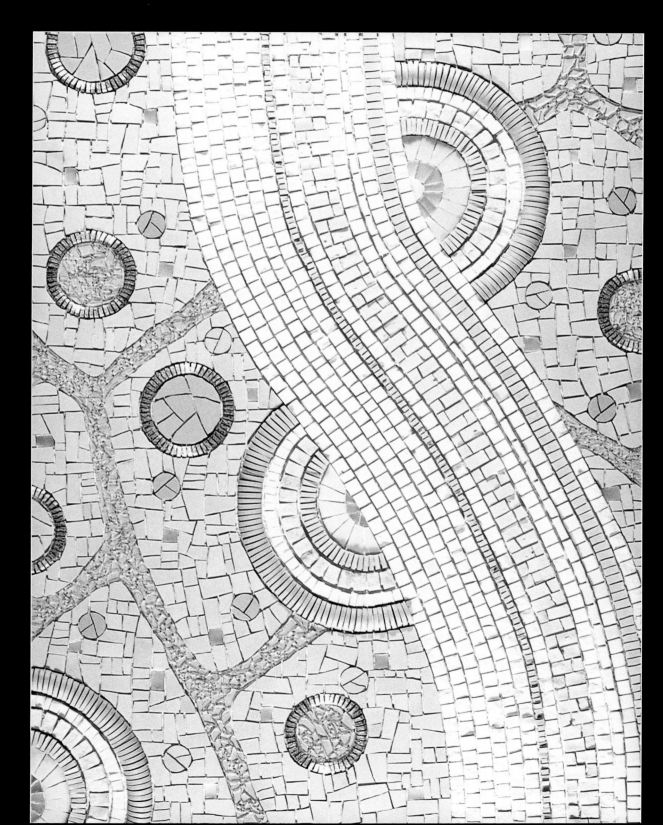

Sonia King
Continuum
2001
26 × 19 in / 66 × 48 cm
ceramic, marble, smalti,
aluminum, glass

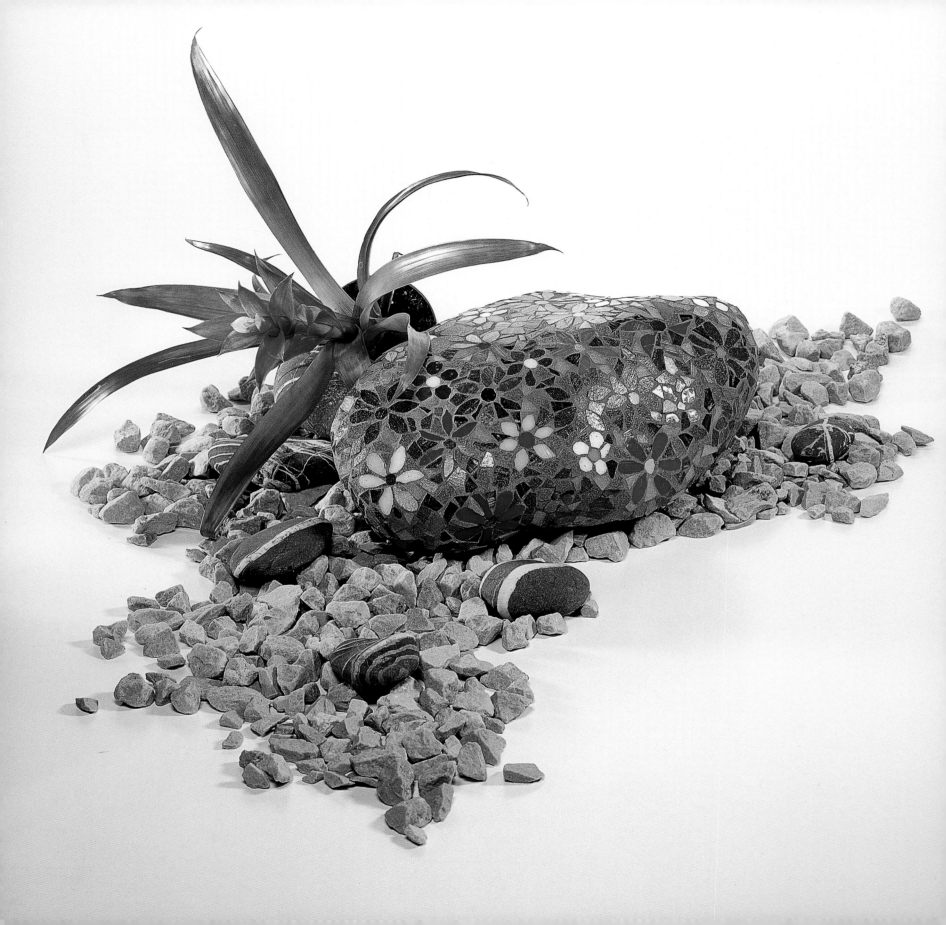

Stone garden decoration

✳ COST ✳✳✳ TIME ✳✳ DIFFICULTY

CREATED BY ANNE READ

For flowers that bloom all year round in sun and shade, you cannot beat a mosaic stone. If you prefer,

use insects, animals or just color and pattern to add interest to your garden or conservatory. This pattern

was inspired by an old pair of 1960s "flower power" pants. The project gives plenty of cutting practice in

nibbling to achieve the shapes you want.

MATERIALS

Stone—about 10¼ × 6 in
(260 × 150 mm) and
4½ in (110 mm) high

Vitreous glass tiles: 120 tiles in
12 different colors for the
flowers; 130 tiles in
8 different greens for the
background; 6 gold tesserae
or broken patterned
porcelain for feature flowers

White craft glue (optional; see
page 54)

Exterior-grade, cement-based
gray adhesive

Exterior-grade, cement-based
gray grout

EQUIPMENT

Chalk

Protective goggles, mask, and
gloves

Tile nippers

Plastic adhesive spreader

Rubber gloves

Bowl for mixing grout

Tweezers or dentistry tool

Towel

Sponge

Trowel

Soft cloth for polishing

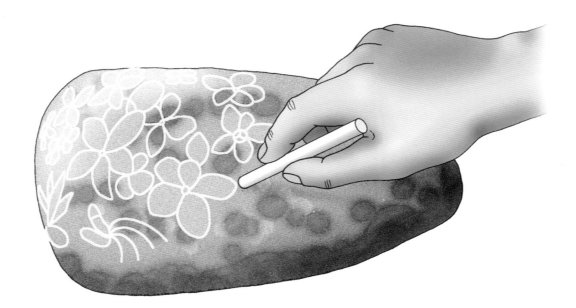

1 Wash the stone to remove any trace of grease, algae, dust or salts. If the stone is very porous, it helps to coat it in a 50:50 mix of craft glue and water; this reduces the porosity and inhibits the cement-based adhesive from drying out as you work. Let the craft glue mix dry. Look at the shape and size of the stone, and work out a rough design in chalk on the stone first, making notes on paper. Cut a supply of pieces first, as you will need to position them quickly in the wet cement-based adhesive.

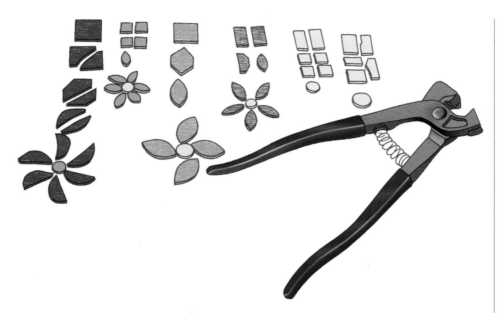

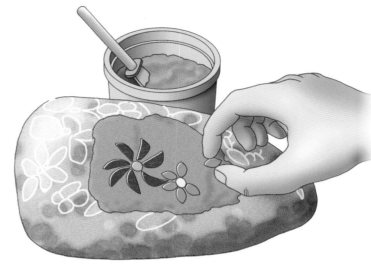

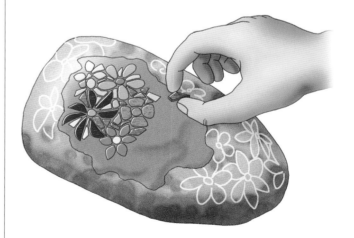

2 Cut the petal shapes in various sizes and color combinations. The same shape in whole, half and quarter tiles makes completely different flower shapes from dahlias to forget-me-nots. From a whole tile, cut off two opposite corners to make a lozenge shape, then nibble around to make a petal shape. From a half tile, cut off four corners and nibble to make a petal shape. From a quarter tile, cut off two corners and nibble into a small petal shape. Cut a whole tile in half to make two triangles, then nibble to form a petal that looks more spiral in shape when put together as a flower. The center circles are cut from squares of differing sizes: cut off the four corners of the square, and then nibble around into a circle.

3 Cut a supply of the background greens to fill in between the flowers.

4 Mix up some exterior grade, cement-based adhesive, and cover an area of the stone—only about 4 inches (100 mm) square. This will enable you to work at a reasonable pace without worrying that the adhesive will dry out. The adhesive should be the thickness of the mosaic tile plus a bit, so that the tiles are embedded in the adhesive and do not touch the stone.

5 Lay the flowers first. The mosaic should adhere to the cement-based adhesive; if any surplus comes up above the tiles, gently remove it with a dentistry tool to leave sufficient room for the grout to be applied later in the gaps between the tiles.

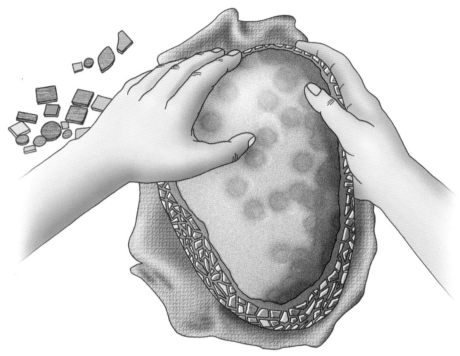

6 Fill in the background with the mix of green glass. The area that has been covered with adhesive will dry at the edges; do not try to get the tiles to stick because they will only drop off later. Cut off the drying adhesive and discard. Apply fresh adhesive up to the cut-away edge and continue working. Never add more water to drying adhesive—this will break the "curing" process and the adhesive will crumble to dust.

7 Keep working until the top and sides of the stone are covered. Leave to dry slowly over two days. You will not be able to reach all the stone to be covered, so do what you can reach comfortably and do the rest when the stone is turned.

8 Gently turn the stone over onto a towel or soft protective material. The adhesive is still drying and hardening, so be very careful when moving the stone. Continue working, leaving an area of plain stone so that it sits evenly on the ground. Leave to dry.

9 After approximately three days, grout using exterior-grade gray grout. The following day, polish up with a dry cloth.

TEMPLATE

12 × 5 × 7½ inches (30 × 13 × 19 mm)

Template is 100%

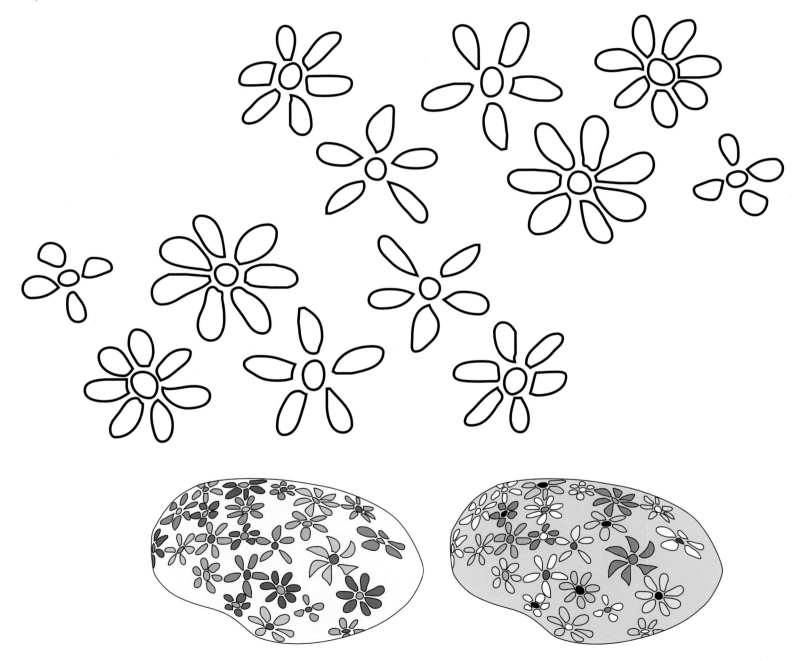

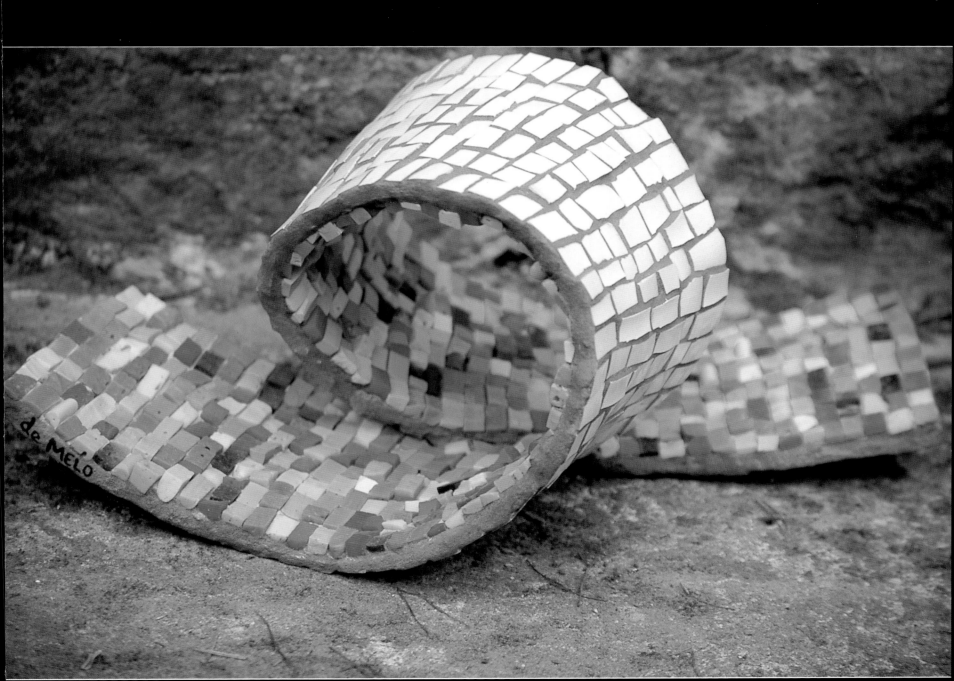

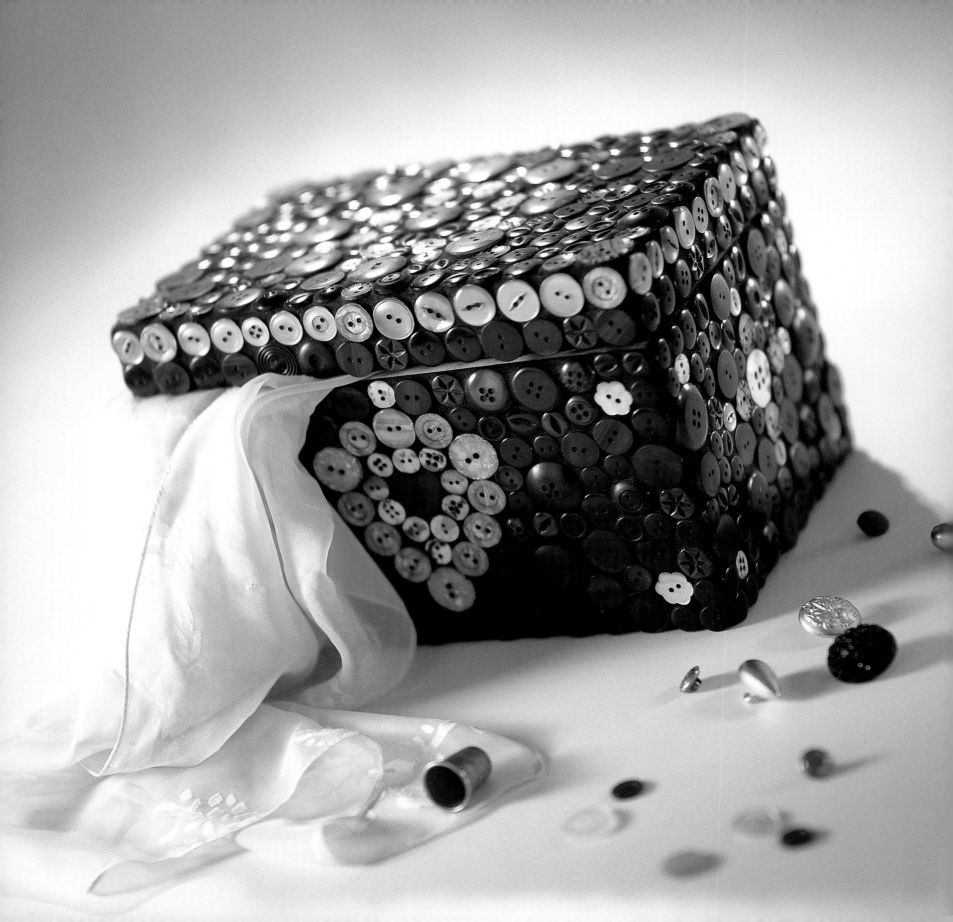

Buttoned jewelry box

MATERIALS

Wooden box

Buttons in various sizes

White craft glue (see page 54)

Strong, clear household glue

Masking tape

Black grout

EQUIPMENT

Sandpaper

Paintbrush

Utility or craft knife

Ruler

Pencil

Protective goggles, mask
and gloves

Rubber gloves

Flexible rubber spatula or
potters' kidney

Cloth or plastic bag

Soft cloth for polishing

✳✳ COST ✳ TIME ✳ DIFFICULTY

CREATED BY SARAH KELLY

The effect of an inlaid box is suggested by using a combination of mother-of-pearl style and dark-colored buttons. The cost of making this box will vary depending on where the buttons are bought and how many of the chosen size are needed to cover the box. Buying the buttons from a haberdashery store can be expensive, so look out for secondhand ones in markets and thrift stores.

1 Prepare the surface of the top and sides of the box. Sand off any varnish or paint, seal with a 50:50 craft glue and water mix and score the wood.

2 Using a ruler and pencil, mark two lines on the top and each side of the box that meet in the exact center. These will act as guides for laying the central motifs.

3 Starting with the lid, use the buttons to create a central motif, working from the center outward. It is very important to get the buttons in the right position before sticking them, as the buttons can't be cut and the clear glue dries quickly and permanently, so repositioning is not possible. Use a mixture of pale, shiny buttons that resemble mother-of-pearl for the patterns and a selection of dark colors for the background, mostly black, with a few dark greens, browns, blues and grays. Once you are happy with the design, stick the buttons down one by one, applying the glue to the base each time. Always follow the safety directions on the glue's packaging, and wear a protective mask against fumes if necessary.

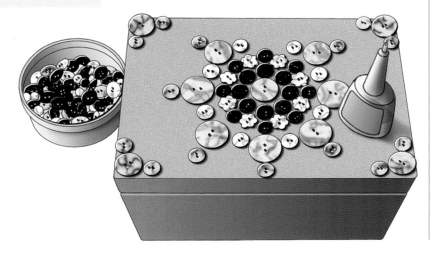

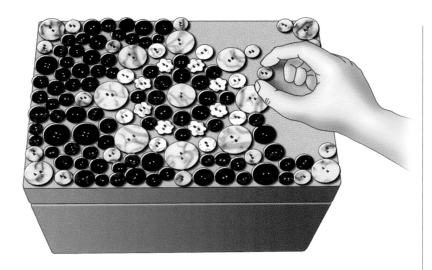

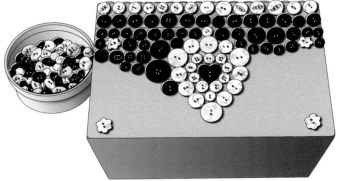

4 When the motif is complete, fill in the background. A variety of different-sized buttons is required to fill the irregular spaces neatly. Work in sections and arrange the buttons in position before sticking them down (you may need to move them around a few times before getting them in the right place). Try and leave as small a space as you can between each button.

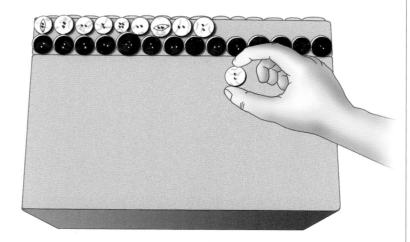

5 Make a border around each side of the lid using lines of buttons.

6 Decorate the sides of the box in a similar way to the lid, but vary the size and complexity of the motifs as desired. You can add borders or simple corner motifs as well.

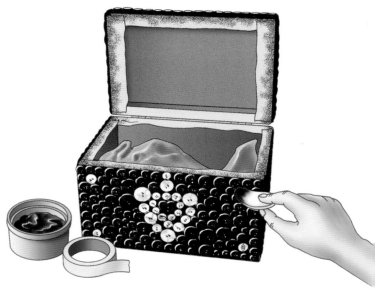

7 Because the glue sets rapidly, it is possible to grout the box almost immediately. Use a black or very dark grout. Before you start, protect the inside edges of the box and lid with masking tape, and place a cloth or plastic bag inside it to catch any drips, as dark grout can stain. Grout the box with the lid open, and make sure that all grout is thoroughly removed from the hinges and the edges of the lid when cleaning. Polish with a soft cloth when dry.

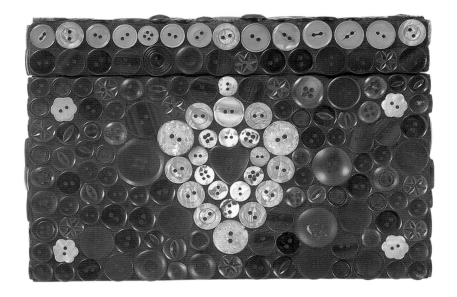

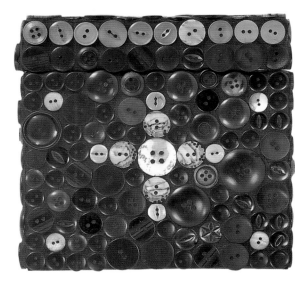

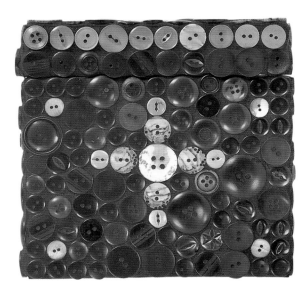

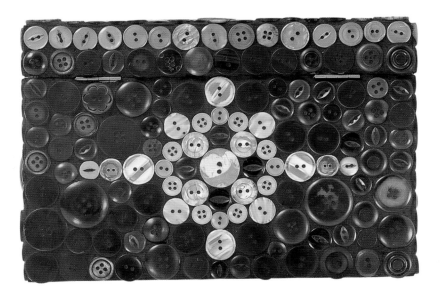

TEMPLATE

9 × 6 × 6 inches (22.5 × 15 × 15 cm)

Enlarge template by 150%

Sarah Kelly
Jeweled Trinket Box
2000
Diameter: 4 inches / 10 cm
glass gems, stained-glass and beads

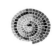

Shell plant pot

** COST * TIME * DIFFICULTY

Cost is based on buying the shells rather than finding them CREATED BY SARAH KELLY

MATERIALS

Large terra-cotta pot with smooth sides

Shells in a variety of sizes, shapes and colors

White craft glue (see page 54)

White cement-based adhesive (this must be frost-proof if the pot is to be placed outdoors)

Cement coloring powders in buff (sand) and brick (terra-cotta)

EQUIPMENT

Large paintbrush

Charcoal stick or pencil

Bowl

Small plastic glue spreader or spatula

The natural beauty, colors and shapes of shells are given real impact in this lushly decorated garden pot. Because there is no cutting or grouting involved, it doesn't take long to make. As frost-proof adhesive is used, it is suitable for either interior or exterior use.

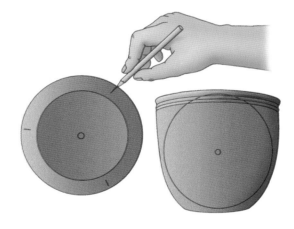

1 Seal the terraa cotta with a 50:50 mix of craft glue and water. When the surface is dry, mark three points on the rim with the charcoal stick or pencil, dividing it into thirds.

2 Draw three large circles onto the sides of the pot, with small gaps between each one. The centers of the circles should line up with the marks on the rim, which ensures that they are evenly spaced. Mark a dot in the center of each circle.

3 Sort your shells into groups of similar types. The circles on the pot are created with a double spiral of shells, combining a line of the same type of shell (in this case, small white cowries which came from a shell mat) with a line of mixed shells that start off small and grow larger as the spiral develops. Lay out a selection of shells in a spiral on your work surface before you start sticking, and move them around until you are happy with the arrangement.

4 As the pot will not be grouted, the color of the cement will show, so it is important to use a good color, which will complement the shells. Mix the coloring powders with the cement-based adhesive in a bowl until you get a sandy color (a lot of buff with a little brick). Put a spoonful into a separate container and add a little water, then smear a bit onto the side of the pot. When this dries, you can see whether you have achieved the desired color. Adjust if necessary.

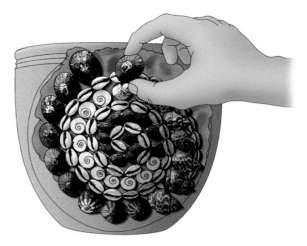

6 Carry on sticking the shells in the spiral shape, gradually increasing the size of the shells in one line, while the other stays constant. If the latter is made up from light-colored shells, try and make most

5 Spoon a larger amount of cement-based adhesive into the container, and mix with water to a make a thick cake-mix consistency. Craft glue can be added to the water for extra bonding strength if desired. Apply to the center of a circle with the spatula or glue spreader. The adhesive base needs to be thick enough to embed the shells but not so thick that it squeezes up over the edges. Press the shells into the adhesive, letting the two lines grow outward together. Try and keep the spaces between the shells as small as possible. You could also use one large shell with its own clearly defined spiral as a starting point and let the lines of smaller shells grow out of that.

TIP

You can also experiment with revealing the undersides of shells—sometimes these are more attractive than the outsides.

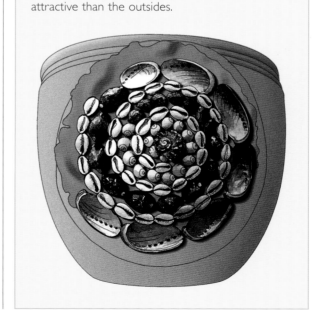

of the other line darker, so that there is a good contrast between the two. Don't take the shells right to the very bottom of the pot—leave a gap of around ⅛ inch (5 mm) and cover it with adhesive.

7 As the spiral reaches the edges of the circle, the line of mixed shells will have to become smaller again to fit in. Let the lines end where it seems natural and appropriate.

8 Fill in the remaining circles in the same way using different combinations of shells, but maintain the idea of two separate lines—one that changes and one that stays the same.

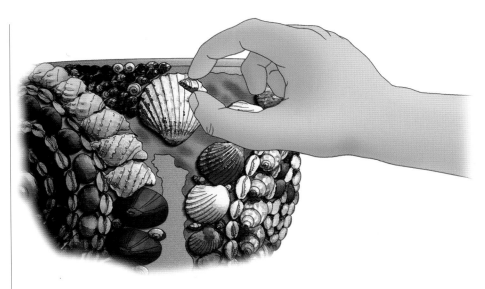

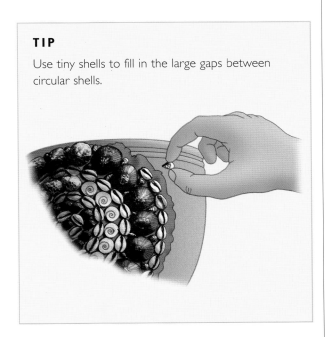

TIP

Use tiny shells to fill in the large gaps between circular shells.

9 For filling the spaces between the circles, use a large shell, such as cockle, in the widest part, and fill the rest of the area with lots of tiny shells (a pair of tweezers may be useful here). This simplicity will create a good contrast with the complex design of the spirals.

10 If the rim of the pot is clean, leave it bare. If not, cover it with a thin, smooth layer of adhesive to tidy it up.

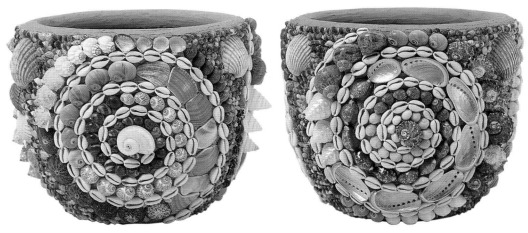

TEMPLATE

Diameter: 11 inches (28 cm)

Height: 10¼ inches (26 cm)

Enlarge template by 200%

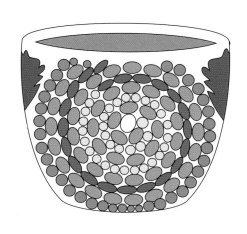

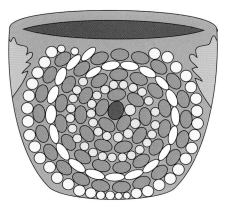

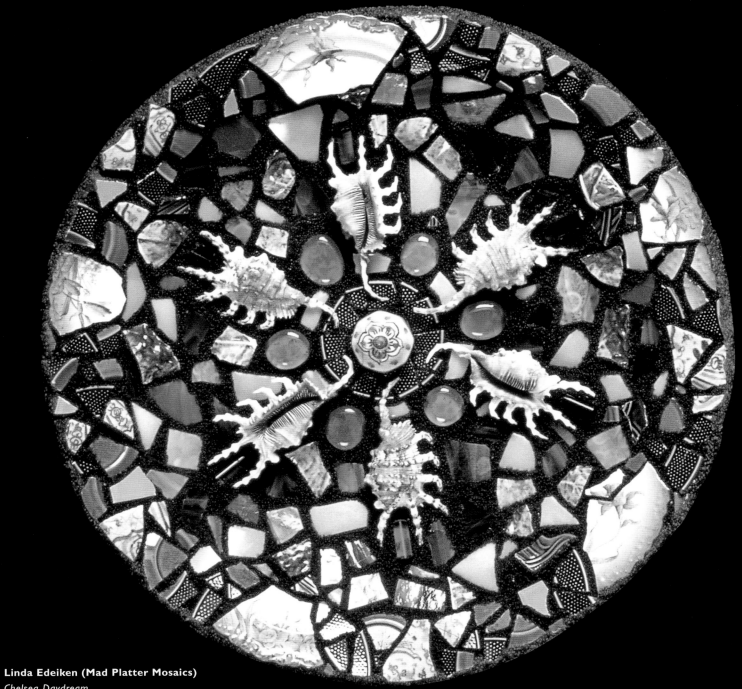

Linda Edeiken (Mad Platter Mosaics)
Chelsea Daydream
23 × 17 in / 58.5 × 43.25 cm
antique china, beaded grout, glass, sea shells

Combining shells with other materials, in this
case, broken china, can create a stunning effect.

Intermediate Projects

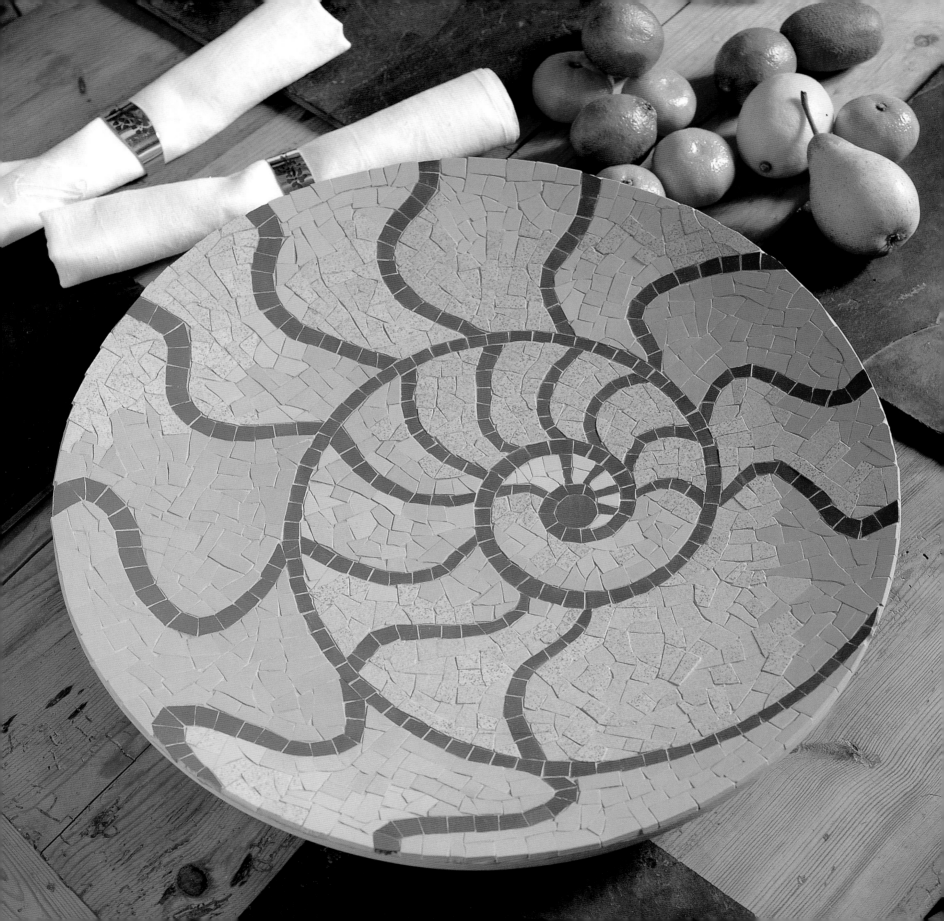

Fossil platter

CREATED BY SARAH KELLY

MATERIALS

Wooden platter—example shown is 17½ in (445 mm) in diameter, with no rim

Unglazed ceramic tiles in various shades of gray, beige and chocolate brown

White craft glue (see page 54)

Cement-based grout

EQUIPMENT

Pencil

Utility or craft knife

Protective goggles, mask and gloves

Tile nippers

Plastic glue spreader

Grouting squeegee

Grout sponge

Bucket

Soft cloth for polishing

✳ COST ✳✳ TIME ✳ DIFFICULTY

This striking fossil design is created using unglazed ceramic tiles, which create a mat effect. The plain and mottled shades blend together beautifully and suggest the subtle natural colors of fossil. Choose a platter (or large plate) that is shallow, perfectly smooth and doesn't have a rim, as this would interfere with the flow of the mosaic.

1 Seal the wood with a 50:50 mix of craft glue and water. Trace or draw on the design freehand with a pencil, then score the surface with a knife.

2 Begin the design with the center of the fossil and the spiraling line around it. Nibble a circle from a brown tile, butter the back of it with the craft glue, and stick it down in the middle of the fossil. Cut some more brown tiles in half, and then each half into three rectangles. Stick these down onto the spiral line, working from the central circle outward. The tiles will need to be trimmed to fit around the tighter curves, especially in the beginning. Continue until you reach the end, trimming the last tessera as required. Don't leave too small a piece at the end, and make sure that it is flush with the edge of the platter and smooth.

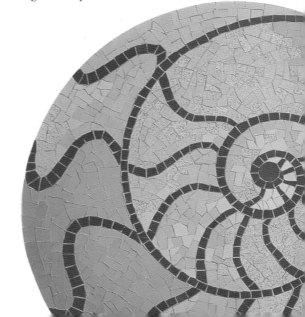

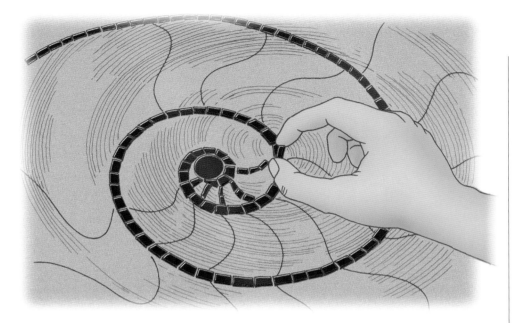

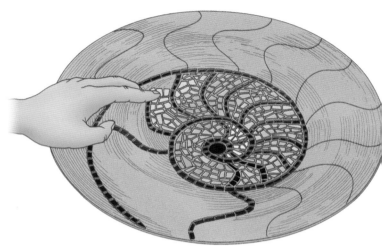

3 Still using the chocolate brown tiles, cut thinner rectangles to define the first radiating lines of the fossil. As these reach farther around the spiral, they start to get thicker at the top, and some tiles will also need trimming to accommodate the curves of the lines. Do three or four lines at a time before starting to fill them in.

4 The spaces between the lines are filled in with a random, crazy-paving style (Opus palladianum), which is very easy to do because it does not require any specific technique. Very randomly break the tiles into pieces with the nippers, with the goal of amassing a variety of shapes and sizes. Starting from the center again, lay cream-colored tiles into the first five spaces defined by the lines, fitting them together like a jigsaw puzzle. Leave small spaces between the tiles, though obviously these will be irregular due to the nature of the technique. Introduce different colors into the next segments. Mix plain and mottled beiges and yellow ocher, using small sections of each color and blending them by adding more and more of another color to the mosaic as it grows.

5 Create additional radiating lines, and continue filling in the spaces. Some segments can be filled in using just one color; others can combine two or three. Follow the colors of the design shown here, or make your own plan for when and how the colors change. The muted colors of the unglazed ceramic make the blending look subtle and natural.

6 When you get to the radiating lines on the outer edge of the design, the ends get subtly thicker, so cut larger tiles accordingly.

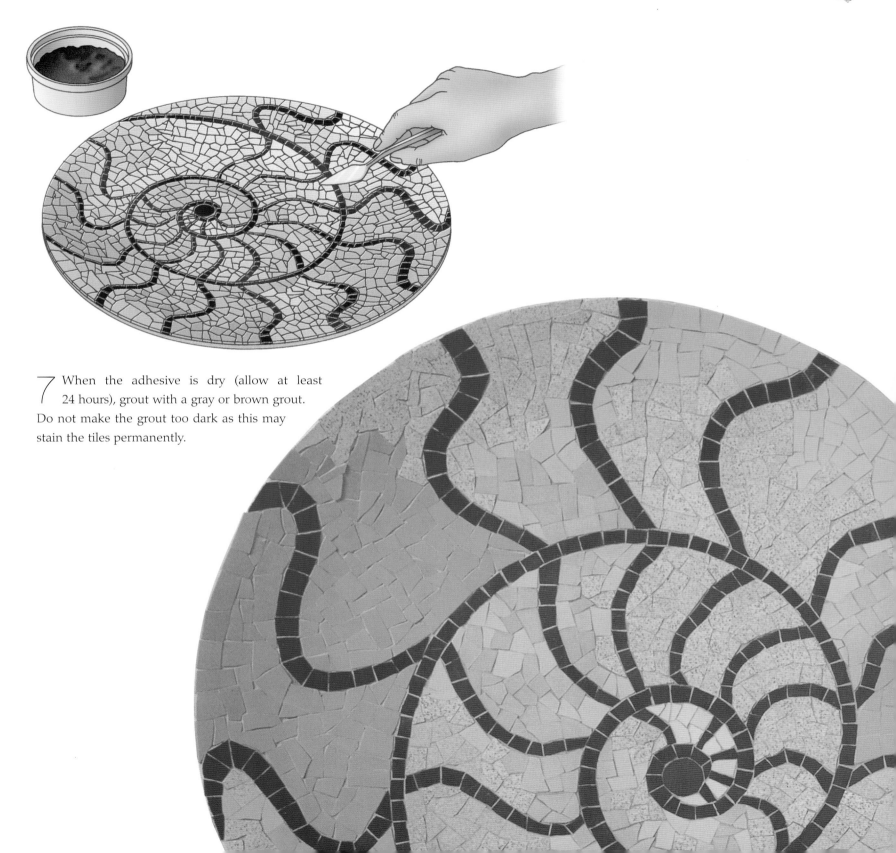

7 When the adhesive is dry (allow at least 24 hours), grout with a gray or brown grout. Do not make the grout too dark as this may stain the tiles permanently.

TEMPLATE

Diameter: 17¾ inches (45 cm)

Enlarge template by 300%

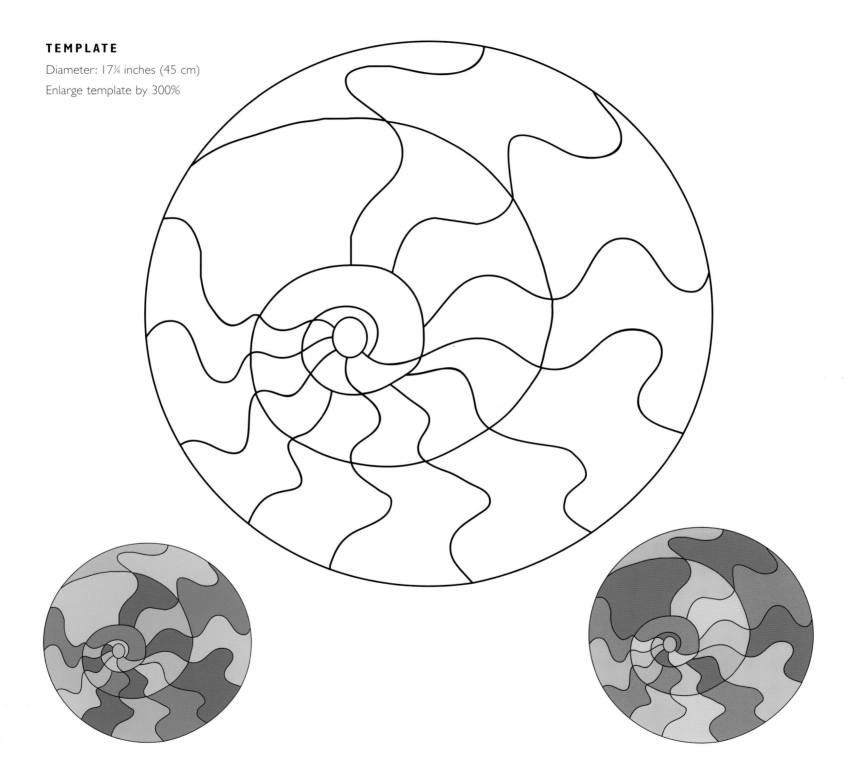

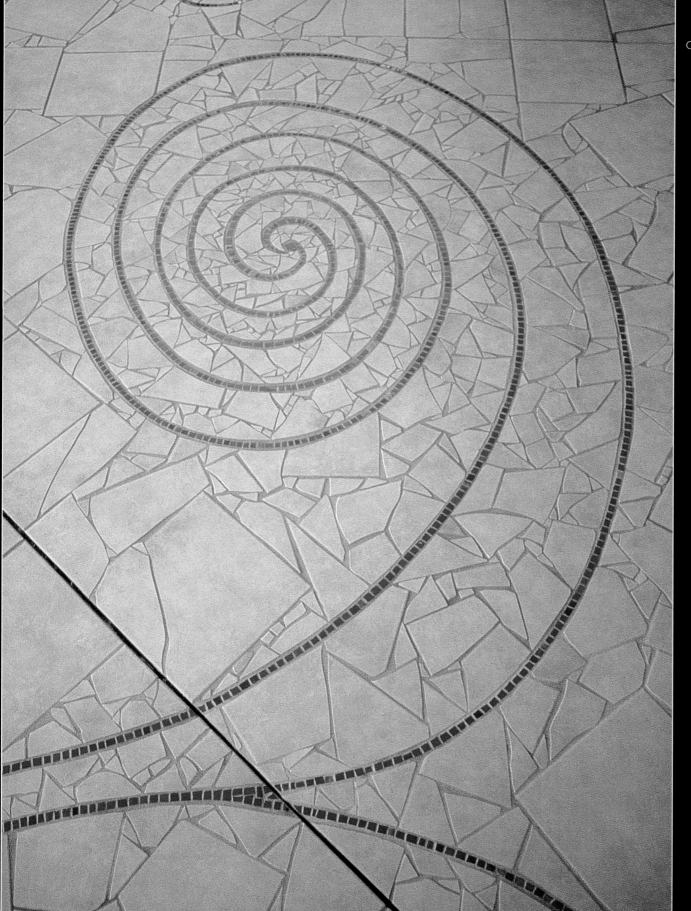

Twin Dolphin Mosaics
*Curved Surface, Highlands
University, Las Vegas*
1997
105½ yd² / 88 m²
whole and broken Italian
porcelain tesserae

The spiral motif has been
executed on a much larger
scale on this tiled floor.
The varying sizes of
tesserae create a dramatic
and contrasting effect.

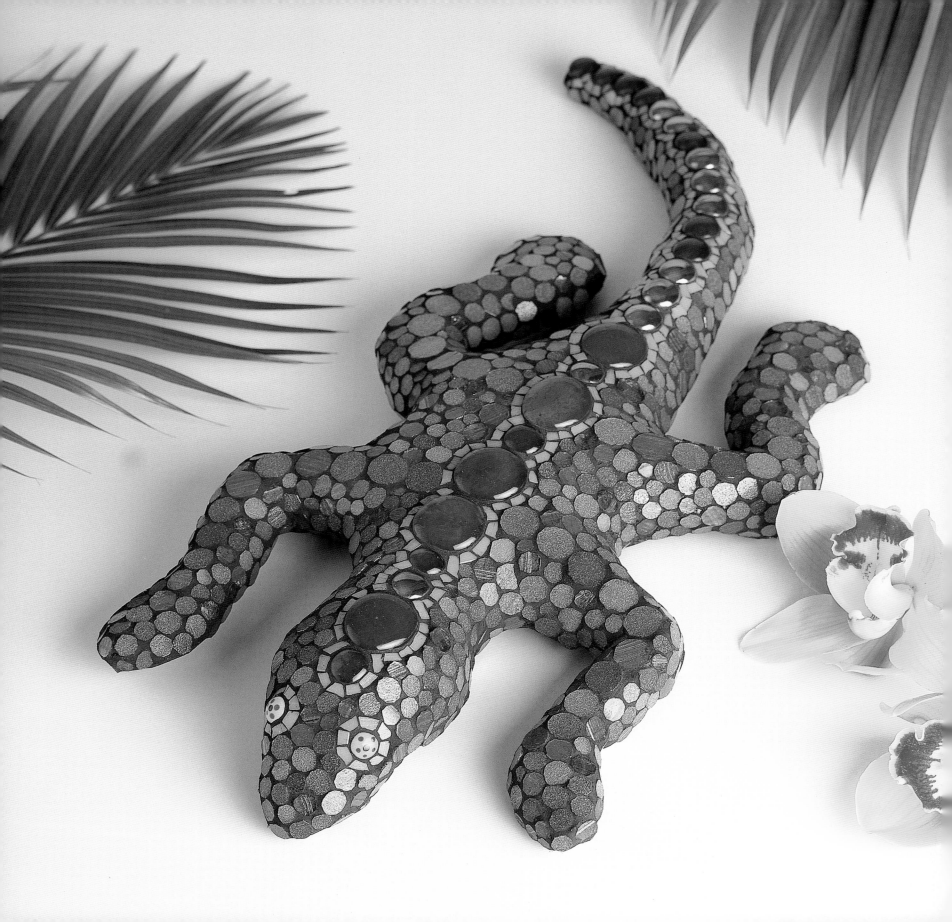

Glass lizard

✳ COST ✳✳✳✳ TIME ✳✳ DIFFICULTY

This time includes drying-out time CREATED BY SARAH KELLY

This lizard has been constructed from a simple wire netting base and is decorated with a mosaic of circles in vitreous glass. The impression of scales that these create is emphasized by the dark grout, which gives the lizard a shimmering, jewel-like quality. It would look great in a garden or conservatory, displayed among foliage or basking on a wall.

MATERIALS

Wire netting

Gauze bandages (wide-meshed crêpe bandages or strips of cheesecloth could be used)

Cement-based adhesive (frost-proof if it will be outdoors)

Sheets of gold or silver leaf

Vitreous glass tiles

Glass nuggets

White craft glue (see page 54)

Beads, buttons or acrylic "eyes"

Dark grout (frost-proof if it will be outdoors)

EQUIPMENT

Wire cutters

Heavy-duty protective gloves

Narrow-headed pliers

Newspaper or plastic sheeting

Rubber gloves

Bowl

Scissors

Board or large tray

Plastic bag

Small plastic glue spreader or spatula

Flexible rubber spatula or potters' kidney

Large paintbrush

Tile nippers

Bucket

Grout sponge

Soft cloth for polishing

1 With wire cutters, cut a section of wire netting roughly 20 inches (500 mm) long and 12½ inches (320 mm) wide, and form it into a cylinder. Wearing heavy-duty gloves, squeeze the cylinder to form the head, torso and tail of the lizard. The tail should be roughly twice the length of the body, but you can extend it with an additional piece of wire if necessary. Don't worry about producing an exact or symmetrical shape, because any little imbalances give the lizard an added sense of liveliness and movement. Don't make the torso too flat, as the weight of the cement-soaked bandages will compress it slightly.

2 Cut four wire netting pieces of 6 × 8½ inches (150 × 220 mm). Form them into cylinders, bend and squeeze them to make the lizard's legs. Try not to let them get too flat or lose their form. Open out the strands of wire at the top of the legs and attach them to the lizard by wrapping the ends around the relevant section of the body. A pair of narrow-headed pliers may be useful here, as this can be a bit tricky.

> **TIP**
> Always wear protective gloves when moulding wire netting to avoid lacerations.

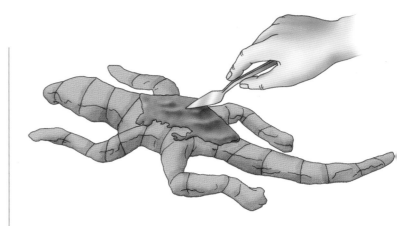

3 Protect your work surface with newspaper or plastic sheeting. Wearing rubber gloves, mix the adhesive with enough water to form a slurry—about the consistency of heavy cream. Cut the bandages into strips of about 20 inches (500 mm) in length (this makes them easier to wrap) and soak them in the bowl of slurry, making sure they are fully covered in adhesive. Starting at the head, begin to wrap the bandages around the lizard, smoothing them as you go. Work down and around the body until the whole structure is covered with a smooth layer of bandages.

4 Cover a board or large tray with a plastic bag, place the lizard on it and leave it to dry. It will need a couple of days to dry out thoroughly. Don't try to speed up this process by leaving the lizard in a hot place, as this may cause the cement to crack.

5 While the lizard is drying out, prepare the glass nuggets, as they also need time to dry. Apply a thin, even layer of craft glue to the back of each one, and lay them on a sheet of gold or silver leaf. They are dry when you can see the leaf clearly through the glass.

6 When the lizard is dry, mix up some more adhesive to a thick cake-mix consistency. Apply with a spatula or potters' kidney to smooth out any irregularities and to fill in any sunken areas on the body. Brush water onto the surface of the lizard before applying the cement to stop it drying out too quickly and cracking.

7 When the lizard is completely dry, you can begin the mosaic. Always wet the surface with a little water before applying any adhesive. Start by sticking

on the eyes (use suitable-looking beads, buttons or acrylic eyes made for stuffed toys) and then surround them with a ring of vitreous glass tiles. These have been cut into eighths and trimmed to fit snugly around the curve. Glue a line of glass nuggets along the spine of the lizard. A mixture of large and small nuggets have been used here, but a line of small ones are fine if you can't find larger ones. You could also use circles nibbled from colored glass, which has been backed with metal leaf in the same way as the nuggets. Surround these with a continuous line of small tiles as was done with the eyes (you may find a pair of tweezers useful for placing these pieces).

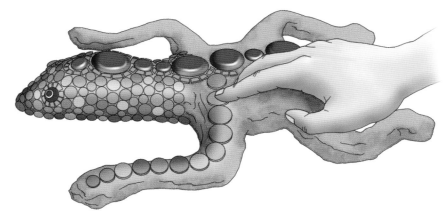

9 Define the legs with a line of circles that start off large near the spine and grow smaller as they reach the feet.

10 Continue in the same way until the lizard is completely covered. Leave to dry naturally. Mix up a black or very dark gray grout, using coloring powder if necessary, and grout the lizard. Work the grout thoroughly into the areas where the tiles end, and smooth over the underside to tidy it if desired. Sponge off the grout, making sure all the excess is removed from around the nuggets, and polish with a soft cloth.

8 Fill in the body of the lizard with a mosaic of small circles nibbled from vitreous glass (two small circles can be made from each tile by cutting them into rough triangles first). As well as greens and dark turquoises, tonally similar colors, such as dark lilac, brown and gray, have also been incorporated.

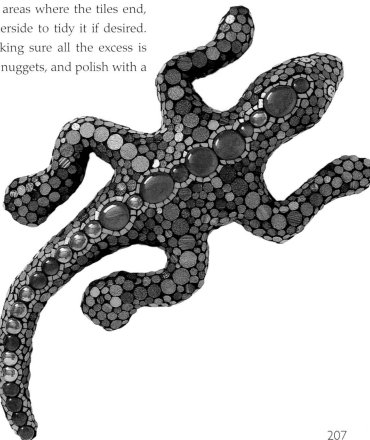

TEMPLATE

Length: 22½ inches (55 cm)

Enlarge template by 200%

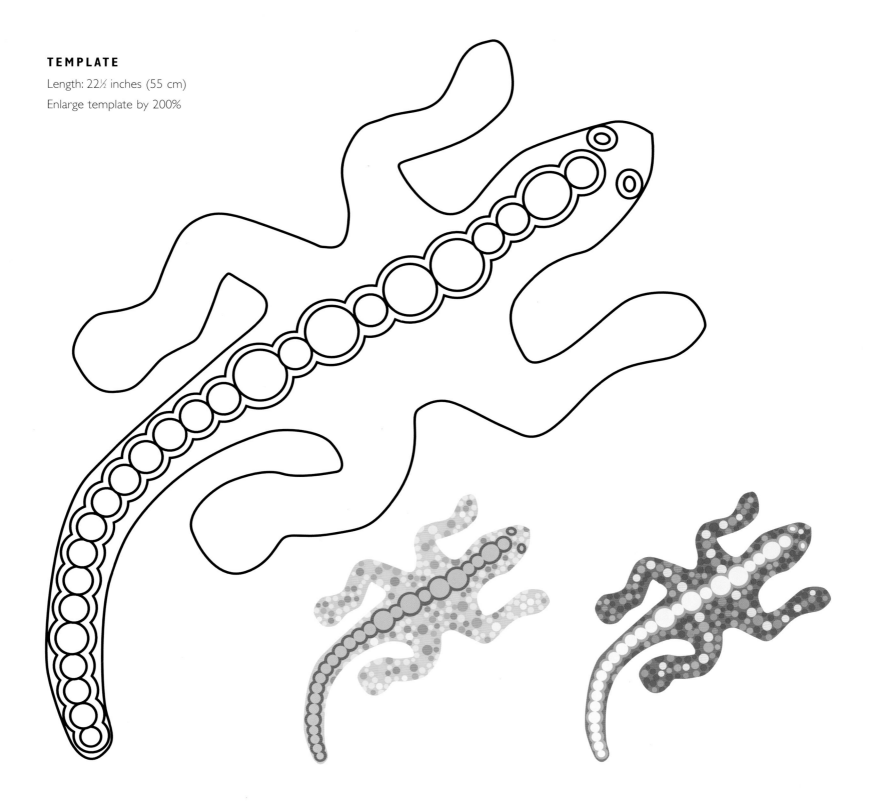

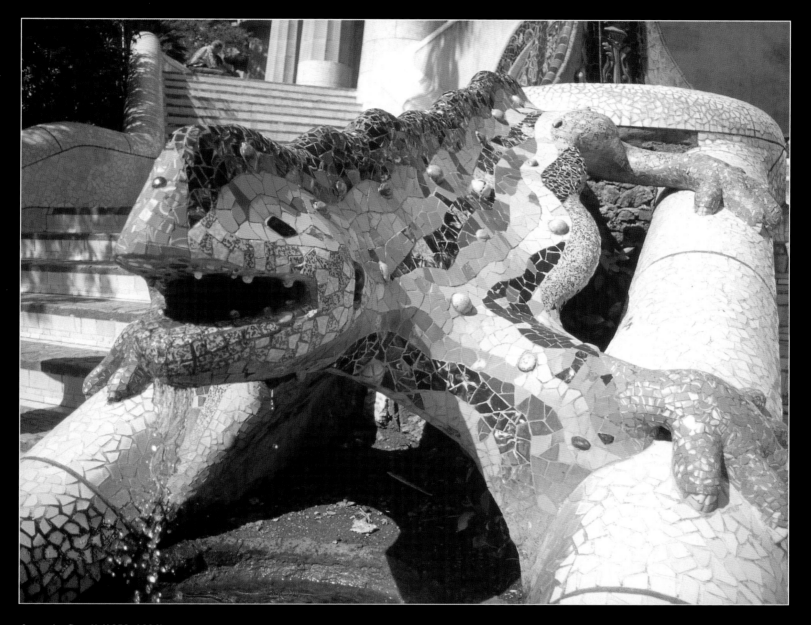

Antonio Gaudí (1852–1926)
Gaudi's larger-than-life lizard stands at the main entrance
to Parc Guell, Barcelona
ceramic tiles and pique assiette

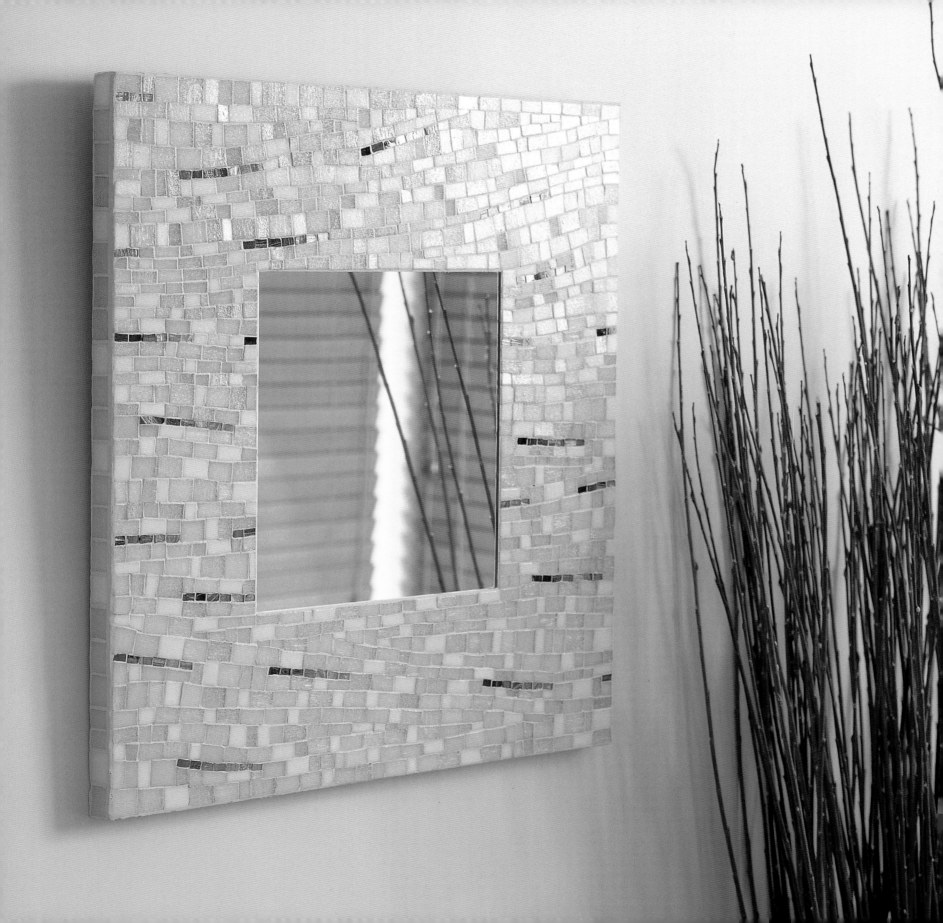

White and bronze mirror

** COST ** TIME ** DIFFICULTY

CREATED BY JULIET DOCHERTY

CREATED BY JULIET DOCHERTY

This mosaic mirror shows the beautiful effect that you can achieve using a very subtle palette of colors. The range of different white tiles used look very similar right up until the mosaic is grouted, at which point they appear to change color, and the subtle differences become apparent. Using a dark grout would be too heavy and using bright white grout would be too clinical, so a slightly off-white, very pale gray color is used. Vitreous glass tiles, which are translucent, change in appearance dramatically and appear to darken once the grout is applied, since the grout prevents light from passing through the tiles. The slivers of brown/bronze contrast beautifully with the pale background and enhance the directional lines of the mosaic.

MATERIALS

Medium-density fiberboard
 (MDF), ½ in (12 mm) thick,
 17¾ × 17¾ in (45 × 45 cm)

Mirror tile, 8¼ × 8¼ in
 (33.5 × 22.5 cm)

Vitreous glass tiles:
 a mixture of whites—bright
 white, blue white and semi-
 opaque white; a mixture
 of metallic dark brown
 and bronze

Resin-based wood glue

White craft glue (see page 54)

Powdered white grout and
 powdered gray grout

EQUIPMENT

Pencil

Felt-tip pen

Paintbrush

Protective goggles, mask and
 gloves

Tile nippers

Rubber gloves

Bowl and spatula for mixing
 grout

Flexible grout spreader

Utility-knife blade

Nylon pan scrubber

Grout sponge

2 D-rings with screws

Picture wire

1 Using a pencil, draw freehand lines across the MDF in a diagonal manner. With a felt-tip pen highlight where you would like the bronze/brown flashes to go.

2 Fix the mirror tile onto the MDF using a resin-based glue. To center the mirror, draw two lines corner to corner, then fix the mirror where each corner is touching one of these lines.

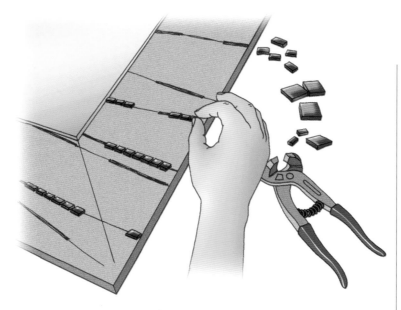

that each piece in a block follows on from the one before. Use a random mix of the three whites, and attach using craft glue. Leave a gap of about $\frac{1}{16}$ inch (2 mm) between the tiles and around the edge of the mirror.

5 At the edge of the MDF, the tiles should overlap the edge by about $\frac{1}{8}$ inch (3 mm). Use a felt-tip pen to mark the tiles before cutting.

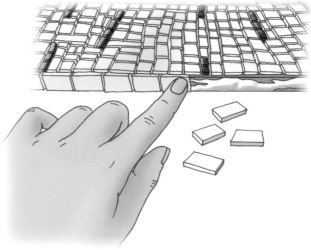

3 To make the thin pieces for the slivers, use the tile nippers to cut a tessera in half, then into quarters and finally into eighths. When you have a selection of these pieces from the dark brown and bronze tiles, arrange them from light to dark. The natural variations in the tiles will show a range of tones. For each sliver, use about six pieces and attach them with the wood glue from light to dark across the line.

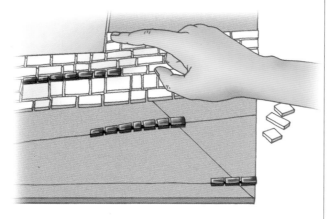

4 Attach the white tiles to the front of the mirror. Work across in blocks using the hand-drawn lines as guides. Cut the tiles, using the tile nippers, so

6 When the front of the mirror is complete, raise it up slightly, supporting it on a pile of books. Cut a selection of the white tiles with which to tile the edges. Cut the tiles so that there is a slight gap of about $\frac{1}{16}$ inch (2 mm) top and bottom. As you are gluing onto a vertical surface, dab plenty of glue along the MDF edge, then use your finger to smooth it out. Wait until the glue becomes tacky before applying a dab of glue to the cut tile and sticking it onto the edge. Speed up the process by using a hair dryer to set the glue slightly. Allow several hours for the glue to dry.

7 Create the correct color of grout by mixing gray and white powdered grout. Mix some white powdered grout and a small amount of gray grout in a bowl. Adding small amounts of water, mix into a smooth paste. Once mixed, test the color by applying a bit to a spare white tile and drying with a hair dryer.

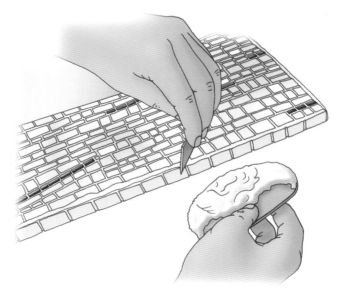

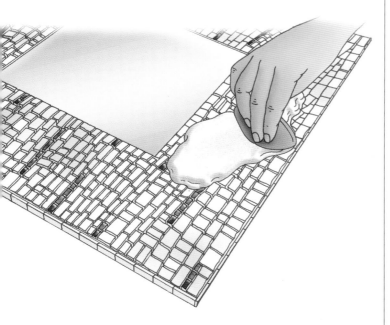

8 Grout the front and sides of the mirror. Using a flexible grout spreader, apply the grout and work into the surface in all directions. Wipe off the excess grout with the spreader.

9 Next, grout the edges. Apply plenty of grout, and carefully remove any excess from the edges with a utility-knife blade; this will create a very professional edge. Carefully turn the mirror over, and grout the gap between the tiles and the MDF on the reverse of the mirror. Again, use a utility-knife blade to remove any excess and create a sharp edge.

10 Leave for several hours for the grout to dry fully before cleaning off the excess grout with a scrubber and water. Sand the edges with a sanding block for a neat right-angled edge.

11 Fix the D-rings and hanging wire to the back of the mirror. The D-rings should be attached with screws one-third of the way down the mirror. Attach wire between the D-rings, and polish the mirror before hanging.

TIP

The quantity of tiles required can be estimated by adding 20 percent to the surface area for wastage due to cutting.

213

TEMPLATE

18 × 18 inches (46 × 46 cm)

Enlarge template by 300%

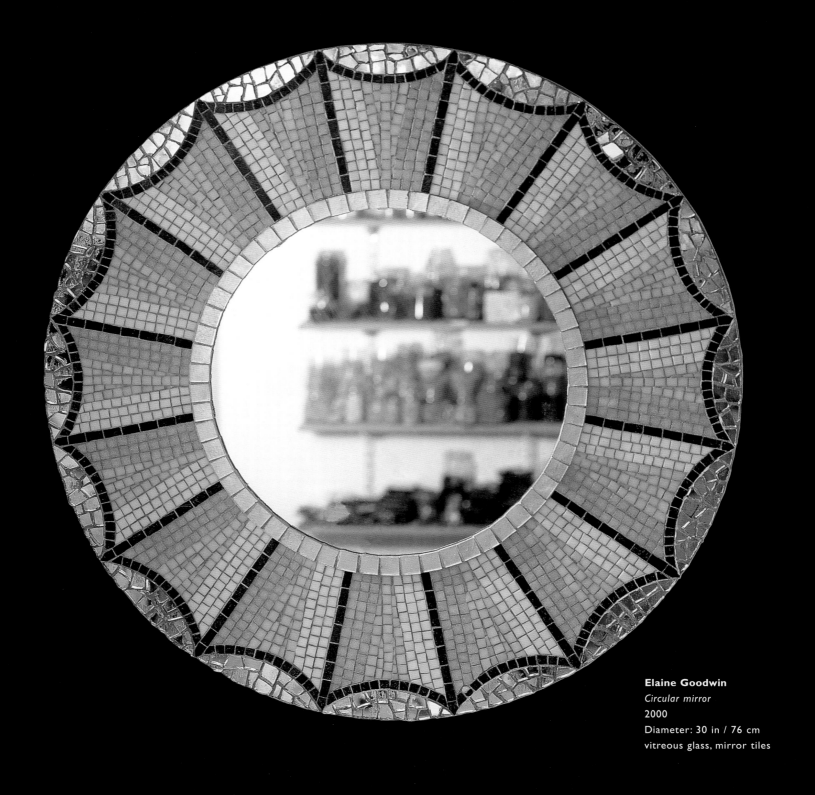

Elaine Goodwin
Circular mirror
2000
Diameter: 30 in / 76 cm
vitreous glass, mirror tiles

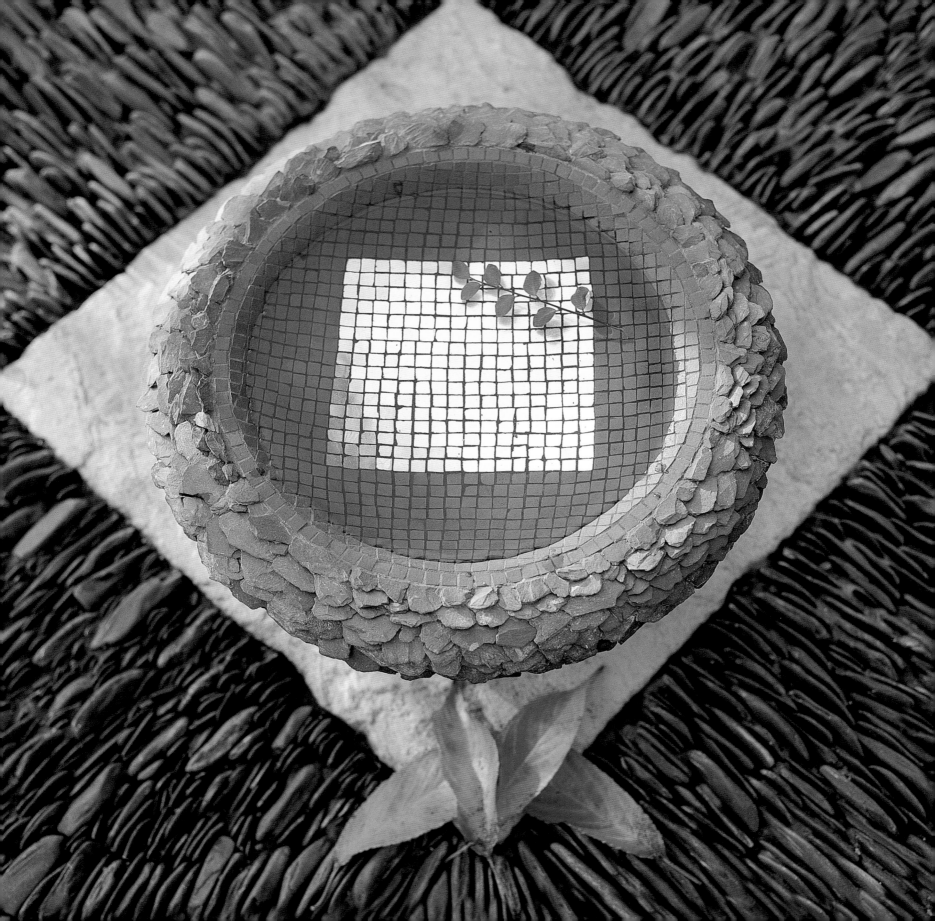

Slate birdbath

✦✦✦✦ COST ✦✦ TIME ✦✦ DIFFICULTY

CREATED BY JULIET DOCHERTY

This birdbath beautifully demonstrates the effectiveness of combining different materials. The gentle curve of the bowl gives the gold square a glinting, faceted appearance, which contrasts with the mat-black porcelain area around it. The smoothness of the inside of the bowl is offset against the textured feather-like appearance of the outer rim, which is made up of layers of slate shale. Slate works particularly well on an outdoor piece as it looks purple/gray when dry and glossy and black when wet.

This project enables a mosaic crafter to develop skills by working on a three-dimensional exterior project. Try to find a birdbath that has a gentle curve and a fairly smooth surface.

1 Dilute craft glue with water in a glass jar until the mixture is runny. Paint this solution onto the bird bath in order to seal it. Allow an hour for it to dry.

2 Draw a square about 7 × 7 inches (180 × 180 mm) on a piece of paper, and cut out with scissors. Position the square in the center of the bird bath and mark around it with a pencil. Next, cut all the gold

 INTERMEDIATE PROJECTS

tesserae you will need (roughly 225 quarter tiles). Using a glass cutter, score a line across the middle of the gold tesserae, and then use the tile nippers to cut along the scored line. Repeat to cut all the gold tesserae in quarters. Use the nippers to remove any rough or uneven edges.

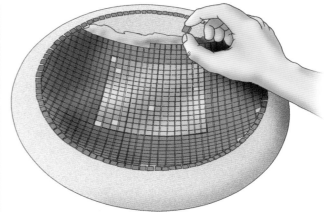

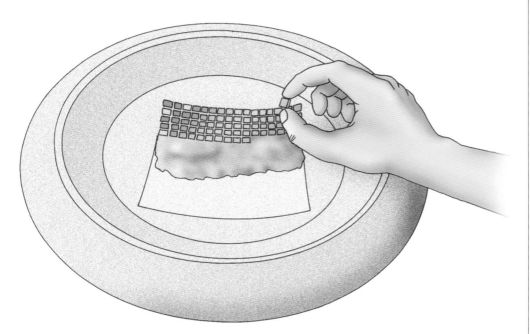

4 Next, cut lots of quarter pieces of black tesserae— you will need over 200 so cut a large supply first, then add more later, as necessary. Mix a small amount of adhesive, and apply to the outer edge of the bowl area. Apply one row of black tesserae to this edge. Fill the remaining segments, making sure that you shape the tiles where a row meets the outer edge. Leave to set for several hours.

3 Wearing a mask, mix a small amount of cement-based adhesive, stirring carefully until you have a smooth, stiff paste. Using the spatula, trowel some of the mixture onto the middle of the square, and smooth it out until it is about ³⁄₁₆ inch (4 mm) thick. Start pressing in the gold tesserae, leaving gaps for grout. When you press the tiles in, you want the cement to squeeze up between them without actually protruding above; if it does, vary the thickness of adhesive accordingly. Keep working around the square until it is the desired size. Use a toothpick to prod the tiles into position. When the square is complete, leave to dry for a couple of hours.

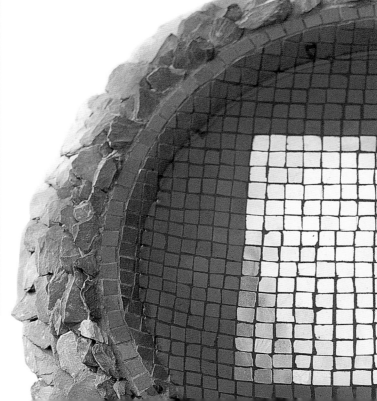

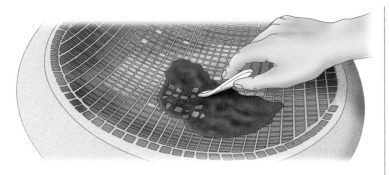

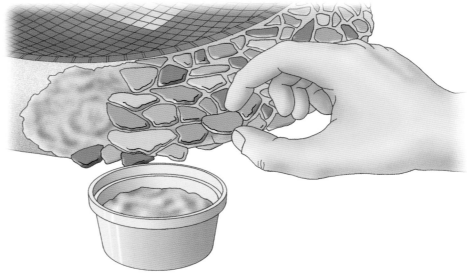

5 Mix the exterior grout into a smooth paste. Using a flexible grout spreader, apply to the tiled area, smoothing it on in all directions. Remove the excess with the grout spreader, and then carefully remove the rest with a slightly damp cloth. Allow a few hours to dry before polishing the gold area with a soft cloth.

6 Rinse a few handfuls of the slate shale in a colander, and spread it out on a towel to dry. Select pieces of thin flat slate for the curved edge. Mix the adhesive and apply to a section of the rim. Starting at the bottom, carefully press pieces of the slate into the cement, and work your way across. Next, do the row above, making sure the pieces overlap like roof tiles.

7 As you work your way around the edge, you may need to use smaller pieces as you get to the top. As you mosaic the circular edge, use smaller pieces of slate that can butt up against the black tesserae. Allow 24 hours for the cement to set fully.

TIPS

Use a toothpick to remove any excess cement from between the tesserae prior to grouting.

TEMPLATE

Diameter: 18 inches (45 cm)

Enlarge template by 300%

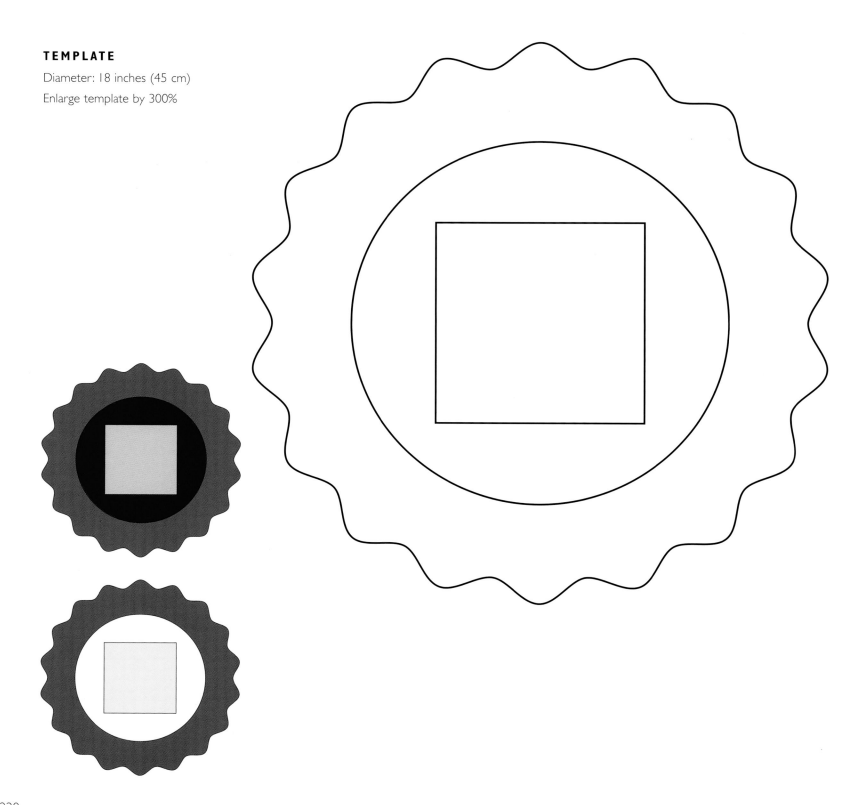

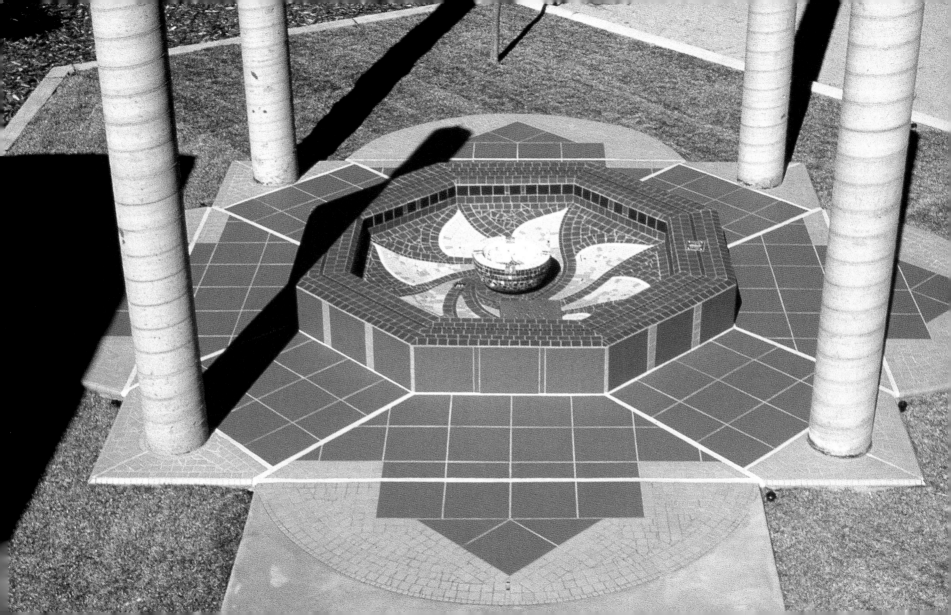

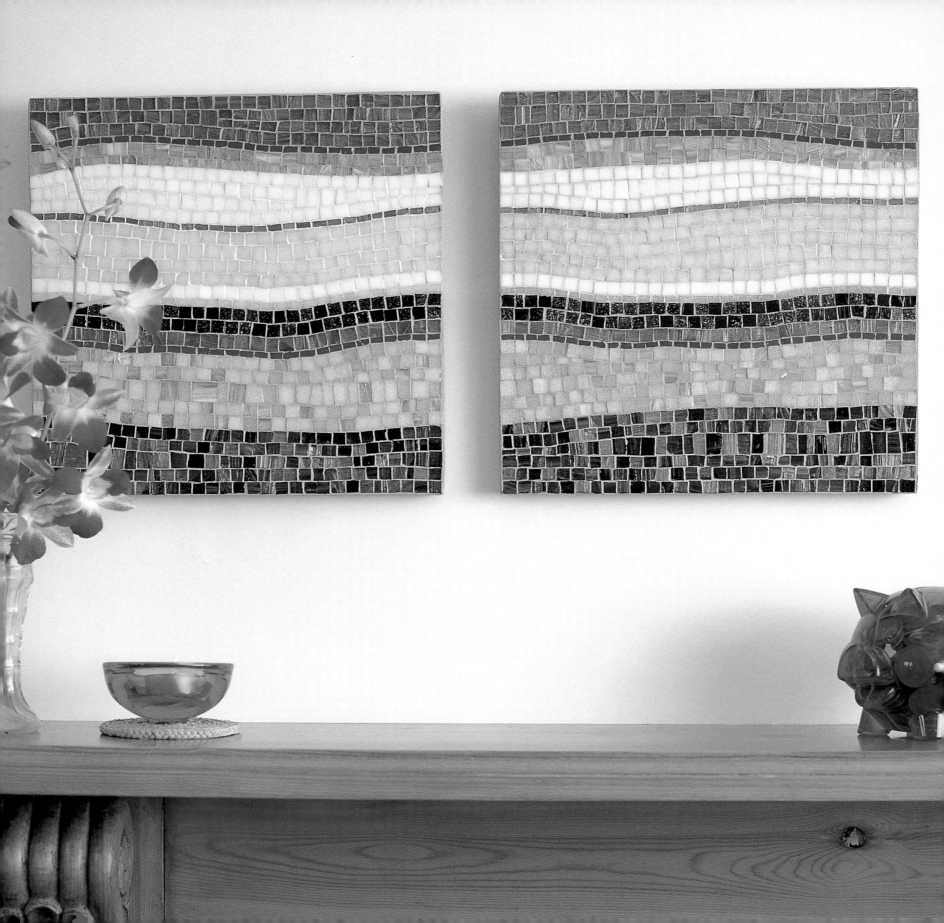

Decorative panels

MATERIALS

2 medium-density fiberboard (MDF) panels

Selection of vitreous glass tiles: dark—black, brown, purple and red; medium—pink, gold leaf and bronze; light—white, off-white and gray

White craft glue (see page 54)

Buff-colored grout

EQUIPMENT

Felt-tip pen

Protective goggles, mask and gloves

Tile nippers

Rubber gloves

Bowl and spatula for mixing grout

Flexible grout spreader

Out-of-date credit card

Utility-knife blade

Sandpaper

D-rings and picture wire

✳✳ COST ✳✳ TIME ✳✳ DIFFICULTY

CREATED BY JULIET DOCHERTY

These mosaic panels are designed to look like abstract paintings that hang together as a pair. This project shows how a subtle array of tiles used together in a simple way can produce a sophisticated effect. The colors are predominantly quite subtle and muted but of varying tones, with the odd stripe or line picked out in dark red or pink as a contrast. The bands of color are mosaiced in a freehand way and flow from one panel to the next. The edges of each panel are grouted and sanded to give a crisp modern finish.

1 Line up the two panels next to each other and draw several free-flowing lines from one to the other. Using the dark brown tiles and the bronze tiles, cut them into quarters. Using them in a random mix, begin to mosaic the bottom edge of the panels. Make sure you overlap the edge by about 1/16 inch (2 mm).

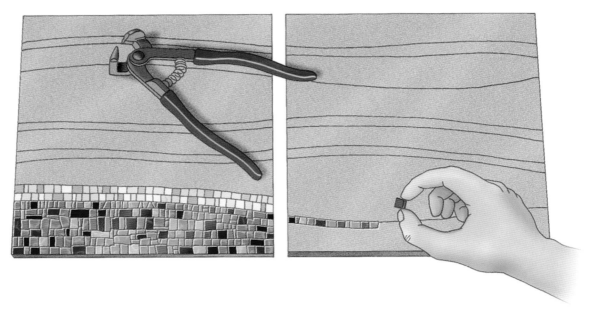

2 When you have mosaiced a couple of rows, mosaic the top row of the brown/bronze band, which leaves a gap in the middle of varying thickness. Carefully cut the tiles to fit this gap, making sure as you do so that the grout gaps are tiny.

3 For the next section up, use a mixture of gray, pale pink and marble colored tiles. Progress in the same manner, starting with the bottom lines, then the top, then filling in the middle area.

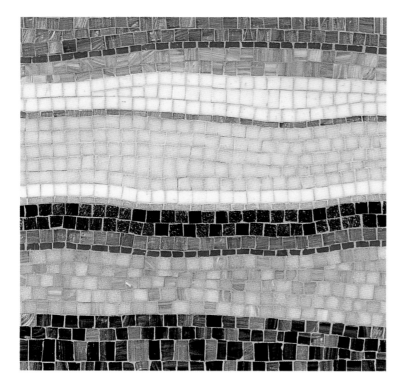

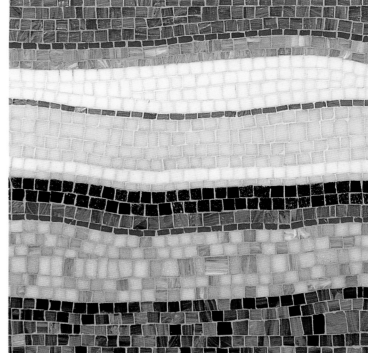

4 Working up, mosaic a line in the dark red as a contrast, using tiles cut into eighths. Follow this with a single row of pink/gold-veined tiles cut into quarters.

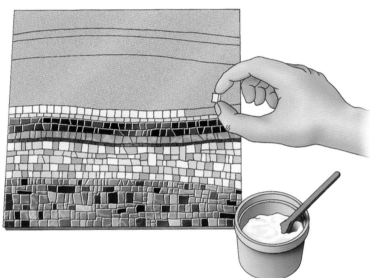

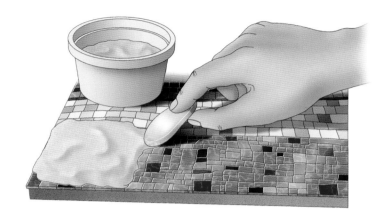

6 Mix up a pale buff-colored grout into a smooth paste and grout the front of the mosaic using a flexible grout spreader. Use an out-of-date credit card to carefully apply grout to the edges of the panel so that it is flush with the tiles.

5 Work your way up the rest of the panel in the same manner, incorporating rows and sections of black/purple, grays and whites. Make sure that the edges of the MDF are slightly overlapped. Leave several hours for the glue to dry.

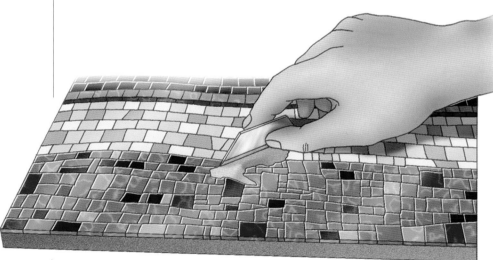

7 Remove any excess carefully with a blade. Allow several hours to dry.

8 When completely dry, sand the edges of the panel so that it is completely smooth and flat. Attach D-rings and picture wire to the back of each panel so that they can be hung from picture hooks.

TIP

When grout dries, it lightens considerably in color. If unsure of the final color, apply some to a scrap of card and dry it with a hair dryer.

TEMPLATE

Each panel: 12 × 12 inches (30 × 30 cm)

Enlarge template by 300%

*Intricate mosaic patterns
were used on the walls of
the Grand Palace, Bangkok*
Glass

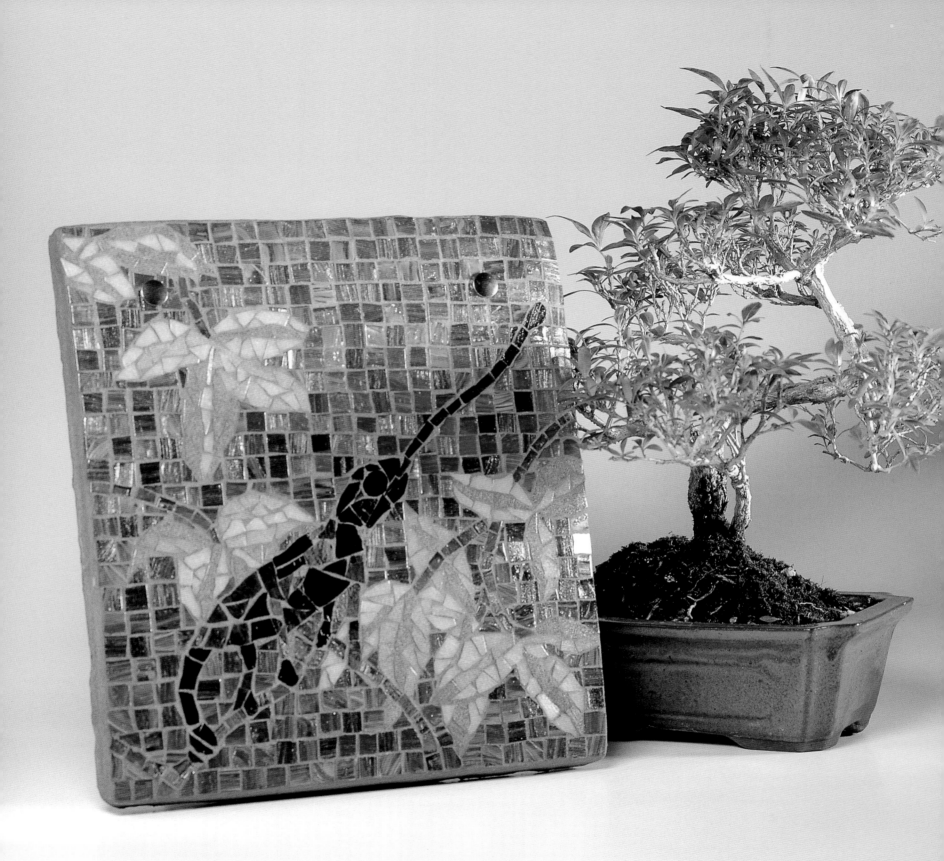

MATERIALS

Roof tile, 9½ × 10½ in
 (245 × 265 mm)

Brown wrapping paper

Carbon paper

Wallpaper paste

Piece of stained glass, 6 × 2 in
 (150 × 50 mm)

Vitreous glass tiles: gold-veined
 pink and purple (120 in total),
 greens (45 in total) and gold-
 veined green (16 in total),
 gold-veined brown (6)

Exterior-grade cement tile
 adhesive, gray

Exterior-grade cement grout, gray

Wire for hanging

EQUIPMENT

Wire brush

Pencil

Sponge

Work board

Masking tape

Protective goggles, mask and gloves

Glass cutter

Metal rule

Tile nippers

Paste brush

Rubber gloves

Grouting squeegee

Spatula

Bucket

Toothpick or dentistry tool

Soft cloth for polishing

Wire cutters

Stained-glass chameleon panel

✸✸ COST ✸✸ TIME ✸✸ DIFFICULTY

CREATED BY ANNE READ

This wonderful piece of stained glass was matched up with some mosaic glass, which inspired the idea of creating a chameleon that changes color to blend in with its background. A concrete roof tile was used as a frost-proof base; two holes are drilled, through which the piece can be hung or screwed to a wall.

1 Remove any loose debris from the roof tile with a wire brush. Put it face down on the brown wrapping paper, and draw around it. Make a mark where the holes are for future reference.

2 Gather various photographs of chameleons, and look at these in comparison to your materials. Cut around an image you like, and position it on the tile to check how it would fit. You are working indirect—back to front on the shiny side of the brown paper. So, draw the design in mirror image—here, the chameleon's tongue will be in the top right corner, so the drawing has it in the top left. Put a piece of carbon paper underneath the picture, carbon side up, and draw around the main parts of the chameleon; this gives a line in reverse on the underside of your picture. Put the carbon paper in position—carbon side down—between the design and the brown paper, and draw around. Look at the lines, you may not want to keep all of them. It is better to keep the image simple. This is just a guide;

when working, you will change some of the lines as you get a feel for the colors and materials. For instance, here, there is no shading and no spots or black lines.

3 Stretch the brown paper—dampen it with a wet sponge and stretch it on the board, securing with masking tape at each corner. This is to eliminate any wrinkling of the mosaic when it is put onto the adhesive.

4 If your piece of stained glass is quite large, cut off a piece. Score a line with a glass cutter, running it down the edge of the metal rule. Put a piece of wood or a pencil under the line and gently push down; the glass will break apart.

5 Arrange the tiles and stained glass on the work until you are happy with their placement. Decide what shapes to cut them both into. For the branches, cut the mosaic tile into equal eighths; for the leaves, cut one tile into six randomly. For the background, cut the tiles in equal quarters. The tongue is equal eighths, with a shaped piece for the end. The main body of the chameleon is made up of random shapes.

6 Start with the chameleon. Paste a small area of paper with the wallpaper paste, and fit in your shapes; remember that the multicolored side goes down on the paper. The eye is black so the black side goes onto the paper. Then work on the branches and leaves, filling in with the background.

7 The background is mosaic tiles cut into quarters. Do not put any movement into the background because the chameleon should not stand out. Start the background from the bottom, and after you have worked a few rows, put a row in the top—make sure you have the same number of pieces in the top and bottom rows. Continue working down from the top—it is difficult to keep everything in line horizontally and vertically, so any discrepancy will be

lost in the middle. Try to position the tiles so that the holes come between two pieces, but do not worry too much if it is uneven.

8 When the piece is completed, leave to dry for a day. Trim off the surplus brown paper.

9 Mix the adhesive following the manufacturer's directions. Spread evenly all over the tile, covering the holes—this is so you have a flat base and your mosaic does not dip into the holes.

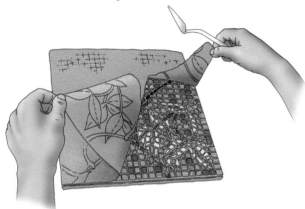

10 Hold the tile (adhesive side down) over the mosaic and line it up. Lower the tile onto the mosaic. Slide a spatula gently under the edges to ensure the mosaic has stuck to the adhesive, and turn the tile over carefully. Dampen the paper with a wet sponge, and leave for 5 minutes. Carefully peel the paper off to reveal your mosaic—right way up!

11 Gently push a nail or tool up through each hole; this will dislodge a tessera and show you where to cut off a tiny piece to enable the wire or screw to pass through. Cut and replace the modified pieces of tile. Check that the adhesive has not pushed up through the joints; leave enough room for grout. To clean up, just leave to dry for a half hour, and you will find that the excess can be easily picked out with a toothpick or dentistry tool.

12 Leave to dry slowly—away from heat or cold —for a couple of days. Grout, dry and polish up with a cloth.

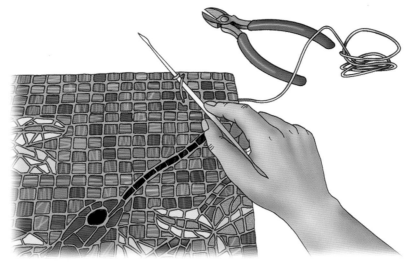

13 To hang with wire, push a length of wire through the hole from the back, wrap around a nail or dentistry tool handle five times to create a ball of wire big enough to block the hole and sufficient to take the weight for hanging. Leave a length of wire long enough to hang and make another ball of wire. Push the cut end through from the other hole, at the back of the tile, and form the second ball of wire. Hang in position.

TEMPLATE

10 × 10½ inches (25 × 27 cm)

Template is 200%

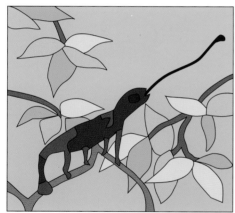

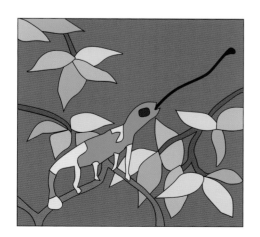

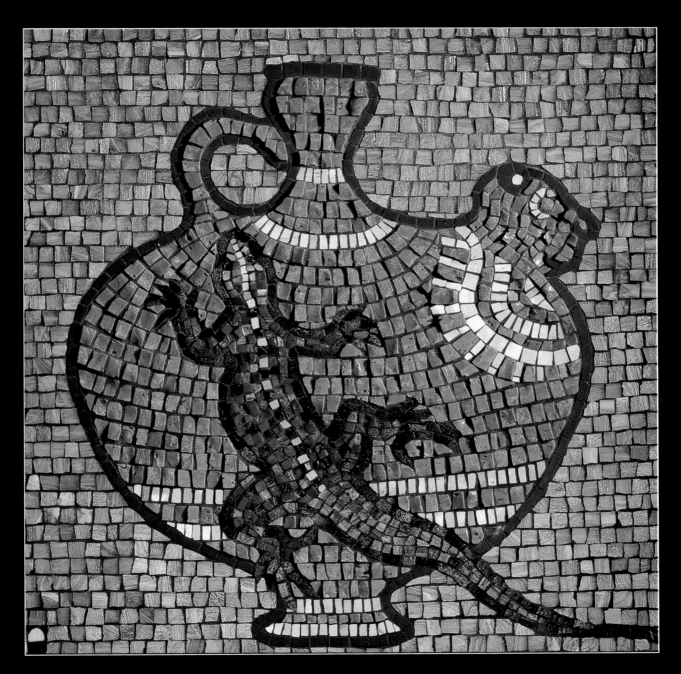

An early work by Elaine M. Goodwin
Lizard with chatti (Indian water vessel)
17¾ × 17¾ in / 45 × 45 cm
gold, smalti and ceramic

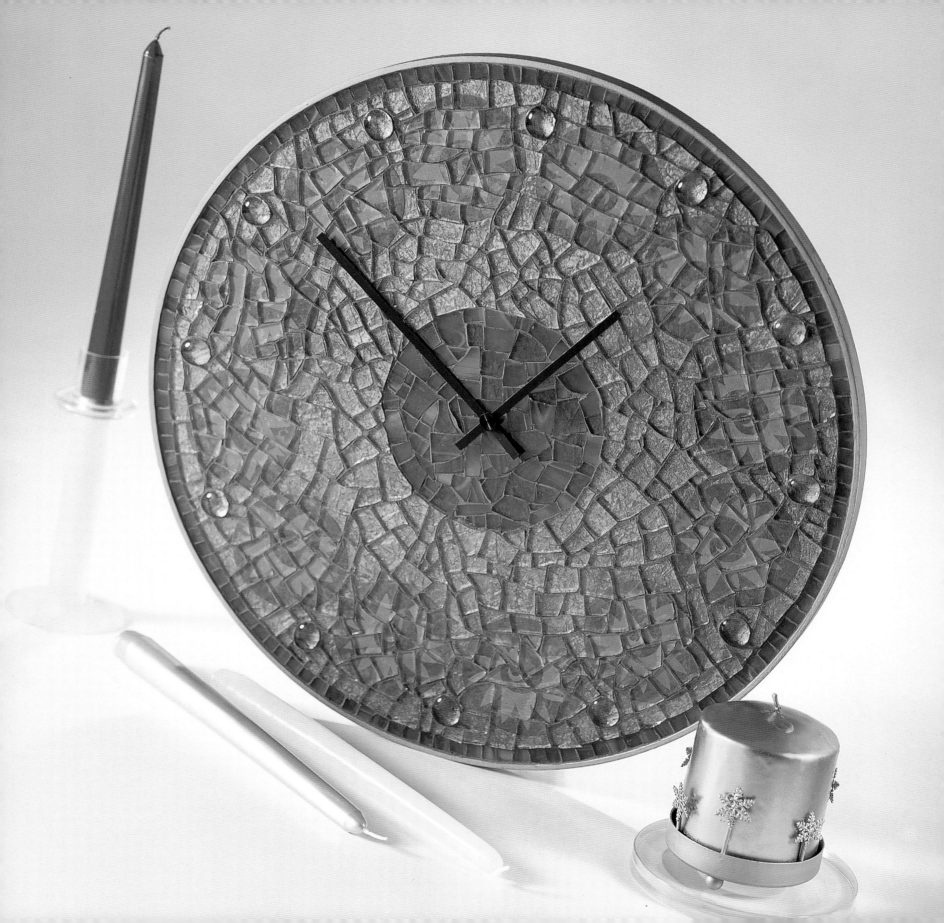

MATERIALS

Wooden disk, about ⅛–³⁄₁₆ in (3–5 mm) thick with a hole drilled through the center wide enough to take the clock mechanism. The disk can be framed if desired

Colored paper—giftwrap or handmade paper with motifs

Nonwater-soluble craft glue

Clock mechanism with hands

Spray glue

Clear and colored glass

Glass gems

Grout

Paint

EQUIPMENT

Protective goggles, mask and gloves

Glass cutters

Rubber cutting mat

Scissors

Tile nippers

Compass

Protractor

Pencil

Ruler

Eraser

Small plastic glue spreader

Rubber gloves

Flexible rubber spatula, potters' kidney or grouting squeegee

Newspaper

Small paintbrush

Glass clock

✳ COST　　✳✳ TIME　　✳✳ DIFFICULTY

CREATED BY SARAH KELLY

Using clear glass in a mosaic enables other elements to be seen through it. This unusual clock is created using a combination of clear and colored glass over a paper pattern. Gold-colored paper is first glued to the base, followed by motifs cut from wrapping paper, which act as the 12 numerals of the clock.

Obviously, it is extremely important that the combined thicknesses of the paper and glass do not obstruct the movement of the clock's hands, so check this at every stage before sticking anything down.

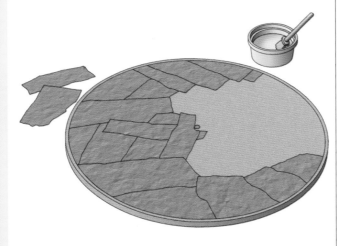

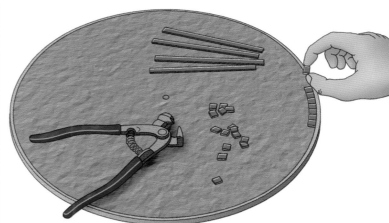

1 Cover the base with colored paper. This can be done with a collage of torn pieces or one whole piece, using the base as a template. Stick it down with craft glue, leaving the hole in the center uncovered. You can use paint instead of paper if you prefer.

2 Use the glass cutters to cut strips of colored glass about ¼–⅜₀ in (7–10 mm) wide. Use the tile nippers to cut these into squares, and stick them around the outside of the clock base to form a border, buttering each tessera with craft glue.

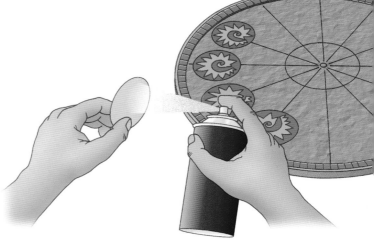

3 Use a compass or protractor to draw a circle in the middle of the clock. Use the protractor to divide the circle into 12 equal sections of 30 degrees, and mark each one with a pencil. Using a ruler, connect each mark with the mark opposite, and extend these lines to the outer edge of the base. These lines will act as a guide for the "numbers" on the clock. Use a very soft pencil and press very lightly, as these lines need to be erased.

4 Use a compass or circular template (a clear glass jar or glass is perfect, as it lets you check the positioning of the circle on the paper) to draw 12 circular motifs on your chosen paper with a pencil (the size of these will depend on the size of your clock base). Cut them out carefully.

5 Spray the back of the circles with the spray glue, and stick them onto the clock base, using the lines you have drawn as a guide (these should line up with the center of each circle). The spray glue allows for repositioning if you make a mistake. Erase the pencil lines when you are happy with the layout (leave the central circle).

TIP

Any number of ideas can be used to create the 12 sections or numbers on the clock. Postcards and photographs (featuring faces, family portraits or signs of the zodiac, for example), collaged numbers, hand-drawn numbers—all of these can be cut into circles and used instead of the patterns shown here.

6 Break the colored glass into small random pieces with the tile nippers, and use these to fill the central circle around the hole in a crazy-paving style.

7 Use glass gems to fill in the spaces between the "number" circles if desired. If your background is dark, you can back these with silver leaf first (allow 24 hours to dry).

8 Break the clear glass into random pieces with the tile nippers, and use these to mosaic the rest of the base. Apply a thin even layer of craft glue to the back of each piece and press firmly into place to ensure that the glue is evenly distributed and that there are no little air pockets under the glass. The tiles should fit together as snugly as possible.

9 Leave to dry for 24 hours before grouting (making sure that the glue has dried completely clear through the glass). Choose a grout that complements the color of the background. The grout should be quite thick, and after it has been applied, it should be cleaned off with newspaper to avoid moisture getting beneath the glass. Paint the edges (or frame) of the base with acrylic or latex paint and attach the mechanism and hands to the clock.

TEMPLATE

Diameter: 16¼ inches (41.5 cm)

Enlarge template by 300%

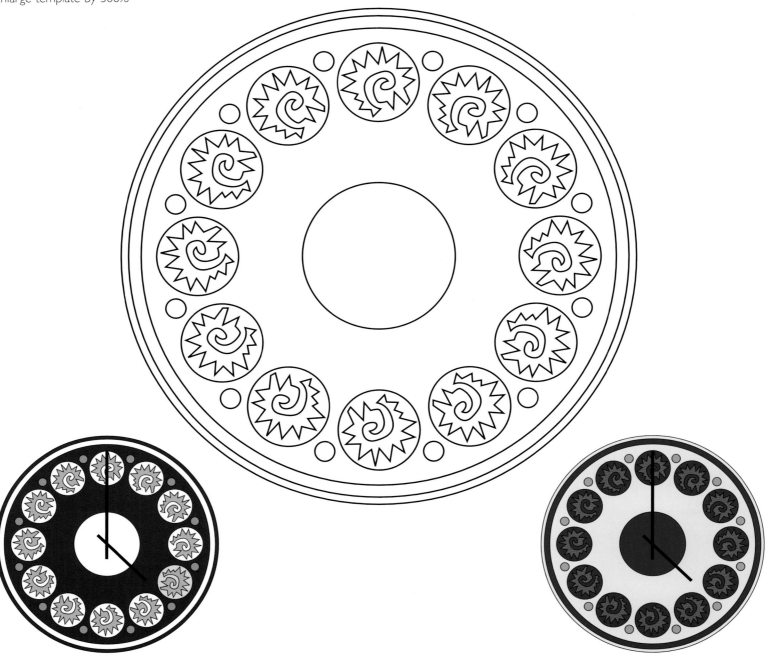

Libor Havlicek
The Sundial
1999
32 × 32 in / 80 × 80 cm
vitreous glass

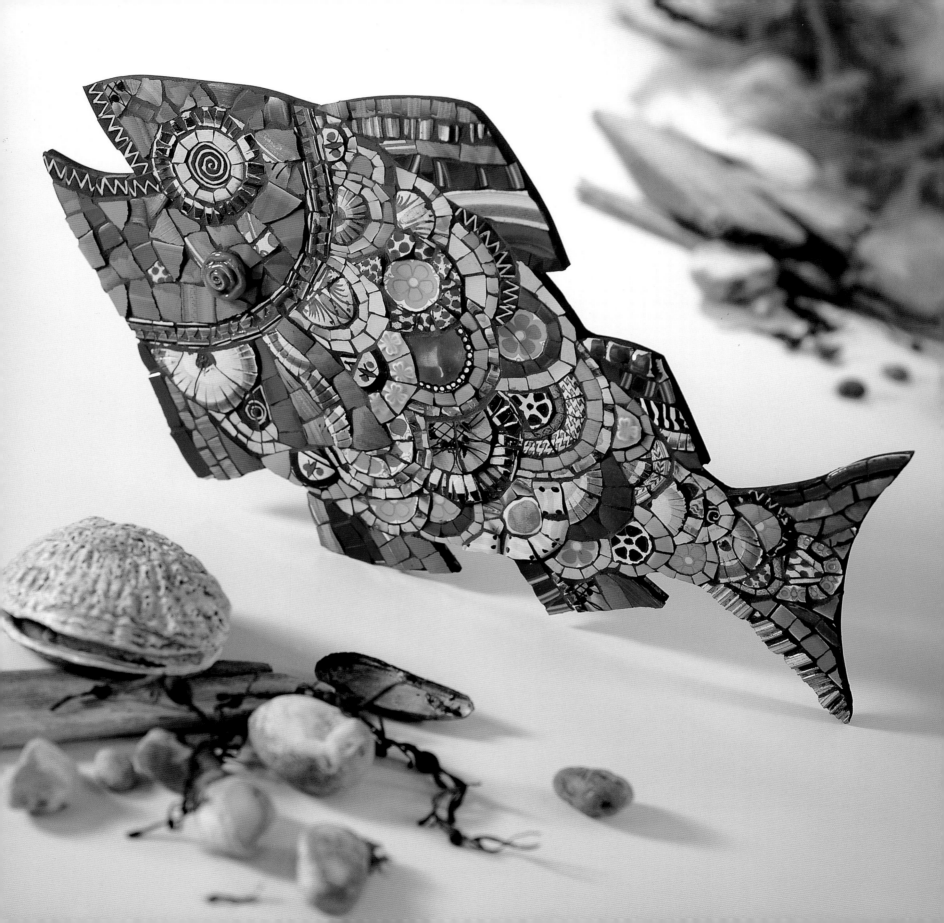

Pique assiette fish

✳ COST ✳ ✳ TIME ✳ ✳ DIFFICULTY

CREATED BY SARAH KELLY

A fish is such an easily recognizable shape that it is possible to take great liberties when decorating it!

This fish's scales are created from tiny motifs and patterns cut from old crockery, and these dictate the

design rather than any attempt at realism.

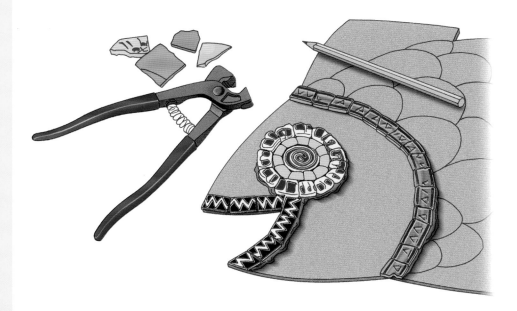

1 Seal and score the fish with a 50:50 mix of craft glue and water, and trace or draw on the markings. Select a good centerpiece for the eye from your collection of broken crockery, china and ceramic, and nibble it into a circle with the tile nippers. Stick the eye in place with the cement-based adhesive. Surround this with rings of small pieces that have been trimmed to fit around the circle. This fish has teeth featuring a zigzag design from a broken plate. Add a band of pieces to separate the head from the body. To raise thinner tiles to the same level as the rest, butter the back of them with cement-based adhesive before sticking.

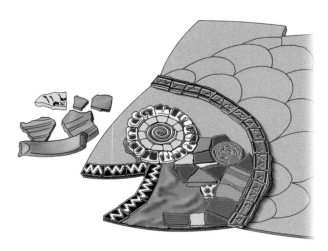

2 Using a mixture of randomly cut pieces in similar colors, fill in the fish's head using a crazy-paving technique. Include any quirky objects or motifs you have, such as this pottery rose, for the cheek.

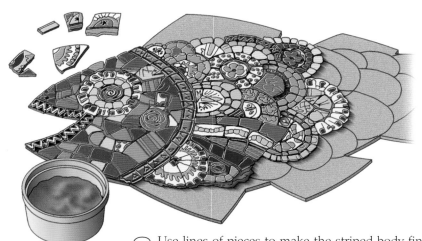

3 Use lines of pieces to make the striped body fin before moving on to the scales. These are created using a motif or pattern cut to shape and laid at the thinnest part of the scale, which is then surrounded by colored rings of tiles. Start next to the head, and gradually work along the body to the tail. Choose colors that complement the ones you have used on the head, including the odd contrasting one to create a lively effect, and mix patterned and plain pieces.

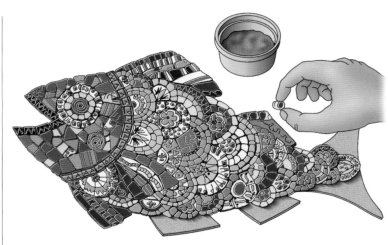

4 When the scales are complete, fill in the remaining fins and tail using stripes in colors similar to those on the head. Vary the methods you use to make each individual stripe—some could be made up of an entire piece of ceramic; others created from smaller tiles.

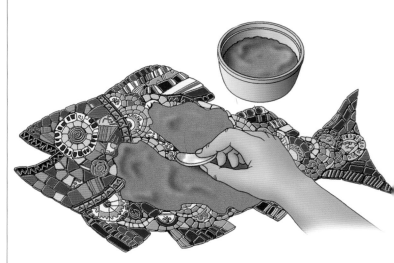

5 Leave to dry for 24 hours and grout using a dark, rich-colored grout. Clean and polish with a soft cloth. Paint the edges with acrylic or latex paint to match the grout.

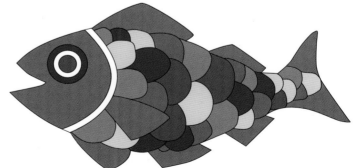

TEMPLATE

Length: 21 inches (53 cm)

Enlarge template by 300%

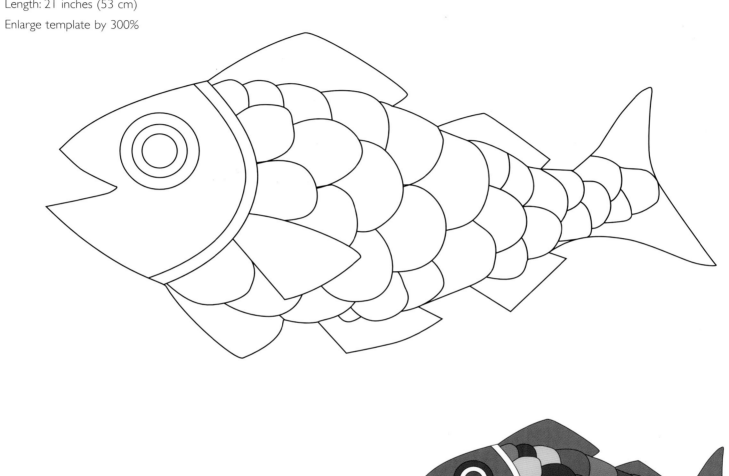

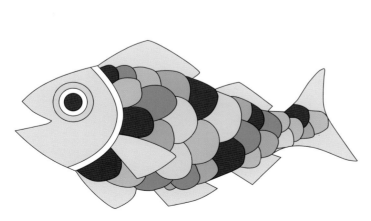

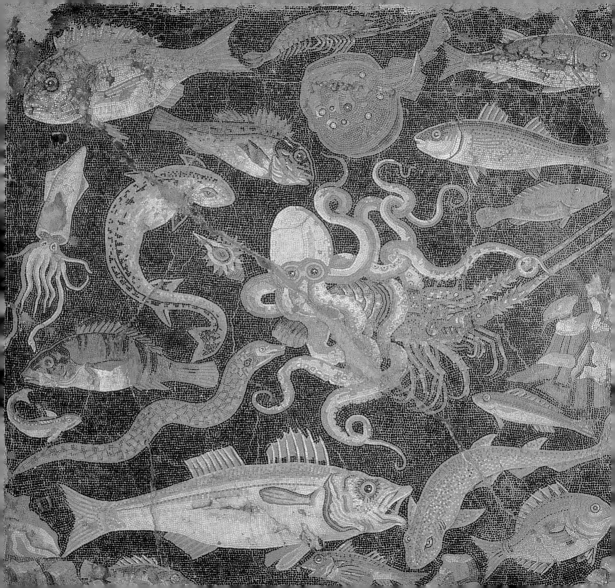

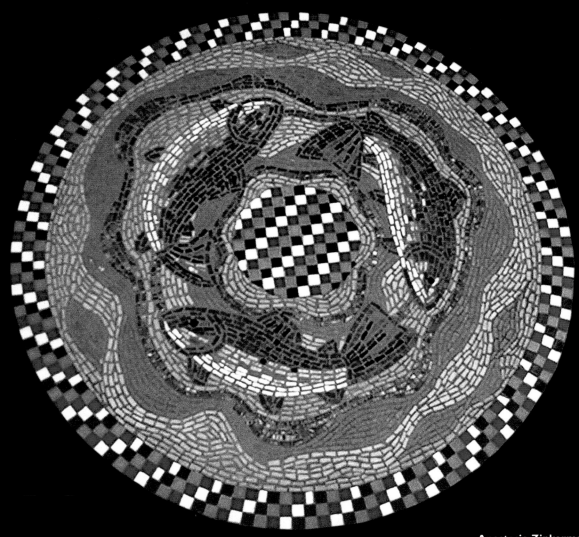

Anastasia Zinkerman
Brown Trout table
Diameter: 46 in / 117 cm
vitreous glass

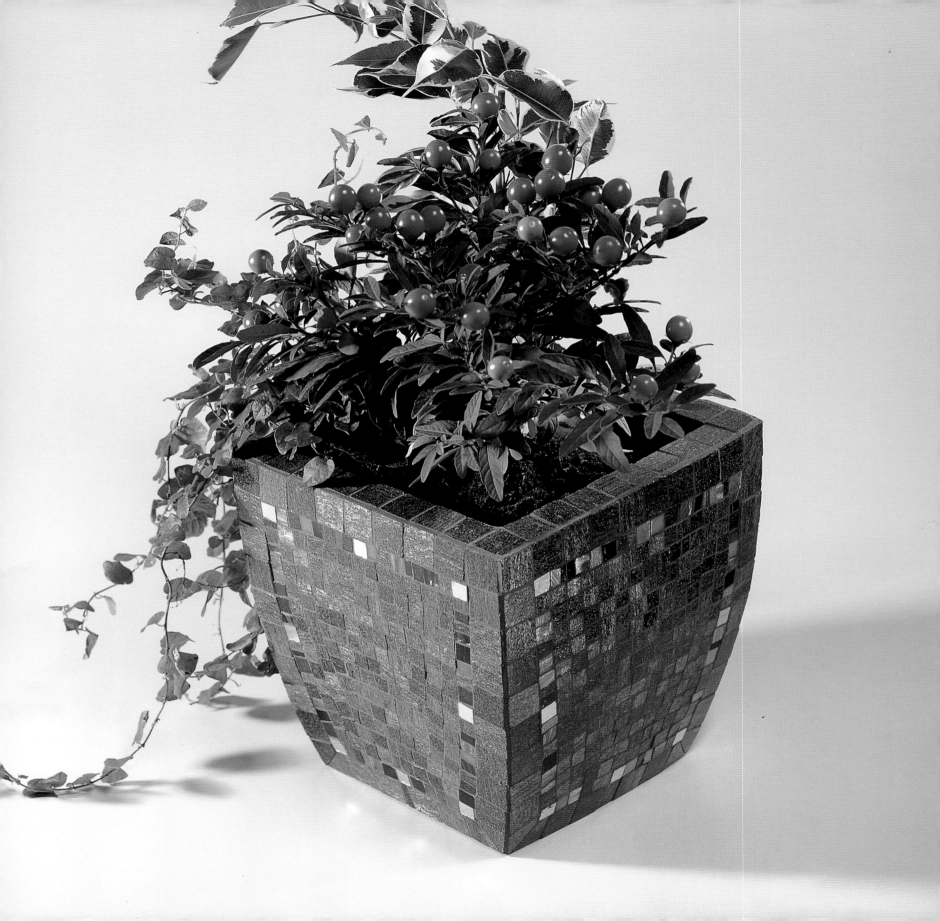

Outdoor container

** COST ** TIME ** DIFFICULTY

CREATED BY ROSALIND WATES

This container has a beautiful, simple form, which provides an ideal base structure for mosaic work. The simplicity of the mosaic design reflects and emphasizes this structure. The background of dark greenish black tiles provides a neutral setting for the glittering, jewel-like colors inset. Each side has a different color scheme, although they all contain some gold leaf and black tiles. One side focuses on blues and greens, one on deep reds and bronzes, one on pale pinks and whites, and the fourth on deeper mauves and purples. However, you could use the same colors on all sides. This container can happily go outside or inside.

2 Mix a small quantity of gray exterior-grade tile adhesive with water to form a thick mud-like consistency—not too dry, not too runny; experience and experimentation will help in gauging this. Lay the container on its side on a "nest" of rags to protect it. Spread one side of the container with the adhesive using the fine-notch adhesive spreader. Spread some adhesive along the corresponding borders of adjacent planes.

1 Seal the base of the entire container with a 50:50 mix of white craft glue and water, inside and out, including the base. Leave until dry.

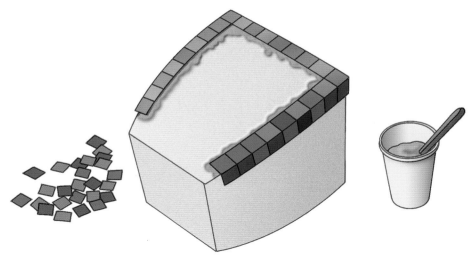

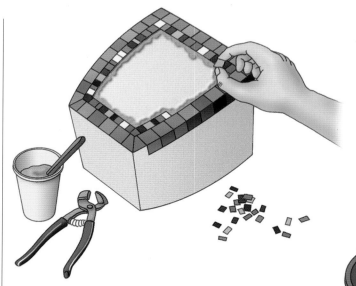

3 Place whole ¾ × ¾ in (20 × 20 mm) background tiles around the perimeter to form a border, pressing them gently into the adhesive. You can "shuffle" the tiles to make them fit evenly, or trim one or two with the tile nippers, or do a bit of both. The ideal gap between the tiles is ⅟₃₂ to ⅟₁₆ inch (0.5 to 1 mm).

4 In order to meet up neatly with the border tiles of adjacent sides, the tiles will have to overhang the corners. Set the corresponding border tiles at the same time, in order to get the beveled corners to meet evenly.

5 For the inset decorative line, cut the colored and bronze-streaked tiles into a selection of quarters, sixths and eighths; likewise, cut a few of the background color. Put one gold tessera into each corner and one halfway along each line. The other colored tiles are mixed up and distributed fairly evenly to fill in the decorative line.

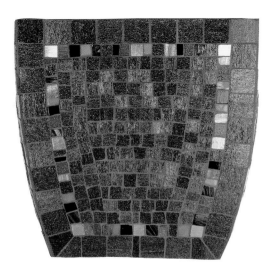

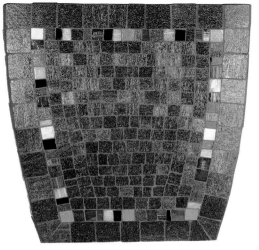

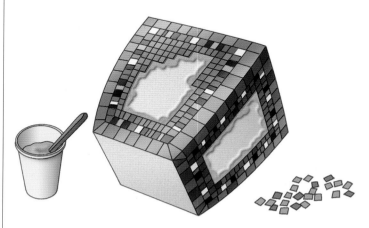

6 The central area is covered with quartered background tiles: first, lay two lines following around the perimeter; second, create horizontal lines straight across.

7 If the adhesive starts to dry out on the surface, scrape it off and apply fresh adhesive using the spatula or mini trowel. Let each side dry thoroughly before turning the container around and completing the next side.

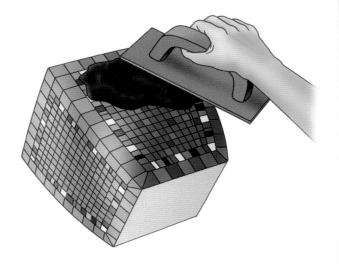

8 To grout the container, use a dark gray grout. The grout used here was officially called "black," but it dried to a perfect charcoal gray. You can try mixing black and gray grout to obtain the ideal shade if you want, but each test sample should be allowed to dry as the shade lightens as it dries. Use the rubber trowel to grout the mosaic. Clean and wipe the surface in the usual way.

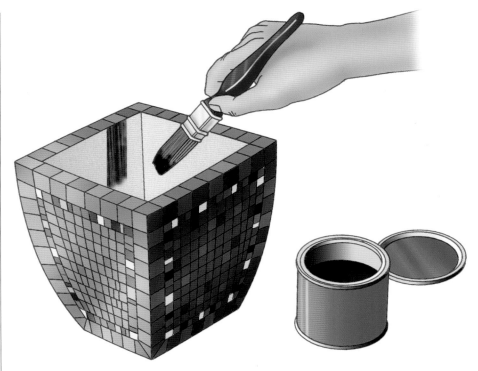

9 Paint the interior of the container with the black mat acrylic paint to finish it.

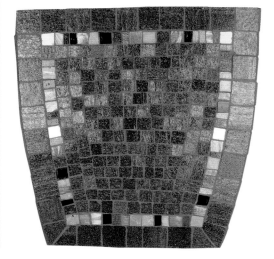
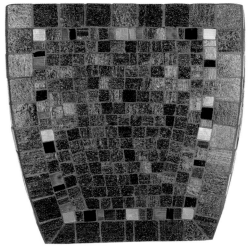

TEMPLATE

8 × 7½ inches (20 × 19 cm)

Enlarge template by 150%

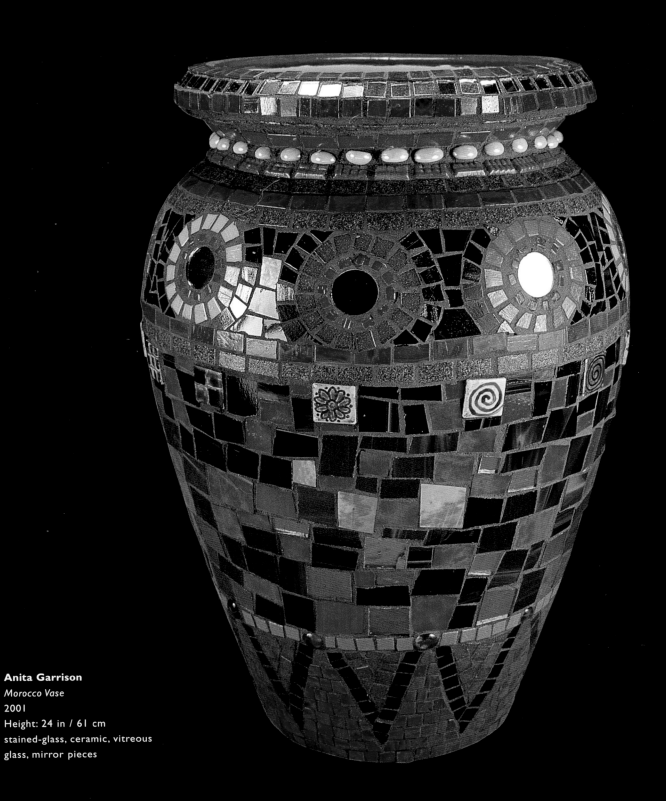

Anita Garrison
Morocco Vase
2001
Height: 24 in / 61 cm
stained-glass, ceramic, vitreous
glass, mirror pieces

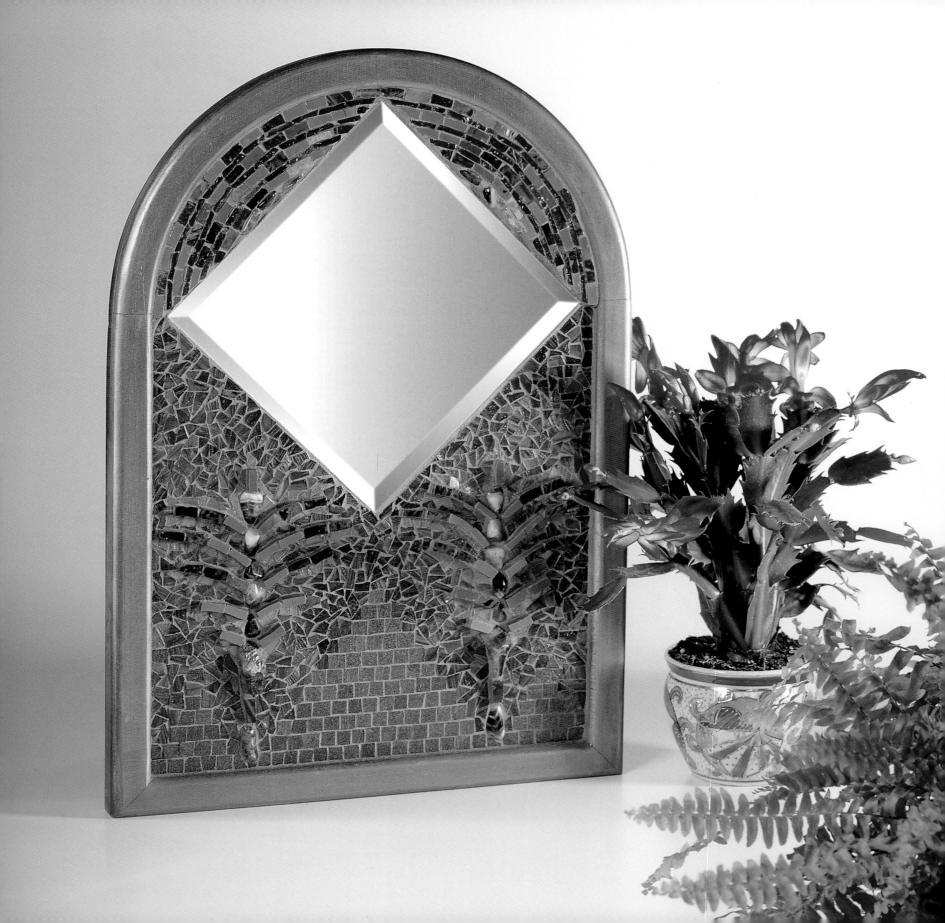

Amethyst mirror

MATERIALS

MDF baseboard with MDF frame
19½ × 13¼ in (50 × 34 cm)

Beveled mirror 7¾ in (20 cm)
square

Amethyst:
2 unpolished pieces
16 polished pieces

Vitreous glass tiles:
50 copper with gold veins—
randomly cut
40 plain purple—cut in
quarters
60 light purple with gold
veins—randomly cut
60 dark purple with gold
veins—randomly cut

150 cubes of smalti in three
shades of purple

White craft glue (see page 54)

Masking tape

Cement-based adhesive, gray

Cement-based grout, gray

Flexible additive

Finishing wax/gilt cream

EQUIPMENT

Protective goggles, mask
and gloves

Tile nippers

Tweezers

Trowel

Sponge

Pot for mixing grout

Soft cloth for polishing

*** COST ** TIME ** DIFFICULTY

CREATED BY ANNE READ

Semi-precious stones are wonderful to work with; they have a design and beauty of their own. There is a happy alliance when stones are mixed with glass. The smalti glass used is ready-cut into cubes, in subtle shades. When the amethyst is polished, it shows up all the layers of color within the stone. To give the mosaic a softer finish, apply beeswax to the mosaic and polish off well. Let the two areas of unpolished amethyst start the design process.

When working on wood or MDF, always seal the surface with a 50:50 dilution of craft glue and water. This ensures a dust-free surface for the grout to adhere to. Leave to dry. Draw around where the mirror is to be positioned.

1 Lay out the stones—trying different patterns and colors until you are happy. Start with three fanned-out motifs, for instance, finally reducing to two. Let the stones make the design.

2 Mark with pencil on the board the positioning of the bottom and top of the motifs so that the two are as symmetrical as possible.

253

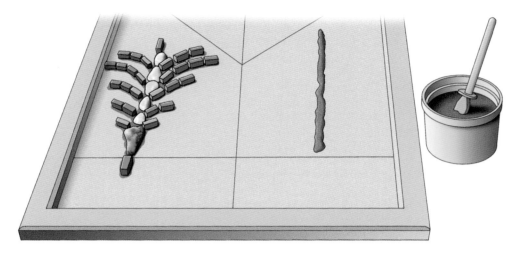

3 Affix the amethyst and smalti to the board with craft glue. Use tweezers to get the pieces at the correct angle to achieve the desired effect for the first motif. Repeat for the second motif.

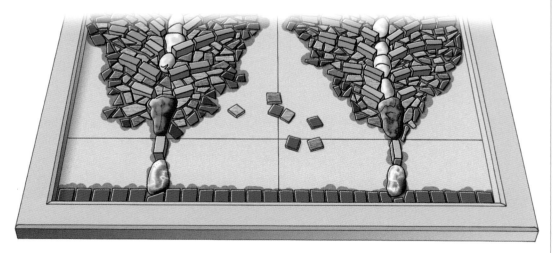

4 Infill the underside of each "branch" of the motif with a row of random copper gold-veined glass. Next, create a row of random light purple gold-veined, then a row of random dark purple gold-veined.

5 Cut the plain purple vitreous into quarters, and affix the bottom row, cutting round the motifs where necessary. Continue until you get to the "southern" point of the mirror position. Ensure you leave a ½-inch (2 mm) gap for grout between the mirror and mosaic.

6 Fill in above the motifs in various light purple gold-veined tiles, randomly.

7 From the eastern to western point of the mirror position, affix a line of smalti around the top arch, alternating the colours. Next affix a line of smalti from east to north to west – along the edge of the mirror position. Remember to leave ½-in (2 mm) gap for grout, as above.

8 The next row around the arch is the copper gold-veined vitreous glass cut in halves with the cut side up, since it reflects the most light. Where the row meets the mirror, cut the first and last piece of tiles with an angle so that it will fit neatly when the mirror is placed.

9 The next row is smalti. Once again, cut the first and last piece with an angle to fit neatly. Continue until you can only fit in three small pieces of polished amethyst. You may need to hold these upright until the glue takes. Prop them with a larger stone temporarily.

10 Put two pieces of masking tape on the mirror, and lower it gently into its place to make sure it fits. Take the mirror out using the tape to pull it up, and set aside. Remove the tape.

11 Squeeze lines of mirror adhesive onto the board, lay the mirror in position, and push in place firmly. Protect the mirror by affixing wide masking tape to the glass. Leave to dry for 24 hours.

12 Remember, when working with wood, flexible additive should be used with the water when mixing the grout. The surfaces are uneven, so to apply the grout, use a paintbrush to push it into all the gaps. The grout should be of a thick consistency that does not easily fall off a spoon when lifted. Wipe off as usual, using dentistry tools to get into all the nooks and crannies.

13 When using smalti and semi-precious stones, whether to use grout is a personal decision. If you are not going to grout, place the pieces close together.

14 Apply the grout, if desired, with a small paintbrush to push it into all the nooks and crannies. Wipe the frame clean of grout.

15 Leave to dry for 24 hours. Remove the tape and clean the mirror. Polish the frame with a tinted wax polish. Highlight the edges with a gilt cream. You could also paint the frame, if desired.

TEMPLATE

14 × 20 inches (35.5 × 51 cm)

Enlarge template by 300%

Sonia King
True Blue (2002)
10 × 12 in / 25.4 × 30.5 cm
paua shell, ceramic, glass

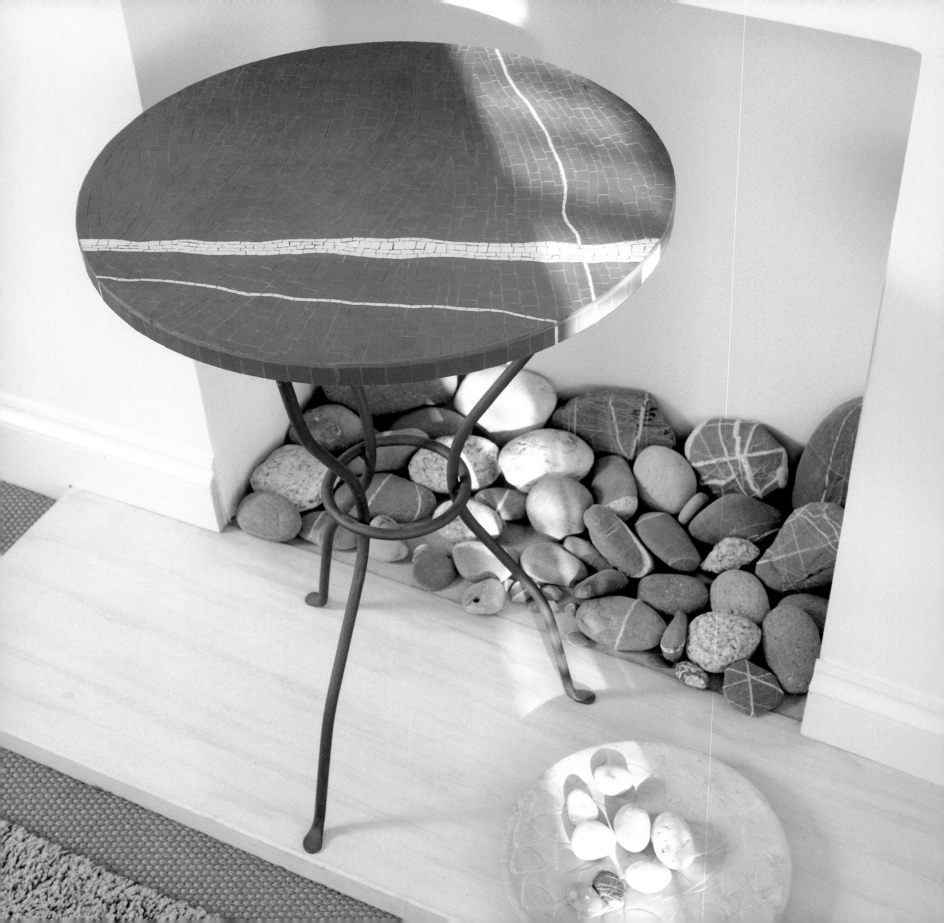

Slate-effect lamp table

✳✳ COST　　✳✳ TIME　　✳✳✳ DIFFICULTY

CREATED BY JULIET DOCHERTY

The inspiration for this mosaic came from rock formations on the Cornish coast in England, where there are large numbers of granite rocks and pebbles that are shot through with stripes of white quartz. Porcelain tesserae, which have a natural mat texture, are used in this project. The palette is restricted to two neutral colors. Because the color palette is so simple, the eye is drawn to the texture and pattern of the mosaic, which is by contrast very complex due to the intricate cutting and flowing movement of the mosaic. Grouting the mosaic in a color very similar to the gray tesserae gives the surface a slate-like quality. This style of mosaic works particularly well with contemporary interiors.

MATERIALS

⁷⁄₁₀-in-thick (18 mm) medium-density fiberboard (MDF), cut into a 20½-in-diameter (52 cm) circle

Vitrified porcelain tesserae in dark gray and white

Resin-based wood glue

Powdered gray grout

EQUIPMENT

Jigsaw

Tile nippers

Protective goggles, mask and gloves

Rubber gloves

Bowl and spatula for mixing grout

Flexible grout spreader

Utility-knife blade

Soft cloth for polishing

Nylon pan scrubber

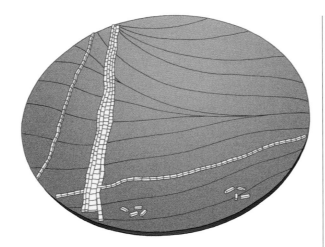

2 Use a felt-tip pen to mark the areas on the MDF circle that are going to be tiled white.

3 Mosaic the white areas with very finely cut pieces of the porcelain tesserae. To make long thin pieces, cut a tile in half, then use the tile nippers to nibble away at the edge until it is thin. Attach the pieces with resin-based wood glue.

TIP

Before you begin, practice cutting the porcelain tesserae. They are considerably tougher than glass tesserae, because they have been high-fired.

1 Use a jigsaw to cut a circle, about 20 in (50 cm) in diameter, out of ⁷⁄₁₀-inch-thick (18 mm) MDF.

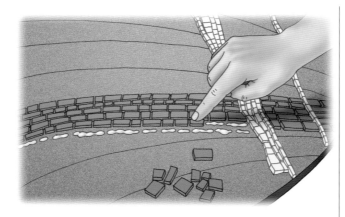

4 Mosaic the remaining surface with the gray porcelain tesserae. Work one line at a time across the surface, varying the sizes of the pieces.

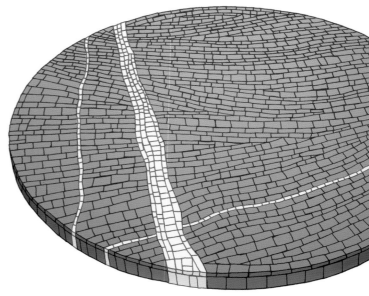

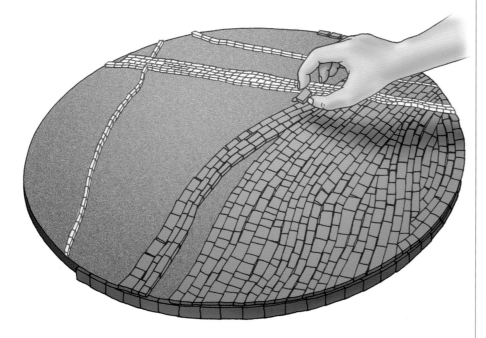

5 Use changes of direction to add movement to the surface. Overlap the edge of the MDF by about ⅟₁₆ inch (2 mm).

6 Mosaic the edge of the MDF. Because you are gluing onto a vertical surface, dab plenty of glue along the MDF edge, then use your finger to smooth it out. Wait until the glue becomes tacky before applying a dab of glue to a tesserae and sticking it onto the edge. Speed up this process by using a hair dryer to set the glue slightly. Make sure that the tesserae are flush with the bottom surface of the MDF to give a smooth edge; they shouldn't require cutting. Allow several hours for the glue to dry before grouting.

TIP

Before you grout the surface, clean it thoroughly with a damp sponge in order to remove any residue of glue.

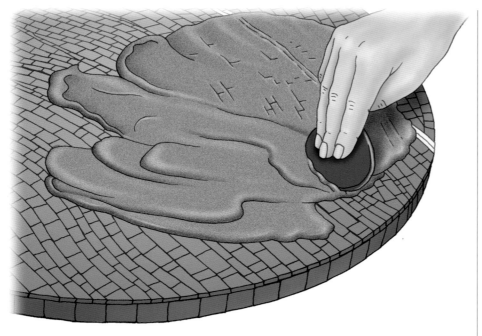

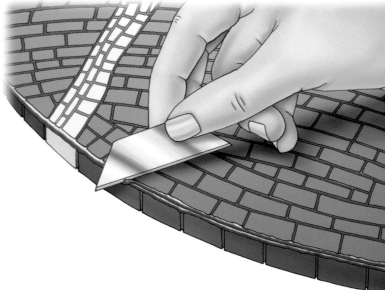

7 Mix the powdered grout to a stiff consistency following the manufacturer's directions. Using a flexible grout spreader, apply the grout to the top surface, and work into the surface in all directions. Wipe off any excess grout with a damp cloth. When the top is complete, grout the edges. Put plenty of grout on, and carefully remove any excess from the edge with a utility-knife blade; this will give a neat and crisp finish.

8 Let the grout dry for several hours before cleaning off any excess grout with a scrubber and water. The edges can be sanded with a sanding block to give a neat edge.

9 Attach the completed tabletop to a wrought-iron base.

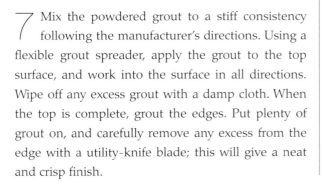

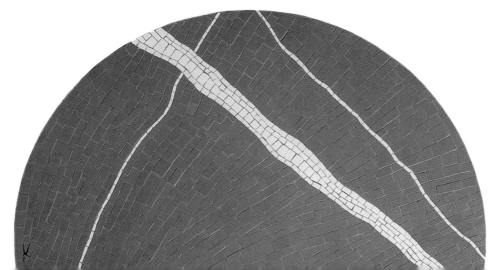

261

TEMPLATE

Diameter: 20 inches (52 cm)

Enlarge template by 300%

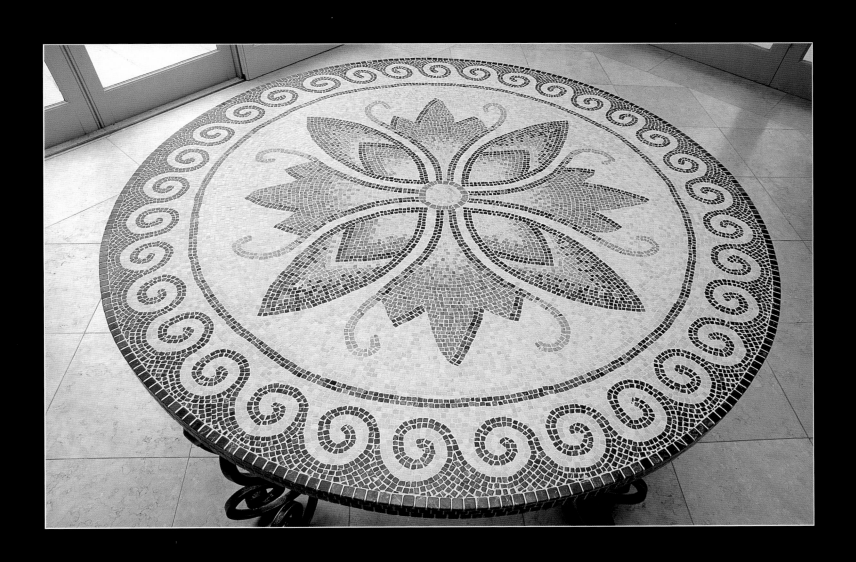

Gordan Mandich
Roman Flower table
2002
Diameter: 51¼ in / 130 cm
marble

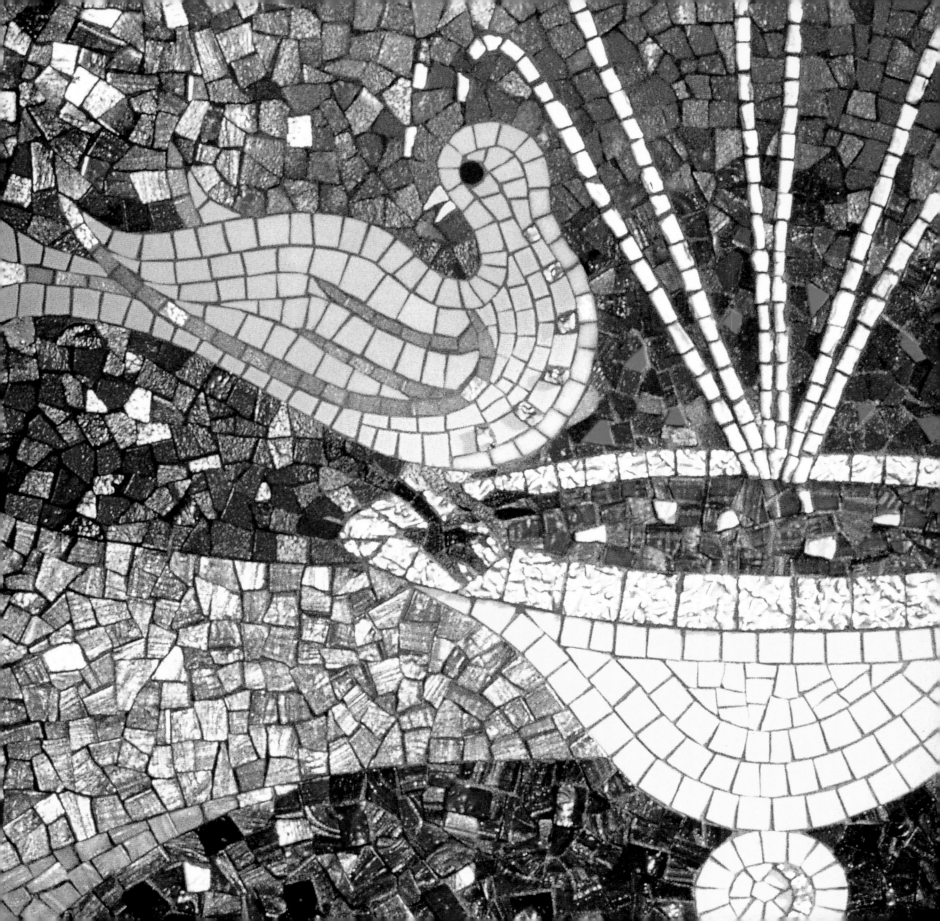

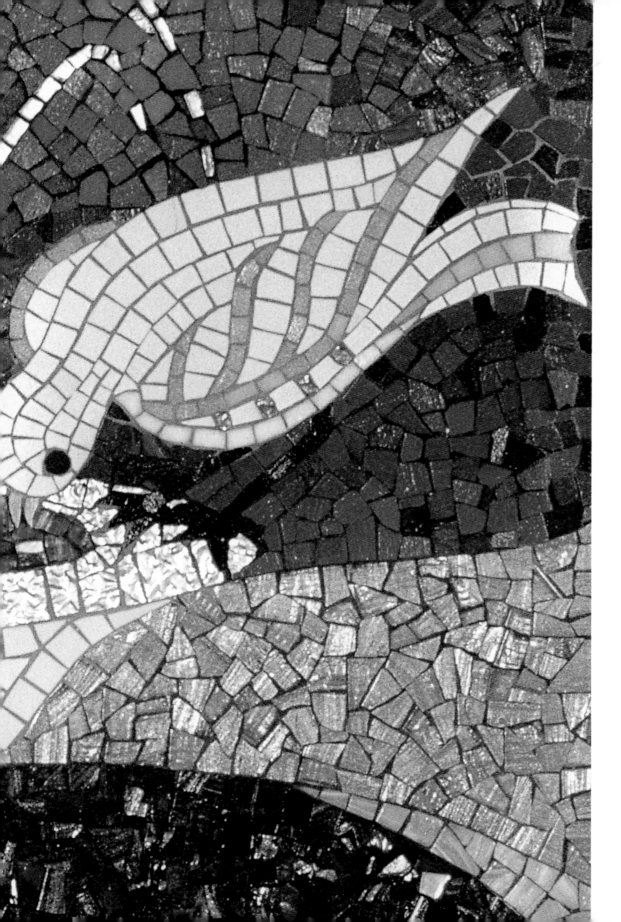

Advanced Projects

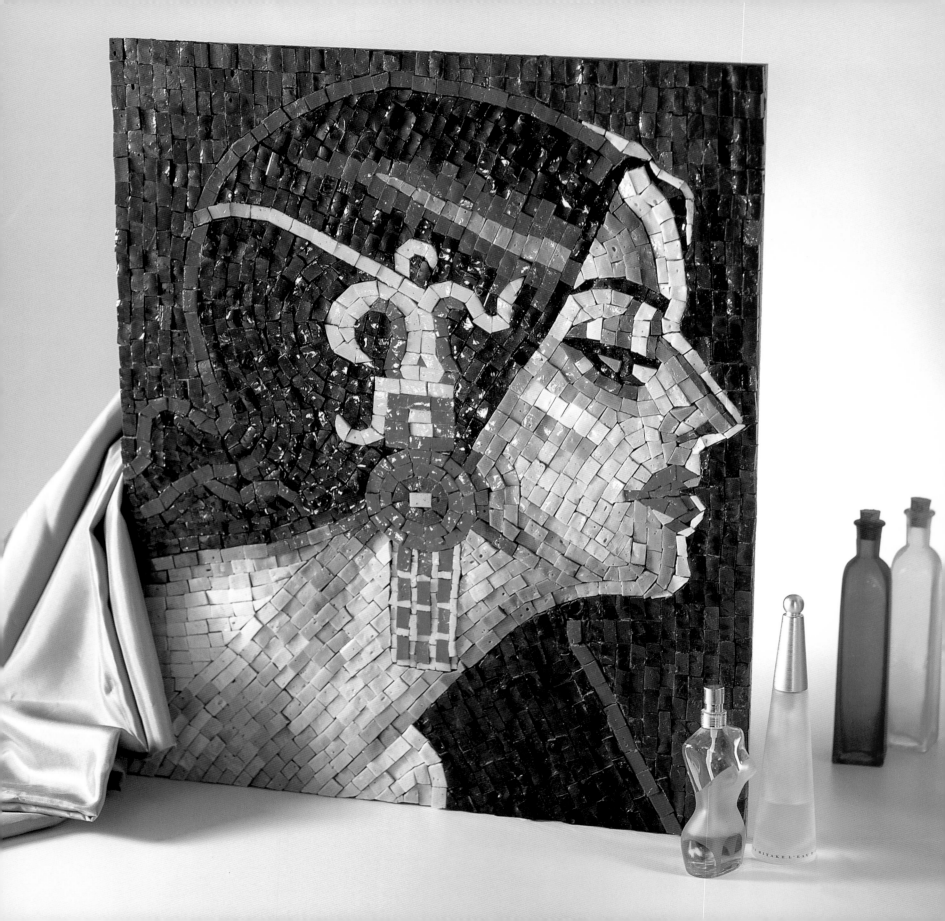

Smalti portrait

★★★★ COST ★★★ TIME ★★★ DIFFICULTY

CREATED BY SARAH KELLY

MATERIALS

Medium-density fiberboard (MDF),
⅜ in (9 mm) thick, 17 × 20½ in
(435 × 520 mm); framed
with strips of wood, if desired

White craft glue (see page 54)

Cement-based adhesive with
latex additive

1 lb (450 g) smalti in each of
red, yellow, three shades of
blue, various shades for the
skin tones

2 lbs (900 g) smalti in black

EQUIPMENT

Paintbrush

Utility or craft knife

Pencil

Long ruler

Tile nippers or hammer and
hardie

Spatula or small plastic glue
spreader

Smalti are the ideal choice for portraits because of the range of colors available, especially in flesh tones. Many of these colors come in gradual variations of tone, which makes it easy to create subtle shading. In this piece, these effects are combined with striking lighting and stylized elements.

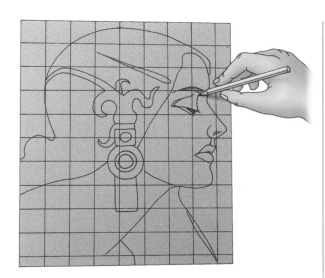

1 Seal the board with a 50:50 mix of craft glue and water. Transfer and enlarge the template of the portrait onto the board using the squaring-up method (see page 144). Score the surface with a knife.

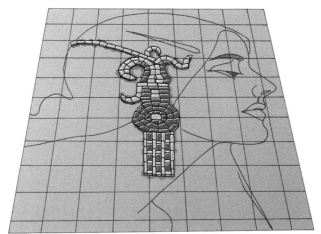

2 Begin the mosaic with the decorative headband. Apply a thin layer of cement-based adhesive to a small section of the base, and gradually fill in the shape. The mosaic remains ungrouted, so the smalti need to be placed very close together. Scrape away any excess adhesive immediately. When this section is completed, outline the hair with a line of smalti. Fill

in the top of the head with almost vertical lines of smalti traveling in the same direction as the section of hair that frames the face. Incorporate blue smalti to give a highlight to the hair. Cut the smalti to fit into the odd-shaped spaces at the edges of the headband.

4 Start the face by doing the eyes and the top section of the profile outline, then fill in the facial areas immediately around them. Continue down the face until all the main features have been filled in.

3 Fill in the rest of the hair by gradually building up lines of smalti on both sides. Cut them to fit into the spaces left in the middle to create a natural directional "flow" of hair. Leave the area under the chin until you have completed the face.

5 Lay the rest of the face using the smalti to suggest natural contours, but maintain a pleasing *andamento* (see page 132). Blend the flesh tones as subtly as you can. Don't be afraid to remove pieces and start again in order to get this to work—it can be tricky.

6 Mosaic the shoulder and the neck, following the outline. Gradually work up to the circle under the ear, then stop and follow the line under the hair, cutting the smalti at an angle when they intersect with the first section. Fill in the area of hair behind the shoulder, working from the outside inward. Finally, create the background from vertical lines of smalti in two similar shades of brown. You can frame the mosaic, or paint the edges with acrylic or latex paint.

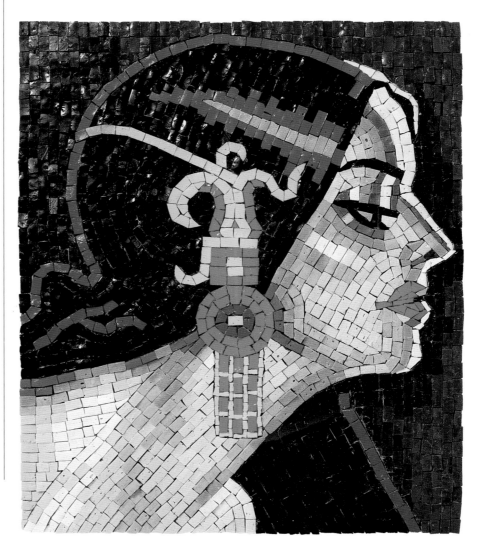

TEMPLATE

18 × 17 inches (46 × 43.5 cm)

Enlarge template by 300%

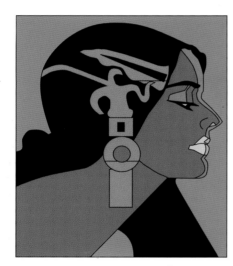

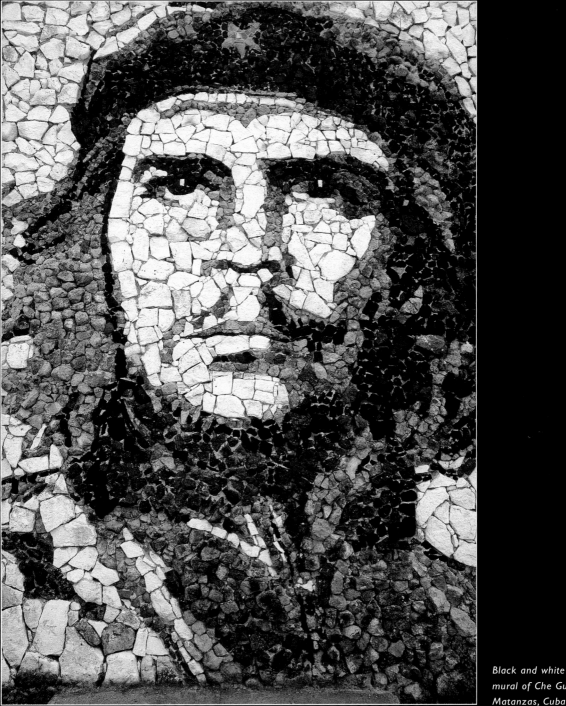

*Black and white
mural of Che Gu
Matanzas, Cuba*

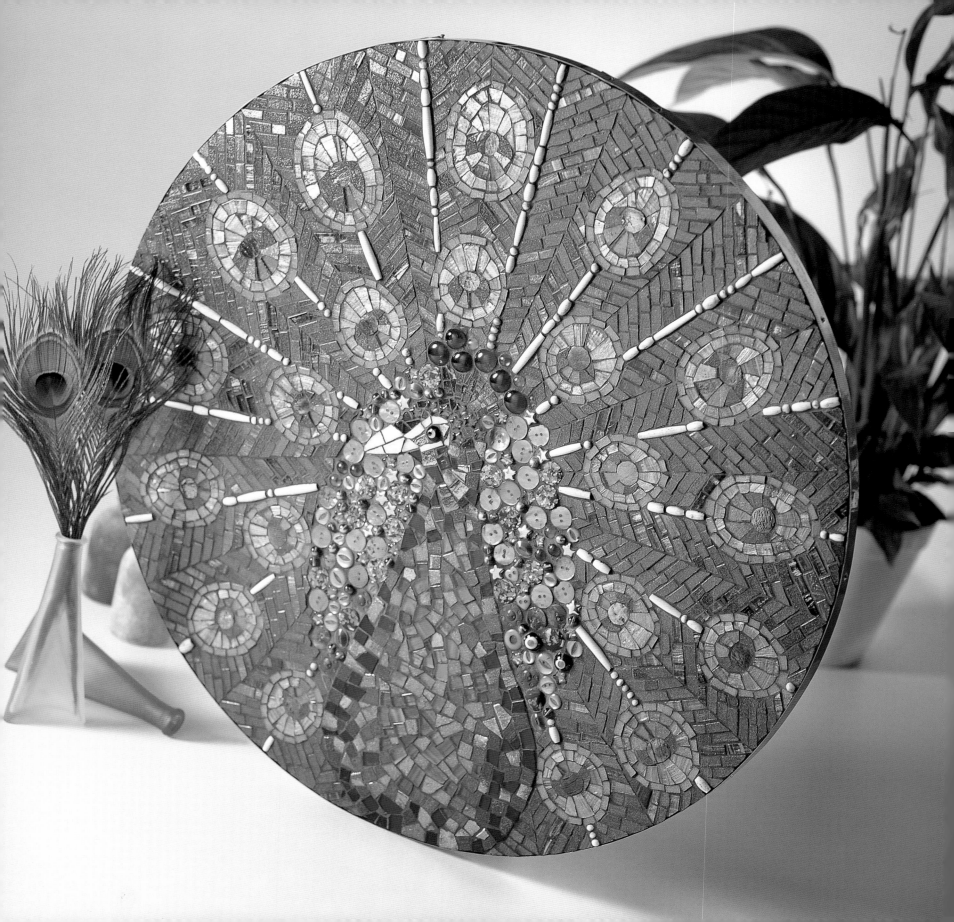

Mixed-media peacock

*** COST **** TIME *** DIFFICULTY

CREATED BY SARAH KELLY

MATERIALS

Disk of medium-density fiberboard (MDF), ½ in (12 mm) thick, 23½ in (600 mm) in diameter

Vitreous glass tiles

Colored glass pieces or tiles

Iridescent glass pieces or tiles

Selection of green buttons

Glass gems

Sheets of silver leaf

Assorted beads

Cement-based adhesive with a latex additive

White craft glue (see page 54)

Copper edging strip, ⅝ in (15 mm) wide, slightly longer than the circumference of the board

Brass pins

Cement-based grout, black or dark gray

EQUIPMENT

Large paintbrush

Large sheet of tracing paper

Pencil

Utility or craft knife

Small plastic spreader or spatula

Tile nippers

Glass cutter and running pliers

Tweezers

Utility-knife blade

Rubber gloves

Rubber spatula or potters' kidney

Bucket

Grout sponge

Cotton buds or old rags

Soft cloth for polishing

Hammer

Colored and vitreous glass, buttons and beads are combined to create this peacock mosaic, but you could add other materials, like glazed ceramic, if you have the appropriate colors. The mosaic could also be executed in vitreous glass alone, using the indirect method. The design, rather than formal laying techniques, takes precedence in this piece.

About 48 hours before starting work, prepare some colored glass and glass gems by sticking them onto silver leaf with a thin layer of craft glue. Cut the glass into smallish pieces—about 2¼ × 2¼ inches (60 × 60 mm) before sticking it onto the leaf, as this enables it to dry out more quickly.

1 Seal the wood with a 50:50 mix of craft glue and water, then enlarge and trace down the design. Score the surface with a knife.

2 Begin with the body of the peacock, starting with the head. Find a suitable eye (a bead, button or acrylic eye designed for stuffed toys), and glue it into place. Spread a small amount of adhesive onto the beak, and fill in using white vitreous glass. Extend these white lines up to and around the eye.

3 Apply additional adhesive to the head area, and push in a selection of dark blue and turquoise tiles, mixing media as desired and buttering the backs of any tiles that need raising. Work down the body in the same way, using shades of darker blue around

the outside, gradually shading to turquoise in the center to suggest light on the iridescent body of the peacock.

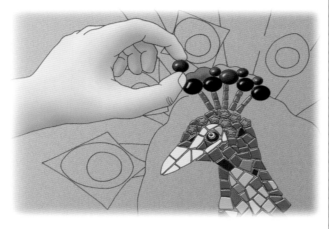

4 Create the peacock's crown with glass gems and lines of dark brown metallic-veined vitreous glass. Fill in the areas between the lines with similar tiles in green, trimmed to fit in the spaces.

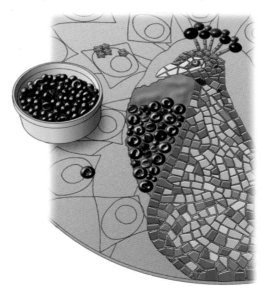

5 Use a selection of green buttons and beads to create the small feathers behind the peacock's body, buttering them if necessary. Use darker, less

shiny ones at the bottom. Buttons and beads with an iridescent or holographic finish look great interspersed with the plainer ones. As these tesserae aren't easily cut, it is advisable to have a good mixture of sizes.

6 The feathers of the tail are tricky. Depending on what you find easier, you can do like areas together, or work on sections. Begin with the oval-shaped feathers. It is best to butter each tessera individually. Start with a black circle nibbled from a tile or piece of glass. Surround these tiles with a mixture of blues, using darker shades in the corners and lighter shades in the center (the occasional piece of silver-backed glass gives a lovely shimmering effect). Cut each tessera to fit snugly around the curve. Tweezers may be useful for placing some of the smaller tiles. Surround this area with copper-colored vitreous glass, again cutting the tiles to fit around the curve of the circle. The smaller ovals can be filled in by one set of tiles, but the larger ones are surrounded by rings of tiles and then filled in with larger pieces. Finally, outline the feather with a ring of green vitreous tiles cut into eighths. Use a utility-knife blade to scrape away any excess adhesive from the base before it dries; otherwise, it will create an uneven surface for the next lot of tiles.

7 The quills are made from cream-colored tubular beads in different sizes to give the impression of the lines being crossed by parts of the feathers. If you can't find similar beads, use ceramic or vitreous glass tiles cut into different lengths. Lay them along every other line marked on the drawing, fitting them around the "eye" feathers and mixing up the lengths as you go. Use plenty of adhesive on all the beads to hold them firmly in place, as they tend to stand out from of the rest of the mosaic and can be quite vulnerable during grouting.

8 From a selection of dark greens and turquoises, cut the vitreous glass tiles into thirds (you can also use similarly sized pieces of ceramic or glass). If you are incorporating the tiles with metallic veins,

use glass or tile cutters to limit shattering and uneven cuts. Cut the end of the tiles at a 45-degree angle, and lay it against the line at the outer edge of the circle, starting from one of the lines not filled with beads. Work until you get to the next line, which also requires a similarly angled edge. Fill in the rest of the section in the same way, trimming the tiles where necessary. Cut some of the tiles to avoid leaving very tiny slivers at the ends, especially at the edges of the mosaic. When this section is filled, move on to the adjacent one, cutting the angles in the opposite direction. Continue like this around the tail section.

9 Leave the mosaic to dry for at least 24 hours, and grout with a dark gray or black grout, taking special care around the beads. Edge with the copper strip, secured with the brass pins hammered in at intervals. Hang using picture fasteners.

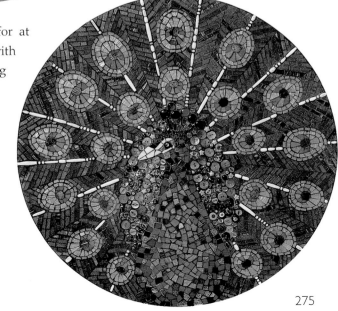

TEMPLATE

Diameter: 23½ inches (60 cm)

Enlarge template by 400%

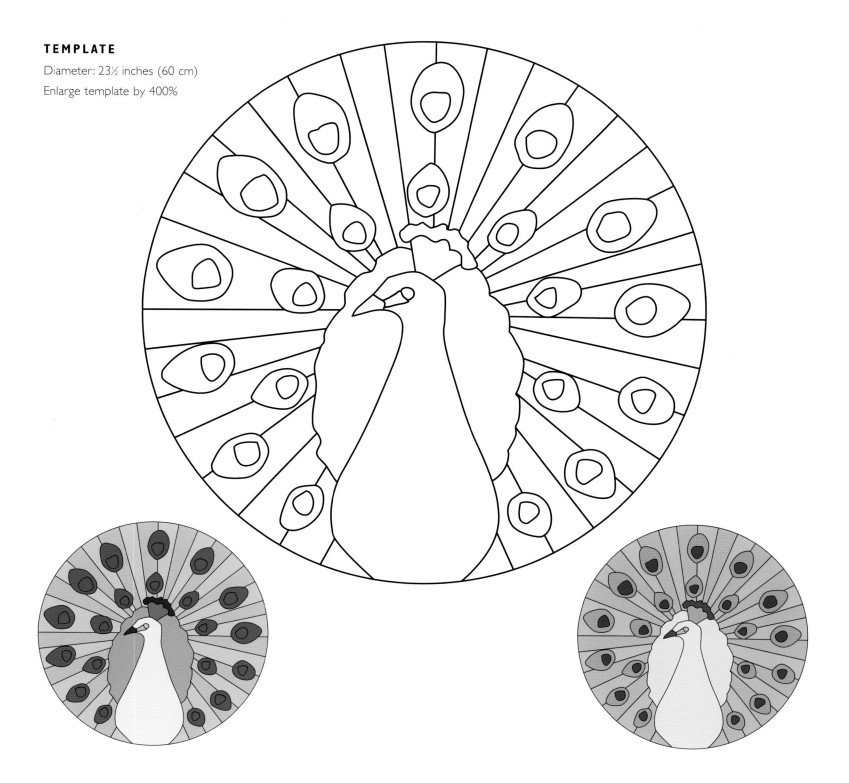

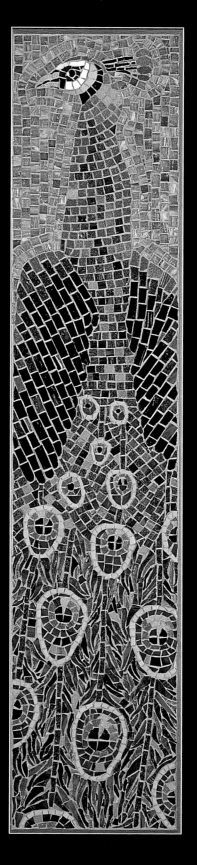

Irina Charny
Peacock
9 × 41 in / 23 × 104 cm
vitreous glass

The lovely colors and patterns found on peacocks make them instantly recognizable, even when in unusual compositions. Instead of showing the whole bird, the artist has chosen a vertical composition, which emphasizes the creature's elegance.

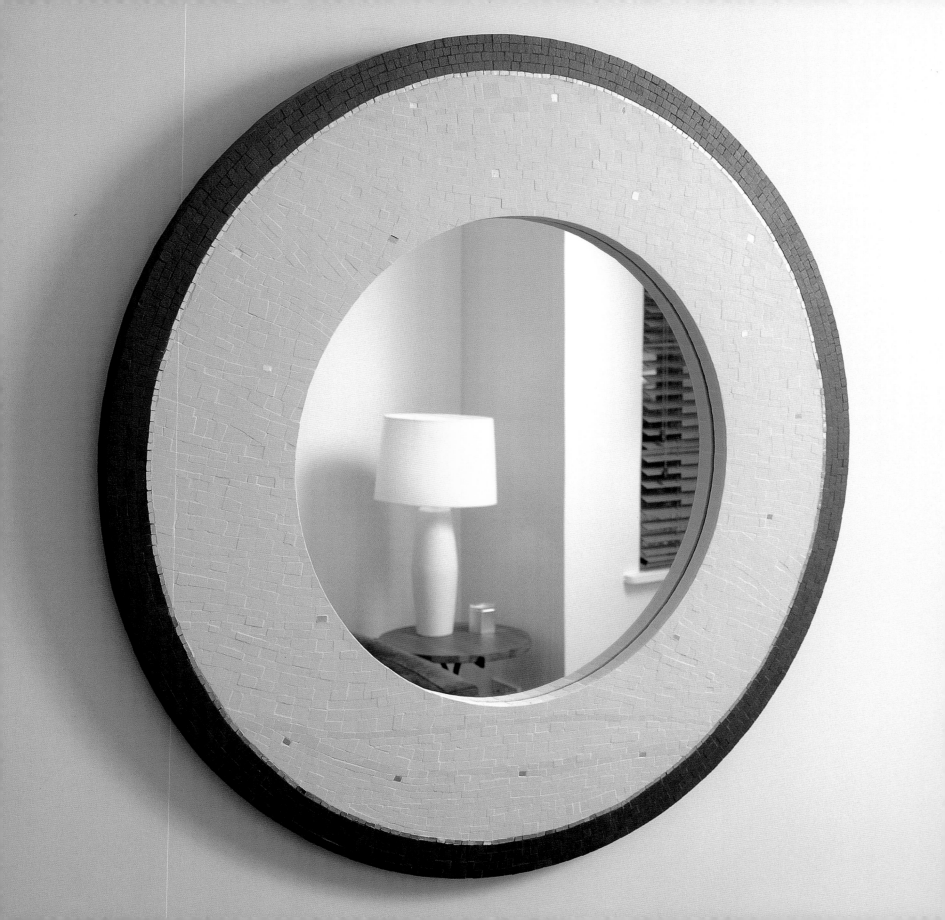

Large circular mirror

**** COST **** TIME *** DIFFICULTY

CREATED BY JULIET DOCHERTY

This project is suitable for a more experienced mosaicist. Most of the mirror frame is mosaiced with cream-colored mat porcelain tesserae that are positioned across the mirror in a horizontal direction, moving from thick to thin to create a sense of rhythm and movement. The outer area of the frame is mosaiced in tiny black porcelain tesserae, which contrast beautifully with the cream. Between the black and cream areas is a very fine ring of gold that is a perfect foil for the matness and simplicity of the porcelain. The black and gold area is grouted with black grout and the cream area with cream grout, which accentuates the texture of the mosaic surface. Having a rebated inner edge to the mirror finishes the piece off perfectly. To achieve this, cut a circle out of the center of the MDF, then rout a 3/16-inch (4 mm) rebate out of the inner circle so that the mirror glass can be fitted into the back of the frame. Alternatively, if you do not require a rebated inner edge, you can glue a circular mirror onto a solid circular piece of MDF.

1 Mosaic the edge of the MDF frame using the black porcelain tesserae. Work around the edge, a section at a time. Apply glue to the edge of the MDF frame, and smooth it out with your finger. When the edge is tacky, apply a small dab of glue to the whole tessera pieces and secure them to the edge. They should be flush with both the top and bottom surfaces of the frame.

2 Mosaic a border of the black porcelain tesserae around the outer part of the mirror frame. Cut the tesserae into quarters and stick them to the outside edge of the top surface of the frame, making sure that they protrude to line up exactly with the edge tesserae applied in Step 1. Carry on applying the quarter tesserae, working inward in rings, until you have a border of the desired thickness—about four rows of the tesserae quarters.

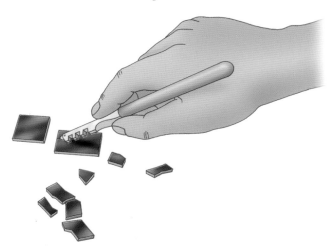

3 Mosaic a single ring of fine pieces of the gold glass tesserae. Cutting the glass tesserae into fine pieces is difficult. A helpful tip is to use a glass cutter to score a line across the back of the tesserae before using the tile nippers to cut the tesserae. The tesserae should break along the scored line. In this way, the gold tesserae can be cut into eighths. Allow for some wastage of the tesserae because cutting into fine pieces is difficult—the tesserae do not always break evenly. Use tiny dabs of glue to secure a single row of the gold pieces carefully around the inside of the black border so that there is a ring of gold.

4 Mosaic the inner rebated edge using the cream porcelain tesserae. Cut the tesserae so that they are just shorter than the depth of the inner edge. Apply the tesserae in the same manner as for the outer edge (Step 1). Make sure that the tops of the tesserae are flush with the top surface of the MDF.

5 Mosaic the remaining area with the cream porcelain tesserae. First use a pencil or felt-tip pen to draw several free flowing lines across the surface of the MDF. These lines mark separate bands of the cream area. Complete the bands one at a time by filling in with cut pieces of the cream porcelain

tesserae. If you wish, include a few tiny fragments of the gold tesserae in the cream area. At the edge of the inner circle, ensure that there is a small gap—about ¹⁄₁₆ inch (2 mm) between the porcelain pieces being applied and the tesserae applied to the inner edge. When the mosaicing is complete, leave the glue to set for several hours before grouting.

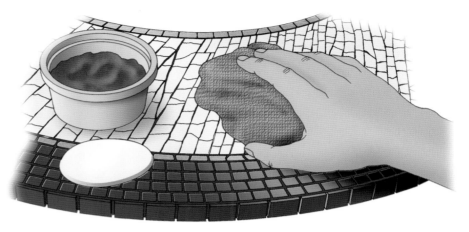

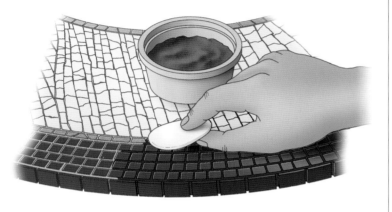

6 Grout the black and gold area with black grout. Mix up the powdered grout with enough water to make a smooth, thick paste. Use a fine, flexible grout spreader to carefully grout the black and gold areas, ensuring that you do not get black grout onto the cream area. When grouting the outer edge, use a utility-knife blade to remove the excess grout. Leave the black grout to dry, and clean up the surface with a damp cloth or scourer.

7 Grout the cream area with cream-colored grout. Apply the grout using a flexible grout spreader, and be careful not to overlap onto the black grout. Grout the inner edge in the same manner as the outer edge in Step 6. Leave the grout to dry before cleaning up with a slightly damp cloth.

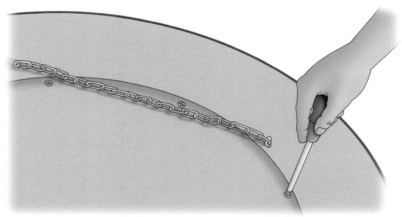

8 Turn the mirror over and drop the mirror glass into the rebate. You can use a small amount of silicone adhesive to fix the mirror if the fit is not exact. Cover the back of the mirror with a thin circular piece of hardboard or MDF and secure this with countersunk screws. Finally, attach a heavy-duty chain with screws so that the mirror can be hung securely.

TEMPLATE

Diameter: 35½ inches (90 cm)

Enlarge template by 600%

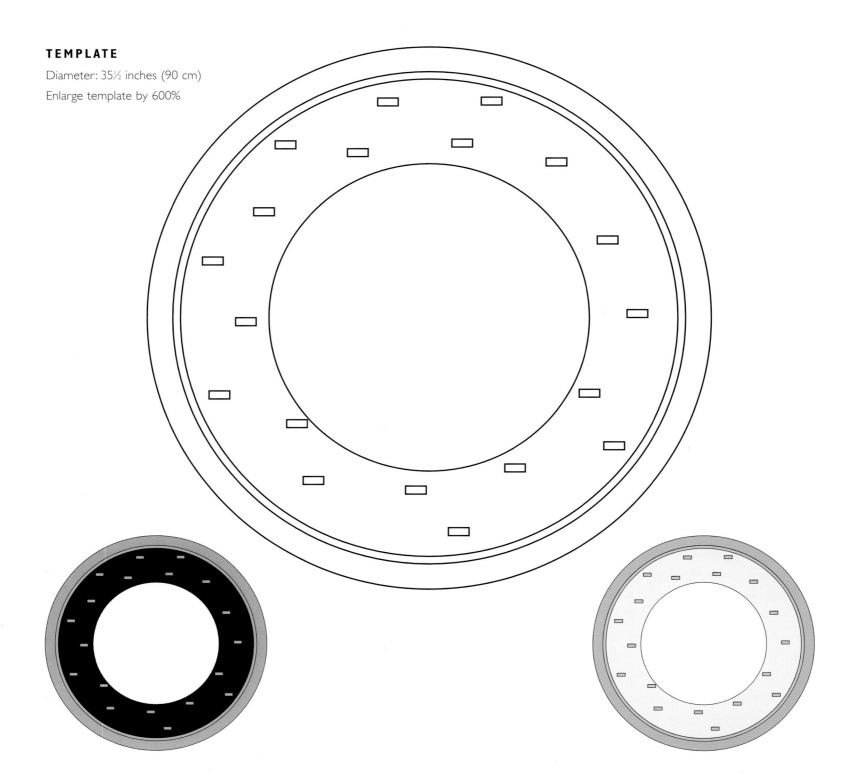

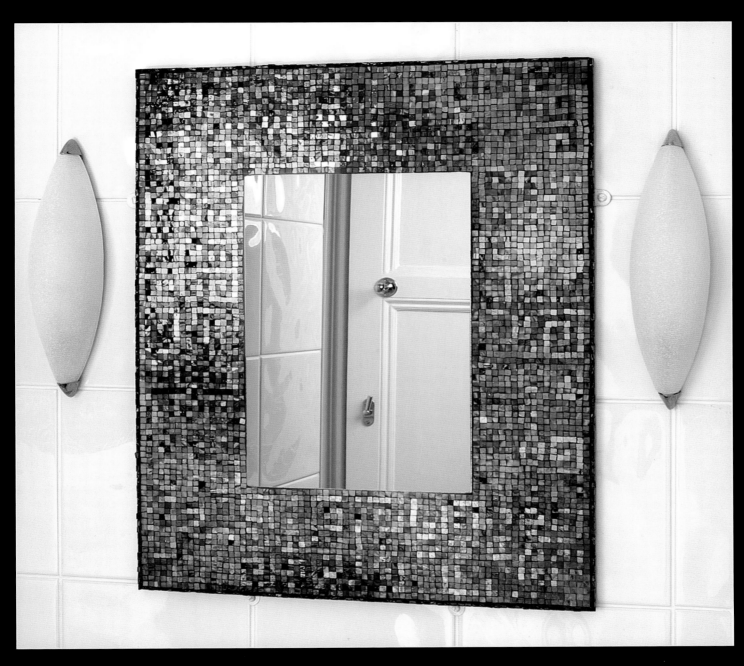

Ruth Coram
Paphos
2000
17¾ × 21½ in / 45 × 55 cm
stained glass, iridescent black, bulls' eye ring mottle

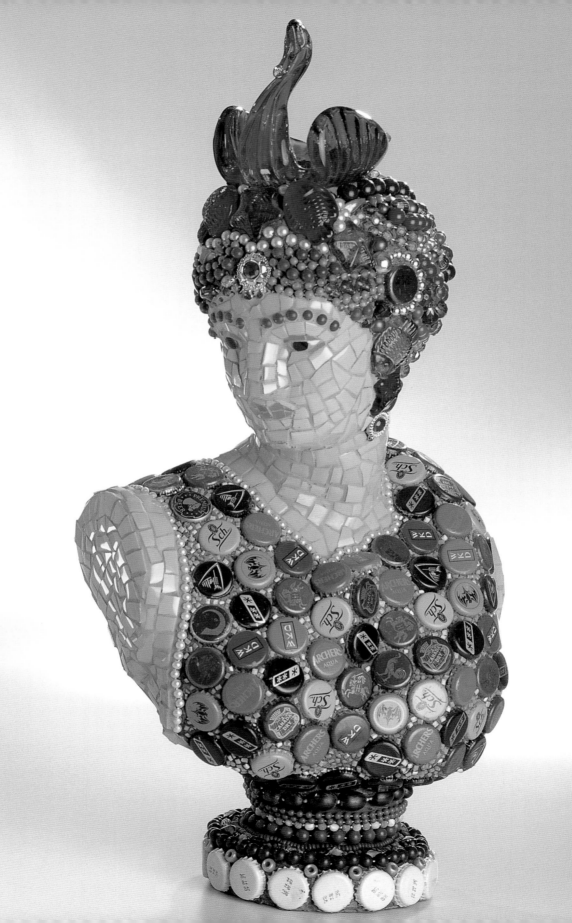

Trash goddess statue

CREATED BY SARAH KELLY

★★★ COST ★★★ TIME ★★★ DIFFICULTY

MATERIALS

Statue base (cement or concrete)

White craft glue (see page 54)

Cement-based adhesive with a latex (or performance-enhancing) additive

Colorant for the adhesive (powder or acrylic paint)

Trash—items used here include necklaces, marbles, glass ornaments, junk jewelry, beads, bottle caps and glittery aquarium beads

Broken china or ceramic tiles

Colored grout

EQUIPMENT

Paintbrush

Small spatula

Scissors

Protective goggles, mask and gloves

Tile nippers

Tweezers (optional)

Rubber gloves

Flexible rubber spatula or potters' kidney

Sponge

Bucket

Towel

Soft cloth for polishing

Found objects and trash are combined to transform a garden statue into a kitsch and completely over-the-top "Goddess." Abandon restraint and let your imagination run riot with materials and color. The steps outlined here represent the processes used in creating this particular statue. These are meant as a guide to the order of the stages and ways of creating certain effects, but your choice of base and materials will alter some of the latter. When you choose the statue, pick one that is really appealing to you in terms of shape and subject. The addition of mosaic will substantially increase the weight of the base, so this must also be a consideration when making your choice. The materials used here make the statue unsuitable for siting outside in unfavorable weather conditions.

1 Brush off any dust or dirt from the base and seal with a 50:50 mix of craft glue and water. Mix a small batch of cement-based adhesive with the additive, and color it with acrylic paint or powder colorant. The adhesive will show through on many areas of the statue, so coloring it makes it more sympathetic to the overall color scheme. Here, blue acrylic paint was added to gray adhesive to make a slate blue color.

2 Apply a thick layer of adhesive to the front of the head and push the household ornament firmly on top.

4 Create a tiara and hanging earpieces with small flat objects and junk jewelry, and fill in any odd spaces with individual beads. You can also make an elaborate centerpiece for the forehead.

3 Use strings of beads for the hair (necklaces where each bead seems to be threaded individually are best, so that they don't fall off when the string is cut). Starting as close to the ornament as you can, push one end of a necklace into the adhesive at the front of the head and continue pressing the necklace down until you reach the back (or the ends of the hair, depending on the design of your statue). Trim off the excess with scissors. Try and create the effect of flowing hair by making some of the necklaces "ripple" over the head. The adhesive should be thick enough to embed the beads but not so thick that it squeezes up and obscures them in any way. Continue working down the side of the head, adding in any other necessary ornaments above the ears. Repeat on the other side.

5 The robe is decorated with a mosaic of bottle caps with decorative aquarium beads pushed into the spaces between (regular beads can be used instead). The sleeves and neckline are then edged with strings of fake pearls.

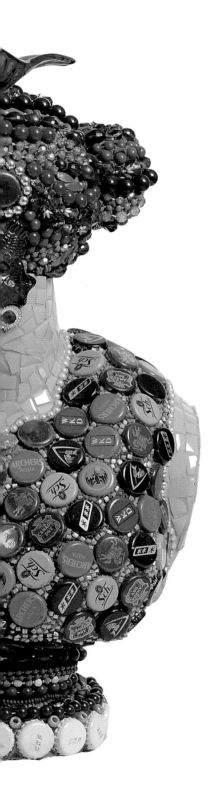

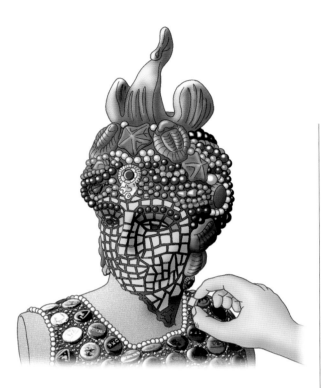

6 Use small sections of necklace to make eyebrows. Make the eyes as realistic as possible using pieces of ceramic nibbled into shape with the tile nippers. Apply the adhesive directly to the base, but make it much thinner than before. The rest of the face and skin are covered with randomly broken ceramic tiles or smashed china in a uniform color. The area around the nose and mouth requires very small tiles to retain the definition of the features. This is tricky, but it is worth spending some time to get it right. Laying the statue down on a folded towel and using tweezers to place the tiles makes this process a lot easier.

VARIATIONS

The options available for your statue will vary enormously depending on what materials you have on hand, but if you have a large collection or are collecting especially, you could try a realistic effect using natural colors. Take inspiration from exotic and elaborate costumes from around the world.

7 If your statue is more of a bust, like the one shown here, decorate the base with more necklaces and bottle tops.

8 Mix up a grout that will dry to a color similar to the skin tone (experiment with a small amount first before mixing up a whole batch). Grout the ceramic areas, taking special care not to get any on the other parts of the mosaic. Clean with a damp sponge, and polish with a soft cloth when dry.

TEMPLATE

Height: 23½ inches (60 cm)

Enlarge template by 300%

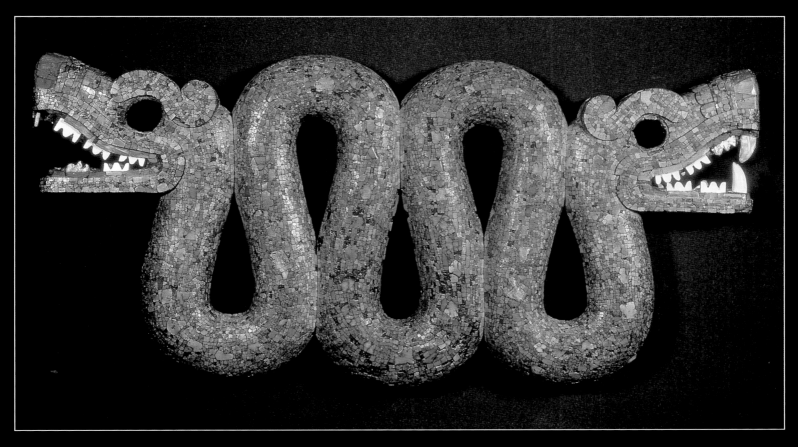

The Serpent God, Mixtec-Aztec

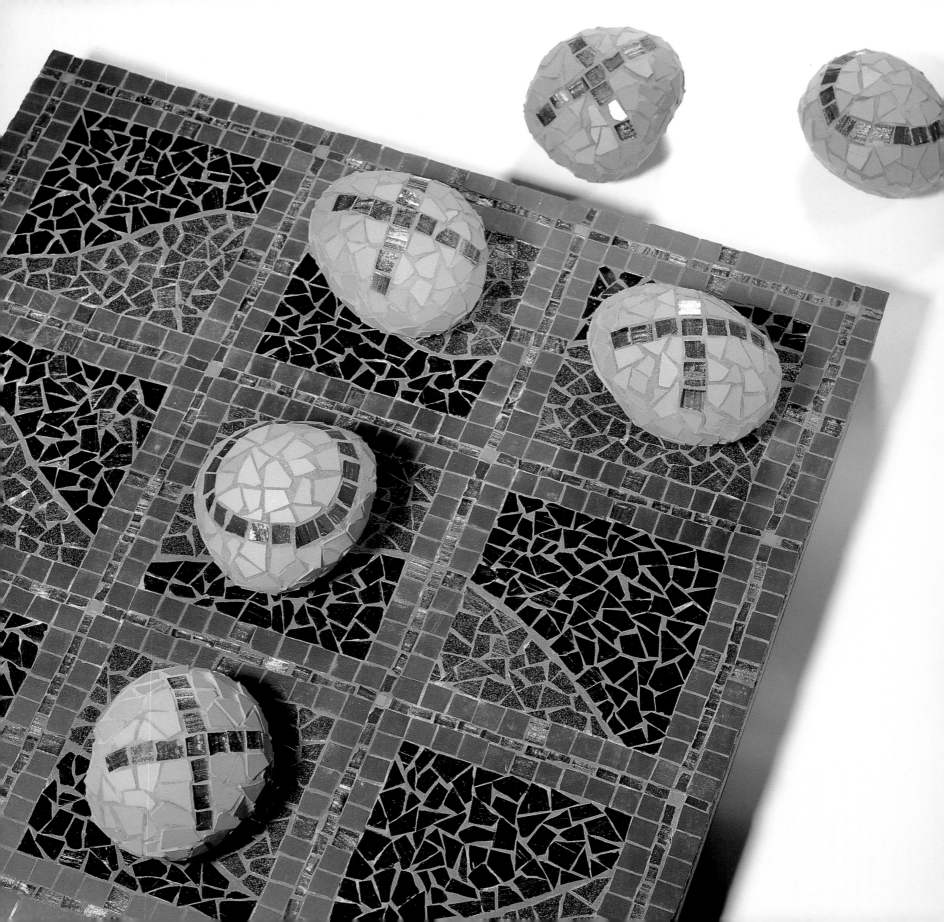

X's and 0's game

** COST *** TIME *** DIFFICULTY

CREATED BY ANNE READ

The additional beauty of mosaics is that they are durable and can serve many purposes—this one is for play, but it can also be used as a practical patio or paving stone. The design was inspired by a long-abandoned attempt at making a quilt. Children often enjoy playing X's and 0's using pebbles. These two ideas have been combined here.

MATERIALS

Mold (see Step 1 for details)

Plywood baseboard 23⅝ × 23⅝ in (60 × 60 cm)

4 wood battens, ⅞ × 1⅞ × 17¾ in (2.2 × 4.7 × 45 cm) each

Screws

General-purpose oil

Slab

Hard sand

Soft sand

Portland cement

Mosaic

Brown wrapping paper

Masking tape

Unglazed ceramic tiles:

 120 black—cut in quarters

 150 gold or ochre—2 cut in sixteenths; the rest cut in crazy-paving style

Vitreous glass tiles:

 110 shiny black (crazy paving)

 170 charcoal gray (crazy paving)

 45 blue with gold veins (8 cut in eighths; the rest in quarters)

 75 green with gold veins (26 in quarters; remainder in eighths)

White craft glue (see page 54)

Exterior-grade grout, black

Mesh

10 pebbles, less than 4½ in (110 mm) in size so that they will fit into the squares on the board

EQUIPMENT

Work board

Ruler

Pencil

Set square

Scissors

Cloths

Protective goggles, mask and gloves

Tile nippers

Rubber gloves

Spatula

Bucket

Sponge

Wire cutters

25-in (65 cm) length of wood strip for leveling

Trowel

MAKING THE MOLD

1 Take the baseboard and square up 17¾ inches (450 mm) from the center; draw lines in pencil on the board. Screw on the outside wood strip, allowing for the loose wood strips that you cut to fit; these are put on their side to give a slab thickness of 1⅞ inches (47 mm). Double-check that when the mold is assembled, the void is still 17¾ inches (450 mm) square. Mark up the loose and static wood strips with corresponding numbers so you know where they go for reusing the mold. Oil the mold and the loose tile wood strip—wherever the concrete may stick needs to be protected.

3 Gather your materials and cut a supply in the shapes and sizes required for each color: the black ceramic in quarters; the green and blue into eighths for the slab and quarters for the pebbles; a gold or ochre tile into sixteenths; the two black glass colors into random shapes; and some gold or ochre into random for the pebbles.

4 Draw your design onto the paper. Remember that you are working indirect, so the image you see will be a mirror image of what you draw now—this is not a problem with this abstract geometric, but if you add letters or numbers, they will be back to front.

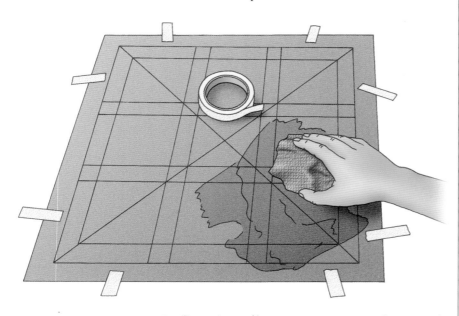

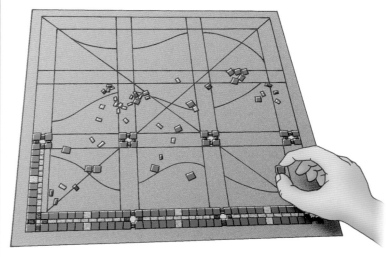

2 Cut a piece of brown wrapping paper big enough to stretch over your work board. Using a damp cloth, wet the paper and stretch it over the board, securing with masking tape on the back. The paper is stretched to reduce the risk of the mosaic buckling up when the wet cement is put into the mold.

5 Start working in the square corner blocks. Brush on a small area of wallpaper paste and affix the cut tiles as per the pattern—flat side of the tile down.

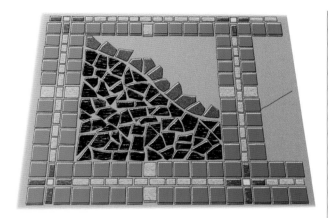

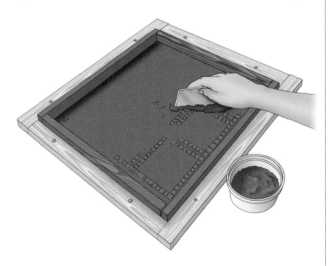

6 Next, work on the columns and finally the crazy-paving centers of the squares in the two colors of black glass: the charcoal one side of the line and the black glass on the other, alternating as you work across the squares. Be careful to keep inside your lines or your mosaic will not fit into the mold. Leave to dry.

7 Trim around the paper as close to the mosaic as possible. Lay the mosaic into the mold, paper side down. Grout this to ensure that all the gaps are filled and the cement does not push through to the front of the slab. Exterior-grade black grout is used for the slab. It is important to thoroughly wipe the grout off the back of the tiles, but ensure the gaps are full. Use only a damp (not wet) sponge, and be patient. It takes time, but it is worth it to get a clean surface of tile for the cement mix to stick to.

8 You can use an ice cream tub as a measure for the slab mix: 2 parts sharp sand, half a part of soft sand and 1 part Portland cement. Put into a dry bucket and mix with a trowel. Pour from one dry bucket into another several times back and forth until all the grains of sand are covered in cement and it is an even color. This is a less strenuous method of mixing. Put some of the dry mix into your third bucket, and keep this as the only bucket you add water to. Add water a little at a time; it is surprising how little you need to get the correct consistency. It should be wet enough to push into the mold but not so wet that a puddle accumulates on the top when the slab dries out or there will be shrinkage. It is best to make up a quarter of a bucket at a time, as a full bucket is heavy to mix.

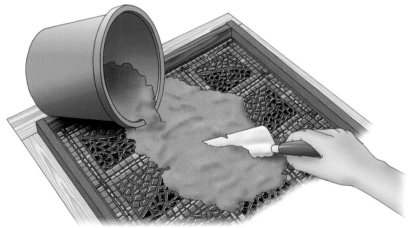

9 Half fill the mold, pushing the cement mix into the corners and tamping it down to remove any potential air bubbles.

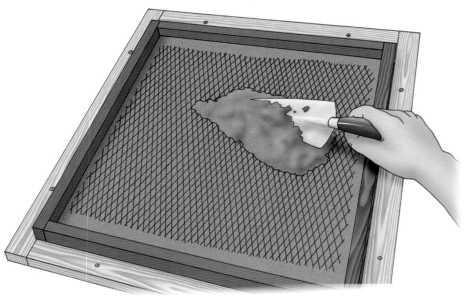

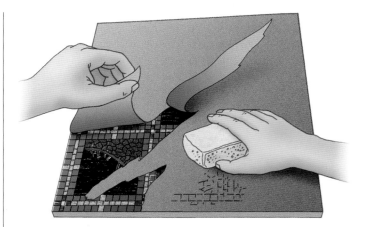

10 Cut the mesh to fit, and lay it gently on top. Apply the rest of the slab mix until the mold is full. With the strip of wood, tap it back and forth in all directions across until the slab is level with the top of the wood surround. Leave to dry out slowly, unexposed to sun, heat or frost.

11 Five days later, unscrew one of the wood strips and take out the loose strips all round. Slide the slab out carefully and gently turn it over. Wet the brown paper and peel it off. Wipe over the slab to remove all loose grout and paste. Regrout the piece.

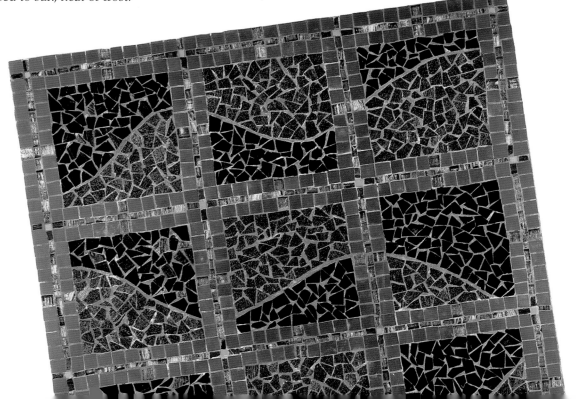

MAKING THE PEBBLES

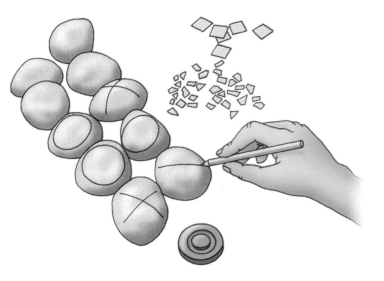

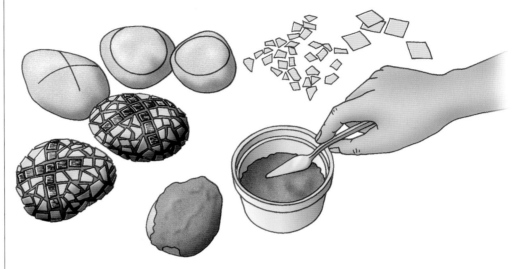

12 The pebbles should be no more than 4½ inches (11 cm) all around. Draw 0's on one side of five of the pebbles, and X's on one side of the other five. Ensure that the 0's and X's are no more than 2¾ × 2¾ inches (7 × 7 cm).

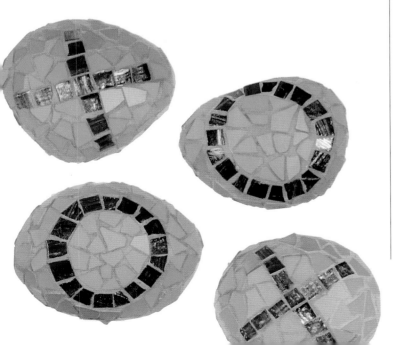

13 Mix up some exterior-grade, floor-tile adhesive, and cover the top and sides of a pebble with it. The adhesive should be the thickness of the mosaic tile plus a bit, so that the tile is embedded in the adhesive and does not touch the pebble. Make a central mark and shape the quarters into a flowerpot shape, with two angled side pieces. This enables you to go round the curves of the 0's. For the X's, find the center, and put three tiles on either side of it in the four directions. Fill in the background with the ceramic gold or ochre taking it around and under the sides of the pebble, but leaving the bottom uncovered. Leave to dry slowly. Three days later, grout using gray exterior-grade grout.

14 The following day, polish all the pieces up with a dry cloth.

TEMPLATE

17¾ × 17¾ inches (45 × 45 cm)

Enlarge template by 300%

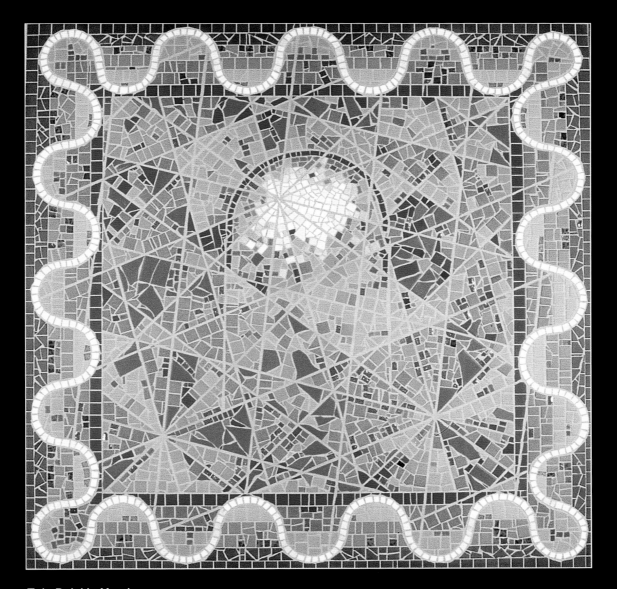

Twin Dolphin Mosaics
Nuovo Mondo
48 × 48 in / 122 × 122 cm
porcelain

Cast-marble paving slab

✱✱✱ COST ✱✱✱✱ TIME ✱✱ DIFFICULTY

CREATED BY ROSALIND WATES

MATERIALS

Casting frame, 12 × 12 in (30 × 30 cm) inside the wood strips (see page 292 for how to make the mold)

Brown wrapping paper

White craft glue (see page 54)

Marble rods or pieces

Vaseline or petroleum jelly

Portland cement

Sand

Reinforcing mesh (you can use wire netting)

EQUIPMENT

Protective goggles, mask and gloves

Scissors

Pencil

Brush

Rags and sponges

Tile cutters

Rubber trowel

Mixing containers and buckets

Trowel for mixing sand and cement mortar

Wooden batten

Plastic sheet

Screw driver

This little panel makes an ideal feature in the garden or a terrace. A series of panels can be used to create a path. Cast mosaic panels are solid, weatherproof and strong. They are ideal for tesserae of uneven depths, as the disparity is absorbed within the panel and presents a flat surface on the top. Marble is not the easiest material to cut, but the beautiful, natural, earthy colors make it well worth the effort. You can buy ready-cut mixed bags of marble tesserae or rods—strips of marble that you cut down yourself. The design of this panel is deliberately simple to show off the beautiful colors of the marble. The tesserae are all rectangular except for the central white and red area. It might be fun to create a series of four: a heart, a diamond, a club and a spade!

1 Cut out a piece of brown wrapping paper 11¾ x 11¾ in (29.5 x 29.5 cm) to fit inside the casting frame. It should be ¼ inch (5 mm) smaller than the actual frame so that when it is placed in the frame, the mosaic ends up inset a little. Because for the most part you are simply working from the outside in on the actual mosaic construction, you don't need a precisely measured design, but you will need to draw the little heart in the center. (To find the center, just draw two diagonal lines from corner to corner. They will intercept in the middle.)

2 Dilute the craft glue with water: one part glue to three parts water. Apply with the brush to the

brown paper, and use this to glue the marble tesserae face down. Start with the black outside border, working your way in toward the center. The tesserae should be about ⅛ inch (1.5 mm) apart.

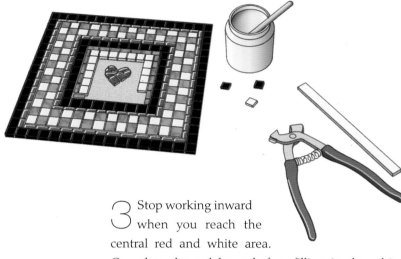

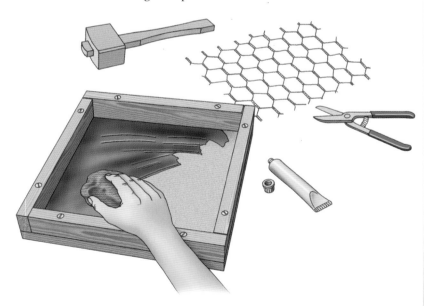

3 Stop working inward when you reach the central red and white area. Complete the red heart before filling in the white surround. The red heart has a line of white marble tesserae contouring the heart shape. A variety of wedge-shaped tesserae will be useful for this.

4 Use a small piece of rag or sponge to smear the vaseline or petroleum jelly over the interior of the casting frame. This will prevent the panel from sticking to the wood.

5 Cut a piece of reinforcing mesh or netting wire with the tin snips so it is slightly smaller than the size of the frame. Use a wooden mallet to flatten it if necessary.

6 Place the mosaic in the bottom of the casting frame, paper side down.

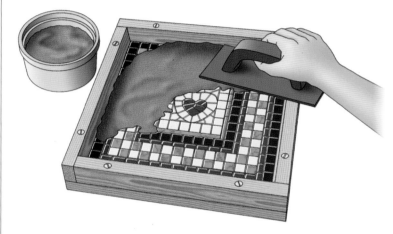

7 Mix a little of the Portland cement with water to form a slurry that spreads easily without being too runny, and grout the back of the mosaic, working the mixture into the joints with the rubber trowel. Gently scrape and wipe off the surplus, so the back of each tessera is clear. Note: Wear rubber gloves when working with cement.

8 Mix up the sand and cement mortar: three parts sand to one part cement, adding water to make a moist but not runny mix. Use a trowel to apply this to the back of your mosaic, and pack it down carefully at the sides and corners. When you have half-filled the depth of the casting frame, stop putting any more sand and cement mix in, and smooth it off.

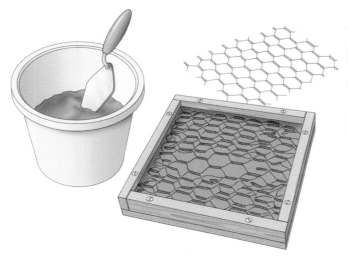

9 Place your reinforcing mesh or wire netting onto the layer of sand and cement mix, and then top up the casting frame with more sand and cement mortar. You can use a rigid wood strip, longer than the width of the frame, to smooth off the surface.

10 Wrap the frame and panel in plastic sheeting to prevent it from drying out too quickly. Leave it to cure for a few days, preferably a week.

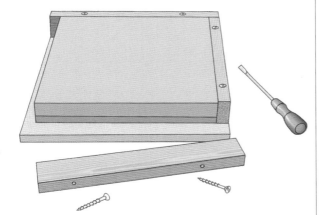

11 Unscrew the wood strips to release the panel, and carefully turn it. (Place a board on the top to form a rigid sandwich.) Remove the baseboard to reveal the brown paper on the front of your mosaic.

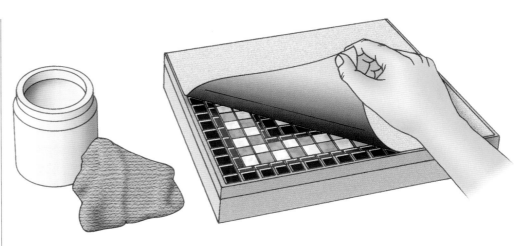

12 Dampen the paper with warm water, using a rag or a sponge. Keep it moist for a few minutes until the brown paper begins to peel off easily. Pull the paper back over itself, rather than away from the panel, to make absolutely sure you don't pull out any tesserae.

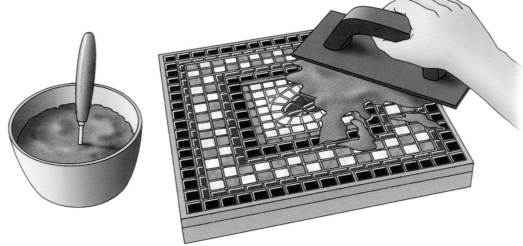

13 Top up the grout with more Portland cement mixed with water. Wipe off the surface, and wrap up the panel again in the plastic sheeting. Ideally you should leave it for another two weeks to cure.

TEMPLATE

12 × 12 inches (30 × 30 cm)

Enlarge template by 200%

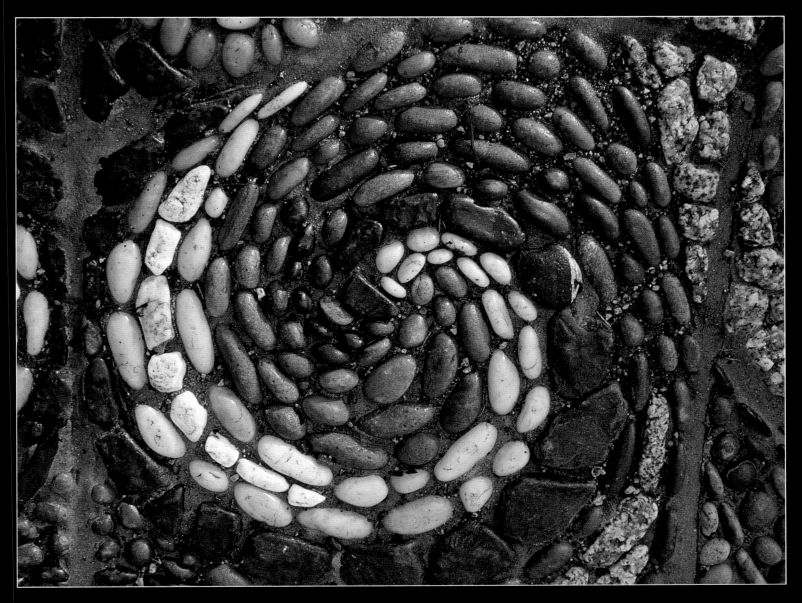

Janette Ireland
Malham Mosaic
7¼ × 7¼ feet / 2.25 × 2.25 m
pebbles, polished stones, granite

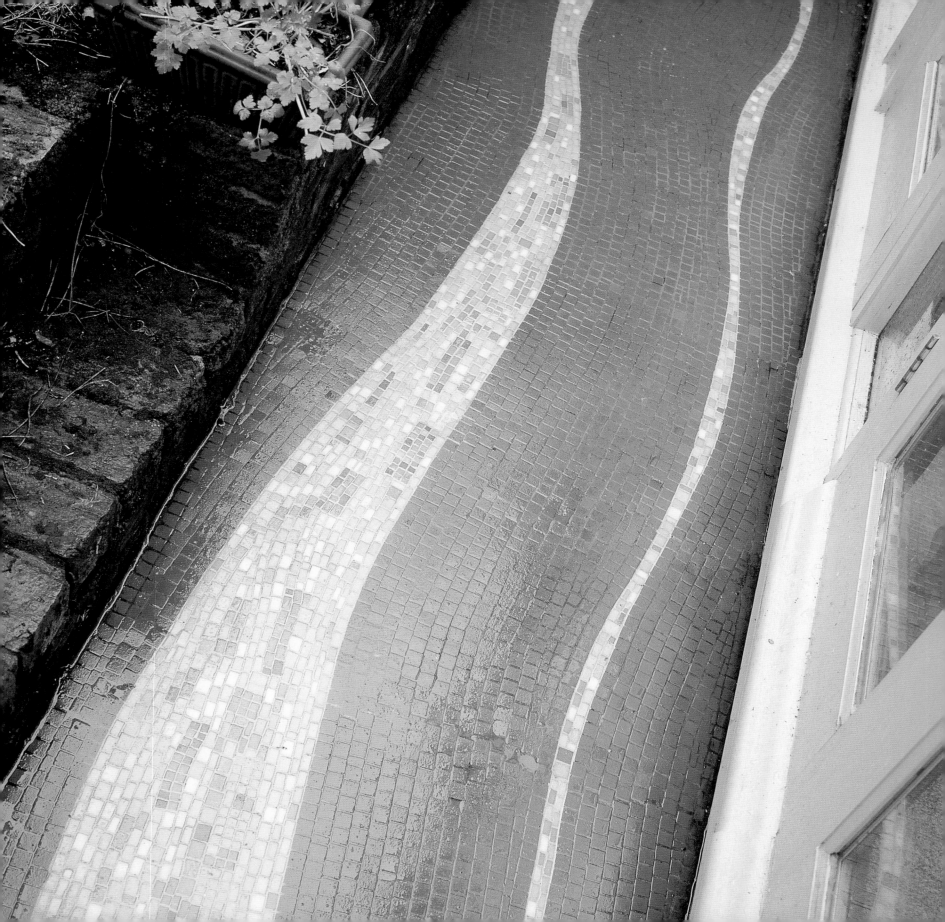

Permanent garden path

★★★★ COST ★★★★ TIME ★★★ DIFFICULTY

CREATED BY JULIET DOCHERTY

Using mosaic on a permanent pathway or other outside area can really enhance a garden. Depending on what effect you want to achieve, the design can either be subtle, using earth and plant shades, or striking, such as this one. The path for which this mosaic was created was directly in front of glass doors, which opened out from the kitchen. It measures 3 × 12 feet (100 × 44 cm) and is composed of a beautiful, flowing inset, which may be adapted for any size or shape of path.

MATERIALS

Drawing paper

Masking tape

Brown wrapping paper

Black porcelain tesserae

Selection of turquoise vitreous glass tiles

White craft glue (see page 54)

Flexible external-grade, frost-proof grout

Flexible external-grade, cement-based adhesive

EQUIPMENT

Pencil

Charcoal stick

Felt-tip pen

Drawing board

Tape measure

Brush

Protective goggles, mask and gloves

Rubber gloves

Bucket and stirrer for grout

Utility-knife blade

Flexible grout spreader

Sponges

Large bucket for mixing Portland cement

Electric drill and attachment for mixing

Wire wool or nylon pan scrubber

Color is often the starting point for design, so the color scheme should be determined first. For this particular pathway, a palette of cool turquoises, which would enhance the garden yet complement the adjoining kitchen, was chosen. To avoid another strong color competing with this, the turquoise was offset against a neutral charcoal color. As for texture, the turquoise would be vitreous glass tiles, the charcoal area mat and unreflective porcelain tesserae. In order to enhance the different colors of the mosaic, the turquoise areas were grouted with green grout and the charcoal areas with dark gray grout.

Once the materials were decided, the design was very simple. The long, thin rectangular form needed breaking up with some gentle curves. The design became two simple swaths of turquoise glass snaking across a neutral charcoal background.

There are two ways of tackling a project of this kind. You could construct the entire mosaic on nylon mesh, then bed it into cement—this is the direct method. Alternatively, you can complete the project using the indirect method by sticking the mosaic face down and in reverse onto brown wrapping paper.

The indirect method was chosen in this instance for several reasons. First, the two different materials (glass tiles and porcelain tesserae) are slightly different thicknesses. Using the indirect method resolves this problem as it results in a perfectly flat surface. Second, the glass tiles were cut into tiny pieces and the tiles are slightly concave on the back. This makes sticking them onto mesh (direct method) both challenging and time-consuming. Finally, the flat surface of the brown wrapping paper enables you to draw the design easily.

A final consideration when completing a mosaic of this scale is time. While the shiny blue/green tiles were cut into pieces to create texture and rhythm, the porcelain tesserae were mainly left in whole pieces.

1 Make a paper template of the path. It is vital that the template fits perfectly as it needs to be flush to all the walls on all sides. The template is made of sheets of drawing paper taped together on site.

2 Lay out a roll of heavy-duty brown wrapping paper with the shiny, ribbed side up. Flip the template onto this, making sure that the underside of the template is facing upward, and trace the outline onto the brown paper. It is important to remember that you are now working on the reverse of the design.

3 Draw the design onto the brown paper with a piece of charcoal. When you are happy with the design, draw it out with a felt-tip pen. As the design is so big, place it on the floor with a drawing board placed under the section being worked on.

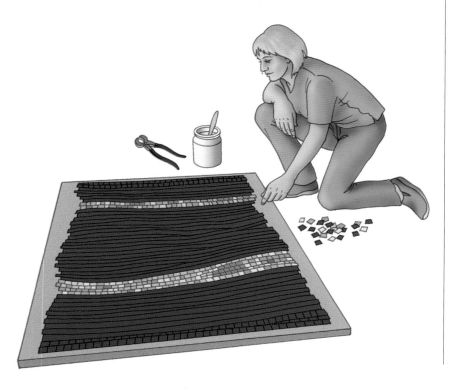

TIP

A project of this scale needs two people to lay it, so make sure you have an assistant.

4 Stick the tesserae face down onto the brown paper. Work along the length of the paper, completing about a 2 × 3-foot (60 × 90 cm) section at a time. It is important to use a runny mixture of craft glue (strong enough to hold the piece on when it is turned over, yet soluble enough to be dissolved with water when removing the brown paper after the mosaic is laid). Paint the craft glue onto the brown paper, then stick the tesserae pieces face side down. Leave gaps of about 1/16 inch (2 mm), no less, so that the grout can penetrate.

5 Once the design is complete, cut it into manageable sections of about 2 × 3 feet (60 × 90 cm). Carefully cut the paper using a utility-knife blade. Pick each section up and turn upside down to check for loose tiles. Stick back on any pieces that fall off. Number each section, and stack the cut sections onto a board for carrying to the site.

6 Make sure that the concrete onto which the mosaic is to be laid is level and in good condition. Scrub the concrete before laying (preferably the day before) with a fungicidal wash in order to clear any dirt and build up of moss, etc.

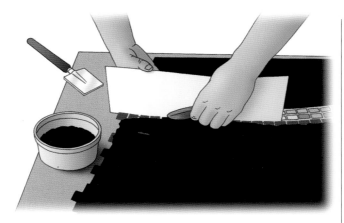

7 Mix enough grout for the first section following the manufacturer's directions. Apply the grout using a flexible grout spreader on the first section of mosaic on brown paper, wiping off any excess with a damp sponge. If there are two different colors of grout, use a flexible piece of cardboard slotted in the $\frac{1}{16}$ inch (2 mm) gap between the tiles to prevent the first colored grout from running into the other colored area.

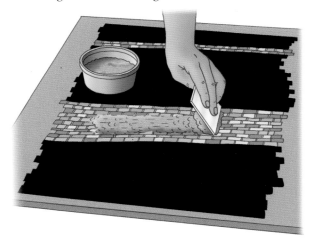

TIP

In order to get the correct colored grout for the turquoise areas, add acrylic paint to a neutral buff-colored grout.

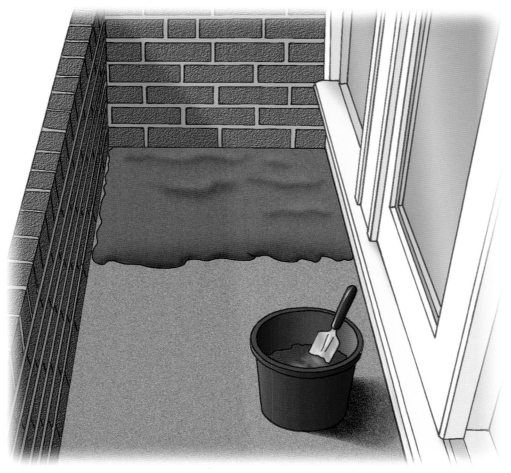

8 While the first section is being grouted (Step 7), your assistant should mix up enough of the cement-based adhesive to cover the area of the pathway for the first section. Do this in a large plastic bucket using an electric drill with a mixing attachment. Lay the adhesive onto the concrete base, and use a notched spreader to obtain the correct thickness, about $\frac{3}{16}$ inch (4–5 mm). Because of the size of the sections, the grouting and laying of the adhesive should be done almost simultaneously to prevent the grout or adhesive from drying too much.

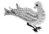

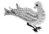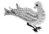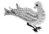

10 Wait for 10 to 15 minutes, and then gently apply some water to the top of the brown paper with a sponge. When the paper changes color, test a corner to see if it peels away easily. Once the paper is soaked sufficiently, gently peel it off.

9 With your assistant, carefully pick up the grouted section and turn it over so that the brown paper is on top. Position it over the area prepared with adhesive, and lay one edge down onto it. Roll the mosaic section into place, but do not press it down with your fingers. Place a board on top of the section and tamp it down firmly with your fists.

11 Repeat steps 7 to 9 for each of the remaining sections of the mosaic.

12 Once all the sections have been laid, you will have a smooth mosaic that has already been grouted. Leave to set for 24 hours before walking on the mosaic. At that time, the edges and joins between the sections can be grouted. You can also fill in any tiny gaps in the grout. Clean up any areas that have too much grout with wire wool or a damp pan scrubber. When the mosaic is completely dry, the glass tesserae areas can be buffed up with a lint-free cloth.

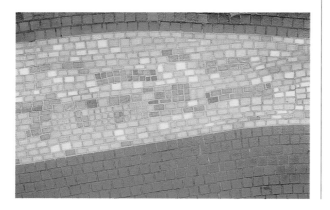

TEMPLATE

12 × 3 feet (365 × 92 cm)

Enlarge template by 2000%

*Mosaic sidewalk in Ponta
Delgada, Sao Miguel
The Azores Islands*

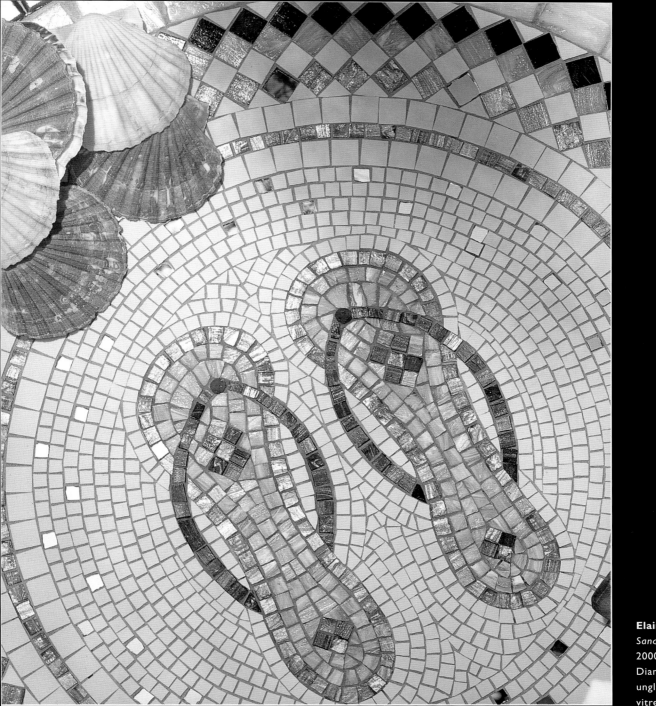

Elaine Goodwin
Sandal Mosaic
2000
Diameter: 24 in / 61 cm
unglazed ceramic, mirro
vitreous glass

Glossary

ACRYLIC PAINT

Water-based paint that can be used to add color to grout and to paint exposed wooden surfaces on a mosaic base, such as the edges of panels and legs of chairs.

ADHESIVE

The medium used to stick the tesserae to the base or sub-structure of the mosaic. There is a range of choices, depending on the base, the materials used and the mosaic's ultimate location.

ANDAMENTO

The term used to describe the flowing lines of a mosaic achieved by laying the tiles in a certain way that is enhanced by grouting.

BASE

The surface on which the mosaic is laid.

BUTTERING

A technique in which adhesive is applied to the underside of the tesserae, as well as or instead of the base, which is more common. Buttering helps to raise the level of thinner tesserae to that of the other pieces.

CASTING FRAME

A wooden frame that is used to cast concrete slabs using the indirect mosaic method.

CURING

The process of drying out cement.

DIRECT METHOD

In this method, the tesserae are attached face-up, directly onto the base.

EMBLEMA

Decorative mosaic panels that are inserted into larger areas such as floors or walls; a technique used by the Romans.

EML

Expanded metal lath, which is applied to a cement "sandwich" when casting slabs.

FILATI (SMALTI FILATI)

Tiny pieces of colored glass used in micromosaics.

GLASS NUGGETS

Small glass "blobs" with flat bases, which come in a range of colors and finishes, such as transparent, sand-blasted or iridescent. Also used in stained glass.

GROUT/GROUTING

The material/process used to fill in the gaps, or interstices, between the mosaic tesserae. It is an important part of the process of mosaic as it helps to unify the design, as well as protecting the mosaic—essential if it is to be placed outside or in wet areas.

HALF-GROUT

A layer of cement-based tile adhesive or cement/sand mix laid over the base to a depth of around $\frac{3}{16}$ inch (5mm)—it will vary depending on the thickness of the tesserae—into which the tesserae can be pushed if they are not suited to grouting in the normal way (for example, smalti, pebbles and shells). Care should be taken that it does not come over the edges of the mosaic.

HYDROCHLORIC ACID

A powerful acid used as a cleaning agent to remove unwanted cement and cement-based products from the surface of a mosaic.

INDIRECT METHOD

Also called the reverse method, it is used when it is necessary to achieve a perfectly smooth, flat surface—for example, on floors. The tesserae are stuck face down on brown paper before being laid onto the base.

INTERSTICES

The gaps or spaces between the tesserae.

KEY/KEYING

The effect, or process, of scoring the base, or a thick layer of adhesive, to provide an effective grip for the tesserae.

MDF

Medium-density fiberboard, created out of densely compressed wood fiber, which is very easy to cut. It is not water-resistant.

MICROMOSAICS

Mosaics created from thousands of minute tesserae cut from glass threads. There can be as many as 1,400 tesserae per square inch (2.5 square centimeters) of mosaic.

MORTAR

A mix of cement, sand and water.

NIBBLING

The action of removing, or "nibbling" away, small fragments from tesserae with the tile nippers.

OPUS

A Latin word, meaning "work." It is used in conjunction with other Latin terms to describe different ways of laying tesserae to create different patterns and effects.

PLYWOOD

A wood formed out of thin layers of lumber laid at right angles to each other. Marine or WBP (weather and boil-proof) plywood are the most water-resistant.

PRE-GROUTING

The process given to the first grouting an indirect mosaic receives before it is laid on the base.

PRICKING OUT

A method for transferring a design onto a rendered wall or cement base, where the paper design is laid over the surface, and the design is pricked through the paper using a thin, pointed tool.

RENDER

A mixture of sand and cement applied to a wall or floor as a base for the mosaic.

SEALING

An important process for preventing porous bases and materials from absorbing moisture.

SLURRY

A thin, creamy, textured mix of cement, sand and water.

TAMPING

The action of tapping down a mosaic on mesh or paper onto an adhesive base using a hammer and a block of wood to ensure flatness.

TEMPLATE

A pattern for a design or a life-sized paper plan of an area to be decorated with mosaic.

TESSERAE

The pieces used in a mosaic (singular: tessera).

ZILLÏJ

A traditional Moorish (Moroccan) form of mosaic made up of specifically shaped pieces of highly glazed tiles that are arranged in complex designs. Each *furmah* (tile) is so precisely cut that the edges join perfectly. Once laid, a concrete mix is poured over the *furmah* to create a slab.

Author biographies

SARAH KELLY

Having initially trained as an illustrator, Sarah began working in mosaic in 1994, first in paper, then glass and ceramic. Experience of mixed media collage led to an interest in creating art from bits and pieces; for Sarah, mosaic represents the pinnacle of this interest. Her inspiration comes from natural forms and decorative art, and she also enjoys the challenge of portraiture using mosaic. Sarah has written three books for children—*Amazing Mosaics*, *Amazing Christmas Mosaics* and *Amazing Spooky Mosaics*—and has worked on private commissions and work for exhibition. Sarah can be contacted at sarahkelly.sarahkelly@virgin.net

ANNE READ

Having recently moved to new, more spacious studios in Devon, Anne can now accommodate of her own larger pieces in glass and ceramic, as well as expand the choice of courses she offers to developing students. Mosaics found Anne, by chance, 10 years ago—it started as a hobby that proceeded to change her life. She gave up her job to work full time on commissions and tutoring. For her own commissions, Anne often has local craftsmen produce custom-made furniture for home and garden, to which she then adds her own personal touch in mosaic. See more of Anne's work at www.mostlymosaic.com

JULIET DOCHERTY

Juliet studied 3-D design at Manchester University, and glass and ceramics at the Royal College of Art in London. She has worked in mosaic for eight years, making mirrors, tables and commissioned panels for galleries and private clients. Juliet's work has evolved from highly colored, jewel-like mosaics into a sleek and contemporary style. Her work draws attention to the texture and complexity of the mosaic by keeping the palette subtle. Juliet is inspired by the simplicity of materials like slate, glass and stone and is particularly interested in the "less is more" concept of design. See more of her work at www.bigwig.net/jdoc/index.htm

ROSALIND WATES

Rosalind is a varied mosaic artist, who works mainly on commissions for private clients, public bodies, arts organizations, schools and communities. Projects range from mosaic floors and walls, swimming pools and jacuzzis to 3-D sculptures and pictures for exhibitions and natural stone. Although versed in traditional mosaic techniques, she constantly explores the creative possibilities of the medium to produce new work. As well as creating mosaics, she also teaches and writes on the subject. More of Rosalind's mosaic work can be seen at www.rosalind-wates-mosaics.co.uk

Artist biographies

LINDA BEAUMONT

For close to 30 years, Linda has been making mosaics for the Public Art Program in Seattle, Washington. Her mixed-media works are often thought-provoking and take their inspiration from the places in which they will be located and the people who will see them.

LIA CATALANO

Mosaic represents a second career for Lia, who spent 25 years in the corporate world. With realistic designs in a classic style, she places a high value on accessibility, and invites her audience to participate as partners, viewing themes through color, texture and movement. Her primary inspiration comes from the enduring beauty of ancient mosaics and the timeless stories they tell.

IRINA CHARNY

Irina Charny was born in Russia in 1962, but now lives in California. Even before she knew what mosaics were, Irina created collages from broken glass, rocks, paper, shells and crockery. As well as conventional tesserae, Irina uses mirror, pebbles, found objects, beads, buttons, wire, handmade ceramic and broken plates in her work.

RUTH CORAM

While working in a stained-glass workshop, Ruth began to pick up and take home the shards of leftovers and experiment with them, finding a passion for mosaics in the process. This accidental meeting has led to almost a decade of creating beautiful mosaics.

LINDA EDEIKEN

After years as an arts administrator, Linda's interest in "making" art was rekindled following a year in Florence, Italy. She is excited by the redemption of antique china and its transformation into a new totality. Uniquely, Linda's work uses glass beads as grout to "frame" the exquisite shards, seashells and figurines.

GEORGE FISHMAN

George became hooked on mosaics nine years ago, while exploring the remains of beautifully patterned fourth-century Roman floors in France. Returning to Miami, he became familiar with the work of two contemporary artists, Denis O'Connor and Enzo Gallo, and began experimenting on his own. He has now made a career out of large-scale mosaic commissions.

ANITA GARRISON

Mosaic artist Anita Garrison runs Looking Glass Mosaics in Chicago, Illinois. Recent works include beautiful mirrors and vases of ceramic, glass and stained-glass.

ELAINE GOODWIN

Elaine has traveled all over the world for her love of mosaic. She was a tutor for several years in mosaic art and design and has continued to tutor at several organizations in India, Australia, England and Italy. Her published works include *Classic Mosaic* and *The Art of Decorative Mosaics*, and she has written for numerous magazines on the subject.

LIBOR HAVILICEK

While working on the interior of a bar in his native Czech Republic, Libor was given a box of broken tiles. This chance encounter was to change his work forever. Since then, he has worked on many projects, great and small.

LAURA HISEROTE

After studying metalsmithing, Laura found herself dissatisfied with metal's chromatic limitations. She was attracted to the diversity and brilliance of glass and began working in micromosaic. Undaunted by a lack of experience, Laura set up her studio in 1997. Since then, she has worked on her own pieces and restorations for the Gilbert and Versace collections. With reverence for musical mastery and minutia of living systems, Laura's micromosaics are inspired by chromatics and geometrics, the microcosm of harmony on Earth.

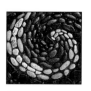

JANETTE IRELAND

At the age of 40, after a career in science, during which time she did arts, crafts and gardening as hobbies, Janette became a pupil to Maggy Howarth, who taught her the upside-down technique of pre-cast pebble mosaics. Some collaborative works with Maggy can be seen in Lytham St Anne's and Bournemouth. Some of her own work can be seen in Stevenage, Preston and Malham.

JAN KILPATRICK

While living on the Coigach peninsula in Scotland, Jan attended craft courses and discovered mosaic. Its range of colors and textures attracted her, as did the challenge of using brittle materials to create movement, and the opportunity to use discarded crockery.

SONIA KING

Sonia's mosaics are created for gallery, architectural, community and home settings. She is the president of the Society of American Mosaic Artists, instructor at the Creative Arts Center of Dallas, and a member of the Associazione Internazionale Mosacisti Contemporanei in Ravenna, Italy. She exhibits internationally as well as in private, public and corporate collections.

HELLO DARLLY GARDEN ART

Holly Henning and Darlene Mace-Harvey work together on Gabriola Island, Canada. They have been friends and glass artisans for over 20 years. Their love of nature, stained glass and the joy of creativity has blossomed into a unique art form that has unlimited possibilities.

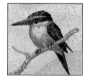

GORDAN MANDICH

Australian-based mosaicist Gordan Mandich has been working in mosaics for the past six years. After years of oil painting he came across mosaics as an art form and discovered new challenges and possibilities in its application. His works include murals, tables, sculptures and fountains. He uses Venetian smalti and marble to create both contemporary and classical pieces.

MARCELO DE MELO

Marcelo is a Brazilian mosaic artist who has been living in Scotland since 1998. The materials he uses are varied: "In my sculptures, the mosaic work is not just the 'skin,' but an integral part of the structure, contributing to its stability." He has exhibited in Brazil, the Dominican Republic, France, Italy, the U.K. and the U.S.A.

TOBY MASON

After developing his own style in stained glass, Toby developed a mosaic-based technique for using the material with colored mirror. He conceives of a mosaic not just in terms of its initial appearance but also in how the light flashes off the faces and the edges of the silvered tesserae.

CLAIRE MILNER

Illustrator, designer, painter and mosaic artist Claire Milner strives to achieve a tactile quality and sensuality in all the images she produces. All of her mosaics, handmade paper illustrations and paintings have two qualities in common: color and texture. The exploration of color as a means to convey emotion is usually her primary starting point.

MOSAÏKA ART AND DESIGN

Mosaïka is a young company, based in Quebec, Canada, with a fresh new take on the ancient art of mosaic making. Founded in 1998, it is the product of the combined talents of its founders Kori Smyth and Saskia Siebrand. Their emphasis is on "art and design," combining a modern aesthetic with exquisite traditional craftmanship.

ANTONIETTA DI PIETRO

Antonietta's mosaic creations faithfully echo traditional ancient patterns and colors, but her designs and methods also include a unique and contemporary look. She does not share the traditional ideas of mosaic theory, which state that mosaics are simply a translation of a painting into other materials such as stone or glass.

CLAIRE STEWART

Having originally trained as an interior designer and paint effects artist, Claire later became interested in mosaics. Her abstract work, mainly panels and mirrors, is inspired by art deco, the 1950s and the 1960s. Her mosaic pieces have also been featured in *The Art of Mosaic*.

TWIN DOLPHIN MOSAICS

Robert Stout and Stephanie Jurs have been creating art for public programs and private clients in the U.S. and Italy for 20 years. In 1998, they moved to Ravenna, Italy, to study Roman and Byzantine mosaic techniques. They are fascinated with scientific imagery and often use this as a starting point. Physicist Richard Feynman put it best: "What men are poets who can speak of Jupiter if he were like a man, but if he is an immense spinning sphere of methane and ammonia must be silent?"

JEANNIE WRAY

Born and raised in California, self-taught mosaic artist Jeannie has been working in the medium for around seven years. She mainly works in stained glass and has one such piece in the Chapel Hill church in Paso Robles, California.

ANASTASIA ZINKERMAN

Like in nature, Anastasia obtains a balance between order and chaos in her mosaics. Inspired by the coast, she captures a flowing movement that is at once stimulating and soothing. Recently, she has been working with glass—due to its great reflection and richness of color—creating tabletops and wall pieces.

Index

Picture credits